RECYCLED CULTURE IN CONTEMPORARY ART AND FILM

THE USES OF NOSTALGIA

The reuse of past images, plots, and genres from film history has become a prominent feature of contemporary culture. Vera Dika explores this practice from a broad range of critical perspectives, examining works of art and film that resist the pull of the past. Dika provides an in-depth analysis of works in several media, including performance, photography, Punk film, as well as mainstream American and European films. Noting the renewed importance of the image and of genre, she investigates works as diverse as Cindy Sherman's *Untitled Film Stills*, Amos Poe's *The Foreigner*, Terence Malick's *Badlands*, and Francis Ford Coppola's *One from the Heart*. Her study positions avant-garde art work within the context of contemporary mainstream film practice, as well as in relationship to each work's historical moment.

Vera Dika teaches American cinema at the University of California, Los Angeles and the University of Southern California. She is the author of *Games of Terror*, has contributed to an anthology on Francis Ford Coppola's *The Godfather* trilogy, and has also published film criticism for the *Los Angeles Times, Art in America,* and *Art Forum.*

CAMBRIDGE STUDIES IN FILM

GENERAL EDITORS

William Rothman, *University of Miami*
Dudley Andrew, *Yale University*

Cambridge Studies in Film is a series of scholarly studies of high intellectual standard on the history and criticism of film. Each book examines a different aspect of film as a social and cultural phenomenon, setting standards and directions for the evaluation and definition of film scholarship. Designed for both film enthusiasts and academic readers, the series is international in scope of subject matter and eclectic in terms of approach and perspective. *Cambridge Studies in Film* provides a foundation in the theory and philosophy of the emerging visual media that continues to shape our world.

SELECTED TITLES FROM THE SERIES

The Cinema of Satyajit Ray, by Darius Cooper
Documentary Film Classics, by William Rothman
John Huston's Filmmaking, by Lesley Brill
Projecting Illusion: Film Spectatorship and the Impression of Reality, by Richard Allen
Interpreting the Moving Image, by Noel Carroll

Recycled Culture in Contemporary Art and Film

THE USES OF NOSTALGIA

VERA DIKA
University of California, Los Angeles
University of Southern California

CAMBRIDGE
UNIVERSITY PRESS

PUBLISHED BY THE PRESS SYNDICATE OF THE UNIVERSITY OF CAMBRIDGE
The Pitt Building, Trumpington Street, Cambridge, United Kingdom

CAMBRIDGE UNIVERSITY PRESS
The Edinburgh Building, Cambridge CB2 2RU, UK
40 West 20th Street, New York, NY 10011-4211, USA
477 Williamstown Road, Port Melbourne, VIC 3207, Australia
Ruiz de Alarcón 13, 28014 Madrid, Spain
Dock House, The Waterfront, Cape Town 8001, South Africa

http://www.cambridge.org

First published 2003

Printed in the United States of America

Typeface Sabon 10/13 pt. *System* LaTeX 2_ε [TB]

A catalog record for this book is available from the British Library.

Library of Congress Cataloging in Publication Data
Dika, Vera, 1951–
 Recycled culture in contemporary art and film : the uses of nostalgia / Vera Dika.
 p. cm. – (Cambridge studies in film)
 Includes bibliographical references and index.
 ISBN 0-521-81568-1 – ISBN 0-521-01631-2 (pbk.)
 1. Nostalgia in motion pictures. 2. Nostalgia in art. 3. Art,
 American – 20th century. I. Title. II. Series.
 PN1995.9.N67 D55 2003
 791.43′653 – dc21 2002035001

ISBN 0 521 81568 1 hardback
ISBN 0 521 01631 2 paperback

To

Henry, Alexandra, and My Parents

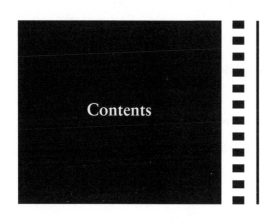

Contents

Acknowledgments *page* xi

1 **The Returned Image** 1
 The Photographic/Film Image 4
 Attacks on the Image 7
 The New Image 8
 The Nostalgia Film 9
 Strategies of Resistance 11
 Mainstream Film in the 1970s 14
 A Cinema of Loneliness 16
 The MOCA Show 18
 Conclusion 20

2 **Art and Film: New York City in the Late 1970s** 24
 The Structural Film 24
 Pictures 26
 Jack Goldstein 26
 Two Fencers 31
 Robert Longo 36
 Cindy Sherman 41
 Amos Poe 47

3 **Returned Genres: The Dream Has Ended** 55
 Badlands 56
 The Return of the Real 65
 The Texas Chainsaw Massacre 66
 The Shootist 78
 The Last Waltz 83

4 **Reconsidering the Nostalgia Film** 89
 American Graffiti 89
 The Conformist 95
 The Rocky Horror Picture Show 103

5 **A Return to the 1950s: The Dangers in Utopia** 122
 Grease 124
 Utopia Rejected 142
 Last Exit to Brooklyn 145

6 **Coppola and Scorsese: Authorial Views** 156
 Apocalypse Now 158
 One from the Heart 170
 The Last Temptation of Christ 188

7 **To Destroy the Sign** 197
 The Loss of the Real 197
 Television 202
 Serialized Forms 205
 The Return of the Classical Film Genres 207
 The Stalker Film 207
 The Western 215
 The Gangster/Crime Film 219
 Conclusion 223

Notes 225

Bibliography 231

Index 237

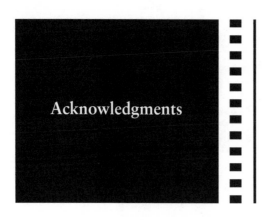

Acknowledgments

I would like to thank Bill Rothman for his interest in this subject from the beginning, for his continued and unflinching support of the project, and for his insights and comments. To be fair, however, Bill's influence started well before the book idea ever came into the discussion. As my professor at New York University, he challenged and inspired me, as did my other teachers, Bill Simon, P. Adams Sitney, Noel Carroll, and Robert Stam, with their innovative inquiry into the study of film. I would also like to thank Marsha Kinder, David James, Nick Browne, and Janet Bergstrom, my colleagues at both USC and UCLA, who have supported my efforts all these years. Some things, however, would never have been written if the computer didn't get fixed or if the documents remained lost. For this I have to thank Ali Nasri for his endless patience and Leiko Hamada for her sense of humor. Of course, the long process of writing a book is also sustained by friends who sit through long-winded discussions of topics they may find of only casual interest. For this I thank Bailey A. Rosen, my lifelong friend, for her conversation and continuing devotion, as well as Yardenna Hurvitz and Wendy Dozoretz, for always having faith in me. In this category are also my champion supporters: my husband Henry, whose love and continued care guides me through difficulty and who graces my life with happiness and understanding, and my daughter Alexandra, whose strength and intelligence makes my whole world shine. I would also like to thank Marian Keane for her hard work and careful comments on reading the manuscript, and my great friend Tom Hopkins, who always loved *One from the Heart*. And lastly, I thank my parents, who loved pictures, and who loved me.

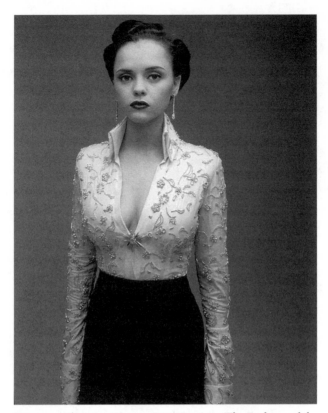

Figure 1. Christina Ricci as Bette Davis in *The Fashion of the Times* (Spring, 2000). Photograph by Marc Rolston.

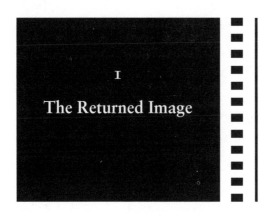

1

The Returned Image

Nostalgia film is historicist rather than historical, which explains why it must necessarily displace its center of interest onto the visual as such and substitute breathtaking images for anything like the older filmic story telling...
> Fredric Jameson, "Transformations of the Image," *The Cultural Turn*

In an initial moment, the aim was the destruction of the (ideological) signified; in a second, it is the destruction of the sign.
> Roland Barthes, "Change the Object Itself," *Image, Music, Text*

Christina Ricci is dressed up to look like Bette Davis (Figure 1) in a *Fashion of the Times* (Spring 2000) photo spread entitled "The Big Remake." What an image this is. Wasn't it just recently (in 1991 as a matter of fact) that Ricci appeared as that adorable evil child Wednesday in the film *The Addams Family,* itself a remake of the 1970s TV show of the same name and adapted from the 1950s *New Yorker* cartoon by Edward Gorey? And isn't Ricci just barely a child now? Or does it just seem that way, not only because this neophyte is presented to look like an actress from a half century ago, but also because the impulse to copy old images and old films is itself moving into its second generation? The practice continues from its first sightings in such films as *Star Wars* (1977) and *Raiders of the Lost Ark* (1981), remakes of the 1950s science fiction films and 1940s Saturday afternoon serials, respectively, to more recent copies such as Gus Van Sant's *Psycho* (1998). Fredric Jameson was one of the first critics to note this style that affected works of high art and popular culture (the Ricci/Davis photo is, after all, an advertisement for designer clothes) and that crossed boundaries among photography, film, music, dance, painting, and literature. For Jameson this tendency was an effect of "postmodernism," a cultural condition caused by the rise of multinational capitalism and characterized by the features of pastiche and schizophrenia.[1]

Jameson's assessments, however, have been widely debated,[2] often resulting in the acceptance or rejection of a theory whose actual practice has not yet been closely described. Jameson's insights are both crucial and prophetic, but they are nonetheless broad enough to allow the peculiarities and differences of many of the works they cover to remain undefined. This book is dedicated to addressing art and film during this period and to noting the possible sites of resistance in this culture-wide pull to the past.

The most crucial aspect of pastiche, as described by Jameson, is its impact on our perception of history. According to Jameson, the use of pastiche, as the imitation of past styles without parody's derision or laughter, is of such insistence in our society that it actually signals an impeded ability to represent our own time and to locate our own place in history. Related to this temporal confusion, Jameson also notes a troubling sense of surface and a loss of meaning in contemporary works. He describes this as "schizophrenia," a quality that renders the signifiers of cultural products (whether the surface of the image, the sounds in music, or the words in literature) dense, material, and so not able to convey their full meaning. From Jameson's description, it seems that this temporal and linguistic density erects a type of barrier, blocking reference to the natural real (that is, to real things in the world) and to history. So when Jameson asks whether there can be a form of resistance within postmodernism,[3] we can assume that if there were one, its purpose would be to rupture these obdurate and a-historical surfaces. Jameson proposes a similar strategy in *Postmodernism, or, The Cultural Logic of Late Capital*. He writes, "Only by means of violent formal and narrative dislocation could a narrative apparatus come into being capable of restoring life and feeling to . . . our capacity to organize and live time historically."[4] The questions that now arise are *how* this might be accomplished in practice and to what extent such an effect could be attained.

In the present study I will consider the possibility of resistance in film and art practice, both commercial and avant-garde, across the decades from the 1970s to the 1990s. The notion of a critical art, however, must be newly formulated for this period since it utilizes a set of strategies less assaultive than those of modernism, yet no less crucial to consider. Hal Foster has already posited the existence of a "resistant postmodernism" in the fine arts,[5] as well as presenting a more encompassing discussion of the return of the real as a thing of trauma in recent works. Here the "real" is posited as the negative of the symbolic, i.e., that which

cannot be represented, but which nonetheless returns in contemporary art through repetition, or by rupturing the image screen erected against it.[6] The formal components of this or similar strategies within commercial film, however, have not yet been addressed. Of course, high art and especially the avant-garde have long staged acts of aesthetic and political resistance, but how do we now approach a commercial practice that uses the components of popular culture to in turn resist them? The answer might be found in the often quoted, but rarely defined, "blurring of distinction between high art and popular culture." The idea of such a blurring is widely used to describe the practice of incorporating artifacts of popular culture into works of high art (Hollywood movies in Godard films, Elvis Presley in Andy Warhol paintings, or B-movies in Cindy Sherman photographs). What can we say, however, of commercial films that also incorporate old movies? Are these merely works of nostalgia as Jameson has suggested? Or can the critical dynamic flow in the opposite direction as well? That is, can mass art be infused with high art criticality, and more, can we claim that it does so in a historically specific way?

To understand such a practice we must first suggest an appropriately new critical approach, one based on the changed status of the photographic/film image itself. In film criticism, this would necessitate a shift away from the modernist concerns with perspectival space, point of view, or with the film apparatus itself. The focus would instead be shifted onto the distinctive structuring of meaning in the photographic/film image, one privileging its temporality and textuality.[7] This shift is especially apt because the practice under discussion often presents the image in a distinctive way. Here the image is seen as "returned" from the past, and is frequently composed of material referencing old movies. That is, the image returns not as representational of the natural real, but as simulacral, as a copy of copies whose original has been lost. A play of references is thus engendered, one now highly coded with pastness. It is here that the connection between high art and mainstream film can be posited. In film, especially in the nostalgia film where high levels of pastiche are used, past film images often return, as do narrative elements from past or outmoded film genres. On this dual register, then, one that concerns *a changed status of the film image, and the return of the classical film genres, both as past coded signifying systems,* we can posit a relationship between high art practice and commercial film practice during this period. Before we can describe the possible methods of resistance within such a

practice, we must look to the significant debates on the photographic/film image across the century. In relationship to these strategies of investigation and breakdown of film as a representational system, we can then better approach the reconstructed images and genres of contemporary practice.

The Photographic/Film Image

It is important to distinguish the photographic/film image from other forms of reproduction, and especially from the current rise of televisual and digital images that threaten its existence. Photography represents a nineteenth-century process, distinctive at the point of its genesis and of its reception. As an imprint of light on emulsion, it has often been described as creating an image more profoundly related to the aspect of reality it reproduces, and as hotter or more personal than those of newer technologies. And for Walter Benjamin, in his famous essay "The Work of Art in the Age of Mechanical Reproduction," the very invention of photography represented a profound anthropological event, one that not only changed the nature and the function of art as a whole, but also introduced the art of film. Over the century of its invention, however, this photographically reproduced image has been interrogated and disrupted by artists and film-makers in an effort to better understand the generating principle of the cinema itself.

In a scene from Jean-Luc Godard's *Les Carabiniers* (1963), for example, an itinerant soldier mistakes the projected film image of a nude woman in a bathtub as being the real thing. This hapless soldier rushes up to the screen, claws at it, and tries to get inside the tub – or at least to see over the side of its enamel rim. All efforts, of course, are fruitless, leaving him only grasping at the bland white film screen, while his body becomes the knobby surface on which the light from his lusted-for object is projected. Nearly a century of film theory has given us insights into explaining both the desire and the illusion that Godard demonstrates in this sequence. Benjamin, for one, noted that this new film medium depleted the reproduced object of its "aura," its presence, while simultaneously bringing it closer to us than it had ever been. Art and nature were no longer objects at a distance. Now the Mona Lisa, the Grand Canyon, and even a nude woman could all be brought into our immediate space, yet be held profoundly distinct from it.

We could then maintain that it is this play of presence and absence, this relay of perpetual and unattainable desire, that causes the film image to hold such fascination for us. But of course film also tells a story. In fact, it is the dual system of image and narrative that compounds our interest in film.[8] The American film industry, especially, has gained its mass-market potential on the active integration of these two systems. In Hollywood, the film image and the narrative continuity are fashioned to render a form of realism, a kind of transparency, through which the fictive world of the film can be viewed. It would seem, then, that it is this composite of image and narrative that holds our fascination and that constructs the mythic and artistic universe of the film.

Certain filmmakers across the history of cinema, however, have seen the Hollywood type of cinematic representation as illusionistic, as embodying a capitalist ideology in its very form. They have subsequently attempted to drastically reduce conventional narrative so that a meditation on the film image could be made more explicit and so that its illusion of a fictive reality could be broken. The Russian filmmaker Dziga Vertov, for example, took this position by relinquishing traditional theatrical artifice and conventional narrative in his film *Man with a Movie Camera* (1929). Although Vertov's film predates Benjamin's essay, it is almost a test case for this renowned critic's analysis of film's properties. The camera eye in Vertov's film is demonstrated to be superior in its visual capability to the human eye. This new mode of reproduction, of perception, is now able to cut deep into reality, showing us multiple views, and, because it is not tied to the physical limitations of the body, even perspectives not humanly possible. We see from beneath a speeding train, for example, but we also see as the camera splits the image in two, superimposes another over it, slows time, or even stops time in a freeze frame. And in Vertov's film this is all done with the apparatus visible: The camera, the cameraman, the film strip, the editing machine, the projector, as well as the theater seats and the audience itself are all manifestly seen.

Man with a Movie Camera is often seen as part of a tradition within the avant-garde that strove to construct film art from the properties theorized as intrinsic to the medium. Vertov's belief in the importance of the photographic image and in its relationship to reality is echoed in the works and theories of Maya Deren, the woman often acknowledged as a pioneer and champion of the American avant-garde film, or "New American Cinema." In her theoretical essay, "Cinematography: The Creative Use of Reality" (1960), Deren argues for a film art that would stay true to

the photographic base of the film image and to its ability to reproduce reality. Deren's belief in the film image lies in her acknowledgment of the unique type of image created by the camera, one profoundly dissimilar from other modes of pictorial reproduction. She argues that all drawing or painting, no matter how "realistic," is ultimately an expression of a personal perception and of the artist's hand. But with a camera, just a click of the shutter and the world imparts an image through the imprint of its light. For this reason, Deren maintains that the photographic image is the equivalent of reality itself and can be manipulated by the artist through a process of creative combination.

Both Vertov's and Deren's theories and film practices may seem quaint to us today. Vibrating in their high modernist moments, they display an unfettered enthusiasm for the cinematic apparatus, for the possibility of forging a new art, and for a belief in reality and the possibility of its representation. In our present world, however, we may find ourselves taking a more tempered, if not less enthusiastic, position. Through more recent theory we have been introduced to the idea that although a photographically reproduced image can be said to be a model for vision, or the "equivalent of reality," it is far from "natural," far from "innocent." In fact, after an image of reality has been imprinted and reproduced, a variety of conditions – namely, culture, history, and ideology – intercede in the reading of that image. Roland Barthes, of course, has been one of the most important writers on the photographic image,[9] and his work was widely discussed in the 1970s. In his various essays, Barthes elaborates on the photographic image as a simple analogue to reality and sees it instead in terms of its structures of meaning. Here he identifies the photograph's indexical mark, its imprint from reality, as delivering a denotative message, and then goes on to note a culturally coded connotative message as well, one that varies according to the context in which the image is placed. In these structures, the photograph is distinctive from all other forms of representation. Although Barthes's work centers primarily on the photographic still rather than on film image itself, his notion of the photograph as a fragment, or "quote," a past frozen moment extracted from the continual flow of time, will be of use to our later discussion.

To return to the bathtub image from Godard's film, then, the misrecognition is ultimately not only on the part of the film's characters, who mistake the image for the real woman, but also on any reading that fails to acknowledge the complex of temporal and ideological components of

this sequence. The film is an "ongoing present tense" (unlike the photographic fragment, which stops time), but it is also a "time machine,"[10] a carrier of once-lived worlds into the present, a quality that connects us to the past by what Barthes calls a "skin" of light.[11] So while the very stylistics of the film, the film stock, the costuming, the camera work, etc., may connote a cultural meaning – among other things, a Godard signature – they also bespeak an era, the historical context of the film itself. And any claim that this sequence represents the "reality" of desire has to succumb to the realization of the patriarchal positioning of the subject. The major impetus of what is represented here, as Laura Mulvey has argued, is primarily a *male* desire.[12]

Attacks on the Image

Even before these theories had destabilized the image and its relationship to reality, however, Maya Deren's belief that film's essence lies in its photographic base was rejected by a generation of 1960s avant-garde filmmakers. Stan Brakhage, for example, saw the very lens of the camera as ground to the dictates of Renaissance perspective (thus not part of film's "essence" at all) and so advocated the willful destruction of the "reality" it produced. Brakhage practiced this destruction by any means necessary: spitting on the lens, for example, scratching the film, painting over it, using "inappropriate" film stocks, or employing rapid camera movements and superimpositions to blur its content, all to create a more personal, expressionistic vision. Other avant-garde filmmakers of the 1960s also strove to eradicate the illusionistic image in their explorations of film form. Peter Kubelka exhibits an extreme example of this tendency in *Arnulf Rainer* (1958–1960), a work that removed the image altogether and reduced film to the rhythmic alterations of white light and black frames.

Perhaps the most influential film of this later "Structural" period, however, was Michael Snow's *Wavelength* (1967). Seemingly returning the representational image to the New American Cinema by featuring a single shot of a receding loft space, *Wavelength* nonetheless reduces the filmed image to the formal properties of time and space. This is accomplished by the eroding conditions of time, a forty-five-minute zoom from one end of the loft to the other, and by the use of colored gels placed over the lens to articulate the image's flatness. But it is the absence of a conventional

narrative itself, a system that usually distracts us from the literal passage of time, that serves to make the image in *Wavelength* palpable *as* an image. Here, across the duration of the film, and the literal experience of cinematic time and space, we are confronted with the two-dimensional quality of the film image itself.

The New Image

By the mid-1970s, however, the avant-garde had seemingly exhausted its reductionist, anti-illusionist meditations on film. Moreover, avant-garde institutions such as Anthology Film Archives, along with its major critics, Annette Michelson and P. Adams Sitney, had become the "establishment," or at least they represented a set of ideas and standards that no longer seemed viable to a new generation of artists. What resulted was a change in practice that was often described as the "end of the avant-garde film,"[13] or as "postmodern art." These terms certainly seemed accurate at the time when describing works that had all the force and enthusiasm of a break with established art institutions, and with modernist practice itself.

This break also evidenced a kind of return to the call once made by Maya Deren. In a distinctive group of works, such as in those of Jack Goldstein and Robert Longo, the photographic base of film was again being acknowledged, although in a highly mediated form. And what looked like a "return to the image" was actually a renewed position from which to stage its investigation. First displayed in 1977 at a group show entitled "Pictures," and later continuing into a wider practice, the new work often centered on film images from the past. These images were pictures of pictures, images that often made reference to older photographic or cinematic sources rather than to a natural real. Moreover, these "pictures" were not necessarily presented in medium-specific form (as mandated by the critic Clement Greenberg and his modernist dictates[14]), but were instead embodied by a number of different mediums: drawing, sculpture, photography, performance, sound recordings, or even film. In this way a number of different mediums could be used to "stage a picture"[15] and so address now the very structuring of meaning and temporality in the film/photographic image.[16]

Aside from the works just noted, the actual films created by the art world during this period were very unlike those of an earlier generation, especially when compared to the highly abstract Stucturalist practice that

immediately preceded it. This was especially true of the New York Punk or "New Wave" (sometimes even referred to as "No Wave") filmmakers, such as Amos Poe, Eric Mitchell, or Beth and Scott B, whose work was purposefully shoddy, unintellectual, and unaesthetic. What's more, these Punk films ironically returned the "image" and "narrative" to the avant-garde after a long period of dissolution, and they did so in terms that connoted the past. Filled with references to Film Noir, Warhol, and European art film sources (and sometimes ironically billed as "Godard remakes"), the Punk films were nonetheless perceived as little more than *fin-de-siecle* jokes and have not been carefully evaluated by avant-garde criticism. The lack of apparent seriousness in these Punk films also made them seem different from the high art work of the period, such as the gallery-exhibited films of Jack Goldstein, the film-inspired photographs of Cindy Sherman, or the multimedia productions of Robert Longo.

The Punk filmmakers produced expendable and largely nonsalable experimental works. It should be noted, however, that these filmmakers and the media artists cited here shared a similar set of tenets and, as we shall see, a similar set of practices. Moreover, they shared a similarly curious long-term goal: many of these "avant-garde" artists wanted to cross not only media boundaries, but art/mass culture boundaries as well. In short, they wanted to make commercial Hollywood movies. And many did just that. Downtown Punk filmmaker Amos Poe, for example, wrote and directed the commercial film *Rocket Gibraltar* (1988), while Kathryn Bigelow directed a number of Hollywood films including *Near Dark* (1987) and *Blue Steel* (1990). Fine artists also moved into the mainstream of filmmaking, with Robert Longo directing *Johnny Mnemonic* (1995); David Salle, *Search and Destroy* (1995); Cindy Sherman, *Office Killer* (1997); and Julian Schnabel, *Basquiat* (1996) and *Before Night Falls* (2000).

The Nostalgia Film

Having noted a tendency to return to past film images in art practice, we next ask, What similar strategies can be identified within the commercial film? Jameson can again provide us with a point of departure. According to Jameson, the return of past forms is especially apparent in what he calls the "nostalgia film." The dictionary defines nostalgia as a "longing for experiences, things, or acquaintanceships belonging to the

past." For Jameson, however, nostalgia in postmodern film is not so much a re-presentation of a particular historical period as it is a re-creation of its *cultural artifacts*. The past is metonymically reexperienced, not only through the represented clothing styles and music, but also through the stylistic elements from films of the 1930s to the 1950s. To understand how these returns operate in practice, however, it is crucial to isolate the properties of the cinematic medium used to create this effect.

Jameson gives us some guidance in this regard. He names *American Graffiti* (1973) as the inaugural nostalgia film, noting the use of 1950s dress styles and period cars to indicate a return to the past. And although another of his examples, *Body Heat* (1981), is set in the present, Jameson maintains that the film nonetheless connotes the past through the 1940s design of its titles, the old-time "feel" of its locations, and the type of actors cast in its roles. Jameson also cites the use of old movie plots in nostalgia films, with *Body Heat* (1981) drawn from *The Postman Always Rings Twice* (1946) and *Double Indemnity* (1944), and *Raiders of the Lost Ark* drawn from the adventure serials of the 1940s. Because of the allusive and elusive referencing of these old movies plots, however, Jameson concludes that the nostalgia film tells us stories that are no longer our own.[17]

In discussing the *mise-en-scene* of the image and the films' dramatic content, however, Jameson's examples comprise the films' theatrical elements and not the medium's ontological properties. We must thus inquire further into how film itself is being manipulated to effect the return of past forms. From Jameson's examples, we can appreciate that the connotative aspects of both image and narrative are being engaged. So, while the period objects in the *mise-en-scene* create the "look and feel" of pastness, this quality is also emitting from the sensual surface of the images themselves. In a way that is distinctive of this era of filmmaking, the lighting, the choice of colors, and the grain of the film, as well as its composition and framing, may all be manipulated to refer to past images. In a similar vein, what is significant is not just that the nostalgia films return to old stories, but also that they return to old film genres, and to those genres' imagistic and narrative signifying systems. The past thus returns through the composite of an old generic universe. *Body Heat,* for example, draws from Film Noir of the 1940s; *Star Wars,* from the science fiction genre of the 1950s; *Silverado* (1985), from the Western; and, as we shall see in our later examples, *Badlands* (1973), from the crime film.

These nostalgia films, however, are distinctive from earlier genre practice because their use of generic convention is often partial, and in many

cases fragmentary. For this reason the nostalgia films are not new examples of old genres in the usual sense. They are reconstructions of dead or dismantled forms, genres that are now returned after a period of absence or destruction. The films are thus better understood as *copies* whose originals are often lost or little known. This type of return then further substantiates Jameson's claim of "schizophrenia" in postmodern practice, and the proposed barrier to the real and to history erected by such an insistent pastiche.

What emerges in the 1970s, then, is a new style of commercial production that engages film on a distinctive imagistic and narrative level, on a simulacral level, and one that often does so in older generic terms. But even with this layering of references, are we to agree with Jameson that the stories presented by the nostalgia films are truly no longer our own? Or can these stories, these images, and the generic universe they invoke be used to do more than obfuscate present history? Can acts of "resistance" be staged even within such a system, and can these commercial strategies be seen as similar to those utilized in contemporaneous art practice?

Strategies of Resistance

Over the past thirty years, from 1973 to the present, an overwhelming number of works have been produced that evidence a nostalgic style. For this reason, I will limit my discussion to a sampling of nostalgia films, primarily to those that manifest a resistance to this pull of the past or that aid in its definition. Within this sampling I will consider the possibility of resistance through a series of oppositions, at times subtle and at others disruptive, of the films' temporal and textual elements. To further explore this dynamic, however, it is important to discuss Roland Barthes's writings on myth and resistance. In these writings Barthes proposes a practice that would either utilize the signification of coded systems as artificial myth, or shake the sign itself to counter its impact.

In *Mythologies* (1957) Barthes expands the definition of "myth" to cover all forms of cultural expression, thus addressing our intention to unite art and commercial film, as well as the film image and genre, as signifying systems. For Barthes, myth is a form of speech, and so almost any production can be myth: written discourse, photography, film, advertising, etc. Moreover, myths speak through a number of formal components defined as the signifier, the signified, and the signification. In explaining

these terms, Barthes draws an analogy between myth and the formal sys-
tem of the dream. Barthes explains that myth and dream are composed of
worked-over languages, found objects, as it were, that in dream are made
up of the previous day's sense impressions and in myth are drawn from
the culturally coded material of a particular society. These raw elements
constitute the signifiers of each form, while the personal association or
cultural connotations they elicit make up its signified. The signification is
subsequently the myth/dream's meaning, one that results from the combi-
nation of the signifier and the signified, the interrelationship of manifest
and latent content. But myth is also the carrier of ideology, an uncon-
scious meaning (as are the repressed thoughts in a dream) of which the
consumer is not aware. To counter this tendency of myth to obfuscation,
Barthes suggests creating an "artificial myth" through the reconstruction
of its signifying elements. Barthes explains:

Truth to tell, the best weapon against myth is perhaps to mythify it in its turn,
and to produce an artificial myth, and this re-constructed myth will in fact be
a mythology ... All that is needed is to use it as a departure point for a third
semiological chain, to take its signification as the first term of the second myth.[18]

In later writings ("Change the Object Itself," 1971), however, Barthes
revises his thinking in a way useful to us because it suggests a strategy of
resistance within postmodern practice. Barthes notes that artificial myth,
as an act of demythifying or demystifying cultural productions, has itself
become a set of stock phrases, a *doxa*. So now

... it is no longer the myths which need to be unmasked (the doxa has taken care
of that), it is the sign itself which must be shaken; the problem is not to reveal the
(latent) meaning of an utterance, of a trait, of a narrative, but to fissure the very
representation of meaning, is not to change or purify the symbols, but to change
the symbolic itself.[19]

To explain how this might work in practice, consider a popular exam-
ple: an anti-smoking campaign presented by the California Department of
Health Services in 1996 (Figure 2). This ad campaign's strategy is in some
ways similar to that of art[20] and film practices in the 1970s and 1980s.
The image in this anti-smoking ad depicts two cowboys on horseback set
against a sunset and riding toward the camera. Along with this denota-
tive information, the surface of the image is strongly coded to recall the
visual surface of the traditional Marlboro cigarette ad. Not only are the
costumes and locations reproduced, along with the colors and textures of
the typical ad, but the image is returned to its source and presented as a

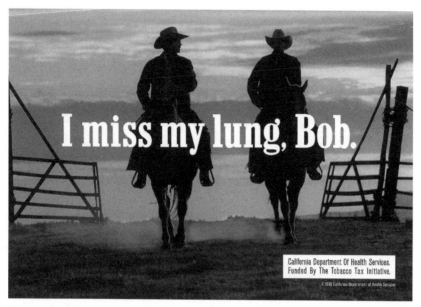

Figure 2. Anti-smoking campaign. Copyright California Department of Health Services, 1996.

highway billboard display. The resulting photographic image, then, does not refer to a lived reality, or even to a fictive one, but to a set of previously existing and highly identifiable images (and ones that, not inconsequentially, also recall the Western genre on film). But while this picture refers to other pictures, a loss of meaning does not result. Instead, the very opposite is true. The meaning is created by the opposition of the image to its accompanying written text, and also by the shifting double exposure between this image and the genre of the Marlboro ad itself.

The friction that results is one that ultimately ruptures the old advertisements' representational surface. In this anti-smoking campaign, the expected written text, "Marlboro," no longer accompanies the image. Instead, the signification of the original Marlboro ad, one that strongly connoted a mythic American self, along with the importance of a pack of cigarettes to fully embody that self-hood, is now juxtaposed against a new narrative that reads, "I miss my lung, Bob." There is a shock of recognition here, as well as a forceful breaking of the earlier mythic system. But now the message ruptures through the past-coded surface of the image to confront the viewer and the present with the trauma of a missing lung. This goes beyond the anti-smoking strategy that might simply

display an image of a smoker's blackened lung, or verbally alert the viewer to smoking's dangers, or even try to subvert the old myth by inverting its strategies (showing cowboys who smoke to be unattractive or hospitalized, for example). It also does more than critically oppose an image against its accompanying verbal text, the formal clash once proposed by Sergei Eisenstein in this theory of montage. Instead, an internal montage has ruptured an established coded system, the sign itself. This strategy will be important to our discussion, especially because it critically opposes past and present, image and narrative, representation and the real, and it does so through a shifting double exposure between the copy and the new context.

Mainstream Film in the 1970s

In 1982 Noel Carroll wrote "The Future of Allusion: Hollywood in the Seventies (and Beyond)," an essay highlighting the significant changes occurring in the mainstream film of the period. Using the term "allusionism" rather than Jameson's "pastiche," Carroll discusses the rising presence of recent films that recycle such elements as plots, themes, lines of dialogues, lighting, styles, and gestures from the history of film into new works. Unlike Jameson (whose essay was published a year later), Carroll does not see this style as being caused by a postmodern cultural condition, but rather he sees it as a result of the rise of film literacy among an educated group of moviegoers and moviemakers. According to Carroll, the varied composition of the audience creates what he calls a "two-tiered system of communication,"[21] sending a special message to the film cognoscenti in the audience, while leaving those less knowledgeable to experience the film on a more immediate level. And although Carroll sees this strategy affecting primarily the dramatic content of the films rather than their cinematic style,[22] he acknowledges the distinctive reuse of film genres in this allusive practice. In fact he notes two often used strategies: "genre reworkings" and "genre memorialization," defining the first as the expressive use of past elements in a new fiction, and the second, as the loving evocation of film history. Carroll is also one of the first critics to note the friction between the old and new genres in such an allusive system. He does not, however, expound on the possible effect of such an opposition, nor does he consider the dialectical potential inherent in the two-tiered system of reading.

As a modernist critic, Carroll is not entirely pleased with the work he is describing. In many ways he sees it as a method of filmmaking that pillages the cinematic accomplishments of the past to bolster the importance of contemporary works. For this reason, Carroll unfavorably compares this practice of current genre memorialization to earlier, in some ways similar, modernist strategies. Godard too had acknowledged film history in his work, quoting classical American films and film genres and forming articulations through their radical displacements. But for Carroll, the more recent American films have little in common with Godard's anti-illusionistic, antinarrative practices. Carroll sees much of the American genre memorializations as being employed to noncritical effect, and as not being aimed at investigating the nature of cinema as Godard had done.

But perhaps most importantly, Carroll's approach does not adequately distinguish among the different generations of American filmmakers who work within genre, nor between those who embrace the past and those who resist it. Carroll, for example, groups together Robert Altman, Sam Peckinpah, Francis Ford Coppola, John Carpenter, and Steven Speilberg as filmmakers involved in genre reworkings and genre memorialization. If one looks more closely, however, it becomes apparent that these filmmakers belong to two distinct generations and that their works often occupy two adjacent, but nonetheless separate, time periods and methodologies. The aesthetic strategies and genre reworkings of Altman and Peckinpah, for instance, exemplify a 1960s modernist sensibility. These filmmakers approached film from a different perspective than did the later generation, and they often took as their goal the *dismantling* of Hollywood forms they still saw as monolithic. These earlier filmmakers were reacting against the classical style of filmmaking, and the classical film genres, as illusionistic systems, and in the case of Altman, even against the film image's claim to reality.

A closer look at this generic approach of the 1960s and early 1970s is significant because it can serve as a counterpoint to later work, not only in the distinctiveness of its cinematic style, but also in its reuse of past coded material. In the revisionist Western *McCabe and Mrs. Miller* (1971) by Robert Altman, for example, the Western's classical style of filmmaking is in some ways dismantled, and the genre conventions are reworked through their inversion. The film image, although still maintaining a transparent relationship to a fictive reality, is presented as dark and often excessively grainy, with incongruous lighting sources that serve to obscure as much as reveal the action and characters. Similarly, the

camera movement, the editing, and sound recording conspire to create a defused, almost disintegrating environment. These techniques of dissolution on the level of the image and the rendition of space are extended to the classical Western's representation of character, setting, and plot, inverting and destabilizing its conventions and the ideology of capitalism and manifest destiny it once embodied. In Altman's film, McCabe is presented as an inarticulate fool rather than a Western hero, and he is shown to "civilize" a town, not by the defeat of its "savage" elements in a manner typical of the genre, but by the establishment of a whorehouse. Once positioned as a small businessman, however, McCabe finds himself helpless against the interests of corporate capital, an impersonal and treacherous system that dominates and ultimately destroys him. Altman is a modernist filmmaker who strives to demythify the Western genre, much as in Barthes's description of artificial myth, dismantling its illusionistic system and exposing its underlying ideological assumptions.

Francis Ford Coppola, John Carpenter, Martin Scorsese, and Steven Spielberg, in contrast, are responding to an *already dismantled* classical American cinema. The practice of this group, which comprised a younger generation, peaked primarily after the historical period of the 1960s (after the end of the Vietnam War and the Watergate scandal). In short, these filmmakers were left with the rubble, with the ruins of a 1960s modernist aesthetic and of a 1960s political movement. For some, such as Steven Speilberg and John Carpenter, the response was largely to reconstruct a cinema in older terms, that is, to go back to old film styles, themes, and images and to resurrect genres. In many cases their works are nostalgic for the past (although I would never call them politically or ideologically mute). For other filmmakers, such as Francis Ford Coppola and Martin Scorsese, the impetus was largely to break from the representational obfuscation that such a re-creation would engender. The strategy of returning to past images and genres, however, is pronounced, and, in their best work, a dynamic of opposition within those internal elements is enacted.

A Cinema of Loneliness

The work of Robert Kolker in A Cinema of Loneliness is important because it presents the genre-reworking methods and practices of American

directors in the 1960s and early 1970s. Here Kolker argues for the existence of a modernist practice of critique within the mainstream American film. In the first edition of his book published in 1980, Kolker discusses the films of Robert Altman, Arthur Penn, Stanley Kubrick, Francis Ford Coppola, and Martin Scorsese, claiming that these auteurs built their critiques around the reworkings of established film genres, systematically investigating, inverting, and ultimately demythifying one genre after another. Robert Altman, for example, not only deconstructed the Western in *McCabe and Mrs. Miller,* as we have discussed, but did the same for the musical in *Nashville* (1975) and for the detective film in *The Long Goodbye* (1973). Similarly, Arthur Penn reworked the gangster film in *Bonnie and Clyde* (1967) and Francis Ford Coppola inverted the conventions of the detective genre in *The Conversation* (1974).

Although most of these directors continued to make films into the 1970s and 1980s, their work often changed direction in the later period. In the second edition of *A Cinema of Loneliness* published in 1988, Kolker responds to the new films of the period by making a rather stunning turnabout. Proclaiming the modernist project he had been describing to be over, and acknowledging the rise of a postmodern practice, Kolker is not pleased with the new type of filmmaking he now sees as "moribund" and "lacking in imagination."[23] Moreover, he is especially disappointed with the films of Francis Ford Coppola and actually removes the chapter he had written on the director's work. Kolker explains himself by saying that after *The Godfather Part II* (1974), Coppola's films had declined to such an extent that they no longer warranted discussion, and that the critical claims he previously made for them were now invalidated.

This retreat is telling of the changes in Coppola's work, and, as Kolker rightfully acknowledges, tendencies that were present from the beginning. Coppola (and Scorsese as well) belong to a post-1960s generation and engage in a practice that distinguishes them from Altman, Kubrick, and Penn. Moreover, they display a style of filmmaking that is not fully served by terms like "genre-reworking" and "genre memorialization." Kolker had extensively covered Coppola's films, *The Rain People* (1969), *The Godfather* (1972), *The Conversation* (1974), and *The Godfather* Part II (1974) in the first edition of his book. In the second edition, Kolker lists the Coppola films that could no longer be approached by his modernist method. These include *Apocalypse Now* (1979), *One from the Heart*

(1982), *Rumble Fish* (1983), *The Outsiders* (1983), and *Peggy Sue Got Married* (1986). I have taken the time to outline Kolker's position because in our discussion, *Apocalypse Now* and *One from the Heart* will be viewed as important cinematic achievements.

The modernist filmmakers had inverted established genre for the purpose of exposing their underlying ideological assumptions. In the later postmodern work, however, the old genres seemingly return in reconstructed form. This strategy does not *demythify* the original. Instead we can note a tendency to *utilize* original forms for critical oppositions or displacements. From this dynamic model, then, we can begin to distinguish forms of resistance within the nostalgic tendency. The renewed status of the image is a central component in this practice.

The MOCA Show

Film and Art after 1946: Hall of Mirrors was an exhibition mounted in 1996 at The Museum of Contemporary Art (MOCA) in Los Angeles and curated by Kerry Brougher. Here Brougher brought together an impressive body of works that engage a dialogue between art and film. Included in this show, for example, were works of high art that incorporate images from mainstream film, films whose images are fashioned in the style of classical painting, experimental films that include mainstream film images, and mainstream visual strategies that are utilized in high art.

To chart the intersection between these previously separate practices of film and art, Brougher expanded a modernist approach to encompass a wider cultural practice. In his catalogue essay,[24] for example, Brougher claims that the Hollywood cinema has been dying since 1945, a situation that ultimately caused it to produce "self-reflexive" commercial films. Noting a similar impetus in the art world, Brougher cites the film-inflected memory boxes of the artist Joseph Cornell in the 1930s, as well as the work of subsequent generations of fine artists who have also incorporated film images and practices into their work.

Brougher claims that the Hollywood cinema takes a self-reflexive stance when it includes images of the apparatus, issues of spectatorship, and stories about the darker side of the industry. *Citizen Kane* (1941) and *Sunset Boulevard* (1950) are cited as inaugural Hollywood films that employ a self-reflexive practice, with the former revealing the film screen, the

projector, and the screening room, and the latter telling a story about workings behind the film industry. However, the incorporation of the apparatus and stories about the dynamic of cinema has a broader history than that cited by Brougher. As already noted, the self-reflexive concerns regarding cinema and the film image started considerably earlier in the century with Vertov's *The Man with a Movie Camera*. Of course it could be argued that Vertov's avant-garde film, as part of the 1920s Soviet revolutionary period, was highly anti-illusionistic and highly formal, and so it is not in the American film tradition. But this is precisely the point. The various modes of reflexivity have long had a historical and critical distinction, with those films that break illusion of the fiction at one end of a continuum and those that depict an illusionistic story of the processes of filmmaking or its apparatus at the other. The latter practice, too, began well before 1945. Buster Keaton's 1924 silent film *Sherlock Junior* is an early example, telling the story of a projectionist who enters the movie image in a dream. In *Sherlock Junior* the apparatus is presented, with the projector, the movie theater, and the screen made visible, as well as the film world into which the lead character, Buster, now enters. To further acknowledge the fantasy potential of the cinema, Buster is shown as returning to his fictive "reality" equipped with the romantic skills he needs to accomplish his goals.

Among films that refer to the processes of their own production while still maintaining the full illusion of the cinematic systems, however, there are also significant differences. *42nd Street* (1933), for example, tells the story of putting on the show in a musical theater, and *Signin' in the Rain* (1952) tells the story of putting on the show in a film musical within the film. The former reveals the backstage, the rehearsals, and the producers, while the latter also includes the camera, the sound equipment, the re-enactment of a 1920s silent film, and the studio system of the film within a film. Is the latter more self-reflexive (i.e., anti-illusionist) than the former because it refers to the process of musical filmmaking rather than to musical stage production? Or are both fully in compliance with the illusionistic conventions, in this case, with the musical's traditional use of such self-reflective gestures in its recurrent theme of "putting on the show"? Or, lastly, is the answer somewhere in between? Such issues are crucial.

Without addressing such considerations the MOCA show incorporates works from 1945 to the present, grouping together films as critically

dissimilar as *Sunset Boulevard, Peeping Tom* (1960), *Wavelength,* and *Body Double* (1984) and artists as historically and conceptually particular as Joseph Cornell, Andy Warhol, John Baldessari, and Cindy Sherman. And although some effort is made to distinguish the practices, the peculiarities of the more contemporary return of past film images, narratives, and genres are not fully taken into account. It is for this reason that the show's exclusions are just as confusing as its inclusions. Where, for example, are Jack Goldstein's film-inspired performances or Sherrie Levine's "art" photographs? Or, for that matter, where are the "Godard remake" Punk films of Amos Poe or "Antonioni remakes" of Eric Mitchell? The changed status of the film image and genre, especially as a nostalgic tendency, in contemporary art and film should be addressed. It is to describing this historically and critically distinctive mode of practice that the present discussion is dedicated.

Conclusion

In this book, we will examine works of film and art that use past images and genres in oppositional ways. The central question that confronts us, however, is whether these reconstructions can effect a true form of resistance through displacement and opposition. Hal Foster has stated it this way:

when does montage re-code, let alone redeem, the splintering of the commodity sign, and when does it exacerbate it? When does appropriation double for the mythical sign critically, and when does it replicate it, even reinforce it cynically? Is it ever purely one or the other?[25]

I will investigate the use of replication and opposition in recent practice and attempt to foreground their operational systems. To begin this discussion, then, it is important to recall Roland Barthes's observation that we are not so much a civilization of the image, but, rather,

we are still, and more than ever, a civilization of writing, writing and speech continuing to be the full term of the informational structure.[26]

The significance of the film image is tied to its narrative context, and when that image is extracted from its sequence, it loses its grounding. The resulting fragment, with its shifting relationship to meaning and to time,

is the single most revealing feature of the film-inspired work of a select group of young artists that emerged in downtown Manhattan in the late 1970s. In Chapter 2, the more influential practitioners of this group will be discussed. Often crossing a number of mediums, from performance, to photography, to Punk film, the art works of Jack Goldstein, Robert Longo, Cindy Sherman, and Amos Poe will be addressed, as will their various strategies of displacement and opposition. In their meditations on the film image, however, important isolations will be made and so aid in our understanding of a wider film practice.

By presenting a discussion of high art practice as my opening analysis, however, I do not mean that these works necessarily influenced commercial film practice. In fact, some of the mainstream films that engage the system of the image and genre may even have preceded the high art works. It is the culture-wide change in practice that is at issue here, with the returned film image in art finding an analogue in the returned images and genres of the mainstream film. The distinction among these works, however, is in their points of possible resistance, and in what their reconstructed texts reveal. Since the commercial films presented here return outmoded generic material, a tension between past and present American values is posited. Jameson had begun his discussion of postmodern practice with *American Graffiti* as the inaugural nostalgia film. I will look deeper and expand this category to include a number of genre-inspired returns from the same period and explain the possible forms of resistance they inspire. Chapter 3 will feature a discussion of *Badlands* (1973), *The Texas Chainsaw Massacre* (1974), *The Shootist* (1976), and *The Last Waltz* (1978), each of which belongs to a distinctive stage of the crime, horror, Western, and rock musical genres respectively. Through these films we will observe a practice that, although referring to the past, destabilizes it in service of the present, and consequently tells stories that are very much our own.

Although we will be looking at genre-inspired films, the chapters of this book will not be organized according to classical genre categories. A more fluid organization will be employed, one that takes into account the historical contexts and meaning of the films themselves. Chapter 4 will thus reevaluate *American Graffiti,* a coming-of-age film, interrogating its purely nostalgia film designation in terms of audience reception and its position as a post–Vietnam War work. The importance of audience response will also be considered in *The Rocky Horror Picture Show*

(1975), a film that draws on a variety of generic sources. The viewers of this renowned audience-participation film revel in the film's images and rupture its surfaces in a carnivalesque display. Chapter 4 will also examine Bernardo Bertolucci's *The Conformist* (1970), another of Jameson's designated nostalgia films. This Italian art film may seem out of place in a study of primarily American films, and in conjunction with a cult film such as *The Rocky Horror Picture Show,* but its inclusion will further define the possible uses of "nostalgia" in contemporary works. *The Conformist* revisits the trauma of fascist Italy, now using the very notion of culpability suppressed in neorealism as a historical rupture to reawaken its contemporary audience.

Historical trauma, and the tension between representation and the real, are central issues in Chapter 5. Here, films set directly in the 1950s, either as revamped musicals or as dramas, are discussed. Rather than being taken as simple nostalgia, however, these films will be considered as traumatic reactions to the present. We will see that in some of the 1950s nostalgia films, the present *is* the past, and history is obfuscated. Whereas in others, this formulation is resisted through a more direct confrontation. In assessing the differences among these practices, I will discuss *Grease* (1978) and *Last Exit to Brooklyn* (1989).

Chapter 6 will address the work of two contemporary auteurs, Francis Ford Coppola and Martin Scorsese, and investigate their practice within this distinctive cultural and historical moment. Francis Ford Coppola's *Apocalypse Now* will be considered, not so much as a work of nostalgia, but as one that confronts the trauma of the Vietnam War and its aftermath. I will then look at Coppola's subsequent film, *One from the Heart,* as it returns (now almost "schizophrenically") to older forms. And lastly, I will address Scorsese's *The Last Temptation of Christ* (1988), a film that takes a different approach to image and to genre, one that now becomes especially important because of its mythic potential.

In Chapter 7 I will look at the returned image as a barrier and a form of retrenchment in popular film, but I make no claims to resistance in most of these works. Instead I will focus on the simulacral images and genres in such 1990s films as *The Truman Show* (1998), *Scream* (1996), and *Dances with Wolves* (1990). Points of opposition and disruption, however, will be gauged in such films as Gus Van Sant's *Psycho* (1998) and Walter Hill's *Geronimo: An American Legend* (1993), and a direct confrontation with the real of the image itself will be considered in Oliver Stone's *JFK* (1991).

Throughout our discussion, then, past images and genres, as examples of worked-over cinematic languages, will be seen as sign systems capable of being reconstructed in oppositional ways to speak critically new texts. Not all these productions, however, evidence a rupture of political or aesthetic significance. It is for this reason that each work will be considered individually, for both its specific and timely contribution.

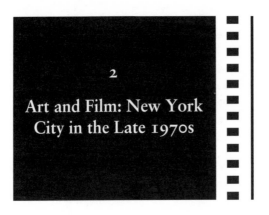

2

Art and Film: New York City in the Late 1970s

The Structural Film

Let us consider the film practice that immediately preceded the late 1970s in an attempt to understand the type of work against which the returned image and narrative were posed. And so, let us look at the practice that still saw itself in clear binary terms as *the* avant-garde film. Envision the pulsating screen of black-and-white frames in Kubelka's film *Arnulf Rainer* (1958–1960), or perhaps Ernie Gehr's *Serene Velocity* (1970) with its violent jolts between depth and flatness, or even the mechanical repetitions of Michael Snow's ↔ (1969). In the last film (the verbal translation of its title being *Back and Forth*), the camera slowly pans across a classroom space, first to the right, and then with a mechanical click, it swings to the left. The camera obsessively repeats this action, accelerating with each successive movement. The informational system of ↔ is thus reduced to its apparatus: the tripod, the camera, and the film whirring through it. The repetitive movement of the camera, aided by the film's lack of narrative, serves to reduce the meaning in the image, drawing attention instead to its two-dimensional flatness and to the duration of its screening time. These avant-garde film viewings, of course, are meant to be difficult, taxing for even the specialized viewer, and engendering a high art experience that Barthes termed *jouissance*, as opposed to the more lowbrow, and easy, *plaisir*.[1]

The Structural Film (as these works are designated) of the 1960s and early 1970s found itself looking for its "essence," that is, for those very properties of the medium that articulate it as such. As defined by P. Adams Sitney, the Structural Film investigated the very frame through which film is brought into being. And in so doing, the image as a unit of meaning was often seen as a simple byproduct, subsumed under the larger meditations

on cinematic space, time, editing, camera movement, and the apparatus itself. Within this context, Hollis Frampton's *Nostalgia* was the first work of the early 1970s to give a glimmer of a new set of concerns on the horizon.

Nostalgia (1971) is a Structural Film about the photographic base of the image, and also about memory and reading, two concerns that (although variously conceived) will feature prominently in many of the works to be discussed here. Still in keeping with the Greenbergian dictum that each medium should ground itself in the conditions of its own specificity,[2] *Nostalgia* visually puns the photographic process by which light burns onto the emulsion of film and imparts an image. As a highly conceptual work, *Nostalgia* presents a number of photographs, each of which is placed on a hot plate and allowed to burn. Then with a sense of ironic displacement that will typify the film as a whole, the filmmaker Michael Snow, speaking in the first person to indicate Frampton himself, delivers an "autobiographical" voice-over. For thirty-six-minutes, Snow's deadpan voice recounts a "personal" history of each photograph, as the image before the camera slowly burns and decomposes into an abstract surface of crumbling gray ash. Often recalling the abstract expressionist canvases of Jackson Pollock, this process of conceptually tracing the history of representation from realism to abstraction is also mimicked on the sound track by the commentary itself. But the viewer soon realizes that the narration does not describe the photographic image presently on screen; rather, it describes an image in an *upcoming* sequence. Through this clash of opposing systems, meaning decomposes much like the crumbling image itself.

Nostalgia is a work that relies on the viewer's inner dialogue and memory, as well as his or her own process of imagining. But this imaging process is continuously frustrated and is ultimately negated. As each narration ends and the photograph slowly decomposes, for example, the viewer is presented with a new photograph. And although the viewer experiences an initial shock of recognition at seeing what had previously been described, the voice-over soon begins again and describes another image not yet seen. Can we adequately imagine the next image without seeing it? Do we remember the story of the image we are presently viewing? And how long can we hold that story in our memory before it too dissolves, taking with it the image now before us? Finally, what is the possibility of fully seeing or hearing, remembering or imagining, when the image is presented in such radical displacement from the text? The

viewer, as the argument goes, is ejected from any hopes of participating in an illusionistic system, and from this distance, is made to confront the very systems of perceiving an image or story. It must be noted, however, that image and meaning have been articulated through their destruction. And so the *jouissance* of high art has destabilized the expectations for an easy *plaisir* as experienced in popular culture.

Pictures

In the late 1970s, however, *plaisir* entered the New York City art world, only now with an equal measure of *jouissance*. It was a quiet revolution at first, but a revolution nonetheless, a radical break that prompted some critics to dub the new work, "postmodern" art. When applied to this new work, the "post" meant an inherent defiance of modernism as practiced by a previous generation and a rejection of its institutions, its methods, and, seemingly, its concerns. A closer look, however, still revealed a commitment to representation. Douglas Crimp first discussed the work of a group of postmodern artists, namely, Jack Goldstein, Robert Longo, and Cindy Sherman, in his influential essay "Pictures."[3] Here I will revisit this early practice, considering its specifically cinematic implications, while also contextualizing it within the downtown music and film scene of the period and, through later chapters, within wider mainstream film practice as well.

Jack Goldstein

In 1978 Jack Goldstein exhibited a film loop as an installation. It was simple, it was beautiful, and it was unexpectedly short. In these qualities alone there was a feeling of liberation, a release from the modernist insistence on shock and frustration. But, in the end, the new set of possibilities proved no less confrontational. *The Jump,* as the film loop was called, drew the viewer into a number of contemplative considerations, a seemingly simple strategy, but one integral to our understanding of this new practice.

Let us try to re-create the experience of watching and reading *The Jump*. As a film loop, *The Jump* did not present a narrative sequence; rather, it showed a continuously repeating simple action – one initially described by

Figure 3. *The Jump,* Jack Goldstein. Copyright Jack Goldstein, 1978.

the title. This "jump" was performed by a rotoscoped image of a human figure set against an elided black background (Figure 3). The silhouetted figure too had been relieved of its distinguishing characteristics, with its body now radiating an exuberant surface of rainbow colors. The figure gracefully leapt up, twirled in midair, and then descended, disappearing into the nonrepresentational substance at the bottom of the frame. The screen went black for an extended moment, and then the figure once again appeared to repeat its action. There was a sense of quiet as the viewer stood before this enthralling yet strangely somber image for as long as he or she chose. The glittering surface of *The Jump* literalized the splendor and fascination of the popular film image, while also alluding to its power in holding our attention through pleasure. But since so much information had been erased from this particular image, its very blankness caused one to ponder, to contemplate, and, ultimately, to search for answers.

By considering this moving image, it soon became apparent that the denotative and connotative aspects elided from *The Jump,* may have been somewhat at odds with its title. Was this a "jump" off a building onto the pavement, say, or a "dive" into a swimming pool? The gracefulness and ease of the action would tend to indicate the latter. And if this reading

is correct, the background and figure detail of the original sequence may have included a diving board and a swim suit to explain this "jump" as a "leap" and then a "dive" into a pool of water. This is all innocent enough one might say, but the fact is that much more had been elided from the image than the denotative elements that comprise its photographic realism. This image had been extracted from its filmic sequence and from its narrative context as well.

But even this syntagmatic sequence would not have given us all of the answers that we need. Also missing here, on a connotative level, is the image's cultural and historical context. In the original image these meanings would have been cued by some seemingly innocuous qualities. Was this a black-and-white film, for example, or a color film? In what era was it made? Does the image document a recent athletic event, at a local university perhaps, or is it taken from some earlier sports tournament? In the original, the grain of the film could have revealed these readings to us by the quality and age of its reproduction and also by any distinguishing insignia. Here, instead, the very existence of these qualities is articulated through their absence and the kind of questions they encourage. Almost in response to these absences, then, a kind of "rumor" (thus mimicking a cultural code) is allowed to circulate through the gallery show of which *The Jump* is a part. Through a series of conversations we learn that this sequence was originally part of a black-and-white documentary film made by Leni Riefenstahl in 1936 called *Olympia*.

Everything changes now as history intercedes. An ominous quality clings to the image, and its very pleasure, even its simplicity, is revealed to be somehow menacing. There is also a vague sense of guilt at having participated in – at having been seduced by – its beauty. But has something been demonstrated to us "self-reflexively"? Have we been made aware of film and the process of its own making? Somehow this term does not fully describe the dynamic at work here, and this is perhaps because it has typically been associated with such a different modernist practice. Although we have been taken to a point of contemplative reading in *The Jump*, it has been through a process quite unlike that presented by Frampton in *Nostalgia*. In *The Jump* the confrontation with the image is not accomplished through its disintegration, but through its "return." In this way, pleasure, although never fully delivered, has been alluded to, and frustration and shock, although still present, have been made less assaultive. But to which components of the film image has our contemplation been directed?

The Jump is a film about film, but not in the usual ways of modernist film practice. It is not about the film apparatus or about the formal properties of film as traditionally conceived, for example, as perspectival space, time, editing, and camera movement. In *The Jump* Goldstein has instead used film to contemplate the structuring of meaning within the film image itself, as well as its very *eidos* (its pastness, and for Roland Barthes, its quality of death[4]). This structuring has been demonstrated through a set of absences, ones that show the image as deriving meaning from more than its denotative aspects, its status as an imprint of light (the index), or from its simple sequence of action. Instead the fuller term of the film image is read through its connotative elements. In this way, this image is not simply "natural" (the equivalent of reality, as Maya Deren maintained), but is a message mediated by culture and by history. In addition, its very pastness creates a sense of melancholy inherent in all photographically based images of worlds and people now dead, and here, one that quickly turns to terror because of its association with the Nazi regime. Moreover, this film loop installation about reading the film image has been presented as a kind of performance in which audience response has had a crucial part in the making of its meaning.

Considering *The Jump* more closely allows us to establish a set of parameters for the art practice that emerges in the late 1970s. There are many generalities that have become commonplace when discussing these works, engendering confusion that must be addressed before we look to other art works from this period and to the wider arena of the mainstream film. Noel Carroll, for example, writes

the extreme emphasis on historical reference and historical pastiches involved in the Hollywood practice of allusionism raises questions about its relation to the phenomenon in the other arts ... [The distinction is that] Hollywood allusionism is undertaken for expressive purposes, whereas postmodernism, like modernism, refers to artifacts of cultural history for reflexive purposes, urging us to view media as media.[5]

Carroll acknowledges a similar tendency toward historical reference in both postmodern art and the Hollywood film of the 1970s. But, true to his modernist approach, he separates the two, allowing Hollywood its "illusionistic" practices and the avant-garde its "self-reflexive" ones. In the works under discussion, however, the two practices are not as evenly cleaved as they once seemed to be. There is more of a continuum in evidence here, with art and film exploring the film medium in distinctive

ways. For this reason, some of the Hollywood films during this period will be shown to utilize past historical references, not solely for expressive purposes, but precisely to contemplate "media as media." In a similar fashion, the art works will not be held as completely separate from their more nostalgic or melancholy overtones.

The opinion expressed by the philosopher Arthur C. Danto, one that has received much currency, must also be reevaluated:

> In my own view, the major artistic contribution of the decade [1970s] was the emergence of the *appropriated image* – the taking over of images with established meaning and identity, and giving them a fresh meaning and identity.[6]

Although Danto's assessment of art practice in the 1970s seems to be more specific than Carroll's, it nonetheless points us in the direction of other popular descriptions of postmodern art, ones which accept appropriation, pastiche, and quotation as its distinguishing features. Danto rightfully observes that the appropriated images are now recontextualized and given new meanings, but he still subsumes any number of works under a single practice, not giving us an understanding of their operational methods.

Particular works from this period, such as *The Jump,* then, confront us with nuances not touched upon by either of the aforementioned explanations. Goldstein has taken us to a contemplation of the very systems by which the film image comes into being and creates meaning through a series of subtle disruptions. This is seen through the oscillation between image and memory, between past and present, and between the culturally coded properties of the image against its now-absent narrative context. These nuances are indispensable to fully understanding the new practice.

Goldstein's work is also seminal because of the number of different mediums he uses. In the 1970s Goldstein often employed a cross-media approach for the purpose of elucidating the status of the film image as a cultural product. These works were embodied in performance, sound recordings, and nonnarrative film and drew heavily from Hollywood movies (rather than the European sources of *The Jump*). It must be noted, however, that this very gesture of utilizing one medium in the service of another is a purposeful departure from the confines of modernist practice, especially as posited by Clement Greenberg:

> The essence of modernism lies, as I see it, in the use of characteristic methods of a discipline to criticize the discipline itself, not in order to subvert it but in order to entrench it more firmly in its area of competence.[7]

Many artists from this postmodern period evaded medium specificity in the contemplation of their cultural forms. As Rosalind Krauss has noted,

For within the situation of postmodernism, practice is not defined in relation to a given medium – sculpture (for example) – but rather in relation to the logical operations on a set of cultural terms for which any medium – photography, books, lines on walls, mirrors, or sculpture itself – might be used.[8]

Two Fencers

Jack Goldstein's cross-media work elucidates how this convergence operates in practice. *Two Fencers,* a film-inspired performance Goldstein presented first in Geneva in 1976 and then again at the Kitchen in New York City in 1978, can be said to "stage a picture."[9] At the performance of *Two Fencers,* audience members entered the gallery space and settled into their seats as a recording played music that distantly recalled old adventure movies from the 1930s and 1940s. In the darkened space, illuminated only by a reddish glow at the top of the gallery, two figures soon appeared. Dressed in traditional white fencing costumes, they began to fence as strobe lights flickered over them and the music continued. In a few minutes, however, the performance was over and the audience members found themselves exiting the theater. What had happened?

The audience of *Two Fencers* had been presented with a single action fragment, a "live movie," as it were, the quality of which was made palpable by the flickering of light on the fencing scene. Mimicking the effect of the filmstrip as it moves through the projector, the performers appeared almost like the substanceless forms of an old movie image. Moreover, the blank white costumes of the fencers, and the sounds of the old time music, allowed audience members to project their memories of images from past movie sources, and significantly, those from the classical period of American film, onto this "screen." These memories, initially formed by the same indexical process of light imprinting on the retina, were now likened to the tracelike images that form the photographic image itself. But perhaps more importantly, the memories were not personal ones, not like the oneric images presented to us by Deren or Brakhage of an earlier avant-garde. Instead, they recalled a *cultural* experience, and they did so by invoking images and stories from past genre movies. In this way, the audience was presented with a cultural memory – a collective movie

Figure 4. *The Quivering Earth,* Jack Goldstein. Copyright Jack Goldstein, 1975.

memory – that not only completed the performance but also united a discursive group, highlighting its own participation in the construction and reception of these images.

It is important to note that the highly coded quality of the music in *Two Fencers* helped cue our cultural imagings. Moreover, during this late 1970s period, Goldstein also presented a series of vinyl records (Figure 4) with such titles as "The Weep" 45-rpm (1978), "The Quivering Earth" 33 LP (1977), and "The Unknown Dimension" 33 LP (1978). Compiled of aural and musical fragments from sound-effects libraries, these records were initially exhibited on the walls of the gallery as art objects in themselves, and as "nostalgic" forms of mechanical sound reproduction. Just as *Two Fencers* had punned on the past quality inherent in the photographic image, these recordings drew on memories taken from our collective movie image bank, but in a way that foregrounded the constructed (i.e., not natural) quality of the sounds themselves.

For example, Goldstein produced a 45-rpm record entitled "The Six Minute Drown," presenting sounds we can identify, again cued by the title, as those of a drowning man. As the 45-rpm record begins to spin, we

recognize the sounds of a man gasping for breath, groaning, and flailing desperately in the turbulent waters. Images of trauma may come to mind, largely drawn from our movie memories, and so as "pictures" of other pictures. The quality of the recording, however, also underscores a sense of pastness, of an old style of filmmaking. But nostalgia is not the whole point here. Instead it serves as an ironic acknowledgement of complicity in a collective cultural experience, as well as a device to interrogate the structures of meaning in culturally coded sound and images from mainstream film. As the record continues, it becomes apparent that the sounds of groaning and splashing are repeating. Because of these repetitions, the meaning of the sounds begins to deteriorate. The sounds lose their illusion of realism, and they even becoming laughable, as do the visual imagings they engender. The "drowning" sounds decompose into ludicrous over-acting, while the "turbulent waters" become the recognizable sound of a hand splashing water in a shallow tub. By the end of the six minutes (three minutes on each side of the record), the sounds have disintegrated into meaninglessness, while their status as fragmented constructed units has become foregrounded.

Jameson's categories of pastiche (as blank parody) and schizophrenia (as the loss of meaning) do not fully describe Goldstein's work. Instead, the very blankness of the re-presented past elements in Goldstein's film loop, performances, and sound recordings have nudged us toward meaning, not a narrative meaning, to be sure, but a critical one. This is because Goldstein's work is still highly self-reflexive, with the point of contemplation now shifted onto the film image itself, foregrounding its denotative, connotative, and especially its culturally constructed qualities through a variety of different mediums. Of course it could be argued that Goldstein's art is not representative of the broader tendency Jameson is trying to outline. Perhaps not, but as we shall see, the tendencies and strategies in Goldstein's work are crucial to understanding the art and commercial film practices during this period.

Unlike most of the work presented in our discussion, however, Goldstein's art occupies a largely noncommodity status. In the tradition of an earlier avant-garde, his presentations are aural and visual events, not easily salable objects. Although they are about mechanical reproduction, the works themselves have a fleeting, ephemeral quality, much like the memory and light traces they are alluding to. The Goldstein work described here was performed and exhibited on various occasions in the late 1970s and early 1980s. In recent years, however, Goldstein withdrew his

work from circulation and retreated from Metro Pictures, the New York gallery that once sponsored him. All that remained was the memory.

This fleeting quality can also be attributed to Goldstein's use of the classical film genres. The culturally coded system of genre is essential to constructing the expectations and dynamic of Goldstein's art, although it is not obviously foregrounded. The coded sounds of romance, adventure, and horror films have all at one time or another been alluded to in his performances and sound recordings. The implementation of genre expectations is also evident in Goldstein's short films, ones that now occupy a highly conceptual plane and so evidence both a rejection and a continuation of the earlier Structural Film practice.

In 1975 Goldstein presented a series of short 16-mm films. Compiled on a single reel and separated by black leader, each film depicts a single action (and so is closer to the status of the photographic still) and is composed of high-resolution color images. The separate "films" are then introduced by titles that are highly coded in generic and/or movie historical terms. These titles included *Shane, Metro–Goldwyn–Mayer,* and *Ballet Shoe* (Figure 5). But the expectations for a story, or even for the Hollywood-style pleasure inherent in the promise of these titles, is never realized. In *Shane,* for example, a German Shepherd dog, framed in medium close-up and almost nostalgically recalling Rin Tin Tin, barks. As a looped image, the barking dog continues through several repetitions and then the film ends. Whatever memories may rise from the 1950s Western movie, *Shane,* for example, or from the 1950s Western TV show *Rin Tin Tin,* as well as any incipient nostalgia, are thus canceled.

In *Ballet Shoe,* the promise of a musical film is similarly thwarted. The film begins with the simple presentation of a ballet shoe on point. The silk slipper is untied by two hands that enter the frame, and then the film ends. In *Metro–Goldwyn–Mayer,* the characteristic logo of a roaring lion bellows and creates expectations for the beginning of a studio production, but then the image disappears. These films do not deliver the generic universe they promise and so do not indulge in the culture-wide tendency to return to the past. Instead, they ironically subvert the sentimentality for a now-dead era by returning us to the present, but they do so by using the highly coded system of past genres and logos to communicate.

It should also be noted that all this causes a sense of unease to arise, not only from the fixed stare of the camera as Warhol had done, but also from the repetition of the actions depicted or by their insignificant completion. What we are given is, literally, a *moving* picture. But the

Figure 5. *Ballet Shoe*, Jack Goldstein. Copyright Jack Goldstein, 1975.

actions are subtly disruptive, confrontational, as in the logo's truncated but repeated roar, or the violent non-progressive barking of the dog, or even in the utter banality of a slowly untied shoe. These disruptions then dislodge the largely simulacral status of the image.

Jack Goldstein's work represents an early art impetus to isolate and meditate on some of the pertinent qualities of the movie image. It must be noted, however, that Goldstein is somewhat older than the other artists presented in this chapter, and perhaps for this reason his securely "postmodern" work still maintains some of the formalism, rigor, and conceptualism of an earlier generation of avant-garde practice and of the Structural film in particular. I will now turn my attention to some of these younger artists whose work takes the film image, and, most explicitly, the movie image, as their point of contemplation.

Robert Longo

The work of multimedia artist Robert Longo adds scale, drama, and sensuality, all aspects of popular film production, to the contemplation of the image. In addition, Longo foregrounds old film genres. Whereas Goldstein refers primarily to classical Hollywood film, Longo alludes to a slightly different and, in many cases, more independent practice. His *Men in the Cities* series (1979–1982) of black-and-white drawings, for example, feature human figures set against an imageless background (Figure 6) and recall a number of cinematic sources. The Beatles leaping against a whitened sky in Richard Lester's *A Hard Day's Night* (1964) comes to mind, or perhaps the moment of arched death in *La Jetee* (1963) (Figure 7) or even Jean-Luc Godard's gangster-inspired *Breathless* (1960) provide other examples. The allusions to cinematic sources, however, do not stop here. Entitled *Men in the Cities* and exhibited amidst bas-relief sculptures of city buildings, the drawings also recall black-and-white crime movies of the 1940s and 1950s, depicting desperate men fleeing and dying on the streets of the big city (Figure 8).

But while these graphite-on-paper images may recall previously seen film images, how can they be described as related to film itself? To answer this, one must look to their mode of inscription and to their relationship to movement. The process of Longo's image making began with the photographing of young men and women recoiling and leaping in violent movement. The resulting color slides were then projected onto white

Figure 6. *Men in the Cities*, Robert Longo, 1980. Courtesy of the Artist and Metro Pictures.

Figure 7. *La Jetee*, Chris Marker, 1963.

Figure 8. *Night and the City*, Jules Dassin, 1950.

paper and the figures were traced in black onto the drawing surface. As a pun on the "tracing" of light onto film emulsion, Longo's drawings add two distinctive features. The first is a stillness that is paradoxically a movement in stasis, and the other is period style.

The stasis in each of these drawings functions as the point of absence, encouraging the viewer to "fill in" the sequence and so complete the meaning of the action. For this reason, innumerable reviews of Longo's work have asked the question, "Are the figures dancing, or are they dying?" The viewer can only contemplate the image's stillness: the image is a frozen unit of movement presenting a configuration of line, stress, and relaxation in the human figure that is not quite reproducible by the artist's hand, but is only capable of being captured in a photograph. This is an example of what Walter Benjamin had called the "optical unconscious," a condition captured and made visible by the camera but not consciously seen by the human eye. But in Longo's work the split second of stilled action is returned to the artist's hand and traced onto the picture plane of drawing. The ironic displacement thus underlines the very singularity of represented movement in the photographic image.

The stillness portrayed in these images also connotes the quality of death that inherently clings to the photograph. In Longo's work, however, there is a tension between the photographic and the filmic. The latter entails time, duration, sequence, and, of course, *apparent* movement. Longo's drawings ultimately privilege the film image rather than the photograph. The importance of this emphasis can best be understood by comparing Longo's work to that of Andy Warhol, an artist who also employed the photographic image in much of his 1960s still work. Warhol's silk-screened images were often taken from photographic stills (head shots primarily) or news photographs, notoriously emphasizing stasis – the fixed stare. But this static quality is also evident when Warhol's prints incorporate movie images. In the silk screen *Elvis I and II* (1964) taken from the Hollywood movie *Love Me Tender* (1956), for example, Presley stands poised, stopped in the action of drawing his gun (Figure 9). The duplicated image, as Elvis stands full figure toward us, is subtly ironic in that it is now Elvis who performs this mythic Western action. But the action itself is static in its truncated motion, mute in its abrupt, almost breathless encounter. This Warhol work gives us no need to consider the outcome of the action or to "fill in" its imageless background. Longo's figures, in contrast, seem about ready to spin off the page. Their emphasis is just as much on

Figure 9. *Elvis I and II*, Andy Warhol, 1964.

dancing as it is on dying, just as much on movement as it is on stasis, and just as much on meaning as it is on its suspension.

Longo's work responds more strongly not only to the quality of an implied sequence but also to images that recall, however elusively, the past of film history (by comparison, *Elvis I and II* presented less of a historical remove from *Love Me Tender*). This referencing of past films is established in *Men in the Cities* through a particular insistence on clothing style as another culturally coded system. In *Men in the Cities*, however, the meanings differ from other nostalgic works cited thus far. Here the style of Longo's figures does not recall the late 1950s or early 1960s style of *American Graffitti* or *Happy Days,* but rather the American crime movies and French New Wave films of nearly the same period. Longo's drawings insist on the look of that era's black-and-white films: black pants and white shirts for men; stiletto heels and black dresses for woman. Hair is cropped short or carefully styled. And while the black-and-white figures may evoke the films of the past, their style of dress is also consistent with the counterculture youth styles worn by the "New Wave" inhabitants of downtown Manhattan.

As a youth style of the late 1970s, however, this reference was not so much a nostalgic tendency as a forceful rejection of the once counter-cultural styles of the hippies.[10] In some ways similar to the rejection of modernist practice itself, this action cannot simply be characterized as returning to a conservative past. Rather, it relinquishes a depleted critical style by using the past as a form of reappraisal. The avant-garde establishment initially found these and other postmodern works difficult to categorize. It was precisely the return to figuration and the insistence on style that staged the first order of their refusal.

Style is also important in Longo's work because, as a culturally coded signifying system, it aids in the completion of meaning in the image, as well as making a connection to a lived moment. The clothing styles in Longo's pictures resemble the contemporaneous styles worn by the regulars at such "New Wave" or New York Punk music clubs as CBGB's or the Mudd Club in the late 1970s. Moreover, when these inhabitants of downtown Manhattan walked through the then-deserted streets of Soho or Tribeca, set against the towering commercial buildings of that district, they seemed quite "like a movie" – a movie once seen but long since forgotten. The gangster/crime genre film had often used the Wall Street area as a setting and as a metaphor for the greed and corruption of capitalist America. Movies were definitely "in the air" during the late 1970s, and on the downtown streets of Manhattan, the memory of those movies seemed to come to life. Art establishments had to be jettisoned as art was incorporated into life. In Longo's work, movies and life were re-presented as drawings, objectifying the society of the spectacle, and teetering between its critique and fetishization.

In returning to these old styles, then, and especially to the work of Jean-Luc Godard, which had staged a similar gesture of citation to the gangster/crime genre, Longo's work (certainly metonymically) is infused with an air of liberation. Rather than eliciting a longing for the conservative 1950s and early 1960s, these images instead recall the resistant practice of the same era. It must be noted, however, that an additional gesture intensifies the feeling. Godard's early work had drawn from the films of Bogart and Hawks. But Longo, as well as many of the other artists discussed here, allows the reference to slip to the unidentified B-movie and so carry with it the freedom of the everyman. In having the audacity to restage a new "New Wave" in 1970s New York,[11] purposefully rendering it a copy of a copy, these artists enacted an ironic refusal of their immediate institutionalized avant-garde past. Moreover, Longo's work allowed for a series of isolations on the film image and its particular capacities for conveying meaning.

Cindy Sherman

Sherman's *Untitled Film Stills* were included in Douglas Crimp's essay "Pictures," along with the work of Goldstein and Longo. Since then, Sherman's stills have been bought by the Museum of Modern Art as part of its permanent collection. Securely positioned as high art, Sherman's

work often shares the gritty B-genre movie feel of Longo's drawings, but also that of the New York Punk filmmakers working at the same time. Although much has been written about Sherman's *Untitled Film Stills*, I will offer a slightly altered perspective by investigating them as "stilled films" and by setting them within a broader context of contemporaneous art and film practice.

The title of Sherman's photographs offers our first cue. By naming this body of work *Untitled Film Stills*, Sherman sets a number of internal contradictions into play. The title at first seems to indicate a body of "unspecified film stills", or perhaps, "film stills from unspecified cinematic sources." In this sense they are "untitled," indicating the artist's hesitation in grounding the meaning of the represented image. On a more literal level, however, one term of the title functions to cancel out the other. In an ironic play of opposites, the term "untitled" is set into friction with the obvious titling of the pieces. The outcome, of course, is that these photographs *are* titled; they are titled specifically as being *film stills* (as opposed to other possible genres of photographic images), a designation that at once clarifies and complicates their meaning.

If we look at the images more closely, however, it becomes apparent that this designation is not as accurate as it first seemed to be. Technically speaking, a film still is a staged photograph of a cinematic production, and not one necessarily taken from the point of view of the movie camera, or even at the time of filming a particular scene. As an appropriation from the flow of the cinematic event itself, and not of the film proper, then, the film still is distinct, singular. Sherman's images, on the other hand, are much more tied to the notion of a cinematic narrative.[12] But this is a created fact, one constructed through a number of absences that nudge the viewer's cultural memory into play.

Sherman's *Untitled Film Stills* are distinctive in that they feature the image of a solitary woman. This focus on a single character, however, is more typical of fashion magazine photographs or of glamour publicity shots than it is of industry film stills. As any of the voluminous quantity of film books featuring stills will attest to, these publicity photographs are often (but not exclusively) peopled by several actors in dramatically suggestive situations. Drama, after all, is built on conflict, and by presenting an image that strongly implies tension between characters, the film still's advertising function is fulfilled. In Sherman's "film stills", however, the represented tension is consistently accomplished by somewhat different means.

Figure 10. *Untitled Film Stills* #23, Cindy Sherman, 1978. Courtesy of the Artist and Metro Pictures.

By calling them *Untitled Film Stills,* Sherman's photographs are cued as constructed film images and not as documentary scenes. But Sherman's stills offer a number of stylistic elements that affect not only the *mise-en-scene* of the image, but its formal components as well, and which ultimately rupture the expectation for a continuous flow of images and views. In these images we see a solitary woman dressed and posed to recall a character in an undefined "1950s," (an era here broadly ranging from the 1940s to the early 1960s) black-and-white movie. This woman furtively looks off screen, or is framed to imply a narrative tension (Figure 10), but the context and the source of the image are unknown. Nonetheless, the image is strongly coded as part of an editing figure of the classical Hollywood narrative film. The act of now recontextualizing these extracted "film stills" into a gallery setting, and of repeating the same "actress" in a varied number of similar roles, serves to highlight that editing figure.

Films constructed in the classical Hollywood style utilize a number of coded camera positions and angles, all interlocking to tell a story. For this

reason each image of the "film stills" presented by Sherman reads more accurately as a "shot," not only from a *sequence*[13] of shots, but from a *configuration* of shots within a coded system. Each of Sherman's shots implies, but never delivers, the subsequent countershot, that is, a shot of that character, sound, or event that would answer the "question" posed by Sherman's dislocated images. Because we are never treated to the image of the absent field, then, we tend to fill in the subsequent image from our own storehouse of cultural memories.

It is generally accepted that Sherman's *Untitled Film Stills* present women in various stock media roles – for example, the "housewife," the "seductress," the "weepy maiden," the "secretary" – and all as objects of the "look." But how exactly does this become a critique of the representation of women? The formal logic that may accomplish this effect begins with the absence of the countershot. Without this returned shot, the "film stills," or better, the "stilled films," symbolically rupture the system of suture as theorized by Jean-Pierre Oudart.[14] According to Oudart, the Hollywood film is constructed so that each successive shot "sutures" the viewers into the illusionistic system and so discourages the awareness that it was the camera's look that created what we now take to be our own view. In *Untitled Film Stills,* however, the status of the image as a still photograph affords a luxury not supplied to us by the ever-forward temporal movement of film. In the stillness of Sherman's "films" we have the palpable sense of peering into a fictional world, literally as voyeurs, avidly consuming the image of a young woman. But soon the absence of the implied countershot (and the fictional character that has perhaps authored our present view) reveals this "look" to be our own and, ultimately, that of the camera itself.

But this unobstructed view, this constant gaze, soon threatens the image itself and begins to dismantle its artifice. For while we are confronted with our own act of looking, at the voyeurism of this almost sadistic stare, its very stillness soon dislodges the status of the nostalgic disguises. It becomes apparent, for example, that Sherman's wigs don't fit quite properly or that they are obviously cheap imitations. We also begin to notice that the attempt at making the artifice look "real" is incomplete. On the contrary, the disguises openly disclose themselves as such. The makeup and the costumes that at first recalled a 1950s past now also connote the flea-market castaway, the slightly rumpled and desiccated quality of an old wardrobe. Especially when the *Untitled Film Stills* are seen in the context of one another, a palpable feeling of "dress up" begins

to accrue to them, as well as the wearing of clothes and styles from a discarded past. Through an act of subtle displacement, then, a delicate but forceful irony delivers the past to us while rejecting it at the same time. Although Hollywood publicity shots often employ high levels of artifice to create their glamour, in Sherman's "film stills" the cracks of this disguise are made visible.

This feeling of artifice ironically clings to the locations chosen by Sherman as well. Whether the images are shot in Monument Valley (recalling the Western) or on a lonely road at night (as in a Film Noir), it is Sherman's manifestly disguised presence, the image framing, and the *Untitled Film Stills* title that render even the most natural of environments "artificial," i.e., fictive. But perhaps the most important quality is in the image itself. These black-and-white images underline their status as slightly ragged duplicates of a now past style of filmmaking. And it is in this artificiality, and this past coded system, that a kind of filtered screen is created through which the images of Sherman, the artist herself, are to be consumed.

This quality of a surface, of a thing in itself, can be seen as an example of what Hal Foster calls, after Jacques Lacan, the "object gaze," the gaze that seems to reflect back and observe the viewer.[15] In Sherman's work this quality is made especially palpable by the reduplication of the artist's image in her various disguises. When viewing Sherman's photographs in a gallery show, or in book version, for example, where all the *Untitled Film Stills* coexist in close proximity, one is confronted with the artist's presence. It is the artist, Cindy Sherman, whose reflection is gazing back. This reflective quality and authorial presence is sometimes thematized in the works themselves and constructed through cinematic conventions.

Untitled Film Stills #81 (1978), for example, presents Sherman as what could perhaps be called a "teenage ingenue." Here, a young woman wearing a flimsy slip gazes at herself in the bathroom mirror. After looking at this image for a while, however, we may notice the uncomfortable quality of her face framed so closely in the mirror. Of course, this is an often-used cinematic convention, one that "cheats," showing us the character's reflected image rather than what by all rights should be the reflection of the camera. But now that face is so centrally featured, and even though this is a fictive construct, we respond on a visceral level based on our experience of lived reality. If we are able to see Sherman's reflection in the mirror, then, by the laws of optics, Sherman's character would be able to "see" us. This imminence of being discovered positions us as viewers, while

ultimately dismantling another fiction. Our position is only secondary to that of the camera, and though we may stand where it once had been, we have never been the true authors of that view. Instead, the artist authored the image, one that now reveals the woman, Cindy Sherman, in the position of the subject. In an elaborate play of looks that recalls the dynamics of the Diego Velasquez painting *Las Meninas*, Sherman is on both sides of the camera. She is both the subject and the object, and we only momentarily stand in her position, viewing just as much as we are viewed.

It should also be stressed that Sherman's represented women in *Untitled Film Stills* are not the female types seen in contemporary Hollywood films. The framing, costumes, sets, and lighting, as well as the victimized characters, all recall a 1950s film image. Why, then, would a 1970s artist involve herself in the deconstruction of female types from another era – from her mother's era? Moreover, why would she return to a prefeminist and decidedly post–World War II period?

In one sense it could be argued, and rightfully so, that Cindy Sherman has deconstructed images of women from her 1950s youth and so exorcised the stereotypical assumptions of female dress and of female desire that shaped her own construction of womanhood. The profoundly nostalgic quality of these images should not be dismissed, however, nor should their deep fascination with the films of the past. There is a sense of melancholy and of wistful longing that emanates from Sherman's works, as well as a sense of dread. The stills themselves serve to reify memory, and they do so through the *photograph,* a medium that so profoundly embodies that property. But they also serve to embody the quality of death inherent in the photographic image. The nostalgic content of the images compound these photographic properties, as does the size of the *Untitled Film Stills* themselves. When seen in the gallery as opposed to reproduced in books, these carefully matted and framed photographs are found to be relatively small – 8″ × 10″ (a fact especially important when compared to their movie references) – and so function almost as whispers from a lost past. The photograph in Sherman's work is here palpably presented as a "time machine," bringing us people and worlds now gone. But this pull into the nostalgic center is counterposed to a new kind "reflexivity," one that contemplates the qualities of the popular film image defamiliarized through the use of photography. We are thus metaphorically confronted with a past that is also present, and with a movie memory that is manifestly embodied by a contemporary *female* artist.

Figure 11. The Ramones, 1976. Photograph by Roberta Bayley.

Amos Poe

> Mainly I helped wipe out the Sixties.
> Iggy Pop

The work of Jack Goldstein, Robert Longo, and Cindy Sherman has taken on an air of high art in the twenty-five years since it first appeared and is now acknowledged as such by critics, museums, and universities. The prevailing mood of the late 1970s, however, especially in the contemporaneous New York Punk music and film scene, was to revel in the expendable. During this time, Punk music was coming into being in New York's East Village, an area adjacent to the Soho and Tribeca enclaves that housed the artists' galleries. Punk music was taking form on the Bowery, at a club called CBGB's. This new music was raw, loud, and amateurish in a way that purposefully copied the garage band sounds of the early 1960s. In 1976, American punk music was performed by such bands as Television, The Patti Smith Group, Blondie, The Talking Heads, and The Ramones (Figure 11), and it triumphed by infusing an ironic art

world sensibility into the more mundane forms and phrasings of popular music.[16]

A central documentarian of this early CBGB's Punk music scene was Amos Poe with his film, *The Blank Generation* (1976). Distinguished as the first Punk rock concert film, Poe's work embodies the ironic and off-hand attitude of the music itself. *The Blank Generation,* which was shot in black and white, includes the performances of such groups as those already noted, as well as others that frequented CBGB's at the time. But this grainy, hand-held, 16-mm, unscripted film is something other than a *cinema-verite* film like many of the rock concert films of the 1960s. To begin with, it is hopelessly out of synch. (Portable synch sound, of course, being the technology that made the *cinema-verite* rock concert films possible in the first place.) Poe instead recorded the sound separately, and then he simply made his "best effort" to match the music track with the image in the finished film. The result is both maddening and mesmerizing. In *The Blank Generation* we are presented with these now-famous bands as they were in 1976, only here their images are dimmed and blurred by the stridently amateurish quality of the filming. In a similar manner, we hear their music recorded to give only a general idea of what those sounds might have been. The resulting reduction in realistic representation, along with the persistent dislocation between sound and image, create an effect that could rival the most ardent avant-garde methods of distanciation and affront.

This impossible pairing, however, also creates a kind of silence, one that gives the images an otherworldly, almost timeless quality. The performances in *The Blank Generation* are of a 1976 event, but the images and sounds now faintly recall a 1950s or 1960s avant-garde past. Not only is the film quality reminiscent of such black-and-white, nonsynch works as Stan Brakhage's *The Way to Shadow Garden* (1955), Jack Smith's *Blonde Cobra* (1963), or Jonas Mekas's *Lost, Lost, Lost* (1949–1963), but the very content of the image renders a kind of "time-tainted" present. For example, Joey Ramone, a lank-haired, impossibly skinny kid from New Jersey, plays early 1960s bubble gum–inspired music while dressed in a black leather jacket like Marlon Brando in *The Wild One.* Debbie Harry, whose bleached-blonde hair recalls not only the look of Marilyn Monroe and Marlene Deitrich, but also Andy Warhol's famous wig, continues the pop music gesture. But does this pastiche simply – "blankly" – repeat the methods of an earlier avant-garde? Or does it, as Hal Foster has claimed for other postmodern works, comprise a "second neo-avant-garde,"[17] one

that actually fulfills or completes the project of the earlier avant-garde of the 1960s for the "first time," that is, one whose subversive inspiration is forever new and distinctive of itself? Certainly there is a rejection of the art establishment here, and with it a gleeful sense of abandon, an air of utter and wild liberation. And what's more, the disposable, second-hand quality of the music and the film, intended to be ironic, remove it from the untouchable realm of high art and bring it down to the people, to "incorporate art into life."[18]

The Punks of the late 1970s were reacting against the depleted *styles* of the 1960s counterculture, as well as of the avant-garde film institutions, not their aspiration to subversion. So what was being called a "post-modern" practice in the arts was taken down to the streets at CBGB's to become simply "anti-60s" style. Punk took on the vernacular because its venue was the more populist form of rock music itself. Moreover, it was reacting against a mid-1970s commercialized rock that had lost much of its oppositional power. The Punk urgency was to reinscribe music and style with a sense of defiance. For this reason, the "back to nature," "peace and love" aesthetic of many hippies of the counterculture was subverted by a Punk artificiality and aggressiveness. Punk was brash and ironic. Punk was antieverything, but most importantly, it was antiart.

In this fevered Punk music scene, and in keeping with the ironic gesture, it seemed as if everyone was either starting a band or making a movie. Lack of experience or the ironically stated "lack of talent" was not a deterrent. The Punks rejected the "genius" status of the avant-garde artist, and the economic demands of Hollywood filmmaking, both of which they saw as exclusionary systems. As a decidedly neo-Dada gesture, the Punk movies made during this period were an interesting and varied lot. I would like, however, to concentrate further on the work of Amos Poe, one of the pioneers of this type of filmmaking and a writer/director/ producer whose early work is contemporaneous with that of Goldstein, Longo, and Sherman. Beyond his initial documentary film *The Blank Generation,* Poe independently produced and directed several 16-mm, feature-length, loosely "narrative" films. It is primarily in their use of narrative that Poe's work counters P. Adams Sitney's claim that the avant-garde filmmaking is distinguished by its nonnarrative form.[19] But, of course, for Poe and the other New York Punk filmmakers, this was entirely the point.

By the mid-1970s the American avant-garde film had been canonized and institutionalized. Sapped of its oppositional energy, it was incorporated into university curricula and its once disruptive works were revered

and housed at Anthology Film Archives. For this reason, any hope of being "good enough" to show at the established venues (that is, to make films adhering to the sensibilities of a previous generation) was cast aside. The Punk filmmakers often sought to show in clubs or other private spaces more in keeping with their own sensibilities and pocketbooks. Club 57, The New Cinema, and The Mudd Club, for example, became some of the more popular new screening spaces. Freed from restrictions, the now-desiccated strategies of an earlier practice could be reevaluated.

The most carefully guarded tenet of the canonic avant-garde film had been its strict avoidance of narrative. As a modernist antirepresentational strategy that included the destruction of the image, the avoidance of narrative was meant to redirect the viewer's attention away from an illusion of reality to more critical or introspective concerns. Seemingly ignoring this stance, the Punk filmmakers made extremely low budget feature-length narrative films in 16 mm or even in Super 8. By stretching the viewing time of their films to feature length (alluding to the Hollywood film) and then calling the loose configuration of events a "narrative," the Punks evidenced a conceptual move that could rival that of the Structural filmmakers. Badly synched, and sometimes washed out in their imagery, the Punk films only apparently returned to image and narrative. Their films did not result in a return to the easy pleasures of conventional representational systems; rather, they returned to an ironic assault on the viewer's art sensibilities. This was made doubly so because they seemed to repeat the "Hollywood" movie gesture of Andy Warhol in such films as *My Hustler* (1965) or *Vinyl* (1965). But it is precisely this notion of a *return* that ultimately enables us to distinguish the Punk practice from that of Warhol. The Punks, and Amos Poe in particular, did not return to Hollywood film to accomplish their ironic gesture. Instead, Poe turned to the European and American art films of the early 1960s and, in a significant way, to those filmmakers, such as Godard and Warhol, who had already processed Hollywood films through their cinematic systems.

During the early days of CBGB's, Poe made two feature-length films: *The Foreigner* (1977) and *Unmade Beds* (1980). While the latter, a very distant remake of *Breathless,* was billed as "a Godard film happening today," both films actually recall a variety of art film sources. I would like to discuss *The Foreigner,* a film written by Poe and Eric Mitchell. This film draws on Godard's early work, at times sharing visual surface reminiscent of *Breathless* (1960) or *Alphaville* (1965), while also recalling Chris Marker's *La Jetée,* the films of Antonioni, or even those of Andy

Warhol. Previous avant-garde works are thus invoked in a casual but not unloving manner. But the pastiche that is used here is not of an "anything goes" variety. Instead, the gesture is at once ironic and nostalgic.

The Foreigner uses a strategy in some ways similar to Sherman's *Untitled Film Stills* by recalling the visual surface of films from another era. Poe's film, however, refers primarily to works of cinema, or high art, and not necessarily to B- or genre movies. Well, not entirely. As we have noted, if these popular culture elements do appear (such as allusions to the gangster or crime film) they do so as a second-order reference to the already referenced films of Godard. The audacity here comes not only from copying what was already a copy, but also from alluding to a radical film practice involved in the deconstruction of dominant codes (of classical film editing or of conventional narrative, for example) without any intention, or possibility, of rupturing those codes again. *The Foreigner* does use anti-illusionistic methods such as purposefully "bad" or offhand acting, loose story, and film images that sometimes trail off into black leader and end flares, but these elements are only examples of *The Foreigner*'s style, now purposefully foregrounded. In this way, the film uses the past in a paradoxical gesture to document the present, the downtown Punk scene of 1978, capturing it as much as Warhol had the art world of his own era.

The Foreigner presents the barest thread of a Film Noir – like story about a man assailed by the corrupt underworld, but the film itself relies heavily on the medium's ability to capture an ongoing time and place. This property of the cinematic medium, once utilized by the neorealists and Third World filmmakers to document the energy, the faces, the streets, and the very feel of recent historical events on film is used by Poe to capture the present through a shifting double exposure with the cinematic past. The center of contemplation thus shifts onto the film image itself, and onto its temporal components. *The Foreigner* captures the reigning "stars" of the Punk scene – Eric Mitchell, Anya Phillips, Deborah Harry, Patti Astor – art world personalities in their own right, it must be added, who were not dependent on their director (as had been Warhol's "superstars") to make them shine. *The Foreigner* also presents the distinctive clothing styles of the period; the downtown locations such as CBGB's, Wall Street, and the Battery; and such Punk music groups as the Slits and the Erasers (Figure 12). *The Foreigner* shows Punk New York of 1977, not only through a medley of locations and personalities but also through the rhythmic presentation of images and music that ultimately create a

Figure 12. Debbie Harry, Annie Golden, The Erasers, and Anya Phillips, 1977. Photograph by Bobby Grossman.

poignant "city symphony" in the tradition of that 1920s avant-garde form.

A sequence that beautifully embodies these qualities begins as Eric Mitchell, cast as the foreigner called Max Menace, walks down a Tribeca

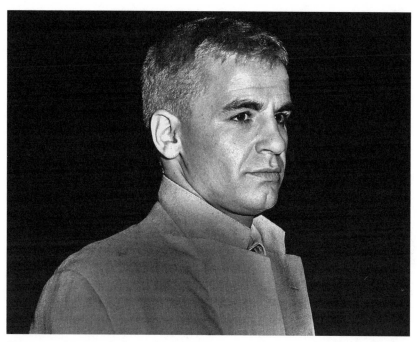

Figure 13. Eric Mitchell in *The Foreigner,* by Amos Poe, 1977. Photograph by Fernando Natalici.

alley. Menace approaches from the extreme depth of the frame as the musical score, a melancholy refrain with a slightly science fiction feel, a Punk anthem, accompanies the image. Resplendent with his white-blonde hair (Figure 13) and white suit (and looking like a classy Dobie Gillis), Menace moves down the deserted alley that is both a testament to New York's nineteenth-century past and to the postindustrial "ghost town" this area had become in 1977. As the music seems to lift the image from its worldly plane, Deborah Harry comes into view in the foreground. Watching Menace approach, Harry calls out to him, her voice passed through an echo system to enhance its surreal quality, "Hey Blondie, got a cigarette?" Menace cannot refuse the request. He turns and lights Harry's cigarette with his. Two dazzling faces are seen in close-up, and time stands still for the silence of a moment. As Menace moves on, Harry turns to the camera. She sings "That Old Blue-Bayou Moon," a German cabaret song made famous by Marlene Deitrich, who, in this lighting and costume, Harry is primed to recall. Harry's face is young and mesmerizing, but always with that "old time" feel, a shifting double exposure now operating on the

level of the image itself. This is the past, but it is also the punk present. This is the Punk era, their music, their styles, and their streets. Through the friction of these temporal modalities, the present is articulated as an indexical mark.

The Foreigner is a document of a specific era and an example of a stylistic strategy. It utilizes the surfaces of older films, ironically displacing them to document its own historical moment. The play of cinematic codes is used to articulate the image as such, now made readable through its ironized reference to the style of dress, of story telling, and of cinematic methods of another era. On the surface of the film image then, that very quality of film as a time machine, as a carrier of past worlds, and as a composite of cultural codes, is foregrounded. As the film unreels, *The Foreigner* articulates that which all film, regardless of its specific time period, brings us: a world that is temporarily anterior but spatially present – a present tense with a memory.

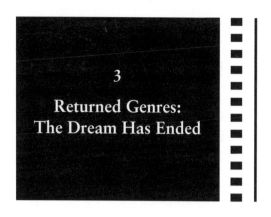

3

Returned Genres:
The Dream Has Ended

With these art world practices in mind, how can we describe the possible similarities and differences in commercial film practice? As we have noted, the impulse to reuse past images and genres is also evident in the mainstream narrative film of the period. Jameson had seen this use of pastiche as a response to the rise of multinational capitalism. If we look more closely at the films themselves, however, especially those of the 1970s, they seem to be reacting to a more localized,[1] if not altogether distinct, cause. In many of these films, the Vietnam War and the upheavals of the 1960s are often cited as the crucial preceding events, resulting in either the denial of those historical disruptions or an active confrontation with them. (The cultural and political battles of the 1960s resonated, as they continue to do today, as a sore spot in the American psyche.) In a practice similar to that of the art world, then, past images and genres in the mainstream film are also set in opposition to new material. Here images "return" as pictures of other pictures, often affecting the very epidermal surface of the film, calcifying it through extratextual references. Similarly, old genres return and also have a tendency to be rendered opaque because of their layered reuse. In a number of mainstream films this pull to the past and to surface is resisted or commented on. Unlike the art works discussed in Chapter 2, however, these films are less concerned with contemplating the nature of film and the photographic image itself. Instead, the systems of the image, of genre, and of the past are put into conflict, not solely to "expressionistic effect," as Carroll had claimed, but to political and social ends. And in a significant number of cases, this is accomplished by rupturing obdurate surfaces to confront both history and the present.

In looking at the nostalgia films of the 1970s, we must reconsider their strong generic component. The recycling of past conventions into new works had once been the very definition of genre production, but the

more recent films can be distinguished by their discontinuous movement, one that *skips a generation* (significantly, that of the 1960s[2]) in its evocation of previous forms. This type of discontinuity imparts an indelible connotation of pastness onto the new works, and it does so in a way that distinguishes them from earlier genre films. Of course it is this tendency to return past cultural artifacts that caused Jameson to cite *American Graffiti* as the first nostalgia film. In the present discussion, however, I will begin with *Badlands* (1973), a film contemporaneous with *American Graffitti* but one that draws heavily on the crime film genre while also taking a more critical attitude toward its material and the present. In this way, the reuse of past images and genres by the commercial film of the period will be addressed. The films presented in this chapter draw on the four major film genres – the crime film, the horror film, the Western, and the rock musical – and represent a significant moment in the history of each form. And while a kind of nostalgia may pervade these films, their emotional tone is better described as rage or despair. At times this quality is presented subtly, but at others, it is a forceful response to an immediate historical condition: to the decline of the 1960s as a political era, and to an altered American sense of self.

Badlands

Terrence Malick's *Badlands* made its debut at the New York Film Festival in October 1973, while *American Graffiti* was released in August of the same year. In both films the 1950s seems to stage a return, but the tone of nostalgia apparent on the surface of *American Graffiti* is seriously damaged in *Badlands*. In fact, *Badlands* not only accosts the vacuity of these supposed "happy days", but also uses the image of the 1950s as an American ideal to cast doubt on the 1970s, the historical present of the film itself. Malick accomplishes this reversal through a series of internal oppositions, confronting past images with the present and past generic elements within a new text. Seen within the contemporaneous historical context, then, the film's title, *Badlands,* takes on two meanings. Obviously, it refers to the "badlands" of Montana where the film reaches its climax. It also refers to the post–Vietnam War, post-Watergate America, as a "bad" land of guilt, disappointment, and tarnished dreams.

Badlands opens with as scene meant to connote the idyllic in American provincial life, and with a system of opposition that will ultimately

destabilize its surface. In this opening sequence we see a young girl, Holly, sitting on her wrought-iron bed. Warm sunlight filters through the window of a flowery wallpapered room as Holly begins to recount her story in voice-over, her speech tinged with a Texas twang. This image and the accompanying musical score initially create a sense of lyrical pastness, but one that is soon disrupted by Holly's spoken text. Delivered with a flatness of tone that will characterize her speech throughout, Holly remembers,

My mother died of pneumonia when I was just a kid. My father had kept their wedding cake in the refrigerator for ten whole years. After the funeral, he gave it to the yard man.

The internal opposition in this verbal statement will be the film's generating principle. The second term is set in opposition to the first, and so it inverts its meaning as well as its tone. The father's assumed sadness over the mother's death and his romantic gesture of keeping the cake is undercut by his giving the cherished memento to the help. The impact is sudden, final, and unmotivated. As the film continues, however, this kind of emotional flatness and abruptness is accomplished by further juxtaposing elements of the image with the accompanying text. At the end of the opening scene, for example, the camera pulls back slowly to reveal a pair of black-and-white saddle shoes at the foot of the bed. Any associations with a nostalgic 1950s mythology, however, are tainted by the ironic quality of Holly's commentary about her father:

He tried to be cheerful but he could never be consoled by the little stranger he found in his house. Then one day, hoping to begin a new life away from the scene of all his memories, he moved us from Texas to Fort Dupree, South Dakota.

The idyll of the saddle shoes is thus juxtaposed with the sense of dislocation, and, more importantly, with the clichéd phrasing of Holly's commentary. Holly's speech has the quality of a journal entry lifted from 1950s popular culture sources such as modern romance magazines or novels. In referring to these popular forms, the film begins to retreat from the personal, moving instead toward a cultural understanding of character and story, and away from realism, to a more direct confrontation with the representational elements of its construction. So when Holly juxtaposes clichéd phrases like "the little stranger he found in his house" or "the scene of all his memories" with the heartland isolation of Fort Dupree, a hollow thud results in emotional terms, subtly distancing us from the film we are watching. It is slowly becoming apparent that the dreamy

Figure 14. *Giant*, George Stevens, 1956. Copyright Warner Bros. Pictures Inc.

bedroom, the girlish voice-over and the saddle shoes are not as innocent as they initially appeared. Instead, the nostalgia for the past is slowly being corrupted, but the extent of it will take the entirety of *Badlands* to fully confront.

Malick continues the process of opposition in the next sequence, juxtaposing the "dreaminess" of the previous image with a dose of "reality." Here we are confronted with the overflowing cans of garbage lining an alley in Fort Dupree, and also with Kit, a young garbage collector. Kit is dressed in cowboy boots, blue jeans, and white T shirt and is played by a young Martin Sheen who is now purposefully fashioned to look like James Dean (Figures 14 and 15). Although the compulsion to replicate the look of 1950s icons has since become commonplace (one need only cite the Marilyn Monroe copies by Madonna, or the numerous Elvis impersonations), *Badlands* is one of the first films in which this practice appears. The allusions to James Dean in *Badlands*, however, is not meant to ridicule the original star, nor is it meant to blankly re-present his image, as might be the effect of other copies. Instead, this Dean replica is set in a new historical context. The 1960s had irrevocably damaged the American innocence and vigor James Dean once signified. *Badlands* thus evokes a

Figure 15. *Badlands,* Terrence Malick, 1973. Copyright Warner Bros. Pictures Inc.

marginalized James Dean, one whose profession is that of garbage man, and whose rebel status is transformed to that of sociopath.

In *Badlands* this "James Dean" is then placed in a picture plane whose images allude to past cinematic sources. Kit and Holly (who is drawn to recall a 1950s "schoolgirl type") are set against locations that bring to mind other pictures. When we first see them, for example, Holly is twirling her baton and walking with Kit along a "typically American" residential street of a bygone era. But not only is the content of the image affected by a sense of pastness, its surface too is tinged with this quality, replicating the very "look" of older pictures, while alluding to 1950s sources. The color, texture, and light of some of these images resemble *Rebel without a Cause* (1955), for example, or later, with Kit purposefully set against the wide expanse of the American prairie, they recall another of James Dean's movies, *Giant* (1956). In this way the story of *Badlands* is palpably brought to us through the filter of past images, generating a subtle friction between that past and our own era, and raising us to the level of representation itself. But although the references to the 1950s are quite strong throughout the film, the exact date of *Badlands* is not given. Instead, it is kept elusive, shifting for most of the film's duration.

The shifting of these temporal modalities is used to evoke the idea of an American myth. Holly's Victorian-style home and tree-lined street then help to complete the image, as do the various locations to which Kit and Holly travel, ones that recall already-seen photographic sources. In the strategy of internal oppositions typical of *Badlands*, however, these subsequent locations are not only rife with picture references, but with historical and political implications as well. For example, the deserts, the prairies, and the wide-open roads, locations often used to connote American freedom and purity, are in *Badlands* subtly undermined by the type of characters set within them. Cast in opposition to the image of an untroubled Americana, these locations are now peopled by the "rural poor," the "downtrodden farmers," the "dislocated cowboys," and the "dead and dying animals," all statically presented against their backdrops. *Badlands* not only undercuts the American landscape's connotations of liberation in this way, but it also hardens them into pictures.

By presenting American settings inspired by photographic sources, the images in *Badlands* may recall the Photorealist painting of the 1960s, which rendered a hard-edged painted surface to mimic the blank recording capabilities of the camera itself. In *Badlands,* however, Malick is concerned not only with the image as a distant pictured object, but also with what it can mean. Whereas the photorealists had rendered static situations with the references of the image purposefully fixed, Malick's film maintains a shifting relationship to a number of sources. The images in *Badlands* thus have a dreamy feel, referring to film and photographic sources and to painterly ones as well. The wide shots of American farmlands, for example, may fleetingly recall the paintings of Andrew Wyeth, while the flatness and banality of small-town streets have something of an Edward Hopper vision. Similarly, the painted billboards looming over an American landscape invoke the graphic work of Andy Warhol, and so openly merge painting with photographic sources. Across the entirety of the film, however, *Badlands* moves away from the realism of a Wyeth or Hopper, and instead edges closer to a Warhol-like sensibility, emphasizing the image as a hardened surface, a thing in itself – a sign.

This concern with the conditions of imagistic representation is underscored in *Badlands* by the character of Holly's father, a sign painter whose job is to restore weather-beaten signs and to paint large billboard ads. The billboard painting on which Holly's father works while talking to Kit, for example, is particularly important because it renders all objects on the same flat representational plane. Shown in long shot against a flat

prairie landscape and cloud-filled blue sky, the effect is to equate the bill-board and the film image itself as pictures. Malick continues his concern with the "pictureness" of the image in a later sequence. Here Holly looks at photographs through her father's stereopticon, and we are given her point of view of starkly receding perspectives. But rather than experi-encing the three-dimensional effect of the stereopticon, we see only the two-dimensional flatness of the film, thus underlying the illusory quality of cinematic depth itself. To these perspectival concerns, Malick then adds contemplation on the temporal status of the film image. As Holly contin-ues to view these Victorian stereopticon photographs – images of women in white lace dresses and of tended English gardens – her thoughts begin to drift. In opposition to these images from the past, she begins to wonder about the future. "Who will I marry?" she asks in voice-over, and "What will he be like?" The audience begins to sense a disconnection between what is seen and what is heard, a disconnection made all the more pal-pable as Holly wonders about the *present*. She continues to imagine her future husband, "Where is he at this very moment?"... "Is he thinking of me *right now*?" In this play of temporal modalities, the friction between the image and the spoken text alludes to the "right now" as the literal time of viewing the film, a film nonetheless recorded in the past and moving into the future.

The internal clash created by the opposition of these pictures and their accompanying context is ultimately used to political and historical ends. The idyllic American pictures, literally presented as the way America *used to* be seen, for example, are contrasted to a number of traumatic histor-ical realities. This is especially resonant when Kit and Holly, on the run from the law, set up "house" in a wooded area. The wilderness location recalls not only pictures of the American landscape often seen in film and painting, but also pictures of the Vietnam jungle regularly seen on the nightly news during the 1960s and early 1970s. Kit and Holly set up camp in this wilderness, making it the site of both middle-class do-mesticity and guerrilla warfare. Holly, her hair in curlers, cooks over a campfire while Kit builds an underground shelter and a spiked pendulum out of branches, referencing the guerrilla practices of the Vietcong. In a gesture that links the Vietcong's struggle to that of Native Americans, Kit is heard making Indian-like warning calls to alert Holly of danger. But the violent shooting of the men who come to capture the outlaw couple breaks any hope of domestic life and any residual connotations of an Eden-like hippie setting. As Kit shoots these lawmen in the back, his lack

of honor and mercy cannot help but recall, especially to the 1973 audience, America's role in the destruction of both Native American and Vietnamese peoples.

Badlands is inflected to connote the 1950s, but since no exact date is given, an indeterminate American past is evoked, recalling different time periods from the Victorian era through to the 1950s. This reference to a mythic American past is intensified by the inclusion of "Musica Poetica" on the sound track, an angelic-sounding score that is juxtaposed with images of distress. The music is paired, for example, with the sight of Holly's house burning to the ground and with mistreated cattle in feed lots. By acknowledging a sense of dis-ease within the idyllic setting of this mythic past, it is not insignificant that the only date given within the film occurs at its end, and only in reference to a future time. Here Kit tells Holly to meet him again on New Year's Day, 1964. And although this date does not place the events of *Badlands* itself, it does alert the audiences to a very significant historical moment, one of an upcoming trauma. The rendezvous date Kit proposes is a little more than a month after the watershed event of the 1960s proper: the assassination of President John F. Kennedy on November 23, 1963.

This date, and the 1960s political and historical era it inaugurates, are of crucial importance to the present study and will often be referred to by the films discussed. The fictional events in *Badlands,* for example, are set at a time *just before* the onset of the 1960s proper, whereas the film itself was released at the *end* of that era, bookending this period of American historical and cultural upheaval. A palpable sense of historical trauma is created by this receding pastness, and ironically, by the impenetrable quality of its images and by the opposition of song and dialogue. In a beautiful and strangely romantic moment, for example, Kit and Holly stop their car in the desert and dance to a song sung by Nat King Cole. Here Cole's song "A Blossom Fell" is meaningfully intercut with Kit's dialogue. When taken within the historical context of the film itself, the romantic lyrics of the song have a double meaning. The "two lips that lied" refer to an unfaithful lover but also to the Watergate scandal and to other deceptions and disappointments of the post-1960s' period:

CiOLE: The gypsy say,
 and I know why,
 a falling blossom only
 touches lips that lie.

A blossom fell,
and very soon,
I saw you kissing someone
new beneath the moon.

I thought you loved me...

KIT: **Boy if I could sing a song like that...**

COLE: You said you loved me.
We'd planned forever...

KIT: **If I could sing a song about how I feel
right now...**

COLE: ...to dream forever.

KIT: **...it'd be....**

COLE: The dream has ended,
for true love died,
the night a blossom fell
and touched two lips
that lied.

The images and music in *Badlands* may initially give rise to feelings of nostalgia for a lost idyllic past. But rather than exploiting this regressive desire, the film consistently fights to undercut nostalgia to make its statement on a post–Vietnam War, post-Watergate present, an era in which the dreams of innocence can no longer exist. This is enabled by the strategies discussed thus far and is further accomplished by the use of genre. *Badlands* is constructed to adhere to the crime film genre of the late 1940s and early 1950s, but it is not a simple example of this genre. *Badlands* specifically draws on the outlaw-couple-on-the-run film, such as Nicholas Ray's *They Live by Night* (1949) or Joseph A. Lewis's *Gun Crazy* (1950), a form long since gone into decline. And although this form had recently been lampooned in Roger Corman's *Boxcar Bertha* (1972), and more nostalgically resuscitated in Arthur Penn's *Bonnie and Clyde* (1967), its return in *Badlands* is distinctive. Malick does not use its conventions to demythify the genre as did Altman in *Thieves Like Us* (1974), or to parody or pastiche those elements, but to utilize its conventions in constructing a new set of oppositions, positioned for a new era.

In *They Live by Night,* for example, the responsibility for criminality had rested on society. Ray's film presented a sweet young couple whose working-class origins gave them no other access to the American dream than to steal it. In Malick's film, however, the American dream itself is

shown to be a set of empty pictures, and thematized by the vacuity of the characters themselves. The young outlaw couple in *Badlands* is not presented as good or worthy. This does not so much invert the earlier film's conventions as negate them. Much like the two-dimensional background in which they are set, Kit and Holly are shown to be seriously devoid of emotion, both in their numb disregard for human life and in their sexual relations as well. Whereas other characters from the history of the crime film, such as Tony Camonte in *Scarface* (1932), had suffered from sexual dysfunction that often included incest or impotence, in *Badlands* Kit and Holly are simply sexually uninterested. After their first sexual encounter, a nonplussed Holly asks, "Gosh, what was everybody talking about?" while Kit, just as clueless, utters, "Don't ask me." And although this couple could be characterized as being psychopathic, like Cody Jarrett in *White Heat* (1949), or even sociopathic, it is perhaps more correct to say that they are just apathetic. They are simply "going through the motions" and, in a sense, "playing a role." This emptiness is extended to their lack of desire for material possessions. When they need food and supplies, for example, they merely "borrow" them from a rich man's house, because, as Kit says with characteristic emotional flatness, its "cheaper and safer than going to the supermarket."

The protagonists of *Badlands* are kids from "nowhere," but throughout the film they never get "somewhere." Instead these outlaws run across a landscape that does not accept them, nor does it allow them in. They stand as paper cutouts against a flat, illusory, picture plane. And since they never desired material possessions, the only way they envisioned participating in the American dream was to *become the image*. In the end, Kit wants to be caught by the police because he knows it will make him a media celebrity. Kit imagines it will turn him into a true individual. Instead, he is only the image of an individual, the image of "the outlaw," a depleted copy. This senseless, passionless hero in *Badlands* is then literally presented as "A Rebel without a Cause" for a new era.

Unlike earlier revisionist genre films by directors such as Altman or Penn, *Badlands,* and the subsequent works to be discussed here, stand in a renewed relationship to the film image itself, especially as it is set against a number of generic and narrative elements. The friction between these two systems allows for a rupture that draws our attention, not to the past, but to the present, while underlining its own status as a sign. In *Badlands,* the historical trauma of loss finds expression in the rearrangement of cinematically coded material. And although I am not claiming that all

the films to be discussed here accomplish their goals in the same way as *Badlands,* all can be seen to demonstrate a distinctly new sensibility. In these films the reuse of older cinematic material does not necessarily result in a feeling of unmediated nostalgia for the past. Instead, the past images and genres are often used to indict the present, not weakening our sense of history, but encouraging us to confront it.

The simulacral quality of the image in *Badlands* and the flattening of its emotional tone seem to function as a screen, or shield, a response against historical events surrounding the film. As we have noted, however, a possible point of rupture comes with the inclusion of a significant date: New Year's Day, 1964. It is significant, then, that *Badlands,* in erecting this screen, cinematically returns to an "eternal 1950s," an era just prior to the trauma of the 1960s, but also that it does so just at the close of that era. *Badlands* was made and released in 1972–1973, the years that marked the end of the Vietnam War and the United States' retreat, but also the beginnings of the Watergate scandal. This historical condition can be seen as a localized cause for the traumatized response of *Badlands,* and one that was cinematically rendered by the calcification of its representational surfaces.

The Return of the Real

In describing photorealist painting in *The Return of the Real,* Hal Foster defines the opaque visual surface of these works of art as a type of "traumatic illusionism."[3] In so doing, he builds on Jacques Lacan's definition of the traumatic, presented at his 1964 seminar, as a "missed encounter with the real." Here the real is missed because it cannot be represented, but it nonetheless returns in the repetition of the traumatic symptom. For Foster the hard reflective surface of photorealist painting serves as a barrier to the real, a traumatic response that blocks it, while also having the real return there. Foster argues, however, that in early postmodern art, and appropriation art in particular, we were not asked to just view the often hard-edged representational surfaces schizophrenically, as in photorealism, but rather to "look through these surfaces critically."[4] (We could say that *Badlands* falls into this category, not only because of its references to photorealism, but also because it blocks a traumatic real, the history of the 1960s, while yet pointing to it.) However, in the later work of the postmodern artists, especially in the 1980s and 1990s, Foster sees a practice

closer to a "traumatic realism."[5] According to Foster, this work, often called "abject art," moves toward an ever more direct encounter with the real as a thing of trauma and seeks to introduce it through assault and nihilism. Foster discusses much of this work in terms of the object gaze, the work of art that observes the subject [as in the later Cindy Sherman photograph, *Untitled* #190 (1989), with its decomposing face and confrontational stare], and also in terms of the imaginary sources of the dismembered body.

The Texas Chainsaw Massacre

The consideration of *Texas Chainsaw Massacre* (1974) may seem like a digression in a discussion so far concentrated on the image as such and on the return of older generic elements. In comparison, the images of *Texas Chainsaw Massacre* appear "realistic" (as if to refer to real things in the world rather to other images) while the film itself is set in the present with few apparently nostalgic flourishes. The condition of these images, however, as well as the generic sources of the film, need closer attention. I would like to re-consider *Texas Chainsaw Massacre* and its representational surface, noting the type of "realism" it engenders. *Texas Chainsaw Massacre* will be shown to ultimately rupture these surfaces, and to do so in a manner distinctive of its historical moment.

The first question that must be asked is one of genre. *The Texas Chainsaw Massacre* is a horror film. Or is it? Not everyone would agree with this classification, especially not Noel Carroll who, in *The Philosophy of Horror or Paradoxes of the Heart,* claims that the horror genre's distinguishing characteristic is the presence of a supernatural monster. He argues, for example, that *Psycho* (1960) does not belong to the horror genre because its "monster" is not a supernatural entity, but rather a man with a psychological disturbance. Carroll thus maintains that *Psycho* is better classified as a "tale of terror." Whether or not we accept Carroll's classificatory schema, we must nonetheless acknowledge that *Psycho* marks a radical break in the history of the horror film, and that it does so precisely in its representation of the monster. And since *The Texas Chainsaw Massacre returns* to many of *Psycho*'s elements, in the type of monsters it constructs and in the generic elements it utilizes, a comparison of the two films becomes important.

Directed by Alfred Hitchcock, *Psycho* is a low-budget black-and-white "horror" film. Hitchcock purposefully made his film in the format of the B-movie because he had been unable to convince the Paramount executives to provide studio backing for *Psycho*. Moreover, Hitchcock presents a horror film that openly breaks with the classical conventions of the genre as seen in *Dracula* (1931), *Frankenstein* (1931), and *The Mummy* (1932), for example, or even in the science fiction films of the 1950s. Beginning with the title itself, *Psycho* indicates the presence of a mentally deranged human being rather than a supernatural monster. In more recent years, the stalker film, a subgenre that owes its central debt to *Psycho*, has continued to feature the twisted human mind itself as the most natural of monsters. But what first inspired Hitchcock to make this radical shift in the status of the monster? In Robin Wood's famous book on Hitchcock,[6] the critic reports an incident that is of importance here. Wood makes a connection between world events and a work of cinema, noting that prior to the filmming of *Psycho* Hitchcock had been commissioned to make a compilation film on the Nazi concentration camps. For this project, Hitchcock studied the photographs, documentary footage, and written accounts of the Holocaust, but he never completed the proposed film. Wood believes this event in Hitchcock's career is not inconsequential in understanding *Psycho,* and I must agree with him. After the devastating events of World War II, Hitchcock seems to have recognized the impossibility of representing evil as a supernatural force. A supernatural monster becomes gratuitous in an era where reason and enlightenment have been rendered helpless in the face of unknowable, yet very human, terror. *Psycho* is a "psychological" film that allows us to get to know Norman Bates and even to hear the psychiatrist's explanation of his psychosis. But the film leaves us ultimately uninformed, even terrifyingly confused, since Norman's mental disturbance can never be fully understood.[7] Surely, historical events have damaged the ability of the supernatural to symbolize evil. Nonetheless, as *Psycho* seems to indicate, to render it natural makes it none the more knowable.

Cinematic attempts to copy the success of *Psycho* in the decade that immediately followed its release were few and far between. Films that did appear, however, such as *Homicidal* (1961), *Maniac* (1963), or *The Psychopath* (1966) were not well realized or received, nor did they generate a true subgenre of their own. In effect, it took fourteen years for *Psycho* to generate its own subgenre, one that is now almost synonymous

with the contemporary horror film. *The Texas Chainsaw Massacre* was the first film to successfully resuscitate structural elements from *Psycho*, a film steeped in the values of the 1950s. And while Hooper's film later inspired such stalker films as *Halloween* (1978), *Friday the 13th* (1979), and even *Silence of the Lambs*(1991), *The Texas Chainsaw Massacre* should be investigated for its distinctive contribution to the form.

The Texas Chainsaw Massacre, like *Psycho,* is loosely based on the real-life activities of serial killer Ed Gein. Although Gein was a lone murderer – a demented Wisconsin mama's boy who butchered his victims – the similarities to atrocities of the Holocaust are nonetheless chilling. Gein's dissociative mania allowed him to meticulously dismember his victims, keeping their body parts in separate jars, and even making artifacts such as vests or masks from their skin. By using Gein as their source material, both *Psycho* and *The Texas Chainsaw Massacre* maintain a perverse sense of assault on the body. *The Texas Chainsaw Massacre,* however, does so with methods crucial to the present discussion and in a way that is distinctive of its historical moment. First, *The Texas Chainsaw Massacre* returns to the *Psycho* model after a distinct period of absence, with *Psycho* positioned at the beginning of the 1960s, and *The Texas Chainsaw Massacre* marking its historical close. But the manner in which *The Texas Chainsaw Massacre* expounds on *Psycho*'s format is also significant.

The Texas Chainsaw Massacre begins with a crawl and a documentary-style statement about the reality of the events we are about to witness. This claim, however, does not make reference to the Ed Gein source already noted, but rather to the totally fictitious story presented as the subject of the film itself. Moreover, it does so with ironic intent, decisively inserting a wedge between the fictive and the real. For here we are presented with a film in the style of realism and with a written claim to reality, but with no referent to an actual event. *The Texas Chainsaw Massacre* presents us with a grainy 16-mm color image and the sounds of a radio announcer to enhance the documentary effect. Depicting the work of grave robbers who make sculpture out of the bodies of the dead, the film begins with decomposing body parts seen in photographic flashes and with a grinning corpse draped around a cemetery headstone. The hideous skinless face of this corpse, however, is telling of the events to follow. Much like the protective epidermis that has been removed from its face, leaving the underlying tissue exposed to the elements, the film's images are increasingly depleted of a shield against the real, assaulting the viewer with the real through trauma.

In the opening title sequence of *The Texas Chainsaw Massacre,* another image manifests an exposed, assaultive surface. Here we see a shot of storms on the Sun, and we hear percussive music on the sound track. As red flares rise menacingly from the Sun's black surface, the notion of searing or burning, of approaching danger without a protective shield, is given visual resonance. Throughout the course of the film, the events will similarly be made grotesque, to the point of becoming surreal, rupturing the film's visual surface through its nihilism. This quality will ultimately link *The Texas Chainsaw Massacre* with the avant-garde, both the historical avant-garde of the Surrealists and the second neo-avant-garde of the postmodern artists. (It is worthy to note, in this context, that *The Texas Chainsaw Massacre* was purchased by the Museum of Modern Art as part of its permanent collection.)

In analyzing the quality of realism presented in *The Texas Chainsaw Massacre,* it must be acknowledged that realism in film is accomplished differently than in painting. Realism in painting is an effect constructed by the human eye and hand. For this reason, photorealism was significant in its attempt to rescind the idiosyncrasies of the artist and instead reproduce in painting the type of image recorded by the camera. Every act of filming, in contrast, no matter how aestheticized, is a photographic document of that event, a recording. Josef Von Sternberg's highly impressionistic film *Morocco* (1930), for example, is nonetheless a document of Marlene Dietrich's performance. In film, realism is a set of conventions, a style. For this reason, I will discuss the realism in *The Texas Chainsaw Massacre* by assessing the surface quality of its image, and then proceed to elements of content and generic conventions.

The Texas Chainsaw Massacre presents a documentary style realism with images imbued with a visual palette of dull reds, browns, and greens. This surface color is a result of the 16-mm format used, and of the low-budget filming conditions, as opposed to the more elaborate, and expensive, Hollywood methods. The image in Hopper's film thus has a grainy texture, rendering its representation rather "thin," especially in comparison to the high-resolution glossy image possible in more expensive films. These visual elements, then, along with the frequent use of a hand-held camera, erratic editing, and the rural, often exterior locations, give the film a sense of immediacy, a feeling of "reality" that links it to the *cinema-verite* style of documentary that emerged in the 1960s. But its allusions to recent film and television sources give it a disquieting tone. The presence of young people within the image, for example, and the 1970s look and

feel of the locations and styles, tend to recall the 16-mm images from the film *Woodstock* (1969), but then with the added scenes of mutilation and death, also the documentary footage of the Vietnam War. At its core, the "realism" of the image in *The Texas Chainsaw Massacre* is compromised with a sense of unease.

While the visual surface of *The Texas Chainsaw Massacre* connotes a perverse documentary, its generic elements refer not only to the horror film *Psycho* but to the Western as well. First, the film is set in Texas, an often-used location for the Western genre, and one used to symbolize the redemption and freedom possible in the American wilderness. In *The Texas Chainsaw Massacre*, however, the location evokes the negation of these principles. After the Vietnam War, sufficient damage had been done to the notion of the American self that the image of Texas could be used to invoke something perverse, even diseased. In *The Texas Chainsaw Massacre*, the realism of its cinematic style is used to render a Texas that is grotesque, not only in the character types that are presented there, but also in the quality of the landscape itself. The majestic wide-open spaces of this once virgin land are here reduced to a few narrowly defined shots of a hot, withering landscape. Moreover, a sense of infestation and of putrid smells is palpable, not only from the decaying farmhouse, which is the site of murder and mutilation, but also from the slaughterhouse with its dead and dying animals. The great cattle drives, like the ones featured in classical Westerns such as *My Darling Clementine* (1946) or *Red River* (1948), must necessarily have ended at slaughterhouses, but viewers had never seen them. In *The Texas Chainsaw Massacre*, however, we are brought to that point, and, by symbolic implication, to the carnage of the Vietnam War. By the mixing of generic references, incorporating Western elements with those from *Psycho*, *The Texas Chainsaw Massacre* dynamizes its political and historical meaning. After the Vietnam War, the classical Western's hope of redemption could no longer be maintained. There was only loss and despair.

It is significant, then, that in *The Texas Chainsaw Massacre* a hippie van, moving across a dried-out landscape, has replaced the Western hero on horseback. Inside the van a rather unattractive group of young people, a "counterculture" depleted of its energy, now read about the end of "The Age of Aquarius" and the dawning of the "Age of Saturn." In seeming compliance with these written predictions, the young people soon encounter a number of oddly disconcerting characters and locations. At a cemetery, for example, they meet a writhing, oracle-like drunkard. At

a roadside stand they receive an invitation to a "bar-b-que" (a suggestion somehow profoundly unappetizing). And then at the fateful house of slaughter, they confront a demented family. The clear generic distinctions among character types that had once operated in classical Westerns and horror films, however, are negated in *The Texas Chainsaw Massacre*. The distinctions among the capable hero, the uncivilized villains, and the dour townspeople are flattened. All characters verge on the grotesque. For this reason, the demented family seems not too unlike everyone else in the film. The villains' working-class attire matches the blue-jeans-style of the hippies, while many of the other characters are physically deformed, in some state of decay, or just plain ugly. The obvious exceptions are the pretty (but far from star quality) young women from the hippie group and the exceedingly ordinary young men who accompany them. But these characters are ultimately rendered "unattractive" as well, largely because they are narratively constructed as expendable. Although Sally, the sole survivor of the group, may be an exception, her character is never fully drawn or psychologized. Instead, we are presented with a set of debased characters and locations that in this "age of malevolence" are tinged with its tone.

This grotesquely "real" environment, which can be seen to embody the soul of a post–Vietnam War America more than any objective reality, is then used to tell a story that similarly displaces its *Psycho* sources. In *The Texas Chainsaw Massacre*, Hitchcock's complex psychological tale of guilt and sexual violence is reduced and abstracted almost to the point of negation. For example, Marion's descent into an underworld where she finds both the punishment for her sins and a grotesque perversion of her wish for a dream lover, is reduced in Hooper's film to a story about five youthful travelers who happen on a rural home and are summarily butchered. There is little psychology, moralizing, or "meaning" to these events. Instead, they are presented as random occurrences or as caused by the position of Saturn. And although the ultimate fate of these young people in *The Texas Chainsaw Massacre* is not unlike that of Marion, the elements of *Psycho* have been distended across the newer film and augmented with a grotesque sense of humor.

The psychotic mother–son combination of *Psycho*, for example, is extended in *The Texas Chainsaw Massacre* to encompass three generations of a dysfunctional family. This includes an embalmed grandmother, much like Mrs. Bates, and a withered grandfather, also like Norman's mother except for the fact that he is still alive. Grandpa is a decrepit vampire and

a suckling infant, much like Nosferatu himself, but he is not supernatural. Instead, Grandpa is very human. In his younger days, he had worked at the slaughterhouse as a killer of animals. But since losing his job, Grandpa and his family have extended his trade to human beings. These demented killers now work from their home, a "killing house" whose geography mimics that of the Bates house, with its distinctive central foyer and staircase leading upstairs positioned to the right.

In *The Texas Chainsaw Massacre,* however, the location of *Psycho*'s kitchen is the killing room itself, complete with meat hooks and freezers. As a place to "prepare the meat," the room is littered with feathers and bones of birds, and the evidence of human bodies as well, again recalling Norman's hobby of stuffing birds and humans. But in *The Texas Chainsaw Massacre* this activity is made even more perverse since there is no evidence of embalming. The dead are not aesthetized, nor are they recast to their original integrated form. Instead they are dismembered, and perhaps eaten. Whether human or animal, they have no spirit. Only bones and droppings remain. And although these bones may occasionally be fashioned into primitive amulets or household objects, such as a lamp made from a hand and forearm, for the most part, they are only trash.

The geography of the house in *The Texas Chainsaw Massacre* helps build suspense in those members of the audience familiar with the original *Psycho*. When Jerry comes to the screen door, for example, this geography, as well as the number and duration of the alternating shots as he repeatedly calls, "Anybody home?" fills us with a sense of foreboding and dread. The type of assault that meets Jerry, however, is so abrupt and violent that it significantly differs from the assault in *Psycho*'s shower scene. *Psycho*'s prolonged attack on Marion's body is in *The Texas Chainsaw Massacre* rendered percussive, singular. The one hollow thud delivered to Jerry's head is then later matched by the unceremonious intrusion of a meat hook into the spine of Pam, another of the film's young victims. Pam gasps for breath as she hangs from the meat hook, while her sexualized body, clothed in shorts and halter top, is only material to Leatherface, her killer. Pam's open mouth, like Marion's, may be a symbolical vagina, but to Leatherface, who scurries around the room like a busy Mom attending to her chores, it has no such meaning. And in response to Pam's breathless whimpers, Leatherface makes sounds at once like a baby's chatter and a pig's squeals. Brutal and random violence is matched with grotesque comedy.

There are many references to *Psycho* in *Texas Chainsaw Massacre*, but these can be more aptly described as generic "revisitations" than as "quotes." That is, the primary attempt in *The Texas Chainsaw Massacre* is not to refer back to a source film nor to render a picture to recall the original. Nor is the film a continuation of a classical generic pattern in the traditional sense. The historical placement of *The Texas Chainsaw Massacre*, as well as its stylistic strategy, inflects the film in a distinctive way. In some ways this work can be seen to fall into the category of the nostalgia film because it returns, after a period of absence, to a horror classic. But *The Texas Chainsaw Massacre* is not simply pastiche. Instead, Hooper's film uses those elements for a renewed assault, one informed by *Psycho* but now set in a new critical context. As the object of the gaze, as well as its subject, *The Texas Chainsaw Massacre* attacks the viewer's psyche by rupturing the protective surface of the image. The real returns as trauma through the viewing of the intruded-upon and dismembered body, through the material surface of the image itself, and through laughter.

What has been constructed in *The Texas Chainsaw Massacre*, then, is a kind of "faux realism," a surrealism if you will, composed of a grainy, repulsive visual surface depicting deteriorating locations and people. But here the image, inflected to the level of both the grotesque and the hilarious, is then ruptured. Like the shower curtain in *Psycho*, this screen is ripped open and the audience is directly assaulted. In *Psycho* we had formed a psychological and physical identification with Marion and her body. When the shower curtain was pulled back, and we were confronted with the murderer in shadow, the subsequent attack was directly inflicted on us.[8] In *The Texas Chainsaw Massacre*, however, our experience of the attack on the victims' bodies is not altogether similar to that of *Psycho*. Although still repulsive and assaultive, our superficial identification with the victims in *The Texas Chainsaw Massacre* has changed our experience of their assault. The film's characters have not been psychologized, and what's more, our sexual identification with them has been incomplete. The women's bodies, for example, have been exposed to the camera from an objective position, not from the point of view of a desiring character, as in *Psycho*. Instead, the film's villains ignore the sexual dimension of their victims. To the demented family in *The Texas Chainsaw Massacre*, the body is sexually manifest but meaningless beyond its material components.

This changed relationship to the body and our identification with it is further encouraged by its represented choreography. From the beginning

of *The Texas Chainsaw Massacre,* many of the characters' bodies are presented as deformed or in disarray, thus causing a disturbance in the viewer. Franklin, for example, a member of the young group, is confined to a wheelchair. Franklin's physical unease and grotesquerie is foregrounded in an early sequence of the film as the overweight young man in his wheelchair is laboriously lifted from the van and placed in a field, where we watch him urinate into a tin cup. Franklin's distorted facial expressions and his belabored gestures as he unzips his fly, along with the erratic editing and camera movement, underscores our revulsion at his physical condition. Franklin's impairments are then grotesquely, and comically, inflected as his wheelchair begins to roll down the hill. Franklin clings to his chair as it bounces dangerously over the steep incline, jiggling his fat body, and finally ejecting him onto the dried grass like a helpless rag doll. This is the body in disarray, the body whose limbs flay erratically, as will Jerry's convulsing body in its death throws, or Pam, with her face wildly distorted and her legs spread wide as she is grabbed by Leatherface.

The body loses its composure and usual alignment in *The Texas Chainsaw Massacre* and is returned to a regressive, almost infantile state. Through these methods our identification with the represented body is altered, especially when compared to images presented in classical films. The choreography performed by dying or falling bodies had earlier been rendered as a kind of balletics, almost rivaling Fred Astaire's dancing in its precision and gracefulness. But in *The Texas Chainsaw Massacre* the grotesque choreography presents the body as the villains of the film understand it. It is the body without a soul. The body as repulsive because it is a category mistake, a human animal. And it is this schizophrenic body, a body without meaning other than its material, that now becomes the abject. The body in *The Texas Chainsaw Massacre* is presented as detritus, as decay, as filth, and as death.

The protective surface of the screen is ripped through by this trauma to reveal a presymbolic state. Robin Wood, in his famous 1975 essay on *The Texas Chainsaw Massacre* entitled "An American Nightmare," was the first to touch on this dreamlike quality, one that recalled for him his own nightmare experiences.[9] Wood, however, did not elaborate on how this film experience relates to the aesthetic practice of Surrealism. As a visual and aural assault, *The Texas Chainsaw Massacre* threatens to return us to a presymbolic state, to the imaginary of the mirror stage.[10] Here we find the body in chaos, at times in disarray or in pieces, and assaulted by a confusion of undifferentiated instincts. Along with the resulting

breakdown of meaning, however, one that doesn't distinguish between sex and violence, nor between body and soul, there is a threatened loss of an integrated self. With the loss of the protective screen provided by the image of an integrated body, the images of disintegration assault our own body. In this way, the cover of realism or naturalism typical of Hollywood films is replaced by a kind of "traumatic realism." And while Foster had noted this as characteristic of 1990s art, and especially in the horror stills of Cindy Sherman, *The Texas Chainsaw Massacre* can also be seen as a new form of American realism as early as 1974. It is grotesque, assaultive, hilarious, and raw, a nightmare delivered in specifically cinematic terms.

The assault on the viewer is then continued through the camera positioning and editing, one that now starts to dismantle the once-secure boundaries of the viewing position. Here the film's characters and locations are often seen from quickly alternating shots, or from odd angles. Overhead shots are juxtaposed with low-angle shots, rapid cutting is used to fragment the visual field, or shots are held for overly long periods of time. Moreover, the camera in *The Texas Chainsaw Massacre* is at times hand-held, uncharacteristically tracking, or even wobbling on its mount, all implying a point-of-view shot that is then never confirmed. Through this fragmentation, this discontinuity in the expected visual field, the viewer is disembodied, further creating an experience of disorientation, or dis-ease.

Physical discomfort in the body of the viewer is further encouraged through the thwarting of expectation and through perverse assault. The women in the film, for example, are at times viewed from low angles, or even from below their buttocks, inviting the sadistic stares of the audience. So when Sally is trapped at the roadside station, rape is strongly implied, and it is fully expected as evidenced by the menacing attitude of her tormentor. But Kirk, the father of this demented family, is not interested in rape as violence. Instead he gets more pleasure from stuffing Sally in a sack and poking her with a stick (in a grotesque displacement of the sex act itself). And much like the Surrealist film *Un Chien Andalou* (1929), which begins with the slicing of a woman's eye with a straight razor, one of the demented brothers, Hitchhiker, cuts his own hand with a pocket knife and then similarly makes a searing incision in Franklin's arm. The effect is one of violent impact on the viewer's body, an effect intensified by the barely audible country music on the soundtrack, thus juxtaposing banality with horror.

Sound is frequently used to enhance the surrealistic assault on the viewer. One needs only to think of the prolonged chase of Sally through the night. In her tortured escape from Leatherface, Sally runs through dried and gnarled tree branches, illuminated only by the moonlight, and accompanied by the unrelenting sounds of the whirring chainsaw, the crackling of the twigs as she passes, and her own screams. But when Sally is later caught and held in bondage, her cries are coupled by those of the deranged male family, a truly surreal chorus. And it is here that *Un Chien Andalou* is once again invoked with the presentation in extreme close-up of Sally's terrified and terrifying eyeball. This eye's spherical surface, so sensitive to light and touch, is riddled with red veins that now recall the storms rising from the Sun in the opening sequence of the film. The eye, one of the most delicate and vulnerable parts of the human body, is here so exposed, and because of our own identification with its act of sight, this searing exposure threatens our own ocular surface.

We recoil from the physical threat of this image and also from a variety of other assaults delivered by the film. The images of abjection abound in *The Texas Chainsaw Massacre*, presenting the body not only in disarray, but also in decomposition and decay. In fact the whole epidermis of the film has been presented as somehow festering with dis-ease, and the very content of the image now adds to this effect. In *The Texas Chainsaw Massacre*, the abject, defined by Julia Kristeva as that which must be pushed away in order for life to continue,[11] forms much of its content. Pam, for example, is thrown into a room filled with the remains of dead birds, their feathers, their bones, and presumably their feces, now scattered amidst the bones of human beings (Figure 16). It is precisely this mixing of human and animal, especially in relationship to the female as the symbol of fecundity, that causes the revulsion. So when Pam looks around the room, observing the skeleton of a severed human hand (again recalling *Un Chien Andalou*), the blanket of feathers beneath her, and the incessant clucking of the chicken (a creature who will share her fate) in an overhanging cage, the young woman vomits. The confusion of animal and human is elsewhere presented in *The Texas Chainsaw Massacre* in abstracted form, but with similar results. In Franklin's family home, for example, a gaggle of spiders is seen in the corner of the now decrepit farmhouse. The accompanying sound effect recalls both the swarming of insects and the hiss of a rattlesnake. And while the festering spiders recall the armpit hair and urchin superimposition from *Un Chien Andalou*, the revulsion in *The Texas Chainsaw Massacre* rises from the slender

Figure 16. *The Texas Chainsaw Massacre,* Tobe Hooper, 1974.
Bryanston Pictures.

interlocking legs of the spiders, ones which now resemble a patch of pu-
bic hair while also retaining their animal movement.

 In *The Texas Chainsaw Massacre* the real has returned as trauma, rup-
turing the membrane of the image by ripping away its protective screen.
Unlike *Psycho,* however, the assault is not only delivered through an at-
tack on the represented human body. In *The Texas Chainsaw Massacre,*
the whole surface of the film has been utilized in this assault, deliver-
ing an unprecedented form of physical, aural, and visual attack on the
viewer. As a return to *Psycho,* the resuscitation of this trauma, and its
accompanying critique of the profound disrespect for human life, must
now be seen in the context of the Vietnam War itself. With the memory
of the massacre at My Lai, the searing of napalm, and the nearly three
million dead on both sides, the film is a metaphor for the war's assault, as
well as for its dispiriting aftermath. Furthermore, while the post–Vietnam
War period can be cited as the localized cause here, the greater context of

postmodernism can also be seen to impact the film. In *The Texas Chain-saw Massacre* we can identify the flattening or confusion of affect, the mixing of genres, and the blunting of narrative, all components that have been cited as features of postmodern film and art. But here these strategies are not used to critique the images and genres in which they are operating. Instead they confront us with the cultural and historical conditions that surround them.

The Shootist

The Shootist (1976) is representative of the Western genre, a form often alluded to but never fully embodied in the films discussed thus far. More-over, this film is composed of many of the Western's classical elements now seemingly reintegrated on the level of image, character, and story. Starring John Wayne, *The Shootist* is classifiable as a nostalgia film because it re-turns to a largely outmoded genre, and because it does so with a sense of regret at its passing. But this politically conservative film also incorporates a sense of endangerment that will eventually rupture its representational surfaces. By the 1970s the Western had been seriously enfeebled, declining in popularity and demythified by a number of filmmakers, as had been John Wayne as one of its leading stars. In *The Shootist* John Wayne returns as the film's hero and plays an aging gunman dying of cancer, a disease afflicting the actor himself. In fact, *The Shootist* was to be John Wayne's last film, with the man so central to the Western dead within three years of its release. In *The Shootist*, then, the real and the fictive converge in a play of generic references essential to our present discussion.

It could be argued, of course, that the notion of the "Last Western" is not new to the genre and even comprises one of its major themes. Almost from the Western's inception, the theme of the fading away of a once-pure American wilderness has been part of the wistful longing inherent in the form itself. *My Darling Clementine*, for example, is John Ford's nostalgic look back at the lost purity of the Old West, a self-conscious act of myth making, with the images themselves presented as if shot through the prism of memory. John Ford's later film, *The Man Who Shot Liberty Valance* (1962), continues the theme of the passing of the West, and then adds to it the passing of the Western itself. Made well into Ford's career, after the demise of the studio system and the rise of television, it is also Ford's personal look back at his own Western films and at the actors,

most notably John Wayne and James Stewart, who participated in them. Don Siegel, the director of *The Shootist*, in contrast, made his film as a farewell to John Wayne as the Western's central actor. For this reason, *The Shootist* is not so much about the passing of the West, or even about the passing of the Western genre, as it is about the death of the Western star, John Wayne, and along with him, the Western hero. In retrospect, it seems that the genre may not have survived this blow, even after a number of attempted resuscitations of the Western in the 1980s and 1990s (which will be discussed in Chapter 7).

In many ways Wayne *was* the Western. He seemed to embody its ideological assumptions as well as centrally participating in its classical forms. In *The Shootist* we see a return to these old forms, to a once vibrant genre, to a classical style of filmmaking, and to the clearly defined image, all systems that had been seriously compromised in the 1960s. On closer inspection, however, it becomes apparent that while the classical representational codes in *The Shootist* are in many ways intact, there is a significant displacement among its internal elements. An integrated style returns to the Western in *The Shootist*, but it does so with an insistence that creates a type of distance. There is something dull, or hollow, about the resulting image and shooting style in *The Shootist*. The film shows the influence of 1970s television with its preponderance of mid-level shots, wooden performances, and a Western setting that is too manicured and too staged. The resulting presentation, however, is not "all wrong"[12] as some reviewers have maintained. Instead, the style perfectly embodies the film's themes of aging and death and raises them to a poetic level.

Presented in a clearly recognizable Western setting, complete with appropriate costumes and character types, *The Shootist* also features a number of actors who had once appeared in the Western during its classical period. *The Shootist* thus demonstrates the consequence of "returning to the past." Many of the actors re-presented in *The Shootist* are now quite old, and the film medium unflinchingly records the debilitating effects of the passage of time. This fact is so inescapable in *The Shootist* that it ultimately ruptures the fiction, as well as the image, in a new and significant way. Not only is John Wayne, the hero of such historic Westerns as *Stagecoach, The Man Who Shot Liberty Valence,* and *Rio Bravo* (1959), returned as an old and dying man but so are a number of notable actors from earlier films. John Carradine, for example, the gentleman gambler from *Stagecoach,* is here presented as the undertaker, his now-real

gnarled and arthritic fingers featured prominently as he struggles to pay
J.B. Books (John Wayne) for the privilege of burying him. The casting
of Lauren Bacall as the landlady, Bond, is manipulated in similar ways.
With her youthful beauty gone and her voice hoarsened with age, Bacall's
presence recalls not only her own past from Hollywood's Golden Age, but
also a number of famous Western female characters (most notably Hallie,
played by Vera Miles, in *The Man Who Shot Liberty Valence*). An aging
James Stewart is re–presented here too, with his history as an important
Western star adding to the gesture, as does the presence of other minor,
but nonetheless significant, characters and actors. Hugh O'Brien, for ex-
ample, menacingly re-creates his television Western role as Bat Masterson.
And a young Ron Howard, a television actor famous for another 1950s
revival, *Happy Days* (1974–1984), plays the part of Gillam, Bond's son,
who [much like the young boy in the classic Western *Shane* (1953)] idol-
izes the famous gunman. The inclusion of these actors, then, especially
those from television (a medium that helped "kill" the Western on film)
serves to underline the passing of time and of the Western hero/star.

 The Shootist, however, lacks the irony and disrespect leveled against
the genre by the revisionist filmmakers. There is certainly no laughter
in the re-presentation of older material in *The Shootist,* but neither is
it simply pastiche. Instead, a subtle system of displacement is set into
motion, operating on the level of the film image and narrative, and made
possible by the juxtaposition of time periods. Here the inclusion of older
actors with a history on film, the references to classic movies, and even the
clips from John Wayne's past Westerns all cue us to the special relationship
we are meant to have toward the image. We are being referred back, not
to a lived reality, or even to a diegetic one, but to a specifically cinematic
past. Our memories of old movies come into play and now serve as an
ongoing double exposure to what we see on screen. The effect is jolting.
Age and death rupture the surface of the image. Time and aging are real
and we are forced to confront them head on. The illusion of a fictive world
in the film is thus broken, with the lived truth of the actors becoming the
subject of the film itself (Figure 17). A close-up of John Wayne's hand as
he loads his gun for the final shootout, for example, perfectly articulates
the conflation of these two worlds. Wayne performs a task often seen in
his past Western roles, but now his hand is swollen with age, covered
with liver spots, and trembling with palsy. And Wayne is not acting. The
camera has simply recorded the actual and terrifying effects of time on
the body.

Figure 17. *The Shootist*, Don Seigel, 1976.

As traumatic realism, this vision tears at the illusionistic surface of the screen. The real returns as the trauma of age. It ruptures the image. In *The Shootist*, however, the deterioration of the body and the indignities it must suffer are also featured as part of the script. During the film, for example, James Stewart plays a physician who examines Wayne's character. Stewart asks Wayne to bend over, "trap door down," for a rectal exam. Even after a long cinematic history of violent battles and near-death experiences, this assault on the Western hero as a mythic figure is unprecedented. Later in the film, the trauma to the Western character, and to the actor as well, is extended to the sight of the once-powerful Books/Wayne carrying a pillow to soften the pain of sitting, and then to scenes of him preparing for his own funeral. But perhaps most poignant is the scene where this virile man falls in the bathtub. The dying Books needs Bond's help to get up, and we are now asked to witness that stage in a man's life where a woman can no

longer be a sexual partner for him, but only a caretaker. The hoots from her son, who mistakenly assumes a sexual liaison between his mother and Books as they enter the bedroom, only serve to underline the old man's impotence. And for this reason, we cringe when James Stewart as the doctor looks right at Wayne/Books and proclaims "You're dying."

These disruptive images are then set against the conventions for the Western genre story, with a similar internal opposition. *The Shootist* is in many ways close in structure to the classical form of the genre as described by Will Wright in *Sixguns and Society,*[13] but it also takes on a number of significant deviations. In the classical Western, for example, the hero, who has superior skill as a gunman, enters a fledgling community, confronts the villains who threaten it, and then defeats those villains to save the community. In *The Shootist* the hero also defeats the villains, but in the end, his action is moot. Not only does Books die in the battle (an empty act of bravura because of his terminal cancer), but, more importantly, his struggles do not save the community. This is because the community in *The Shootist* is "mature," well passed its uncivilized or outlaw stage and so not in need of being saved by the hero. Books's very presence in *The Shootist* is outdated, as is his moral code and its national implications. So when Books/Wayne proclaimed a distillation of this code to a late 1970s' audience: "I will not be laid a hand on, I will not be insulted, and I will not be wronged. I don't do these things to other men, and I won't have it done to me," it fell flat. When seen from this post–Vietnam War perspective (and in context of Wayne's often unpopular support of that War), the Western's once-defining statement justifying the hero's use of violence as an act of self-defense no longer carried the unanimous support it once commanded.

The Shootist thus re-presents the Western in a highly referential form, and then allows its internal elements to confront present history. The memory of past images and past stories clash with those presented on screen. In commenting on its present moment, *The Shootist* understands the eventual passing away of the old movie pictures through time and through death. Beyond the regret for that loss, however, it demonstrates the hubris in having assumed that they could have lasted forever. In a gentle way, then, the film is also critical of Wayne for having taken the Western myth perhaps too seriously, and for not entirely separating fact from fiction in his own beliefs. The sadness on the part of its apparently conservative filmmakers, however, comes from the knowledge that the

Western had once been the carrier of American values and that in the post–Vietnam War era those values were in disarray. There is a palpable sense of regret at the loss of an assumed American honor embodied by this genre, and so *The Shootist* differs from the revisionist Westerns that had instead sought to unmask its ideological assumptions. Even from its conservative perspective, *The Shootist* effectively "kills" the classical Western and its hero, or perhaps it only delivers a postmortem.

The Last Waltz

Martin Scorsese's *The Last Waltz* (1978) is a rock concert film that uses techniques in some ways similar to those just cited. In *The Last Waltz,* however, the nostalgia for the past has shifted onto images and sounds evocative of the 1960s. Rather than being recalled as a period of disruption, however, the 1960s are here remembered as the glory days, as a time when the counterculture embodied the hopes and dreams of a generation. But this look back incorporates a sense of irony, one set into motion by Scorsese through a manipulation of film form. Scorsese is renowned for his deep appreciation and knowledge of film history, its images, its stories, and its styles, as well as being credited as an editor on the famous rock concert film *Woodstock* (1969). In *The Last Waltz* Scorsese subtly transforms the conventions of the rock concert film and sets them in renewed relationship to its subject matter. It is through the resultant clash of elements that the film's ultimate effect is created. Permeating the film is a tone of nostalgia (especially meaningful to the baby-boom generation), and a regret for both the passing of the 1960s and the dreams encoded in its aesthetic forms. In this way *The Last Waltz* is not so dissimilar from *The Shootist,* except that now the nostalgia is fashioned for the Left, yet gently critical of it.

The postmodern works of the classical film genres we have discussed thus far – those drawing from the crime, horror, and Western – were all produced from 1973 to 1978, and they occupy a distinctive position in the production of their particular genres. This is especially true of *The Last Waltz,* a rock concert film, and by extension a musical, that is poised significantly in the history of that form. The classical musical peaked in the 1950s but had since gone into decline, losing its prominence for many of the reasons noted in the other genres, but now with a new permutation:

the rise of rock music. Moving away from the swing music featured in the classical musical, rock needed a new cinematic form, one that responded to its immediacy. As Jane Feuer points out in her study *The Film Musical,* however, a number of strategies from the classical musical were nonetheless incorporated into the rock concert film,[14] especially those traditionally used to assuage the loss of the live performer and to ensure audience involvement. In both musical forms these tactics often included the foregrounding of a love interest among the principal characters, shots of the stage from the point of view of the audience, and a self-reflective story line about putting on the very show the film audience is about to see.

Woodstock, for example, presents a story about putting on the rock concert itself. In further compliance with the conventions of the backstage musical, it also features the stage from the point of view of the audience, personalizes both the performers and the audience, and embodies the classical musical themes of love and utopia through community involvement. One could argue, of course, that *Woodstock* is merely presenting the rock concert event as it unfolded before the filmmakers, and so it is an example of *cinema-verite,* an unscripted documentary style consistent with the spirit of the music and the times. As practiced by such filmmakers as D. A. Pennebaker and the Maysles Brothers, this style rejected the conventional methods of Hollywood and instead assumed that the ongoing event could be captured by the filmmaker's personal use of a hand-held 16-mm camera, synchronous sound, and "nonpreconceived" editing. But even with these methods the rock concert film (or "rockumentary") was not entirely released from complying with the conventions of the classical musical or from itself being codified into a recognizable form. Films like *Monterey Pop* (1969), *Woodstock,* and *Gimme Shelter* (1970) have established the conventions for the rock concert film. I will consider *The Last Waltz* in relationship to these generic conventions, and as the swan song for the rock group The Band, for the 1960s, and perhaps for the *cinema-verite* concert film as well.

In 1976 Robbie Robertson, the lead guitarist of The Band, asked his old friend Martin Scorsese to film the group's farewell concert at the Wintergarden Theater in San Francisco on Thanksgiving Day. The Band had been Bob Dylan's backup group in Woodstock, New York, during the 1960s, and this final concert was to be attended by many of their musical friends. Appearing with them was not only Dylan himself but some of the most influential and representative musicians of the era. These included Eric

Figure 18. *The Last Waltz,* Martin Scorsese, 1978. Photograph by Jack Badger.

Clapton, Neil Young, Eric Hawkins, Muddy Waters, Joni Mitchell, and Ringo Starr. In keeping with the grandeur of the occasion, then, Scorsese brought the production crew and equipment from the mainstream, high-budget film he was currently working on, his postmodern musical *New York, New York* (1977). In so doing, Scorsese began a process that would eventually destabilize the filming conventions of the *cinema-verite* rock concert film. Rescinding the immediacy and grass-roots conception of that form, Scorsese invited Boris Leven, the acclaimed Hollywood art director, to provided the sets for *The Last Waltz.* Far from relying on the natural surroundings of the event, Leven decorated the stage of the Wintergarden Theater (where The Band had performed their first concert) "nostalgically," that is, with the shimmering chandeliers and tasseled velvet curtains (Figure 18) once used on the set of *Gone with the Wind* (1939).

Scorsese also brought the director of photography from *New York, New York*, Michael Chapman, along with a few of his other "friends". These included no less than *six* additional cameramen, some of whom were the most distinguished professionals in the business. Present to film the concert were Laslo Kovacs, A.C.S., Vilmos Zsigmond, A.C.S., David Myers, Bobby Byrne, Michael Watkins, and Hiro Narita. Along with them came a sound and editing crew of equally high proficiency, with the equipment to match. Panavision 35-mm cameras were used and mounted on elaborate craning and pana-glide equipment, and the sound (to "be played loud" as the opening titles nostalgically instruct) was recorded in Dolby stereo. In completion of the gesture, *The Last Waltz* was released and distributed by MGM/UA.

This type of professional recording capability alters the conventional look and feel of the rock concert film. *The Last Waltz* presents us with a beautiful image, one bathed in the gold and red tones of the Thanksgiving season, but one also in keeping with the high-density, highly produced images of contemporaneous Hollywood films. The grainy images of the 1960s *cinema-verite*-inspired rockumentaries had once embodied a sense of immediacy and directness in tangible relationship with the events and the rock music itself. *The Last Waltz* counters this convention by pairing a high-definition Hollywood image with a rock concert event. What results is a kind of veneer placed over the rock image, a laminating, or metaphorical embalming. The rock concert event is thus seen through the patina of the glossy image, which fixes it, as it were, and so quite consciously relegates it to the past. Through the calcification of the image, *The Last Waltz* chronicles the end of The Band and, symbolically, the end of a cultural era.

Viewed today with the hindsight of more than twenty-five years, The Band and their friends look quite young indeed. But in 1976 their presence was meant as a marker of fading youth. The images of these now-grown men and women were intended to evoke regret at the collective aging of a generation, its music, its principles, and even its aesthetic assumptions. Many of the musicians in *The Last Waltz* were still in their thirties at the time of the filming, but to a generation that had built much of its musical and political agenda on the idea of youth, this came as a rude confrontation with reality. The kids of the 1960s were now adults, and Bob Dylan's anthem "Forever Young" had special poignancy as it was sung by perhaps the most emblematic musician of the era. Scorsese presented these

regrets with a good dose of celebration, but there was also a degree of distance, a position accomplished by further displacing the rockumentary's established conventions.

In *The Last Waltz,* for example, the high-powered cameras set on elaborate cranes move in lyrical compliance with the music, concentrating on the musicians' faces and registering both their effort and their ecstasy. Here the music is presented in an almost seamless flow, made stirring by the superb quality of the recording and by the associations it engenders. To see these legendary performers together is celebratory. To confront their passing is sad. But to listen to them talk is pathetic. Through the temporal structuring of the film itself, and by a series of interviews interspersed among the musical numbers, we are confronted with the fact that The Band has outlived its time. Scorsese objectifies the notion of looking back by beginning *The Last Waltz* with the closing number of the concert. From this perspective, then, and in keeping with the conventions for both the backstage musical and the rock concert film, we become acquainted with the principal performers. In *The Last Waltz,* however, the interviews with The Band were also conducted after the completion of the concert, causing the musicians to speak of that event, as well as their youthful memories, in the past tense. We watch as these grown men now tell age-inappropriate stories about the joys of turning cigarette machines upside-down and of getting girls. The internal clash that results, however, does not diminish the accomplishments of The Band or the 1960s. Instead, the music and its energy is intensified in its singularity. *The Last Waltz* is a celebration of a musical era seen at the moment of its passing, and it is brought to us in a form that embalms a time now acknowledged as gone.

It is not insignificant to note that Amos Poe's Punk rockumentary *The Blank Generation* was made one year before *The Last Waltz* and that both films occupy the same cultural context with the emergence of Punk music and postmodern art of the late 1970s. In their films, Poe and Scorsese moved beyond the 1960s, Scorsese with an ambivalent sense of regret, and Poe with a Punk attitude of rejection at those depleted styles. Each filmmaker returned to the past with a degree of "nostalgia," but in using the rockumentary form they shifted its conventions, restating them for contemporary usage. Scorsese accomplished this by filming an iconic 1960s rock group in calcified *cinema-verite* style, whereas Poe redoubled the musical gesture of Punk, mixing popular usage with the avant-garde and

dismantling the form through offhandedness, fragmentation, and irony. In both films the styles of the 1960s are replaced, not with a conservative agenda, but with a new aesthetic strategy. *The Blank Generation* and *The Last Waltz* replaced methods that had lost their efficacy, their power to communicate, and their ability to inspire with a new configuration of elements.

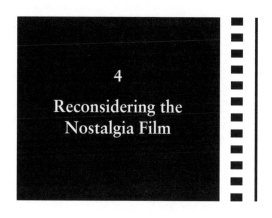

4

Reconsidering the
Nostalgia Film

The films discussed in Chapter 3 respond to the localized cause of a post-1960s era. Their highly coded images and generic sources refer to the past, but not to screen the present. The present intercedes and ruptures the nostalgic surfaces through trauma or displacement. With these observations in mind, I will reconsider two films classified by Jameson as nostalgia films, *American Graffiti* and *The Conformist,* and another seemingly incongruous addition, chosen because it wreaks havoc on the very notion of nostalgia, *The Rocky Horror Picture Show.* As films of the early to mid-1970s, these works strongly refer to past cinematic images, styles, and genres. But they do not render an experience of nostalgia as much as a direct confrontation, serving to indict the historical or societal conditions of those eras. In this chapter, I will explore how these films confront the present through historical trauma, or through a carnivalesque immersion into an already compromised screen image.

American Graffiti

Fredric Jameson designates *American Graffiti,* which was directed by George Lucas, as the inaugural film of the new style of commercial filmmaking, and compared to the works already discussed, it seems a much purer example of the nostalgia film. Not only does *American Graffitti* return to the styles and songs of a trouble-free pre-1960s era, one before the political disruptions of the 1960s proper, but it also embodies an apparently noncritical, pleasurable style of filmmaking. The film could thus be seen as a guilty pleasure, an easy diversion that resuscitates a peaceful bygone era, nostalgically re-creating our youthful innocence. It must be noted, however, that the historical disjunction between the events

presented in *American Graffiti* and the era in which the film was originally shown results in a friction that speaks to the effects of the 1960s on a generation. Moreover, *American Graffiti* invokes that historical period directly, eliciting a sense of regret and of confrontation with it.

The nostalgic quality of *American Graffiti* is first cued by its title, which appears in neon-inspired graphics. This neon style connotes a 1950s form of sign writing, and as the term "graffiti" implies, also alludes to popular messages left in public places, or metaphorically, on our consciousness as well. In this sense, *American Graffiti* is very much about remembering the past (the past here, literally, as etched memory). The emphasis, however, seems not to be on a personal past, but rather on an American cultural and historical past. True to Jameson's claim, *American Graffiti* is a reconstruction of styles from a prepolitical 1960s era, one strongly evocative of the 1950s. The past is re-created in the film's *mise-en-scene*, for example, through the distinctive style of its cars, clothing, and music. Chevrolets, Edsels, Cadillacs, as well as the crinoline skirts, letter sweaters, and the music of The Coasters, all sweep us back into a joyous sweetness, connoting the imaginary security of an ordered America and the exuberance of its styles. To similar effect, *American Graffiti*'s colors are often presented in primary hues, while the image itself has a shimmering reflective surface reminiscent of hard-shine paint of the automobiles it so prominently features. It is a simulacral image, referring to a lost time, to past images, and to its own status as a commodity sign.

As in *Badlands,* the very opaqueness of the visual surface, referencing other visual and generic sources rather than "reality," can be seen as a kind of cover, or screen, against the real. In *American Graffiti* the surfaces inspired by the past once again seem to have a nostalgic effect, drawing us back to a utopian time, far from the troubling realities of then-recent history. It must be noted, however, that in *American Graffiti* these nostalgic surfaces are not meant to recall two-dimensional paintings as in *Badlands*. Instead, they refer to the image styles of 1950s films and to the seeming stability and clarity with which those stories were once told. On a surface stylistic level, then, the viewing of *American Graffiti* is similar to repositioning a film like *Rebel without a Cause*, with its high saturation color and its period-style clothes and cars, squarely into 1973. But rather than simply re-presenting these past film styles, *American Graffiti* accomplishes a number of discontinuities that ultimately serve to destabilize its surfaces. And this is initially accomplished by separating the style of the image from the type of past that is represented.

If one were to compare *American Graffiti* to the youth genre films from the 1950s, for example, there would be significant differences in their stories and in their emotional tone. The 1950s youth films often presented cautionary tales regarding the problem of "juvenile delinquency." *Rebel without a Cause,* for example, depicts a number of dysfunctional families and their teenagers' resultant psychological problems. Although this film may seem mild by today's standards in the representation of sex and violence, it nonetheless includes gang members in a knife fight, a fatal car accident, and the police shooting of a minor. *American Graffiti* is instead a curiously gentle story, presenting a group of uniformly good, kind, and considerate teenagers. In this way the "return" in *American Graffiti* specifically constructs the past and its youth as innocent. The greater forms of violence or cruelty in *American Graffiti,* for example, include getting "mooned," or being hit in the face with a water balloon. Even the gang members who menace one of the film's central characters, Curt, turn out to be harmless guys whose threats result only in good-natured ribbing. And in almost fairy-tale fashion, all of the central characters really care for one another. Steve, the good hometown boy, loves his girlfriend Laurie and doesn't leave her. The "trashy" Connie (a Connie Stevens look-alike) is actually a delightful girl with true affection for the nerdy boy, Terry. And Curt, the most thoughtful of the group, not only receives a phone call from his dream girl in the white Corvette, but also gets to meet the legendary (and very approachable) disc jockey Wolfman Jack.

The saccharine quality of *American Graffiti* may at first seem too simplistic to embody its era, or even to generate a dramatic narrative. Where, for example, is the conflict in a film so filled with pleasantries and nostalgic blandishments? Before we dismiss them, however, we must note that the referents of many of these 1950s situations (however idealized) are not so much drawn from 1950s movies, as they are from the personal memories of a broad-based cultural group. The cars, the clothes, the music, and the pranks are also intended to have a lived resonance, not only for a particular generation but for all those Americans who lived as adults through the previous ten years, from 1963 to 1973. And it is precisely this conflict between memory and history – the tension that comes from the juxtaposition of the coded material against the historical context of the film itself – that encourages a new set of meanings to arise. Seen in this clash, *American Graffiti* has the structure of irony, producing a feeling of nostalgia but also of pathos, and registering the historical events as the cause of an irretrievable loss.

The story of *American Graffiti*, for example, is engaging and easy to follow, but it is not as conventional as one might imagine. Instead, the narrative is almost Altmanesque, involving one night in the lives of four characters in which nothing of importance happens. As a coming-of-age film, it presents a series of events loosely based on the moment of leaving home and going off to college. But in *American Graffiti* the underlying conflict and danger come primarily from the audience's own knowledge of the impending destruction of this innocent world with the coming of the 1960s and the historical events that were to follow. This charming group of teenagers, for example, and their archetypal departure for college, resonate with historical specificity. The poignancy of that realization continuously underscores the events of the film. The film viewers' historical position, referring back to 1962 from 1973, allows for a critical disjunction fueled by the knowledge of recent history (Figure 19).

At the time of its release, many members of *American Graffiti*'s audience could still remember the era represented in the film as part of a personal past. (A situation, it must be added, that changed significantly as the craze for returning to the 1950s continued across the 1970s, 1980s, and 1990s.) But for this early 1970s audience, watching *American Graffiti* has a bittersweet quality, one that destabilizes the purely nostalgic events presented on screen through the inconsistency of seeing this era represented in glowing terms. *American Graffiti* presents a story that is a veritable compendium of era-specific language, styles, and teenage pranks; but behind the now reconstructed innocence there lurks the nagging question: "Were we ever so innocent?" The answer is, of course, "No." So while many members of that earlier generation may remember the distinction between the "collegiate kids" and the "greasers," or buying liquor without an ID, or cruising main street to find the love of one's life, the now-grown audience of the 1970s can appreciate its unspoken contradictions. A little historical knowledge will tell you that the collegiate kids – that is, the middle class kids of the 1960s – went to college, and the greasers – or working-class kids – went to war. In addition, buying liquor without a valid ID may be remembered as not so innocent to a generation that experimented extensively with an entire spectrum of drugs and alcohol and that smoked cigarettes with such abandon. And similarly, the necking and sexual fumblings represented can only seem quaint (and nostalgic) if one does not know the history of this era's lack of effective birth control and sex education, as well as the absence of legal abortion.

Figure 19. *American Graffiti,* George Lucas, 1973. Copyright
Universal City Studios, Inc.

Even on this seemingly innocuous level of teenage memories, then, un-
comfortable contradictions begin to destabilize the pure nostalgia of the
events. But perhaps the central contradiction comes from the date in which
the film is set. It is 1962. As in *Badlands,* the recognition of this pre-trauma
date is subtly yet pointedly interjected as we learn of Curt's plans to be a
presidential aide and to one day shake the hand of John F. Kennedy. The
film's contemporaneous audience is keenly aware that President Kennedy
will be assassinated in 1963. So as Curt boards the plane on his way
to school, waving goodbye to his hometown friends who call, "See you
soon," the audience understands, again through historical experience, that
the lives of these young people will be significantly altered by the upcom-
ing events. Curt, like so many during those years, is leaving his American
hometown and his 1950s youth and heading to the future in the 1960s,

a profoundly disruptive period of war, protest, and innovation. But it is the end titles of *American Graffiti* that ultimately serve to acknowledge what has remained largely unspoken throughout the film.

As the film's end titles roll, the face cards of the major male characters are presented along with their accompanying biographies. We learn that like many young men of the period, the film's characters chose life paths primarily determined by the Vietnam War. The possible paths were clearly demarcated: A young man could leave home to fight and possibly die in Vietnam, escape to Canada as a draft dodger, or, lastly, chose to stay and marry as a way of avoiding the draft. In *American Graffiti* each option is presented as a literal or metaphorical death. For this reason, the entire group of leading males in *American Graffiti* "dies" after its end. Terry, the working-class boy who does not own a car and is not going off to college, is listed as missing in action in Vietnam. Curt, the college-bound writer, dies a cultural death as a political exile in Canada, while Steve, who decides to stay home, dies a spiritual one as a family man and insurance salesman in Modesto, California. And lastly, John, again fashioned to look like the 1950s rebel James Dean and so not able to live into the future, dies an ignominious death at the hands of a drunk driver. The "1960s" are thus fashioned to a particular meaning in *American Graffiti*. They are invoked to reference the effects of the Vietnam War on a generation, with the enforced gaiety of the film set against this historical loss.

But the major question is one of reception. Is this a message received? Or has the easy pleasure of watching *American Graffiti* lulled the viewer into its illusionistic play without the critical distance needed for "resistance" in its true form, or at least in its modernist form? In *American Graffiti* the answers seem grounded in the generational makeup of the audience. In fact, the two-tiered system that Noel Carroll had noted as part of the allusionistic practice of films from the late 1970s seems to be operating here, only not quite as he had assumed. The knowing members of the audience do not simply understand the allusions to film history as a "wink" from the director. In *American Graffiti* this wink also includes some important political and historical information. *American Graffiti* is underscored by a culturally specific awareness that this era never quite existed as presented nor would we want to return to it. Through this particular re-creation of the past, and the undeniable pleasure of reexperiencing it, *American Graffiti* subtly confronts a generation with its moment in history.

The Conformist

The new style of cultural production is not limited to American works. Practices in other countries, especially in societies strongly influenced by U.S. economic or cultural presence, show a similar significant shift in style beginning in the 1970s. Most notable among these is the work of German filmmakers such as Wim Wenders [*Alice in the Cities* (1974)] and R. W. Fassbinder [*The American Soldier* (1970) and *Ali: Fear Eats the Soul* (1974)], whose referencing of American films also become apparent at this time. And despite appearing almost two decades later, the films of Hong Kong director John Woo [e.g., *The Killer* (1989)] show similar tendencies. In all of these works, the past returns through a variety of cinematically coded systems and then, depending on the concerns of the filmmakers themselves, is put to particular uses.

The Conformist by Bernardo Bertolucci is an Italian film also cited by Jameson as an example of the nostalgia film. This film, however, does not return to the film genres of the past and so seems to belong to the traditional category of the historical film. But Jameson's designation is correct because *The Conformist,* like *American Graffiti,* re-creates the past through the presentation of past cultural artifacts. *The Conformist* not only recreates the 1930s styles of clothing and décor in Fascist Italy, but also recalls the very look and feel of film images from the period. Any notion that *The Conformist* may inspire nostalgia to return to a Fascist period, however, is misleading. *The Conformist* is an indictment of the Italian Fascist period and the members of the social class that allowed it to happen, many of whom could still be counted among the film's contemporary audience. Why, then, should this "nostalgic" style, one admittedly pleasurable, aestheticized, even "bourgeois" in its beauty and sensuality, be applied to the telling of Bertolucci's anti-Fascist story?

The initial answer to this question is that it creates a feeling of melancholy, one engulfed by a sense of loss and of guilt, in the very evocation of the past. Through the visual re-creation of the process of memory as a structuring principle, *The Conformist* forces a confrontation in 1970 with what had been suppressed in the Italian cinema for over twenty-five years. Although the World War II period had been represented by the neorealists in the immediate postwar era, these films were tales told from the perspective of the victors, and often from the point of view of the

Resistance instrumental in freeing Italy from Fascist control. In these films, the Italian people, that is, the working class, are often presented as the victims of a cruel war. In fact it took a generation for Italian filmmakers [not only in *The Conformist* but also in such films as *The Garden of the Finzi-Contini* (1970) or *Seven Beauties* (1976)] to return to the World War II era and actively confront issues of Italy's culpability and complicity.

In *The Conformist* Bertolucci returns to the Fascist period in a style that often reverses the aesthetic of the neorealists. Bertolucci challenges the very notion of "reality" so central to the neorealist filmmakers. The neorealists had put their faith in the ability of the film medium to record the present. By using nonactors and, most importantly, by recording the very time and place where events had recently occurred, these filmmakers strove to capture the feel of the historical moment. Within this neorealist practice, then, fiction films such as Roberto Rossellini's *Rome, Open City* (1946) were infused with a documentary feel and a sense of immediacy. But in *The Conformist*, Bertolucci is faced with a different historical challenge. In 1970 Bertolucci returns to a 1930s Fascist era, to the past of his fathers, and, in so doing, to a time for which he has no direct memory. In fact, he is returning to a time he knows only through photographs, through cultural artifacts, and through the stories told to him by family and friends or through historical accounts. And it is perhaps because of the conflicts in remembering this period that Bertolucci presents a past tinged with the sense of melancholy and death typical of the photograph itself. Moreover, it is a past driven by a son's search for truth, thus creating a cinematic memory in which Bertolucci both indicts Italy's Fascist history, and confronts it.

Adapted from an Alberto Moravia novel, the film tells the story of a Fascist, Marcello Clerici, once a university student, who comes to Paris to kill his exiled anti-Fascist professor, Luca Quadri. The obvious Oedipal implications of this quest, and the sadness and the treachery of it, are highlighted by Bertolucci's own personal comments on the story. Since Bertolucci himself had recently undergone psychoanalysis, the filmmaker saw a parallel between himself and the character of Clerici in that Bertolucci too had found his own way of "killing the father."

At first I tried to make films out of a desire, a need, to do something different from what my father had done. He was a poet and I wanted to compete with him by doing something else. I started writing poetry too, but saw that I would lose the battle. So I had to find a different area from which to compete.[1]

In making *The Conformist,* Bertolucci also rejected his cinematic father, his mentor Jean-Luc Godard. As Bertolucci claims:

The Conformist is a story about me and Godard. When I gave Professor Quadri Godard's telephone number and his address (in the film), I was kidding. But later I said, "Well, perhaps it has some meaning ... I am Marcello and I make Fascist films and I want to kill Godard who is a revolutionary, who makes revolutionary films, and who was my teacher.[2]

One could say that Bertolucci is acknowledging a move from modernist to postmodern practice, since he is moving away from the film form utilized by Godard, away from the latter's aggressive stance toward the audience, and away from his openly self-reflexive practices. Godard's revolutionary practice had championed the use of film as "cinema stylo," to write essays with film, and as "cinema rifle," to realize a Left radical cinema. In the preceding quote Bertolucci claims a deviation from the Godard style. It can hardly be said, though, as Bertolucci claims, that his own films are "Fascist."

Although *The Conformist* is highly pleasurable in its sumptuous visual presentation and ultimately cohesive in its story, it is still highly fragmented in its narrative structure. In fact, it is only through several viewings that the film's story, one that interweaves the main character's mental states and reconstructs the past through memory, can be fully understood. Moreover, special attention is given to the image as such in *The Conformist* through self-reflexive strategies. But regardless of these Godard-like characteristics, Bertolucci is correct in noting a deviation in style and emphasis in his film. In deviating from Godard, Bertolucci achieves his political goals by the sensual re-creation of the past, one that owes more to the oneric structures of Federico Fellini [*8 1/2* (1963)] or Alain Resnais [*Hiroshima Mon Amour* (1959)] than to those of Godard. Bertolucci, however, utilizes the structure of memory in *The Conformist,* not to make a Fascist film, or even a lyrical or surrealistic film, but rather, to confront the Fascist period by returning to it through a specifically cinematic memory.

The visual style and narrative structure of *The Conformist* represents the Italian Fascist period from the perspective of 1970, through the prism of the past. This style presents us with an objectification of memory, utilizing the film's narrative structure and visual surface to take us back in time. Here the past returns through its pictures, often seen in soft focus or bathed in hues of blue or gold, and through the evocation of the cinematic

and graphic styles of the 1930s. But now this arguably "nostalgic" surface is set against the historical events represented by those images and, most importantly, is placed in direct confrontation with the Italian audience of 1970. Here the past returns as a repressed memory. In this way, the audience is placed in a position similar to that of Clerici, who, through his ruminations, returns to a past trauma and to a present realization.

Clerici's memory of a childhood trauma, one that involved a forbidden sexual encounter and a supposed murder, as well as his confrontation with the present, is a complex metaphor for the psychology of the film audience itself. The confused and extremely painful memory that threatens to engulf Clerici is not entirely understood by the now-grown man. And although Clerici ultimately learns that he did not murder the male chauffeur who seduced him as a child, this knowledge does not free him. Clerici is still the murderer of Professor Quadri, he is still the criminal of Fascism, and he is still the hateful perpetrator of his own conformism. And in the final moments of *The Conformist*, Clerici confronts his own true nature. He sees that he is everything that the Fascists and he himself had hated and that he had always suspected himself of being. He is different, a homosexual, a non-conformist, and Clerici finds that his only redemption lies in accepting who he is. All that Clerici had tried to repress thus comes to the surface.

The Conformist stands in metaphorical relationship to Clerici's trauma. The film itself is the raw center, the cinematic trauma that now returns to disrupt the present. Through it the audience confronts a period that had been submerged in Italian film behind the cloak of neorealism. Here we see the possibility of describing neorealism itself as a form of traumatic illusionism in that its apparently "realistic" surface has actually functioned as a cover for the real. (In *Rome, Open City*, for example, Anna Magnani – who plays Pina, a highly sympathetic character and representative of the Italian working class – plaintively asks her priest about the war and the occupation, "Doesn't God see us?" Here Pina and the Italian people are presented as the war's victims.) The trauma that is confronted in *The Conformist* is of the middle- and upper-class support for the Fascist regime that led Italy into war and into acts of atrocity. Even through its highly aestheticized and illusionistic surfaces, the film confronts its audience with the real through trauma. Trauma here is openly presented as history. In this way Bertolucci indicts his national "fathers" as Clerici does his own father, who has been confined to a sanitarium. Clerici says to this obviously insane figure, "You tortured didn't you? You gave castor oil? You

killed?" The answer is of course, "Yes," and the character of Clerici gives some of the most damning class-based reasons. The central issue in *The Conformist* is the fear of being different, and the decadent concerns that supported the upper classes in their compulsion for conformity and their retreat from dissent. In the film we see the voluptuous need to be in fashion, the vain love of beautiful possessions, the fear of sexual difference, and the hypocritical compliance with the laws of the Church. The fear of difference and of the harsher realities of life is answered by constructing a wall of illusionism behind which the real is hidden. *The Conformist* ruptures that illusion through a cinematic return that directly confronts that era.

In *The Conformist,* several time periods are collapsed into a series of ongoing present tenses interweaving to form the narrative generated from Clerici's consciousness. The story is constructed out of a series of flashbacks to various traumatic stages in Clerici's life: his seduction as young boy by his chauffeur, his murder of Professor Quadri in 1938, and his helpless viewing of the fall of Fascism in 1943. Certain ambiguous scenes are also included and stand as Clerici's possible fantasies. The interweaving of past time periods is then objectified on the level of the image itself. The image and the *mise-en-scene* in *The Conformist* have undergone a manipulation that mimics the intrinsic pastness of the photographic process. Not only is the 1930s period evoked by the style of cars, clothes, and décor and by the sumptuous musical score, but also by the design of the film images themselves. Here the images recall the chiaroscuro lighting popular in films of the 1930s, their composition, and their romantic content. To counter a sense of nostalgic reverie, however, they also menacingly present the bombastic painting and architecture of the Fascist period, artifacts that dwarf the individual with their overpowering mass and scale.

A process is then set into motion that makes palpable the image as a thing in itself. The flatness of the image is invoked, Godard-like, through the use of reflections on the surface of windows, creating a double exposure with the images behind the glass. Unlike Godard, however, this is not meant to break the illusion of the fiction. Instead, it becomes fully integrated into it. The double-exposure technique, for example, is utilized in the train sequence that depicts Clerici and his new wife, Giulia, on their honeymoon. In a highly sensual moment, the newlyweds begin their lovemaking in the left foreground of the image. Behind them, the frame within a frame created by the train window forms an often-used

cinematic metaphor for the film image itself. Here it undergoes a number of permutations: first as a representational image of a landscape, then as an abstraction of swirling lights and colors as if recalling the films of Stan Brakhage, and finally, as flickering black-and-white light as in the cinema of Peter Kubelka. In this way Bertolucci is registering the uses of the cinematic image as representational, as abstraction, and as pure light.

These articulations of the image, and the poles between illusion and reality, are also directly addressed in the text of the film itself. On meeting with Luca Quadri (whose last name means "paintings" or "pictures" in Italian), Clerici recalls the professor's lecture on the metaphor of Plato's cave. Clerici recites it for Quadri:

Imagine a large underground space in the shape of a cave. Inside are men who have lived there since infancy, and who are chained and made to look at the back of the cave. Behind their shoulders, far away, glows the light from a fire. Between the fire and the prisoners, imagine a low wall, similar to the small stage on which a puppeteer presents his puppets. And now try to imagine some men who pass behind that wall carrying statues of wood and stone. The statues are higher than that wall, the chained prisoners of Plato! What do they see?

In this sequence, Quadri is outlined as a shadow figure, an image created by projected light much like the illusions created by the fire in Plato's cave. And Clerici, too, is seen as a reflection of light onto the back wall of the professor's study. Each character is articulated as a substanceless form, as an illusion. But here the metaphor of illusion and reality is lifted from a purely self-reflexive film plane. We are directed not only to the state of watching the film, to the illusionistic play of light and shadow, but also to the political and historical situation in Italy during the Fascist period. The illusionism of the film image is equated to the Italian decadent penchant for artifice, for the false front, for the lie that hides the truth. Much like the tanks that were ordered around the block by Mussolini to create the illusion of a well-equipped Italian army for Hitler's benefit, or the Fascist-commissioned graffiti scrawled on walls that Il Duce himself grew to believe, Quadri tells Clerici that Italy is living a lie. Italy has become unable to distinguish its own lies from the truth.

In this film, the past returns as image but also as historical trauma. The trauma is registered by the direct confrontation with that past by cinematically rendering it "nostalgically," that is, palpably, experientially. Through it, Bertolucci, as the son of his national fathers, indicts them by reintroducing the cultural memories of the past into the present. In one of the final

Figure 20. *The Conformist,* Bernardo Bertolucci, 1970. Copyright Mars Produzione, S.p.A. Roma.

sequences of the film, Bertolucci again uses the cinematic metaphor, the revelation of the image as such and of the image as screen, to articulate the inaction of the Fascist, Clerici, as well as of the Italian populace. Clerici sits motionless, frozen, much like the film viewer in his/her theater seat, as Quadri is assassinated, Caesar style, by a group of Fascists who now repeatedly stab the professor (Figure 20). Quadri's terrified wife, Anna, also watches, but then she suddenly bolts, running and throwing herself against the window of Clerici's car. Clerici sits in the back seat, as Anna is now seen from inside the vehicle, through the frame within a frame of the rear widow (Figure 21). He watches impassively as Anna beats on the window with her hands, and metaphorically on the image screen itself, rendering it a hard, material surface. And both we and Clerici watch as Anna cries and rages at this man who was once her lover and who is now her supreme traitor, a coward in his immobility. Clerici's gun is on his lap. He could act. Clerici could shoot Anna, he could shoot the Fascist driver, or shoot himself. But Clerici does nothing. He simply watches.

Since the audience watches too, it is similarly indicted. The members of the Italian audience in 1970 and, by extension, the Italians of the Fascist

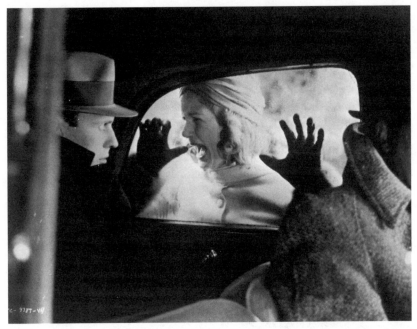

Figure 21. *The Conformist*, Bernardo Bertolucci, 1970. Copyright Mars Produzione, S.p.A. Roma.

period, are indicted for what they did not do during that era. They let it happen, because to be part of the crowd was safer than to be an individual, to act out of conviction. And for all those Italians who, like Clerici's blind Fascist friend, Italo, did not see the truth, their excuse is now rescinded. At the end of *The Conformist*, Italo too is exposed. Although he cannot see, he is now *seen*. As Clerici and Italo move through a crowd of anti-Fascists at the fall of Mussolini, Clerici points to his blind friend and denounces him as a Fascist. Italo can no longer hide. In a similar vein, the pleasurable surface of *The Conformist*, the *mise-en-scene* with its elegant hotels, expensive restaurants, and Paris couture clothes, had served to create a participation in a clearly distinct social class. Now, it is directly to the bourgeoisie that this indictment is addressed.

The image of *The Conformist* returns as historical trauma. Since the real cannot be directly represented, it makes its inclusion through this rupture. The film is thematically about the return of trauma, about the repressed fear of homosexuality, and about the guilt of murder, all finding their way to the surface. This coming to the surface of submerged impulses

is again registered at the end of the film with the fall of the Fascist regime. This fall breaks the beautiful and elegant worlds staged within the film as we now find Clerici and Giulia reduced to poverty. Gone are the fabulous clothes and the exuberant laughter; even the art-deco lighting and décor have been replaced. Their house is somber. The only joy comes from the Clericis' young daughter whose innocence and gaiety makes the parents' guilt all the more palpable. The parents are in defeat. Their shortsightedness has led to their downfall. And just as Italo is exposed for the Fascist that he is, Clerici is exposed, but also finds solace in, what he had always feared himself to be: a homosexual. He (and those in Italy), who had so much wanted to conform to the norms of the group, and who had been unable to stand up for dissenters, for communists, for Jews, or for homosexuals, is now forced to face himself. And as the film closes, in the bedroom of his male lover, Clerici becomes what he himself had persecuted.

The Rocky Horror Picture Show

As we can see from the previous two examples, another of the distinguishing characteristics of the nostalgia film seems to be its unique dependence on audience response. In some ways similar to the film *Nostalgia* by Hollis Frampton, or other avant-garde works such as *Wide Angle Saxon* (1975) by George Landow, or even Anthony McCall's *Line Defining a Cone* (1976), the final completion of the work comes through the audience's active reading and interaction with the film. In *American Graffiti* and *The Conformist,* for example, this response depended on the audience's personal or historical memories. The issue of audience participation, however, becomes problemitized in *The Rocky Horror Picture Show* because of the way it incorporates avant-grade elements into a mainstream film. And although we have already noted the crossing of boundaries between high art and popular culture, in *The Rocky Horror Picture Show* we are faced with a new set of concerns. In this ostensible nostalgia film, a response is elicited that is more typical of the avant-garde than of the mainstream film, and it is one that now destabilizes the cinematic illusion through the audience's spontaneous voiced participation and physical performance. While it could be said that the avant-garde strategies of "distanciation" and "anti-illusionism" thus move into the mainstream, it is also important to consider how these once-oppositional responses are

altered when evoked from a general audience, and within a commercialized setting.

Technically speaking *The Rocky Horror Picture Show* is a mainstream film since it was produced and distributed by a major studio, Twentieth Century Fox. But its initial run in 1975 was a box office failure, causing *The Rocky Horror Picture Show* to find its way to the midnight screening at the Waverly Theater in Greenwich Village. Here this mainstream film soon earned a reputation as a cult phenomenon. If we look more closely at the content and form of *The Rocky Horror Picture Show,* however we see that it was never fully served by the term "mainstream." After all, the story of *The Rocky Horror Picture Show* depicts flagrant homosexuality, bisexuality, transvestitism, and cannibalism, while its form is a strange admixture of classical horror and musical genre conventions presented in a highly ironized and discontinuous manner. Even with this apparent flaunting of mainstream sensibilities, can we say that the film accomplishes an "avant-garde" gesture? Certainly the popular response to the film, which breaks the usual silence and immobility of the seated audience with its ritualized chants and floor shows, could be said to break the cinematic illusion, or alternately, to criticize the status quo of middle-class sensibilities. But does this rather debased commodity have a relationship to the avant-garde with its claims to oppositional art and political aspirations? Or is it simply a category mistake, a popular phenomenon that corrupts the very notion of the avant-garde? To answer these questions, I first consider *The Rocky Horror Picture Show* in the early days of its run, when it was still the site of innovation and carnival.

The Rocky Horror Picture Show was written by British actor Richard O'Brian and was first produced in 1974 as a stage play both in England and in Los Angeles before it was made into a film by Twentieth Century Fox. But the film's resulting audience participation was a phenomenon that arose spontaneously over the course of its run as a midnight movie in New York City. As J. Hoberman reports in his book *Midnight Movies,* the first voiced response to *The Rocky Horror Picture Show* came from Louis Farese Jr., a usually quiet schoolteacher who had seen the film several times and apparently felt "distanced" by the long pauses between lines of dialogue. In the fall of 1976, five months into the film's midnight run, Farese watched as Janet Weiss, the young protagonist of *The Rocky Horror Picture Show,* covered her head with a newspaper to shield herself from the rain. Losing his control, Farese finally shouted out at the screen: "Buy an umbrella, you cheap bitch!" Farese's disdainful outburst

at the screen met with laughter and encouraged others in the audience to voice their opinions. The use of self-proclaimed "counterpoint dialogue"[3] soon became a free-form response to *The Rocky Horror Picture Show*, and later, in 1977, through the leadership of another regular, Sal Piro, it slowly became a standardized text, repeated verbatim at each screening. As was apparent from Farese's first comment, however, the audience's remarks were not especially profound or even funny, and they certainly did not rise to the "professional" level of a cinematic writing. Instead, they reflected the everyman status of the viewers, rupturing the cinematic event with discontinuous and often base remarks that effectively dismantled the divide between the film and the theater space, forcibly interjecting the audience *into* the film itself.

This quality of disruption and immersion was then extended to the ritualistic props and gestures displayed by the audience during the viewing of the film. Rice was thrown during the wedding sequence, for example, water pistols sprayed when it rained on screen, and toilet paper rolls hurled through the air at the mention of "Dr. Scott." But instead of "distancing" the audience by breaking the exclusivity of the fictive events and the illusion of the screen image, the audience became part of the show and, as Hoberman claims, made the film a much more "live" experience.[4] But the compulsion to "live it" or "be it" as both the tag line and the song in the film encourage, is nowhere better demonstrated than in the act of imitating the physical look of the screen characters themselves, a practice spontaneously adopted by the film's regulars. Here the audience members sought to duplicate the costume and makeup of the characters (to "become" the pictures) and then staged a live performance in front of the film's screen images. But to say that the effect of this action is to rupture the fourth wall of the filmed illusion in a Brechtian manner is not fully correct, nor is the modernist assumption that the proclaiming of the film image as such will necessarily result in a distanced, intellectual response to the represented events. Instead, the impulse to enter the image was coupled with a simultaneous pull in the other direction. In this way *The Rocky Horror Picture Show* effectively *extends* the fourth wall, moving it from the surface of the screen to the back wall of the theater, encompassing the audience and including live action, filmed image, and audience participation as part of the show.

In the compulsion to crawl right up into the screen image, Benjamin's observation about the basic property of film that brings experiences ever closer while keeping them profoundly distant is recalled. In fact, the

audience of *The Rocky Horror Picture Show* could be compared to the soldier in *Les Carabiniers* who so desperately wanted to possess the image of his object of desire, only to find a flat white screen and the insubstantiality of projected light. In *The Rocky Horror Picture Show,* however, the pain of absence has resulted in a form of denial, one in which the screen images are "entered," or "possessed," and are sensually projected onto the bodies of the costumed audience members who now bring them to "life." In this way the compulsion "to become the picture" also recalls Buster Keaton's *Sherlock Jr.* Here too the normally shy protagonist had entered the movie image in a dream and won his object of desire. The audience of *The Rocky Horror Picture Show* seems to have a similar kind of objective and experience. A major difference, however, is that Sherlock had longed for a conventional hetrosexual union, whereas in *The Rocky Horror Picture Show* the dream is of homosexual expression and, more than that, of pan-sexual liberation. The ultimate effect of *The Rocky Horror Picture Show,* then, is not one that necessarily inspires the viewers to a modernist contemplation of the illusion created by the cinematic apparatus, nor does it lead them to judge the film's represented events in a critical manner. Instead, the audience responds in wild exuberance and in carnivalesque celebration. Unlike the protagonist in *Sherlock Jr.,* then, the audience does not simply "dream" participation in the cinematic image, but rather, strives to "become it."

The "carnivalesque," as described by Mikhail Bakhtin, is the spirit of carnival transferred onto literature and theater[5] and, in this case, into film. The world of carnival is a vibrant, popular expression in which the conventions and practices of society are turned "upside down." Through a public display of laughter, song, dance, and disguise that is subversive of established and repressive societal norms, members of the upper classes can become the low, and those on the bottom can occupy a higher position. Businessmen can dress up as whores, and whores as princesses, and all, for one brief utopian moment, can inhabit their wilder fantasies. Extending Bakhtin's notion, Robert Stam, in a study entitled *Reflexivity in Literature and Film,* discusses a "carnivalesque modernism"[6] that utilizes the spirit of carnival and includes the theater and film works of Alfred Jarry, Luis Buñuel, and Jean-Luc Godard. Stam, however, notes that the once-vibrant popular practice of carnival in fact became ossified in Europe during the modern period and was kept alive in the practices of the avant-garde, of the Dadaists and Surrealists in particular, themselves marginalized as the expressions of elite groups. The spirit of carnival also influenced these works, but now in particularly modernist form.

Stam discusses the carnivalesque strategies that resulted in these formally aggressive and often self-reflexive avant-garde works. They include the carnivalesque penchant for the aleatory, as in the random and recombined poetry of Tristan Tzara, the discontinuous presentation of time and space in Bunuel's *Un Chien Andalou,* or the radical fragmentation of narrativity in *Les Carabiniers.* He also notes the tendency of the carnivalesque to revel in the material body principle, that is, in the functions of the body's lower stratum – copulation, thirst, hunger, defecation, and even cannibalism – and cites the scatological references of Jarry's play *Ubu Roi* (1896) and its cannibalistic sequences. In this way, the avant-garde works aggressively confronted the viewer with unconscious desires for sex and savagery, and they did so, incongruously, with convulsive laughter. In keeping with these more instinctive or primitive concerns, Stam also notes the tendency in both *Ubu Roi* and *Les Carabiniers* to reduce language to its material plane, draining it of its figurative and meaningful usage through incongruent juxtapositions and radical displacements. These strategies are then joined to ones that reduce the audience's identification with the two-dimensional characters, thus creating a critical distance from which the audience can appreciate the self-reflexive effect. In *Les Carabiniers,* Stam describes how this ostensible war film ultimately serves to demythify war and the war film, as well as the antiwar film itself.

The perplexing issue that we have before us in *The Rocky Horror Picture Show* is one that could be termed a "carnivalesque postmodernism," for this film certainly incorporates many of the conditions of the carnivalesque, and it does so in a manner that joins it to earlier avant-garde works. Yet *The Rocky Horror Picture Show* must be distinguished from modernism's abstract criticality. As a postmodern work, it displays attributes typical of the new style of practice to emerge in the mid-1970s, and it does so by merging pleasure with the previously distinct characteristics of the avant-garde and those of mainstream film. *The Rocky Horror Picture Show,* however, presents its own kind of liberatory effect. It sublates the usual distinctions supported by the institution of art between itself and the conventionality of the mainstream film. And it does so, not to de-mythify the genre films it draws on, but to introduce a whole new kind of subjectivity, one radically disruptive of its visual surface. The question now is: what becomes of the spirit of carnival when it is transposed onto the American genre film? and on to the images it produces?

The Rocky Horror Picture Show begins with an image that combines the two major genres forming its source, the classical musical and horror

film. As the film opens, a pair of Technicolor red lips emerge from the depths of a black background and come into close-up, soon filling the entirety of the screen. As a matte effect often used in the classical musical (in the "Broadway Melody" number in *Singin' in the Rain,* for example), the visual result reduces the image surface to its two-dimensional plane. The large red lips then begin to sing "Science Fiction/Double Feature," a song that is made up of fragments taken from the 1950s subgenre of the horror film. Almost like the avant-gardist Tristan Tzara who advocated constructing poems by cutting words from a newspaper, putting them in a bag, and then rearranging them at random, the words and phrases of the opening number are also recombined. But in *The Rocky Horror Picture Show,* the film titles used in the song, as well as major personality or character names from 1950s films cited, are strung together only partially at random. Instead, these words are made to comply with a rhyming structure, and then interspersed with phrases that create a rudimentary, if discontinuous, cohesion. For example: (I have italicized the words that refer directly to the Science Fiction genre.)

> I knew *Leo G. Carroll*
> Was over a barrel
> When *Tarantula* took to the hills.
> And I really got hot
> When I saw *Jeanette Scott*
> Fight a *triffid* that spits poison and kills.
> *Dana Andrews* said prunes
> Gave him the runes
> And passing them used lots of skills.
> And *when worlds collide*
> Said *George Pal* to his bride
> I'm going to give you some terrible thrills.

The effect is absurdist (a quality that will characterize the dialogue, the songs, and the narrative organization of the film throughout) and discontinuous, but this disruption is not experienced as hostile or aggressive by the film's audience. Instead, the *The Rocky Horror Picture Show* audience responds with wild jubilation. And while this may suggest a desire to enter the image – to take control of it – as already noted, it also takes carnivalesque inversion and extends it formally onto the linguistic level of the film. The audience responds to the playful recombinations of the lyrics, to the pleasurable music, and to the equally pleasurable (i.e., nostalgic) quality of the song's references, with its own interjections. Moreover, it

does so en masse, in the form of a ritualized chant, and with scatological intentions. For example, consider the song lyrics and the audience responses:

SONG: When I saw Jeanette Scott
 Fight a triffid that spits poison and kills

AUDIENCE: ... **big skills** ...

SONG: Dana Andrews said prunes
 Gave him the runes

AUDIENCE: ... **give him the shits** ...

SONG: And passing them used lots of skills

AUDIENCE: ... **big kills** ...

SONG: And when worlds collide

AUDIENCE: ... **Boom!** (*clap*)

SONG: Said George Pal to his bride
 I'm going to give you some

AUDIENCE: ... **some prunes and some pills** ...

SONG: terrible thrills.

The audience's response takes the professional status of the mass-produced screen song and fashions it to its own needs, but it also brings to the surface a carnivalesque meaning that belies the entirety of the film. The "lower body principle" of carnival is in full force in *The Rocky Horror Picture Show,* and even from this opening sequence, defecation (as in the shouts of "merde!" in the beginning of *Ubu Roi*) is manifest. Of course, this meaning is only partly sublimated in Richard O'Brien's lyrics, "Dana Andrews said prunes/ Give him the runes," but then the audience plays with the film, bringing to the surface what had been linguistically evaded, and unambiguously returns, "... give him the shits!" The audience's scatological remarks continue through the course of the film. In response to the character's name, "Ralph Hapshat," for example, the audience members chant, "Half-shit!" And in the display of shooting off water pistols and throwing toilet paper in response to the character of Dr. Scott (referring to the toilet paper brand name), the communal response also underlines the lower body principle at work in the film. Unlike the intention of the earlier avant-garde, however, the scatological references in *The Rocky Horror Picture Show,* and the anal eroticism it implies, are not meant to

shock or to alienate the audience. Instead, the audience helps create it, and revels in the disruption.

From the film's opening lyrics, then, we know we will be participating in an alternative, even somewhat transgressive experience. The gigantic lips that dwarf the audience only serve to enhance this feeling. The dominating full mouth suggests sexuality, orality, fellatio, and cannibalism, all actions that will be featured in the film, or strongly suggested by it. But on a symbolic level these lips also suggest the linguistic play that will engulf the image with the audience's response, and perhaps even encourage it. Moreover, this play of voraciousness will ultimately consume the distinctions between the space and time continuum of the theater and that of the image, as well as between the spectators and actors, and between the various represented film genres.

For this reason, it is important to note that *The Rocky Horror Picture Show* began as a stage play that utilized movie references. By transferring the play onto film, those references were not only returned to their inspirational source, but they were also reintroduced to the spatial and temporal dynamic particular to film. And in so doing, the carnivalesque inversion of the spatial and temporal continuity of "the well-made film", or "the well-made play" seen in avant-garde works such as *Ubu Roi,* is given new possibilities in *The Rocky Horror Picture Show.* In Stam's assessment of *Ubu Roi,* for example, the spatial and temporal coordinates of the conventional play are conflated in this avant-garde work, creating instead an experience of being "everywhere" and "nowhere" at the same time. Stam notes that in the production notes of that French play, Jarry explains that *Ubu Roi* is set in "Poland, that is to say, Nowhere. Nowhere is everywhere, and first of all in the country where one happens to be. That is why Ubu speaks French." This sense of being set everywhere and nowhere, yet right here at the same time, permeates *The Rocky Horror Picture Show.* In this postmodern film, however, the experience is constructed through nostalgic references to the past films, but it is then contrasted to the temporal status of the image itself and to that of the theater space.

The nostalgic elements of the *The Rocky Horror Picture Show* take us back to the 1950s, but not entirely without derision. The film starts in a place called Denton, at the laughable "straight" wedding of Betty Monroe and Ralph Hapshat, complete with a picture-book church and garishly dressed relatives. Seen from the perspective of the 1970s, this highly coded sequence takes us back to the style of the 1950s in mildly

parodistic form (and I say "mildly" because during this era the pleasurable aspects of this return are too widespread to be denied). We are meant to think of that past and its clearly defined gender roles (Betty Monroe, for example, is described as a "good little cook" and Ralph Hapshat as being "in line for a promotion"), as well as its uncomplicated acceptance of monogamous heterosexuality, as conventions of a bygone era. And although the audience may be "set at a distance" by this sequence, it is not assaulted. Instead, it will be the subsequent dislocations of time and place that will further erode the film's sense of illusionism.

The first of these dislocations occurs during the wedding sequence as Brad and Janet, two of the film's central characters, wander from the church setting into a cemetery. Here a billboard of a giant red heart looms over the gravestones as the couple sings their love song, "Damn It, Janet." The Technicolor look of the image and the synthetic quality of the sets seem to place it within the conventions for the classical Hollywood musical, but the bricolage technique noted in the opening sequence is here further extended. A reading of this sequence as a simple parody of the Hollywood musical film is thus destabilized. Instead, additional incongruities begin to appear, pictures that refer to other pictures, such as the two characters dressed to mimic Grant Wood's 1934 painting "American Gothic," are now interjected into the church scene. And while these elements alert the viewer that the events in the film are not to be taken seriously, nor as represented realism, they also begin a play of time and place that continues throughout the film.

This obviously past-inspired environment, one that is the film's ostensible present tense, is again shifted in the following scene. Here Brad and Janet travel through Denton (Ohio?) and pass a "castle" along the way, an occurrence that is not considered unlikely or strange to them. Once inside the castle, the location is equally incongruous in terms of the types and eras of the people, costumes, and materials presented, while still maintaining its status as the old dark house of the classical horror movies. That is, this structure recalls both the horror films of the 1930s, with their low-budget production values and stagelike sets (*Dracula*, for example, or *Frankenstein*), and the funhouse attractions popular at amusement parks of many eras. Through this play of references, then, the connotations have shifted from the 1950s of the opening sequence of *The Rocky Horror Picture Show*, taking a slide into the 1930s of the horror film, to the ongoing present tense of the amusement park. This condition of being

everywhere and nowhere at the same time is of course not lost on the film itself as it "self-reflexively" (and repeatedly) urges us to "Do the Time Warp – Again." The temporal and spatial slide in *The Rocky Horror Picture Show* does not stop here. It will ironically continue into the future of the film's story, and beyond the film itself, as the characters plan to leave their 1930s film-inspired setting and return to a 1950s-Science-fiction film-inspired outer space and to their beloved planet, "Transsexual." .

As noted, these spatial and temporal inconsistencies, as well as their generic reconfigurations, do not result in the audience's shock at the disruption of its expectations for the "well-made genre film." Of course, one could argue that these supposed avant-garde strategies have long since become clichés and are now simply coded styles that can themselves be reused, if not entirely without meaning, then certainly devoid of their original impact. But this is entirely the point. The reconfigured conventions in *The Rocky Horror Picture Show* stage a new effect. To begin with, the audience spontaneously responds by interjecting its own kind of "time warp" to the film. In *The Rocky Horror Picture Show* the spatially disjunctive world of the film takes a new direction. Because of the audience's voiced and gestural responses, the normally present tense of the theater experience is transformed and inverted to include all of the spatial and temporal modalities of the film itself. That is, the ongoing present tense of the film, along with its encoded pastness, now "lives" in the theater space. In this way, the carnivalesque quality utilized by *Ubu Roi,* and by carnival itself, one that transforms the present into a spatially and temporally suspended universe, is re-created in the *The Rocky Horror Picture Show.* We are in the everywhere and nowhere of Jarry's *Ubu Roi,* but also, as *Rocky Horror*'s narrator tells us:

> And crawling
> On the planet's face/
> Some insects
> Called the human race/
> Lost in time
> And lost in space/
> And meaning

But even with these lines, which come at the end of the film, the audience supplies its own responses. *Rocky Horror*'s audience in unison chants, "The End," and then lets out a resounding cheer. In the resulting

silence that follows, a single voice calls out above a lonely clap, "Yeah! Bravo! One more time ... Well, are you going to play the movie again or what? You mean I gotta go *home?*" Time is circular for *The Rocky Horror Picture Show* regulars. Going home is only temporary, and for some, the *Rocky Horror* experience will be repeated hundreds, even thousands of times. This compulsive behavior, and the need to periodically reconfirm membership in a community, has led many commentators to call it a ritualistic or even "religious" event. The similarities between Church litanies and *Rocky Horror*'s audience chants are commonly acknowledged, with the film's relationship to the symbolic elements of the Catholic mass, including a "father" who creates life and the "sacrifice" and subsequent eating of the "body and blood" at the "last supper." Here it may seem that we are in the arena of the historical avant-garde, particularly the Surrealism of Buñuel, who used blasphemy as an aesthetic strategy. That the "god-the-father" in *The Rocky Horror Picture Show* is a transsexual monster (by way of a Frankenstein movie), and that the "sacrificial lamb" is a rock-and-roll biker who is ax-murdered and then cannibalized, would certainly seem to qualify it as blasphemous. But while the converted religious symbols in *The Rocky Horror Picture Show* are certainly hilarious, they do not wholly result in blasphemy because their intent is not to ridicule the Catholic Church. Instead, the recombinations of these forms (while drawing fully on their cultural power) help to create a liberatory effect that is, in the end, carnivalesque.

The quality of language spoken by the audience encourages this experience of liberation. It is true that the structure of *The Rocky Horror Picture Show* audience response is in some way similar to that of a Church litany with its counterpoint rhythms and codified repetitions. But as Hoberman has noted, the leader of the *The Rocky Horror Picture Show* event, a role originally created by Sal Piro, performs a function more like a camp counselor than a priest. This leader guides the audience (some of whom are "virgins" since they have never before attended this rite of initiation, or, "First Communion") through a chant that plays with language. And although it could be argued that the audience's standardized response removes it from the realm of the liberatory, it is the renewal of community bonds that is of importance here, as well as its newly found control over the image. Similarly, in the early days of *The Rocky Horror Picture Show* (1976–1977) the interjection of private speech was a more fluid and ever-changing event, but its later codification and subsequent religious reference is ultimately what gives it its communal power.

The *The Rocky Horror Picture Show* audience response results in the carnivalesque democratization of language. Usurping the speech of the powerful – in this case, the mass-produced film – and taking it down to the level of the people, the audience disrupts the usual interchange in a movie theater, one in which the audience is silent and the movie speaks. Instead, as Hoberman has noted, the audience talks back as one might to a TV screen at home. But in *The Rocky Horror Picture Show* the talking is done in public, and in unison, and this makes all the difference. A verbal carnival ensues, one that extends the aleatory effect of the film's opening number, "Science Fiction/Double Feature," with its often incongruous juxtapositions, nonsequiturs, and literalization of meaning, and continues it through the film – audience interchange. As the spontaneous creation of a popular group, however, this interchange is often base, crude, or simply banal, reflecting not only the interests of its largely teenage audience, but also its nonart, nonprofessional status. Yet it is precisely this pedestrian quality that gives it power within its group. For example:

FRANK: ... that's how I discovered the secret – that elusive ingredient – that ...

AUDIENCE: **Who is your favorite character in Star Trek?**

FRANK: ... spark ... that is the breath of life.

AUDIENCE: **Are you going to fuck everyone in the audience tonight?**

FRANK: Yes ...

AUDIENCE: **Do you know about gay sex?**

FRANK: ... I have that knowledge ...

AUDIENCE: **What do you hold under your arm?**

FRANK: I hold the key ...

AUDIENCE: **... to life?**

FRANK: ... to life ...

AUDIENCE: **... itself?**

FRANK: ... itself!

A kind of dance with the film ensues, on one level producing a countertext that exerts dominance over the image and the film's text through literalization, absurd juxtaposition, and repetition. But the audience's interjections also provide an alternate, unintended meaning to the screen

dialogue, thus creating a new composite text. In some ways this is similar to the absurd accumulations in avant-garde works such as *Ubu Roi* and *Les Carabiniers,* as described by Stam, and their liberation of language from its usual cultural hierarchies. *Rocky Horror's* audience steals the power of the corporatized film image by talking back to it, belittling the characters, making manifest its desire to sexually possess them, and interjecting scatological or prurient remarks that bring to the surface the film's innuendoes and double entendres. As a consequence they further dismantle an already fragmented and recombined cinematic form, now through a use of language that tends to literalize and fragment meaning.

Since *The Rocky Horror Picture Show* is a celebration of the flesh where all permutations of sexual pleasure are encouraged, the breaking down of existing boundaries in the hierarchy of language is both consistent with its themes and apparent in other areas of the film's organization. Unlike Godard's films of radical disjunction and confrontation, however, *Rocky Horror's* elements seem to have a surface consistency. But this is only apparently so. *The Rocky Horror Picture Show* is much like the Frankenstein monster itself, made up of disjunctive parts recombined for an audience already primed to the pleasures of disjunction. The narrative of the film, for example, its costumes, characters, and emotional tone, are made up of reorganized but discontinuous generic elements. Within this recombinatory impulse, the conventions of the horror and the musical genres, rather than being absurdly paired, actually form a cohesive unit in support of the film's themes, becoming a primary vehicle for its realization.

Only a select audience, of course, experienced these discontinuities and base displays as pleasurable. For many, especially the mainstream audience that rejected the film in its initial run, *The Rocky Horror Picture Show* was offensive, silly, and just plain bad. Conversely, the art world saw *Rocky Horror* as a popular phenomenon, an example of kitsch, and certainly not rising to the level of high art or the avant-grade. Nonetheless, the peak years of *The Rocky Horror Picture Show* (1976–1978) closely converge with the rise of postmodern art practice discussed in Chapter 2. These years were also the most active for Punk movies in the East Village, for Punk music at CBGB's, and for disco at the uptown Studio 54. The audience for *The Rocky Horror Picture Show,* however, was not part of any exclusive in-crowd. *Rocky Horror's* was instead a marginalized audience, at first made up of homosexuals and bikers, and later of teenagers, as well as other ordinary people whose lives were not necessarily glamorous.

(Dori Hartley, for example, a regular who impersonated Frank-N-Furter, was a bank teller, and Sal Piro, one of the event's originators, was a part-time high school teacher.) And unlike the velvet rope policy at Studio 54 or at the equally selective Punk hangout The Mudd Club, there were no entrance restrictions to see *The Rocky Horror Picture Show*. In the spirit of carnival, *Rocky* was an event to which anyone was welcome. Not surprisingly, many of its regular audience members were people who didn't fit in at the more elite night venues in New York City. They were the ones that were lonely enough, marginalized enough, or just plain weird enough to make going to see *The Rocky Horror Picture Show* one of their primary occupations. Or as Sal Piro described it, "*Rocky* for me is not a religion, it's a way of life."

But what are the elements in *The Rocky Horror Picture Show*'s cinematic presentation that encouraged this response? For one, *Rocky* plays havoc with traditional genres. In carnivalesque fashion, the film absurdly pairs conventions from the horror genre and from the musical, forms seemingly incompatible in emotional tone and visual style. Noel Carroll has claimed that the distinguishing characteristic of the horror genre is the feeling of revulsion it creates. The musical, in contrast, as defined by Jane Feuer, presents a utopian world and evokes the experience of what it would feel like to be free. In *The Rocky Horror Picture Show,* the pairing of these apparently incongruous genres is played for laughs. But the laughter is not necessarily aimed at ridiculing the original genres themselves (although it draws on our knowledge of those forms), nor is it meant to demythify them. Instead, the usual division between generic forms is ruptured in *The Rocky Horror Picture Show* through carnivalesque laughter.

The character that best embodies this dynamic is Frank-N-Furter, the film's ostensible "monster" and the figure who ultimately ruptures both the illusion and the temporal confusion through a radically new subjectivity. Played by Tim Curry in an inspired performance that has linked him irrevocably to the character, Frank-N-Furter, in typical horror monster fashion, is interstitial, a category mistake, because he defies the laws that maintain distinct and separate boundaries. Frank-N-Furter is a new entity, a female–male, a girl with a penis, and so a creation that may inspire revulsion, even fear, in some viewers. And Frank can certainly be seen as an insult to that dominant male gaze to which the cinema has been theoretically structured. According to Laura Mulvey, the visual pleasure of the cinema has been constructed to accommodate the desires of the male

Figure 22. *The Rocky Horror Picture Show,* Jim Sharman, 1975.

viewer whose unconscious it objectifies, and for which women have been positioned as the object of the look. But in *The Rocky Horror Picture Show* the camera holds Frank-N-Furter squarely in that feminized position. This transsexual monster is presented *to be looked at.* The audience voyeuristically gazes at Frank-N-Furter in close-up (Figure 22), in erotic repose, and with a full frontal display of his genitalia, presented, like the body of a woman, through revealing silk lingerie. As a confrontational figure, Frank is a true image of horror when viewed by the hetrosexual male viewer Mulvey theorizes, and perhaps to patriarchy itself. Yet to the new subjectivities the film posits – to homosexuals, bisexuals, transsexuals, and even to new kinds of heterosexuals – Tim Curry's Frank-N-Furter is an image of wild liberation and sexual desire. Or, as Hoberman has noted, one that sent many members of its largely teenage audience, male and female alike, into an erotic frenzy that made them feel "a lot like fainting."[7]

But Frank-N-Furter does not just mix male and female attributes. He is a composite figure who mixes any number of references and attitudes. For example, Frank is not only a sexual object but also the perpetrator of action and sexual aggression in the film. In addition, as the "monster" of this "horror film" he is its emotional center, combining elements of Bela Lugosi's Dracula, with his (now feminized) high-collared jeweled cape and dramatic makeup, as well as thematic elements from the character of Dr. Frankenstein. Like that mad doctor of old, Frank-N-Furter, too, is the "maker of a man," but now one with openly homosexual orientation (rather than the implied subtext of James Whale's *Frankenstein*). And in his fetishization of femaleness, it is no wonder that Frank-N-Furter, presented in nylon stockings and bustier, also recalls Marlene Dietrich's Lola in *The Blue Angel* (1930), and later, in his pearls, heels, and green hospital scrubs worn as a dress, Joan Crawford in *Mildred Pierce* (1945).

This composite figure, a misfit in the true sense of the word, who ruptures the screen surface with difference, is set in a world that similarly compounds genres and allusions in a fragmented, discontinuous sea of references. The other characters in the film, for example, also refer to a variety of stock horror types. Brad and Janet are the normal heterosexual couple [a convention of the classical horror film seen in such works as *Frankenstein* or *Dr. Jekyll and Mr. Hyde* (1932)] now confronted with the unconventional sexual threat of the monster. Magenta and Riff Raff recall the servants from James Whale's *Old Dark House* (1932), while the character of Riff Raff simultaneously evokes Igor from *Frankenstein* and, through a later change of costume, a space alien from the science fiction subgenre of the 1950s. These horror-inspired characters are then set in a melieu that itself recalls, again in fragmentary and discontinuous fashion, the settings of the horror film and the science fiction film. The castle of these often gothic-inspired horror stories is also presented, but so is the obviously fake equipment similar to those seen in science fiction films of the 1950s (for example, the "high tech" device that emits the "transit beam").

But *The Rocky Horror Picture Show* also incorporates conventions from the classical musical. The film, for example, is shot in high saturation color and the sets are arranged so that the space can readily be used as a dance floor. This too is a convention of the musical, especially the integrated musical of which *The Rocky Horror Picture Show* is a postmodern example. In keeping with that tradition, *Rocky Horror* does not limit the presentation of musical numbers to a formal stage performance; rather,

includes song and dance as part of its narrative. Moreover, the emotion that the film inspires is much closer to that evoked by the musical than it is of the horror film. *The Rocky Horror Picture Show* inspires glee in its selected audience. Primarily through its horror monster and his crossing of sexual boundaries, it creates the utopian feeling of what it would feel like to be free.

These qualities of liberation are then extended to the film's represented community, one that now encourages the film's audience to participate. As Jane Feuer tells us, however, the classical musical, too, had inspired a sense of community through the inclusion of folk themes, as seen in films such as *Oklahoma!* (1955) or *Seven Brides for Seven Brothers* (1954). Here the performers were not presented as the talented professionals that they were. Instead, they were fictionalized as "ordinary folk," much like the members of the audience themselves, and then represented as part of a singing-and-dancing community. The audience could thus identify, and perhaps indulge, in the illusion that we too could sing and dance if we had the chance. "Ordinary folk" like Gordon MacRae and Howard Keel, for example, and now Tim Curry and his dancers, could give us an increased sense of belonging.

It must be noted, however, that in *The Rocky Horror Picture Show*, the "folk dancers" (they are actually given this name within the fiction) are made up of a misfit crowd of castle regulars. Wearing penguin-like tuxedos jackets, white shirts, and tight black pants (and so ironically recalling the Punk style of the period) these dancers are made up of a variety of misfits: tall people, short people, withered old men, women with red frizzy hair, and even an "Arab" complete with a headdress. These are the "normal" people, the misfits, just like us, who do the Time Warp, and with whom the film's narrator, now looking directly into the camera, urges us to dance along! In *The Rocky Horror Picture Show*, of course, the audience does just that, singing and dancing in the aisles and thereby extending the space of the film's castle dance floor to that of the film theater itself.

This sliding between previously established distinct categories in *The Rocky Horror Picture Show* is ultimately put to the service of its sexual themes. The film encourages the breaking down of restrictions regarding sexual object choice. Not only is homosexuality presented as an option, but so are all kinds of transsexuality, or better still, *pansexuality*. Numerous pairings, couplings, infidelities, and even female desire (punctuated by Janet's song "I Want to be Dirty" – a feeling seldom expressed by the "good" girl in film) are featured. This carnivalesque lower body

principle is then extended to scenes of further transgressions. For example, the "mercy killing" of Eddy is played for laughs, and even scenes of his subsequent cannibalism are rendered as humorous. This is certainly "the world upside down" of carnival, which breaks down, not only the standards of good taste and decorum, but also the barriers that limit collectivity. These societal limitations often include restrictions regarding the choice of sexual partner, gender roles that limit modes of behavior and desire, and, although presented to a lesser extent here, even restrictions imposed by class and political affiliation, all of which restrict the coming together of individuals as a group.

But because of the pleasure *The Rocky Horror Picture Show* provides, as well as this surge toward collectivity, it seems that its characteristics have more in common with the true spirit of carnival than with the avant-garde proper. Stam's comments on carnival in Latin America are insightful on this issue. Stam argues that whereas carnival retreated to the elitism of the avant-garde in Europe, it remains a vibrant people's tradition in Latin America. For a brief period of time during the year, the people from this region give expression, through street theater and folk music, to all that established powers in their societies try to repress. This, however, is not accomplished through hostile or aggressive strategies of the avant-garde, but through a disruption that incorporates the people's laughter and pleasure. Stam argues that the exuberant cultural expression of carnival is then transposed onto the cinema and literature of Latin America.

Although it would be tempting to include the annual Halloween celebrations in Greenwich Village, or those in West Hollywood, for example, as American versions of this exuberant populist display, the spirit of carnival described by Stam can also be identified in the *The Rocky Horror Picture Show* event. Here, too, we have a display of collectivity, of laughter, and of the popular expression in song and dance for the purpose of breaking down boundaries imposed by society and for the creation of a new collectivity. In what can be called a carnivalesque postmodernism, *Rocky*'s members act out their fondest desires, not only in crossing gender and (in fantasy) sexual boundaries, but also by transgressing the separation between screen actors and spectators in their confrontations with the image. And so in true American fashion (and perhaps in Warholian style) anyone in the *The Rocky Horror Picture Show* event could become a "star" – especially, a "movie star."

During 1977 and 1978 *The Rocky Horror Picture Show* allowed a group of people to exercise some control over media speech, to shape it,

and to be shaped by it. After this period, however, the quality of spontaneity and exuberance of the event itself became conventionalized and ossified. For a brief moment, however, *The Rocky Horror Picture Show* represented a popular expression that utilized elements of carnival and of the avant-garde to incorporate art into life. And it did so by rupturing the film image, denying it its full ability to screen the real, and presenting "American Youth" as a much more traumatized presence, as well as a much more exuberant one, than had other 1950s nostalgia movies. In the end, the "sweet" conventional image of Brad and Janet was presented derisively rather than nostalgically. The timorous young couple met their nemesis at Frank-N-Furter's castle and in the theater seats at the Waverly as well. In this setting the "normal" hetrosexual monogamous image of the 1950s no longer effectively represented American youth. This is perhaps why the *The Rocky Horror Picture Show* phenomenon began in the United States, and specifically in New York, where the events of Stonewall, with gays fighting back against the aggression of the police in 1969, had since militarized the gay rights movement and the community. This is also perhaps why, with the massive onset of AIDS in the 1980s, *The Rocky Horror Picture Show* lost its exuberance and today carries with it its own sense of nostalgia, now for that spirit of carnival in the late 1970s when all things seemed possible.

In answer to Jameson's question, then, of whether there can be a form of postmodernism that resists the logic of late capital, we have noted a number of films that approach that condition. These ostensible "nostalgia" films used the imitation of past codes, admittedly not to subvert or ridicule the original films or genres in the modernist sense, but, rather, to construct a new system of meanings through the critical displacement of its elements. We have seen that this reformulation has often served to rupture or dislodge the screen that blocks access to the real, here posed as history, or as sexual difference, in postmodern society. Of course, in modernist terms, *The Rocky Horror Picture Show* can still be seen as caught in the web of illusionism because it lacks an intellectual distance on the part of its audience. As a postmodern carnival, however, it can be appreciated as the recombination of worked-over languages to now stage a popular transsexual event.

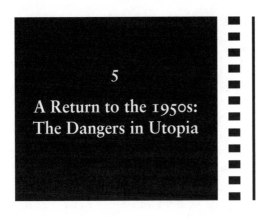

5
A Return to the 1950s:
The Dangers in Utopia

The nostalgia film seems to privilege a 1950s past. And although many of the films already discussed have included images and genres from the 1930s and 1940s as well as the 1950s, it is this latter period that is referenced with more insistent regularity. Of these films, however, only *American Graffiti* and *Badlands* have come close to being set in that decade. In this chapter I will consider films that not only recycle past forms and styles from the 1950s, but do so by setting their stories specifically in that period. These films, which were produced in the late 1970s and 1980s, return to the past from a changed historical perspective and so display an attitude significantly different from those already considered. Here the meaning of the 1950s is changed. In *Grease,* for example, the past is embraced with new fervor, whereas in *Last Exit to Brooklyn* it is indicted as never before.

Jameson has already noted the privileged status of the 1950s in postmodern works, but he has not considered the variations among these 1950s representations, nor how they have altered over time. Before we address these issues, we must consider *why* Americans found the return to the 1950s so fascinating. Jameson supplies an answer to this question by observing that 1950s-inspired postmodern works (such as *American Graffiti*)

set out to recapture ... the hence-forth mesmerizing lost reality of the Eisenhower era; and one tends to feel that for Americans at least, the 1950s remain the privileged lost object of desire – not merely the stability and prosperity of a Pax Americana but also the first naïve innocence of the countercultural impulses of early rock and roll and youth gangs.[1]

Jameson's observation seems especially apt when applied to the movie *Grease,* for it, too, attempts to combine the security of the 1950s with its

countercultural impulses. But in *Grease* the 1950s return with an emotional tone far from the melancholy and loss of many of the films already discussed. Here the past is reconstructed, through the film's *mise-en-scene* and through the resuscitation of the classical musical in "rock 'n' roll" form, to create a feeling of unfettered happiness. It should be remembered, however, that *Grease* was released in 1978,[2] a transitional period in American history. At this time, after the disappointments of the immediate post–Vietnam War period, many of the cultural and political advances of the 1960s were being challenged and about to be reversed with the approach of the Reagan era. As an expression of this shift, the cynicism of *Badlands* or the derision of *The Rocky Horror Picture Show* is in *Grease* replaced with a full-blown return to the classical musical's themes of heterosexual love and utopia. Moreover, the notion of a lost past evident in the earlier 1970s films is replaced with an insistence that the past can somehow be made present, or perhaps, that the present *is* the past. Unlike the critical disjunction created by a similar time warp in *Ubu Roi,* or even the carnivalesque inversion engendered by *The Rocky Horror Picture Show,* the time confusion in *Grease* mixes past and present, blurring their boundaries in a way that was enthusiastically accepted by its contemporary audience. But as with any act of denial, the cracks in this reformulation of history and of politics were difficult to paper over. So while *Grease* is not a nostalgia film that actively confronts history, the friction that results from its internal disjunctions will help us to further understand the reuse of past forms in contemporary cultural practice.

The whole question of nostalgia is a thorny one, however. Although the films discussed in previous chapters have had a complex relationship to the 1950s, we have yet to find an unambiguous longing to return to that era as the term might imply. Jameson, in fact, has also readdressed the meaning of nostalgia in a recent essay, "The Transformations of the Image" (1998). Clarifying his own use of the term he writes,

The nostalgia film [is] a misnomer to the degree to which the term suggests that genuine nostalgia – the passionate longing of the exile in time, the alienation of the contemporary bereft of older historical plenitudes – is still available in postmodernity. The latter, however, is anything but alienated in that older modernist sense: its relationship to the past is that of the consumer adding another rare object to the collection, or another flavor to the international banquet: the postmodern nostalgia film is then very precisely such a consumable set of images, marked very often by music, fashion, hairstyles and vehicles or motor cars . . .[3]

Grease

Grease seems to embody this redefinition since its 1950s elements are obviously drawn to engender maximum box-office appeal. However, *Grease*'s commodification of the past does not (as Jameson has claimed for the nostalgia film) diminish narrative and leave us only with its glossy imagistic surfaces. *Grease*'s reassemblage of past artifacts is a complex one, placing the members of its audience in a shifting relationship to its elements and engendering multiple readings. And although *Grease* can be said to evoke personal memories of the past from its adult audience, or to re-create a kind of 1950s proper for its younger members, both of these readings are in the end illusions. *Grease* recasts the past in present terms to address the contemporary needs and wishes of a cultural group. In this suppression of history, however, the film's illusionistic surface is ultimately threatened with disruptive meaning.

 With this impulse to merge past and present, we can imagine the marketing of *Grease* to have gone something like this: Nostalgia for the 1950s is selling right now, and so is liberated sexuality. Why not combine the two? *Grease* thus incongruously fashions a 1950s where sexually liberated behavior is appropriate and where dreams of youthful innocence are once again possible. In fact, it could be said that in *Grease* the "sexual revolution" returns as a 1950s musical. And while this may seem paradoxical since the sexual revolution was a specifically 1960s cultural phenomenon, and the 1950s was a decade renowned for its sexual conservatism, the contradictions found a highly successful, and seemingly easy, recombination in *Grease*. However, in *Grease* there is always the nagging sense of a countercurrent. What is the gain, for example, of re-setting a 1960s sexual revolution, one that allowed women to express their sexuality on a more equal plane with men, in the 1950s? Put another way, why cast a sexually liberated present in terms of the past if not to in some way curb current advances or to reinstate older restrictions? The resulting contradictions, then, along with other oxymorons in *Grease*, such as the lovable ethnic youth gangs, the nonthreatening bad girls, and the easy-listening rock 'n' roll, not to mention the veritable erasure of Blacks and gays, ultimately threaten the film's surface with historical instability. Despite *Grease* attempts to suppress these contradictions, it never fully does so.

 Grease utilizes a number of methods for restabilizing these possible disruptions. To begin with, it returns to a previously integrated genre, the

classical musical. The full impact of this return, however, can perhaps best be appreciated when *Grease* is compared to the disruptive musical forms immediately preceding it. As noted, these rockumentaries, such as *Woodstock* or *Gimme Shelter,* or the revisionist musical *Nashville* (1975), had broken down the conventions of the classical Hollywood musical. *Grease* returns to the *intergrated* style of the classical musical after these 1960s assaults on that form. In fact, *Grease* is more consistent with such musicals as *Singin' in the Rain* (1952) or *The Band Wagon* (1953), reinstating their Technicolor images and generic conventions. *Grease* presents us with a dazzling visual surface, song and dance that once again flow seamlessly from its narrative development, and an exuberant story of untarnished love and friendship.

In *Grease,* however, a subtle derision often accompanies these characteristics of reintegration, but one not strong enough to rupture its fictional surface. The social mores of the 1950s, for example, as well as the clothing styles, are gently parodied. The popular message of the film is that sexual liberation is better than the 1950s sexual repression and even that the period styles are somehow quaint in their pastness. The audience has a sense of looking back with a loving yet subtle smirk, a gentle ribbing at how far we've come from this earlier stage of development. But there is no true critique here. The attitude built into *Grease* is that the past is somehow silly. And I would contend that it is this attitude, one which places the viewer in a privileged relation to the past and its foibles that contributes to the immense popularity of the film. In *Grease* the disruptions of the past are restabilized by presenting them a-historically and by rendering them harmless.

It is crucial to note, however, that the 1950s did not always signify "harmless fun" to American audiences, especially not in the 1960s when this era was generally regarded as a failed historical period. When ShaNaNa (the group that subsequently appeared in *Grease* and wrote a number of its songs) first appeared at Woodstock in 1969 and performed 1950s style rock 'n' roll in full period costume, their act was an active parody of a now discarded past. Dressed in skin-tight gold lamé outfits and greased-back hair, ShaNaNa sang and danced to an audience of young people whose hippie clothing and naturally flowing hair stood in stylistic counterpoint to their own. The retro style of ShaNaNa, and the easy listening rock 'n' roll they performed at this concert, was juxtaposed with the aggressive and politically resonant music of the late 1960s. ShaNaNa embodied forms that were now considered "old" by the hippies. To the

audience at Woodstock, then, these forms were to be rejected, along with the bourgeois lifestyle, restrictive social mores, and conservative politics that they came to represent.

In 1978, ten years after Woodstock, the 1950s had returned to mean something completely different to Americans. Why did the 1950s suddenly look so good to us, and especially to the baby boom generation that had so recently rejected it? Furthermore, although it may be argued that the 1950s were now experienced as a more secure period after the trauma of the 1960s, why return to a past already seen as failed? Could it be because this return was not about going back to the adult world of the 1950s, but to our own symbolic youth, and especially to adolescence, a stage now seen as pleasurable to a nation grown "old," that is, damaged, by contemporary events? Whereas in *Badlands* and in *American Graffiti* this youth was seen as irretrievably lost, in *Grease* it returns as re-gained. (This is perhaps why such *Grease* cast members as Olivia Newton John, John Travolta, and Stockard Channing, often criticized for being much older than the high school characters they portray, actually serve the meaning of the film quite well.) Here the feeling of retreating to an earlier developmental stage is pronounced, not only in the film's simplistic attitude toward sexuality and history, but also in the rendition of its generic material. In *Grease* the past elements return "bigger and better than ever," but as with the dream of renewed adolescence, with a marked second-hand quality. *Grease* is made up of pictures drawn from other pictures, as simulacra that bear little relationship to the real. These representations are recombined to sell the notion that innocence in American life is not extinct, and in so doing, they attempt to block or even reverse the events of the recent past.

The playful conceit of *Grease,* especially for the older members of the audience, is that it returns to us a time as if from our own personal memories. There are many inside references aimed at those who lived through the 1950s and so remember the meaning of such cultural artifacts as circle pins, Italian Swiss Colony wine, and films like *A Summer Place,* as well as the male practice of having a condom ready in one's wallet. This fabricated memory is now reconstructed, along with the insistence that it necessarily elicits a happy time, and then sold to younger audiences as a past that once existed and that is now relevant to them. *Grease* is a coming-of-age film with the perennial challenges of school, friends, and developing sexuality. But the reconstructed past in *Grease* does not in fact present a personal memory, nor does it allow for personal failings. Instead, *Grease* represents a collective "memory," and so it tells us more about the culture of 1978 than about a personal psychology or developmental stage.

In fact, it is precisely *Grease's* attempt to render adolescence harmless that makes it different from many other coming-of-age films, and especially from the 1950s youth film it so openly invokes.

Numerous coming-of-age films make up the associative surface of *Grease* and can be identified primarily by the pastiche of scenes, the appropriation of plot elements, or the re-presentation of distinctive images. But although *Grease* is made up of these old pop images, it is not constitutive of them. Instead it recombines those elements as worked-over languages to now present a 1950s fashioned to contemporary needs. *Grease* refers to *West Side Story* (1961), *A Summer Place* (1959), and *Where the Boys Are* (1960), and, through an association with its leading "greaser" characters, to Marlon Brando in *The Wild One* (1954) and James Dean in *Rebel without a Cause*. It is significant that adolescence in these older films was represented as a time filled with personal and social dangers. And while *Grease* also deals with teen pregnancy and gang rivalry, the newer film strives to eradicate un-pleasure rather than explore the causes and possible solutions to these problems as had its earlier counterparts. For *Grease,* the 1950s is reconstructed as a time of simple conflicts and ultimate "happiness." In this way, the film strives to repress any remembered personal traumas of an adolescent past, as well as any regional, class, race, or gender conflicts from that era. What we get instead is commodified memory, one now set in a mythic past where all hurts are resolvable. *Grease* thus constructs a fantasy of how we may wish life could have been in the past, but most importantly, how we wish it could be in the present.

Of course, it is not uncommon for Hollywood films, especially musicals, to construct a fantasy of utopia for its audience. What is significant in *Grease,* however, is its particular rendition of utopia and what must be suppressed to achieve it. The tensions inherent in this double movement find its beginnings in the opening sequence of the film by condensing a number of extratextual references. The film opens with an image of ocean waves breaking against the reefs and is accompanied by the 1950s song "Love is a Many Splendored Thing" on the soundtrack. From these elements the associations begin to converge. The theme song is taken from the film *From Here to Eternity* (1953), while the shot itself is almost identical to the one that begins *A Summer Place*. Even if these specific associations may not be accessible to all viewers, the sumptuous sentimentality of sound and image support the themes of returned love and romance.

The subsequent shots continue this effect by presenting two young lovers on the beach. Here additional associations come to mind, ranging

across such films as *On the Beach, Beach Blanket Bingo* (1965), and *Where the Boys Are.* But the close-ups of the young couple serve to complicate these references. The lead character, Sandy (Olivia Newton John), is fashioned to look like a sweet, blonde, middle-class girl reminiscent of Sandra Dee, the star of *A Summer Place,* but her co-star does not fit the match. Danny Zuko (John Travolta) is not at all like Troy Donahue, Sandra Dee's preppie co-star in that earlier film. Instead, Zuko looks like an Elvis Presley – style greaser, or perhaps even like one of the gang members from *West Side Story* (Figure 23). *Grease* thus begins to distinguish itself from the earlier films it invokes. Any connotation of real social problems in the interaction of a working-class ethnic boy and a middle-class white girl, for example, is summarily squelched. Instead, Sandy quickly reveals that she is from Australia. This single characteristic of difference, one defused of contentious racial, ethnic, or class implications (while also explaining Olivia Newton John's Australian accent), will then distinguish Sandy's behavior and style from that of her peers.

The tendency in *Grease* to tame or defuse previously disruptive societal issues is further enhanced in this early part of the film. After the scene just discussed, for example, a title sequence accompanied by the film's theme song is presented. At first the title song seems much too incongruous to be seriously considered, but then again this is precisely its appeal. The song is fragmented, made up of bits of clichéd countercultural wisdom and issues of teen angst. As in the theme song for *The Rocky Horror Picture Show,* the fragmented elements display an almost dada-like dislocation and are linked together with only seemingly more cohesion. But in *Grease* little or no disruption results. This may be due to the upbeat music, the 1950s-inspired cartoon images that accompany it, or the lyrics themselves which now incorporate tamed countercultural issues. This soothing effect is continued by the familiar-sounding disc jockey voice of Frankie Valli. Here, in true "time-warp" fashion, the adults in the audience are addressed as kids again, and the kids, as 1950s teenagers, are told to "get out of bed" and "get ready for school," while the disc jockey plays for us a "new old favorite." Grease's theme song follows:

> Grease is the word
> (it's the word that you heard)
> it's got groove, its got meaning.
> Grease is the time, is the place,
> is the notion.
> Grease is the way we are feeling.

Figure 23. *Grease*, Randal Kleiser, 1978. Copyright 1998 by Paramount Pictures.

What are the implications of being told that the word "grease" has "groove," that it has "meaning"? At first this may seem like a completely nonsensical claim, unless we begin to look at the word associatively and metonymically. On one level, "grease" refers to the hair gel for 1950s "DA" hairdos. Or, by association, it can refer to the "greasers" themselves. A return to their stylistic era, however, can only be understood as a "groove" (a 1960s term) by 1978 standards. In the 1950s the term "greasers" was often used derisively; it was meant to identify working-class, often ethnic youths, who defined themselves by aggressive clothing styles and defiant behavior. In the 1950s this "rebel" type became popular in films such as *The Wild One* or *West Side Story*. But in *Grease* most of these 1950s connotations have been tamed or altered. In the opening song, for example, the term "grease" refers primarily to the culture-wide return to the 1950s artifacts themselves. Read in this way, then, the line "Grease is the way we are feeling" is quite literally correct. For especially in 1978, a return to 1950s styles was very much "in the air", and very much a marketable commodity.

In light of this homogenized and marketable return, what do we make of the song?

We take the pressure
and we throw away,
conventionality belongs to yesterday.

There is a chance that we
can make it so far,
if we start believing now
that we can be who we are.

The contradictions inherent in this statement make it almost impossible to unravel. According to these lyrics, which "yesterday" are we supposed to understand as being "conventional"? Is it the 1950s as seen from the perspective of the 1960s generation? Or are we to position ourselves within the 1950s time frame of the film itself and reject the 1940s as "conventional"? Or then again, are we to position ourselves in 1978 and see the 1960s as "conventional"? Clearly, meaning and time collapse here and give way to a mythic time where "yesterday" simply refers to the "stodgy old time of our parents," an eternal period existing across *all* generations. What is being presented here, then, is the notion that "grease" – to be understood as a generalized marker for teen rebellion and liberation – still has currency today. The supreme fiction of *Grease* is that the teen rebellions of the 1950s and the sexually liberating 1960s are still intact and, moreover, that we will somehow participate in their continuation by watching this film! This of course is quite a staggering assertion in 1978 when American society is actually headed in the opposite direction, toward Reaganomics and neoconservatism. And it is even more surprising because *Grease* is in many ways a supporter of that neoconservative trend, returning to the classical musical form, to a reintegration of the image, and to a tamed content antithetical to the disruptions of youth gangs, the counterculture, or aesthetic modernism itself.

But even though *Grease* strives to suppress true rebellion, its association with styles and issues that are potentially disruptive because of their historical proximity to these countercultural movements threaten its surface. The nearly seamless pleasurable experience of *Grease* thus becomes tinged by these societal conflicts. *Grease* necessarily engages rock 'n' roll and alludes to the Korean War, as well as raising issues, through proximity and sometimes through direct reference, of ethnicity, gender, race, and class. Because of the threat posed by such controversial topics, however, *Grease* attempts either a superficial and tame presentation of the problems or their active suppression. In attempting to identify this historically relevant material we again encounter the problem of the two-tiered system of reading engendered by *Grease*. Although I will view the material largely from an adult perspective, it must not be assumed that these concerns are entirely lost on the younger viewer. Even for such a viewer,

disturbing information is being constructed. In *Grease,* a number of the 1960s advances are either presented in the process of being reversed, or they are simply submerged by the film.

This process of suppression in *Grease* is initially presented on the level of the image, and it is accomplished primarily through a system of schematization and hyperbole. A superficial sense of order and homogeneity is created through a *mise-en-scene* that features clothing styles from the past as nostalgically succinct. By selecting a few of the most identifiable (and in some cases subversive) styles of the period, and then presenting them in bright colors and expert workmanship, a system is created that renders the image uniformly attractive. These schematic styles include the "Pink Lady" silk jackets, the soft sweater sets of the girls, and the high-cuffed jeans and motorcycle jackets of the boys. A similar quality of high-definition attractiveness is maintained in the selection of the film's locations as well. Since the film is set in Southern California, the weather is presented as uniformly sunny, and the chosen locations, such as the high school grounds, the soda shop, and the girls' bedroom, all welcome the viewer into a period-specific environment of consistent ease. What results from these manipulations is an image set in high relief, dominated by a visual palette of intense reds, yellows, and blues, and allowing the viewer a nondisruptive distance from which to revisit the past.

Even within this surface of visual pleasure, however, the ethnically composed youth gangs are given a rudimentary but still socially resonant representation in *Grease.* This is especially true of Danny Zuko's gang, the "T-Birds," one composed of lovable, cartoonish figures who do not overtly threaten the viewer or the characters in the film. When a rumble is threatened, for example, a member of the T-Birds, Kenickie, brandishes his knife, while another, Sonny La Tierra, "menacingly" lifts his plastic water pistol. But as their surnames tend to indicate, several of the gang members are marked as being of "Italian" extraction.[4] And while this, too, is played for laughs, not all of its meanings can be entirely suppressed. Italian surnames are also featured among two of the girl gang members, Betty Rizzo and Marty Maraschino, as well as the fiery dancer, Cha Cha De Gregorio. Ethnic distinctions in *Grease,* however, are not overtly mentioned or even clearly distinguished,[5] nor is the potentially disruptive lower-class background of some of the characters, a distinction evidenced only by their mannerisms, dress, and speech. Consequently, the rival gang leader of the "Scorpions" seems to gain his adversary status solely from his badly pockmarked skin and thin greasy hair. In similar

manner, Kenickie (of possibly Polish origin?), is never put at odds with his Italian-American friends. Nor are these characters engaged in any class or ethnic-based confrontation with the Anglo, middle-class Sandy Olson, or with her jock boyfriend Chisolm.

This noncontentious use of ethnicity in *Grease* aids in the construction of utopia. The rough edges from a 1950s past have been smoothed over and a new and simpler past has been reconstructed. After all, this isn't a story about gang violence or ethnic tension, it is a story about love and sex in a now reconfigured 1950s. But the submerged tensions of its historical suppressions begin to rise in *Grease* through the very allusions it makes to earlier films and to the changing meaning of ethnicity in society. In *West Side Story,* for example, the ethnic composition of youth gangs was meaningfully and clearly presented. In this film, the "Jets" were the white gang at odds with the Puerto Rican "Sharks." Since *Grease* so openly references *West Side Story* through an insistent pastiche of its styles and scenes, it is not inconsequential to consider why the gang members' ethnicity in the newer film has been changed from Puerto Rican to Italian. Perhaps this change could be said to accommodate a 1978 contemporary taste in which Italians were more marketable than Puerto Ricans as film characters. Or it may be claimed that it is simply true to fact, since greasers in the 1950s often included working-class Italian-American youths. But yet the nagging question still remains: Why is it that in 1978 "Italian" is a more suitable marker than "Puerto Rican" (or "Hungarian" or "Asian") in the creation of utopia?

It is undeniable that the reference to Italian ethnicity in *Grease* is part of a general marketing strategy. After the success of such working-class Italian- American characters as Arthur Fonzarelli in *Happy Days* (1974–1984) or Vinnie Barbarino in *Welcome Back Kotter* (1974–1979) and Tony Manero in *Saturday Night Fever* (1978) (both played by John Travolta), the use of this type in *Grease* adds to its wide popular appeal. In the 1970s the Italian-American character had returned in film and television as a type of rebel. At times he was fashioned to be a sexy nonconformist as in *Saturday Night Fever,* while at others times, as in *The Godfather* (1972) and *The Godfather Part II* (1974), he was an outlaw hero whose excessive violence was understood as necessary. But the meaning of Italian-American ethnicity in American film and in society has varied over time. In the 1970s the meaning of this ethnic group had significantly changed from what it had been in the 1950s, and also from what it had been in the earlier part of the twentieth century.

During the early days of immigration, from 1890 to 1920, the waves of Italians coming into the United States, most from the southern provinces and from Sicily, were stereotyped as dirty, illiterate, and violent new arrivals by the Anglo-Saxon majority. After decades of decreased immigration and increased intermarriage, however, Italian Americans became a less-discriminated-against group. Even so, the 1950s stereotype of the Italian-American greaser demonstrates that some of the earlier prejudices remained intact. As "greasy," working class, and potentially violent, they were still perceived as threats, if now only to their local communities. By the 1970s, however, Italian Americans had become almost entirely assimilated into American society. They were no longer (except perhaps in the romanticized imagination of TV and Hollywood – or the farther reaches of Brooklyn) "Other" in relation to the American mainstream. But the historical prejudices that render certain ethnic groups such as Italians, as well as Latinos or Native Americans, as possessing an excessive sexuality and propensity for violence, along with a lowered intelligence, can still be seen to operate in *Grease*.

Grease seems to posit a simulacrum of the Italian-American greaser, a replica for which the original has been lost, yet it still regards that copy with some of the older prejudices. That prejudice is apparent in *Grease* since it positions the viewer to stand in judgement of the Italian-American character as a "noble savage" with pronounced sexual and rebellious tendencies. In *Grease* these characteristics, which themselves have a "nostalgic" quality in their pastness, serve both to exalt and demean him. In 1978, the Italian American in *Grease* fascinates because he represents unbridled freedom while no longer threatening society. The Italian-American greaser is ethnic difference and class distinction with no hint of urban decay or violence. But just as he signifies sexual and personal liberation, the reuse of this ethnic stereotype allows us to rekindle old prejudices. We can look down on him (however lovingly) because of his Italian-American ethnicity. This attitude, of course, is used to advantage in *Grease* because a comic character is not our equal, but can be held in loving contempt. In this symbolic way, Danny is part of our historical as well as developmental past, a past made less threatening by rendering this character as Italian American.

Italian-American markers are also used to define many of the female characters in the film, with different but no less ambiguous results. Betty Rizzo, Marty Maraschino, and Cha Cha Di Gregorio are all given Italian surnames (with Cha Cha compounded by the Hispanic reference of her

first name) thereby allowing for a number of easy assumptions to be made about their characters. Rizzo and Cha Cha, for example, are presented as being sexually active, and in the case of Cha Cha, as also being an exceptionally fiery dancer. And although Marty's sexuality is merely alluded to because of her collection of overseas boyfriends (Rizzo calls her a "One-Woman USO"), the implication is that she, too, is sexually eager. These are Italian-American "bad girls" and are coded as such on any number of levels. Rizzo and Marty, for example, wear skin-tight clothes and are members of a girl gang suggestively named "The Pink Ladies," while Cha Cha attends a Catholic school, and, as lore would have it, has a bad reputation. In *Grease,* however, all this is used to construct a feeling of liberation and is enhanced by juxtaposing these extroverted females with the blonde, sexually repressed, Anglo girl, Sandy Olson. Of course, it could be argued that the designation "Italian American" is here emphatically used to construct a new type of female character, one that is more passionate and more reflective of the liberated sexuality of contemporary American women. But, as we shall see, the issue of female sexuality is a volatile one and is not so easily tamed in response to current popular notions.

I would instead argue that the inherent threat posed by female sexuality is both heightened and controlled in *Grease* by defining these characters as Italian American. To accomplish this, however, the stereotype of the Italian-American women has been altered. Traditionally, this character on film has not always shared the same status as the Italian-American male. Especially in films like *The Godfather,* the Italian-American woman is shown as homebound, tied to the responsibilities of her family, and subjugated by the laws of the patriarchy. But in other films she is presented as passionate or aggressively sexual, as is Serafina in *The Rose Tattoo* (1955), Cesca in *Scarface* (1932), or Angie in *Love with the Proper Stranger* (1963). In *Grease* the Italian-American bad girl is given considerably more freedom than some of her cinematic ancestors, but her characteristics are an admixture of these ethnic stereotypes and our collective "memories" of the 1950s.

Rizzo is the bad girl who hangs with the greaser boys. And although Rizzo may have had a counterpart in a 1950s lived reality, the social consequences of her actions (unwanted pregnancy, social ridicule, or early marriage) would not have been treated with such frivolity. Instead, some of the condescension with which this "type" of woman was regarded in the past is now *returned* by her more current representation in *Grease.* As in the case of Danny Zuko, a shifting double exposure between liberation

and condescension is set into play. In *Grease*, Rizzo is liberated but she is also cheap. This constant tension between a lived reality, and the return of this 1950s character, is what ultimately threatens the pleasurable surface of the film.

First it must be stressed that in 1978 the notion of the "bad girl" is to be taken with ambivalence. In *Grease*, female sexuality is championed to the point that these *good* bad girls are given freer sexual expression than many of the males in the film. In *Grease* it is good for the girls to be sexually active. The boys, in contrast, talk big, but in actuality, many, except for presumably Zuko himself, are not sexually experienced. Instead, they amuse themselves with sexual curiosities of how long "it" takes, or simply with looking up girls' skirts. So when Kenicke is confronted with Rizzo's aggressive sexuality, he has to admit he hasn't used his condom since he bought it in the third grade. The boys are thus presented nostalgically, as the way teenage boys were in the innocent 1950s, or perhaps even as embodying the male fear of female sexuality in the contemporary audience.

The only exception to this "innocent" sexuality is Rizzo herself, a female who displays the kind of unbridled sexuality that is in most movies typical of young males. Rizzo (the only female in *Grease* to be called by her last name) simply wants to get laid; "love" is never stated as a motivating cause. "I'm going to get my kicks while I'm still young enough to get them!" she declares as she scampers out a window on her way to find Kenicke for a sexual liaison. With similar brashness she is unfazed by the lewd remarks and gestures delivered by boys. When Zuko quips, "Bite the wienie, Riz." Rizzo responds with characteristic sexual appetite, as well as with a sexual threat. She wiggles her tongue between her teeth (implying castration) and answers, "With relish!"

Rizzo's liberated sexuality, however, is especially distinctive when seen in opposition to the repressed Sandy Olson. In fact, Rizzo denigrates Sandy's sexual attitude in a song that she sings in the pajama-party sequence. Here Rizzo dons a blonde wig in obvious reference to the cliché of the "pure" blonde woman in films, and to Sandra Dee in particular. She sings:

Look at me I'm Sandra Dee
Lousy with virginity.
Won't go to bed
Till I'm legally wed.
I can't!
I'm Sandra Dee.

At this point Rizzo, being the antithesis of this sexual attitude, collapses onto the bed and spreads her legs wide for the camera.

And later she sings:

Hey, Troy Donahue –
I know what you want to do.

By citing Sandra Dee and Troy Donahue, *Grease* once again references *A Summer Place,* a film that starred both of these actors. It could be argued, of course, that these references are merely fragmentary asides and do not warrant a sustained comparison between the films. Although this is certainly true of many uses of pastiche, a limited comparison between *A Summer Place* and *Grease* would be relevant here, especially because *Grease* takes the attitude of having superceded the 1950s film with its liberated sexual mores. A closer look, however, reveals this not to be the case. There had been many advances in the realm of sexual politics by the time *Grease* was released in 1978, most importantly, the introduction of birth control pills and the legalization of abortion, but *Grease* does not present a more insightful sexual attitude than did *A Summer Place.* In fact, *Grease* struggles to suppress what *A Summer Place* had attempted to explore.

Although *A Summer Place* and *Grease* are very different in tone and genre, they actually share a similar theme. Stated in the flippant language of *Grease* this would be: When should a girl put out? *Grease,* however, deals lightly with what had in 1959 been a pressing social issue. *A Summer Place,* for example, is a drama and not a musical, and counter to what one may expect, it is not about a virginal girl who refuses sex until marriage. Instead, *A Summer Place* is a maudlin tale about a sweet blonde good girl, played by Sandra Dee, who has a meaningful relationship with her boyfriend, played by Troy Donahue. After much deliberation and soul searching, she chooses to express her love sexually. Told from the perspective of two well-to-do but dysfunctional families, this 1950s psychological drama also touches on issues of alcoholism, infidelity, and divorce, as well as the lack of birth control and abortion during the era. Because of the social and psychological setting, then, Sandra Dee is depicted as having to pay the price for her sexual activity. In *A Summer Place,* she gets pregnant and is forced into a teenage marriage with Troy.

Of course, it could be argued that many members of *Grease*'s audience may not have seen *A Summer Place,* or if they had in 1959, they probably didn't remember it. The same could be said for another film alluded to in

Grease, Where the Boys Are, but it must be noted that the adult audience of 1978 could surely position their memories in the 1950s. However, a conscious awareness of the past films, or the era, is not the point. Instead, it is the supplanting of that memory that is at issue here. For this reason it is interesting to compare *Where the Boys Are* to *Grease. Where the Boys Are* also takes the proper sexual behavior for young women as its central theme and then shows some winners and some losers at this social game. Here again it is the blondest and the frailest girl (that is, *not* the tramp) who is shown to be too naïve to form satisfying heterosexual relationships. Played by Yvette Mimieux, this character vacations with her friends in Fort Lauderdale (perhaps explaining why the "fun" connotation of this reference still lingers) and gets into trouble because she believes the lies of the men she dates. Whereas her friends are much more savvy, dispensing limited sexual favors and flirtations to find "love" and a prospective marriage partner, this weaker character's missteps lead to her gang rape and a compromised future. *Grease*'s references to such beach movies as *Where the Boys Are* must thus be seen as highly selective. From the perspective of *Grease,* the social mores of the past did not have a political or historical component. Instead, the 1950s sexual repression was simply silly in its lack of modern awareness. Now, presumably, we are liberated.

"We," of course, refers primarily to women. In the 1960s the availability of the pill encouraged changes in female sexual behavior and, for the first time in history, made even "good" girls sexually active. Although these issues may not easily lend themselves to the more conservative themes of the classical musical, *Grease* tackles them in characteristic fashion. To gain the widest possible audience, *Grease* upholds the illusion of female sexuality as easily available, and, quite incongruously, that it was so even in the 1950s. But female sexuality is not without its threat. And one might speculate that too much female aggressiveness, both in the sexual and economic arena, was now posing a perceived danger to the emerging conservatism of the pre-Reagan era. *Grease* can thus be seen as an attempt to tame the newly liberated female sexuality engendered by the 1960s and the women's movement of the 1970s. Curiously, it does so through the character of Rizzo.

One of the more troublesome aspects of *Grease* is that it reintroduces the "good girl–bad girl" opposition, however compromised or rearranged it might now be. As a consequence, it reintroduces a convention that was purposefully avoided in *A Summer Place* and *Where the Boys Are.* In both

these 1950s films, the sexually active girls are all regarded as "good," and it is instead society's restrictions that are regarded as harmful. But now in *Grease* a reactionary sexual politic returns in the name of liberation. In fact, *Grease*'s construction of the blonde white woman and dark ethnic woman in the respective roles of good girl and bad girl is actually a convention of many even older films. In *My Darling Clementine,* for example, the blonde white woman, Clementine, is pure enough to settle in the New West, whereas the sexual dark-haired Mexican woman, Chihuahua, is too wild and must die. Since *Grease* is positioned in a post–sexual revolution, post-civil rights era, it is aware of these film historical conventions, and it presumably tries to update them. In *Grease* the "bad girl" Rizzo does not end up dead, or pregnant, or even rejected. She survives into the future with her boyfriend, Kenickie, who now wants to marry her. In utopian fashion, Rizzo accepts his proposal, and all seems to end well for the ethnic dark-haired bad girl. But this facile reconstruction on the level of the film's manifest content does not prevent deeper meanings from effecting this character. Questions still linger about Rizzo's aggressive sexuality and the way that it must ultimately be suppressed.

Grease presents us with a shifting double exposure, one that engages both past and present mores. From this standpoint it could be said that the reintroduction of the good girl–bad girl dichotomy is done in good fun and is intended only to spoof these outmoded distinctions. It could even be said that the reintroduction of this opposition in *Grease* actually inverts the old dichotomy, now allowing the "bad" sexual ethnic woman (i.e., the unconventional, uncontrolled woman) to be the *correct* model for liberated female sexual behavior in 1978. After all, the audience identifies strongly with Rizzo's sense of liberation during the course of the film, and Sandy, in the last sequence, changes her style of dress and so "becomes" a bad girl like Rizzo. But the notion of the bad girl dies hard, as do her more threatening characteristics. For this reason a counterreading is not only possible, but is inherent in the construction of the bad girl Rizzo.

In *Grease,* the resurrection of the opposition good girl–bad girl can also be seen as a renewed attempt to control female sexuality. Rizzo is an imposing figure because she is not only sexually free, but sexually aggressive as well. Almost mannish, she wants sex with more frenzy than do the boys and she is more experienced than they are. And to complete the threat, Rizzo gets pregnant! This Dyonisian figure, who brings both pleasure and threat to her audience, is then characteristically humbled.

Pregnant and unmarried, she is forced by the camera to wallow in her demeaned status, as she sings her only solo musical number, "There are Worse Things I Could Do":

> There are worse things I could do
> Than go with a boy or two.
> Even though the neighborhood thinks
> I'm trashy and no good,
> I suppose it could be true.

And while the song continues with a comparison between this behavior and that of the good girl "tease" who flirts with all the guys but never sexually delivers,

> I could stay home every night
> Wait around for Mr. Right.
> Take cold showers every day,
> And then throw my love away
> On a dream that won't come true,

it also points to Rizzo as a once-again punished and pitiable female:

> I could hurt someone like me,
> Out of spite or jealousy.
> I don't steal and I don't lie,
> But I can feel and I can cry.
> A fact I bet you never knew.

Rizzo is a shifting figure, one that is good and bad, pleasurable and threatening, and aggressor and victim. In this sequence she becomes the victim of a society that looks down on her. The song seems to indict "the way we were in the 1950s." In terms of the film viewer of *Grease*, however, Rizzo is caught in the stare of the camera. She clutches her books, bows her head in shame, and sings a song that ultimately bestows on *her* the blame for her status. In fact, nothing in the song, or in the film, deals with the repressive societal conditions that helped create this behavioral dichotomy for women in the past. Without sex education, birth control, and abortion, the sexual mores Rizzo is championing for women were, and still are, self-destructive. So, to the women in *Grease's* audience old enough to remember this era, the image of Rizzo can be pitiful, especially since it is embodied as the behavior of "that" type of woman. And to the females (and males) that only know the past through this film, the sexually aggressive ethnic woman is presented as bad or demeaned. In either case,

the realities of female sexuality now threaten the insistence on utopia in *Grease.* It is not surprising, then, that Rizzo has to be quickly removed from any such danger. As the film ends, she enthusiastically cries out to Kenicke, "I'm not pregnant!"

This is very convenient for Rizzo, but then of course, *Grease* is a musical. Just as conveniently, Kenicke asks Rizzo to marry him by saying, "I'm going to make an honest woman out of you." Here again Kenicke is speaking an anachronism that belongs to a different generation. [A more contemporary attitude is evidenced in *Sid and Nancy* (1986) when Nancy's uncle asks Sid if he plans to make an "honest woman" out of his niece. Sid guilelessly replies, "Nancy has always been honest with me, sir. She's never lied."] In *Grease,* however, Kenicke's proposal is received with great joy as Rizzo accepts (Figure 24). Rizzo's wild behavior is thus tamed into a heterosexual marriage, much as Sandy is now tamed in a skin-tight black spandex jumpsuit. While it is true that Sandy's outfit connotes her changed sexual attitude and her changed status from good to bad girl, as does the song she sings with Danny Zuko, "You're the One That I Want," nothing in the film has shown Sandy to be sexually active. Of course, we may assume that Sandy will have sex with Danny in the future, or that she will marry him. But as far as *Grease* itself is concerned, Sandy has remained the virginal good girl. The only change is that she now gets to wear a really cool new outfit. In this way, both Rizzo and Sandy have been tamed and their sexual threat has been contained.

Grease's insistence on uninterrupted pleasure and suppression of reality is overtly stated at the end of the film. Here one of the characters worries about graduation: "What if we never see each other again?" This is answered in characteristic *Grease* fashion. The teenager's fears are quelled by an obvious untruth that interestingly eradicates the effects of time: "Of course we will. We'll always be together!" The film then ends with the following lyrics:

We'll always
be together . . .
Together . . .
forever . . .

The untroubled a-historical utopia that collapses various time periods, however, has some uneasy moments in *Grease.* What are we to make, for example, of the kimono Marty gets from her boyfriend in Korea (reminding us of the bitter Korean War from 1950 to 1953), or of the

Figure 24. *Grease,* Randal Kleiser, 1978. Copyright 1998 by
Paramount Pictures.

fact that Eugene doesn't like to dance "boy-girl" (Eugene is a homosexual
in an era of serious, often violent, repression against gays)? Uncomfort-
able memories of historical conflicts begin to emerge even though the film
tries to diminish their importance. If we look closely we can note some
disruptions. For example, we can see that there are just two Black stu-
dents in the film and that they are visible only briefly in the background
at the school dance. This is a troubling absence when one considers that
the 1950s era depicted is one before civil-rights legislation and the de-
segregation of schools in the South. Moreover, *Grease* is a rock 'n' roll
revival movie that includes songs originally written by African American
artists, such as "The Stroll" and "The Hand Jive," but which now features

only one Black musician on the school stage with an all white band. The impulse to eradicate disturbance is then extended to the music written expressly for the film. Here the rock 'n' roll inspired tunes have been homogenized and turned into pop versions of that once countercultural form. The originally threatening inspiration of rock 'n' roll itself, seen by many parents in the 1950s as music of the devil, has been tamed. In *Grease* songs like "Hopelessly Devoted to You," "You're the One That I Want," and "Summer Nights" (currently one of the most popular Karaoke songs of all time, probably because of the sexual double standard it promotes) have distilled the source Black music into sugary pop songs.

Much as Jameson had claimed, the past in *Grease* returns to be packaged for popular consumption. But it also returns with an immediate social and political purpose. *Grease* presents us with a conflation of lived memories, movie memories, and present mores. From these worked-over languages, a 1950s is constructed that reverses the recent past in the service of an emerging present. The fear of recent advances for women, for example, is tamed in *Grease* by a return to old sexual oppositions. Similarly, the fear of emerging ethnic and racial groups in the 1970s, and of gay liberation, is contained by the virtual eradication of their historical presence. Moreover, the fear of aging itself is in *Grease* assuaged by the return to cinematic forms, and to the period styles, of the baby boomers' adolescence, and with them, the attendant promise of perennial youth. *Grease* thus constructs the illusion that we can return to an updated version of the 1950s where we are forever young, white, straight, middle class, *and* sexually liberated. In this way, *Grease* strives to eradicate the more threatening aspects of race, gender, and class raised by recent 1960s progressive movements, while also indulging in the titillation of still-marketable sexual freedoms.

Utopia Rejected

In the light of these conclusions, it is important to note that many films released contemporaneously with *Grease* reveal a societal tone far from the utopian constructions noted here. These films are instead fraught with a continuing sense of unease and include such titles as, *Halloween* (1978), *Saturday Night Fever* (1977), *The Shining* (1980), *Apocalypse Now* (1979), *Friday the 13th* (1980), *The Alien* (1979), and *Pennies From Heaven* (1981). Like *Grease*, however, these films also return to old film

genres. But while *Halloween, Friday the 13th,* and *Alien,* for example, can be traced to *Psycho,* these late 1970s variations multiply the number of murders to serial killer proportions. Similarly, *Saturday Night Fever* and *Pennies from Heaven* are musicals that tell stories about the difficulties of life, now *without* the promise of utopia. And lastly, Francis Ford Coppola's war film, *Apocalypse Now,* tears at the curtain of illusion erected by such films as *Grease* and the attending cultural obsession with the happy 1950s to address the trauma of the Vietnam War and the dissociative reality behind it. From this perspective, then, we can see that *Grease* responds to its cultural moment with utopian fantasy rather than with confrontation or aggression. But *Grease* is not alone in returning to the 1950s proper as a setting. The obsessive revival of this era has continued through the decades of the 1970s and the 1980s (and, in many ways, even into the 1990s).

Although the 1950s metonymically returns through the reuse of its distinctive film genres (a topic we will explore further in Chapter 7), a number of films in the 1980s specifically reference the era itself. Such films include *Streets of Fire* (1984), *Back to the Future* (1985), *Peggy Sue Got Married* (1986), and *Last Exit to Brooklyn* (1989). The 1950s in these films is not presented as a time better than our own or as a place we might long to inhabit. Instead, each film takes a distinctive and often quite troubled approach toward the re-creation of that era.

Streets of Fire by Walter Hill, for example, is a self-proclaimed "rock fable," a musical that abstracts time, space, and narrativity into a dystopian yet eternal 1950s. Many of its characters are drawn from old movie sources (Cody is a "Westerner," McCoy a "soldier," and Raven a biker like that in *The Wild One*) and now inhabit an artificial, obviously set-constructed 1950s world. The location of *Streets of Fire* looks worn and dirty, almost postapocalyptic. Along its abstracted sets, the usually bright colors of the classical musical are darkened into a Film Noir–like image where the streets are slicked with a nearly incessant rain. Moreover, the traditional utopian narrative of the classical musical has been reduced to a bleak "mythic" tale (in some ways like the Greek myth of Helen of Troy) of abduction and rescue. But although *Streets of Fire* makes reference to a number of earlier genres, these allusions are not sustained. Instead, they are fragmentary, disconnected, and ultimately used to deplete narrative depth, while drawing attention instead to a play of surfaces. In this way, *Streets of Fire* presents a combined past/present/future made up of crumbling shards from past stories. Much as in the famous Luis Borges

allegory, a decomposing map has now replaced the kingdom and the real itself has been lost.

Streets of Fire is thus more reflective of the process of representation itself than it is a return to the 1950s proper. That is, it does not primarily present elements from past artifacts to return to that era by association, nor is it simply an example of such postmodern features cited by Jameson as the "waning of affect" or the "enfeeblement of narrative" in the nostalgia film.[6] *Streets of Fire* comments on these very conditions through hyperbole. It accentuates the loss of the real and the domination of past images through disruption and recombination. In effect, the film attempts to destabilize representation, especially of the simulacrum, by the fragmentation of the simulacrum as such. There is no solace in the past presented in *Streets of Fire,* and there is little security in its discarded artifacts.

As we have come to recognize, not all returns to the 1950s are equal. Two films continue in this vein, *Back to the Future* and *Peggy Sue Got Married,* both of which are romantic comedies that do not directly comment on the simulacral image, although they do much to utilize it. These two films tell the story of time travel back to the 1950s. And although they approach this period more nostalgically and gently than does *Streets of Fire,* they too find a past that is flawed and that ultimately yields no security. In both these films, the past is refashioned to explain ongoing cultural concerns to contemporary audiences.

Back to the Future, directed by Robert Zemeckis, for example, is quite confident in its 1980s values and its neoconservative attitudes and attempts to impose them, not only on the past, but on the present and the future as well. In this film, the young 1980s character, Alex, returns to the 1950s of his parents. In a color-saturated world dominated by bright reds and blues and situated in the "small town USA" of the 1950s imagination, Alex encounters his parents as teenagers. Unlike any imagined ideal, however, his parents are less than exemplary. Their attitudes and their behavior, as well as the past they live in, are ineffectual and outmoded. In fact, many of his parents' problems in later life are shown to stem from their failings during this period. But because of Alex's advanced 1980s abilities, as well as his contemporary strength of character, he is able to intervene and change their destiny. Alex corrects what was deeply dysfunctional in his parents 1980s life by adjusting their 1950s past. So when we see Alex's family in the present, his father is no longer a fumbling loser. He is a successful author who owns a BMW, lives in a lovely

suburban house, and is married to a svelte and attractive wife. Moreover, the high school bully who once menaced Alex's father is now his servant. As a wish fulfillment fantasy, however, *Back to the Future* tells us more about Reagan-era America and its materialistic career-oriented society than about the 1950s and its social realities.

Peggy Sue Got Married by Francis Ford Coppola takes a slightly different twist on the notion of time travel to the past. Here the lead character, Peggy Sue, is a newly divorced adult woman who returns to her own past in the 1950s. The film thus addresses the adults in the audience more than it does their children. And since we are openly revisiting "our own" past, the question of memory and nostalgia become more central. When Peggy Sue arrives in the 1950s, for example, she discovers that her high school days may have been "innocent," but they are better describable as downright, well, *adolescent*. From the perspective of Peggy Sue's adulthood (and our own), the past is seen as a developmental stage, and so one that must necessarily be left behind. The 1950s teenagers in *Peggy Sue Got Married* are not just better looking versions of adults, with more vitality and more romantic prospects than their older selves. They are also immature, inexperienced, and thus prone to making mistakes. When Peggy Sue returns to her own past she finds that she wants to leave, but she also finds that she is not willing to change this past to correct her future. She is given the chance to right the wrongs of her high school years by rejecting the man she will marry and eventually divorce, but Peggy Sue chooses not to. These "errors," after all, have given Peggy Sue her children, and she won't change that. Of course this is Coppola's very personal statement on the perils of returning to the past, but it also can be said to stand in metaphorical relationship to the cultural impetus to return to the 1950s. The past is indeed a foreign country, and it cannot be used to erase history and the present.

Last Exit to Brooklyn

Last Exit to Brooklyn delivers the strongest injunction against the culture-wide obsession to revisit the styles and images of the 1950s. Made in 1986, nearly fifteen years into the recycling of this era and its artifacts, the film presents Brooklyn, New York, in 1952, a place now seen as riddled by the difficult realities of race, class, and gender conflicts. Adapted from the 1954 American novel by Hubert Selby Jr. and directed by Uli Edel, the film

is a German rather than American production. Perhaps this distance from American culture is what gives the film its searing injunction, confronting the viewer with disturbing historical and social realities. *Last Exit to Brooklyn* gives us another look at the "greaser" or the "rebel" in working-class American society, and in so doing, it ruptures the giddy assumptions of films like *Grease*. The film is set in an often-shocking working-class environment and views men, women, gays, Blacks, and the Korean War with an attitude that can no longer be described as "happy days." In *Last Exit to Brooklyn* we are returned to a historical period before the civil-rights movement, before women's and gay rights, and to a place where social class impacts every aspect of people's lives.

Last Exit to Brooklyn foregrounds many of the ills of the 1950s to counter the a-historical rendering of this era pervasive on film and television. And while the film utilizes typical images from this era, its purpose is not to allude to past films but to history itself. *Last Exit to Brooklyn* requires the viewer to respond critically to the film's characters, to compare them to recent constructions of 1950s screen types, and to acknowledge their racial, class, and gender status. To elicit this response, the social conditions referenced in *Last Exit to Brooklyn* are not always directly represented in the film. Instead, *Last Exit to Brooklyn* presents these issues allusively, relying on the viewer's attention and historical consciousness to complete their meaning. But all this is not to say that *Last Exit to Brooklyn* presents us with a 1950s "reality" any more than does *Grease*. Rather, it allows us to reconsider some of the representational constructions from that era. *Last Exit to Brooklyn* shatters the viewer's expectations by presenting a whole new 1950s, one perhaps visually recognizable, but now containing characters and events that must be read on their own terms.

The film of *Last Exit to Brooklyn* is rendered in a style very different from the literary material on which it is based. The book had presented each of the five major characters in separate chapters and speaking in their own distinctive voices. The film instead interweaves these characters and stories. Moreover, it rewrites them to foreground issues of race, class, and gender in ways not always central to the novel. The translation of the literary work onto film then constructs a visual world to accommodate these characters and their world. But perhaps most importantly, the resulting film is placed within a changed historical context. Shifted from the 1954 publication of the novel to the 1986 milieu of the film, these past social issues are seen from a changed historical perspective and in comparison to other such representations of this era on film.

Last Exit to Brooklyn, shot primarily in a studio in Bavaria, Germany, with only a few exterior shots of Brooklyn itself, is only apparently more realistic than *Grease.* Although certainly presenting us with a grittier environment than *Grease,* the sets in *Last Exit to Brooklyn* are often obviously artificial. This constructed environment, however, is not presented in the bright colorful tones often used to recall 1950s films. Instead, it is fashioned to refer to other representational sources. *Last Exit to Brooklyn* presents us with a dark and brooding picture world, at times reminiscent of the Brooklyn paintings of Edward Hopper, and at others, of the inner city streets of *West Side Story.* But the film does not fulfill the expectations these references may engender. The opening sequence, for example, and the title "Brooklyn, 1952" that accompanies the image are now paired with low ominous music, alerting us to a whole new approach to this world. A moving camera shot swoops down over a set of the Brooklyn waterfront at night, evidencing the same gliding ease often used in the musical film. But no gaiety will follow. No song and dance numbers will buffer the dark scenes of life. Instead, the social conditions so often submerged or disregarded in recent 1950s nostalgia films are foregrounded. A critical montage is thus set into motion between the class-based historical issues in *Last Exit to Brooklyn,* and its coded 1950s images.

This clash, however, is often prompted by a set of absences that allude to historical and social contexts without directly presenting them. The critical distance that results from encouraging the viewer to fill in the missing information is apparent from the opening sequence of the film. *Last Exit to Brooklyn* begins with a crane shot that lowers to frame a group of soldiers as they stride through the Brooklyn streets at night. The historical fact that in 1952 these rowdy soldiers on leave are eventually on their way to the Korean War can only be deduced by the viewer's active participation. Without this direct information, however, we can only watch as this group of soldiers, obviously drunk and looking for trouble, approach several neighborhood thugs. Standing outside a seedy bar and illuminated by a pulsating red-and-blue neon sign, we see the original greasers of the 1950s images, now devilishly handsome with their slicked-back hair and dapper clothes.

With these bad boys is TraLaLa, the bad girl, similarly iconic in her skin-tight clothes, high-heeled shoes, and white blonde hair that recall Marilyn Monroe. But any romantic or nostalgic feeling that might accrue to these characters is quickly dispelled. Soon after we meet the inhabitants of this brutal neighborhood, they begin to abuse each other verbally in the heavy accented tones of the Brooklyn underclass. The aggressive

young men demean TraLaLa, and she boisterously answers them in kind. No sympathy is needed or wanted here, and any incursion from the outside world is to be repelled. We will come to understand that this is an insular, territorial world, a fact abruptly underlined when the soldiers try to intervene on the "lady's behalf. TraLaLa turns toward the camera and bellows at them, and at us, "Go fuck your mother!" So while the world of *Last Exit to Brooklyn* may be visually recognizable, it is inhabited by a whole new set of characters.

The soldiers' next comment serves to further define a time and a place for us, as well as a set of disturbing social conditions. When the Brooklyn thugs redirect their aggression from TraLaLa to the oncoming soldiers, one of the GIs retaliates with a defiant verbal affront, "I'll cut your Nigger-lovin' hearts out." Delivered in a heavy southern accent, this comment gathers further meaning because it alludes to an earlier historical confrontation, one now restaged as this "Confederate" soldier finds himself on "Yankee" turf. And although there are no African Americans in this sequence, nor will there be for the remainder of the film, the allusion to this racial group points to an ongoing condition within 1950s American society dating from the Civil War. *Last Exit to Brooklyn* now more openly presents us with a time before the civil-rights legislation of the 1960s, the ferocious struggle for which is rarely mentioned in the 1950s nostalgia films. Based on knowledge of the social conditions in the 1950s, one can deduce that an African American would have been killed entering this Brooklyn community and violating its primitive dictates of territoriality. Through this structuring absence, then, one that alludes to but ultimately negates the presence of Blacks, this Brooklyn community is defined as a *white* enclave. Moreover, as will become apparent later in the film, this is also an Italian-American working-class community. Unlike in *Grease,* however, the ethnic markers in *Last Exit to Brooklyn* have been recontextualized within their appropriate historical and cultural setting. There is no sugarcoating here that would conveniently place these 1950s working-class ethnic characters within a middle-class setting, taming them as being uniformly "white" and so without ethnic threat or social meaning.

"Brooklyn" in this film is also meant on a metaphorical level, foregrounding the conflicts of a particular social class. In 1952, a time before the 1960s advances, this is a place where human beings behave in less than enlightened ways toward each other. The young toughs in *Last Exit to Brooklyn* are not fun-loving greasers but brutal inhabitants who display little or no sympathy for the rights of others. These base characters,

however, are not the only ones to evidence such an attitude. In fact, almost all the characters in the film, the "good" and the "bad" alike, indulge in callous or violent behavior. But these failings are not determined by the shortcomings of the individual or those of the ethnic community. Instead, the cause is shifted onto the overriding social conditions of a preenlightened 1950s era. The lives presented here allow no escape; they are lives of violence and intolerance, or lives in which the existing social mores threaten to continue into the next generation. By thus presenting the characters in a community of relations with one another, *Last Exit to Brooklyn* allows the viewer to consider how the determinants of class and historical positioning affect the lives of the individual.

One of the pivotal concerns of *Last Exit to Brooklyn* centers on the lives of women in the 1950s. In order to present a more complex understanding of these issues, the film constructs images often reminiscent of 1950s cinematic sources, and then counterposes them to characterizations and stories that clash with those expectations. Within this dynamic, the story of TraLaLa in *Last Exit to Brooklyn* presents one of the film's most poignant and disturbing examples. TraLaLa is a dead-hearted bad girl, and not inconsequentially, a Marilyn Monroe look-alike who much more resembles one of Madonna's imitations. In this film, however, she is presented with no hint of irony. Rather, her stereotypical look is meant to symbolize the "original" after which many of the sanitized Hollywood imitations, from Marilyn to Madonna, are modeled. TraLaLa is the sexually promiscuous girl from the lower classes, a foul mouthed and unfeeling character, and so quite the match for the bad boys in the neighborhood. But her life is shown to be far from happy or appealing, and is certainly not meant as a romanticized metaphor for "women's power." The viewer is instead encouraged to reconsider these clichéd expectations for the 1950s bad girl against the class-based realities of TraLaLa's life.

TraLaLa runs with the bad boys. Together they "roll" unsuspecting soldiers who wander into their neighborhood, with TraLaLa promising them oral sex while the boys steal their money. On occasion TraLaLa will even turn tricks if the need arises. Through her unconventional sexuality, TraLaLa has attempted to break free of the confines of her class, but she ultimately finds she cannot escape. The boys, for example, play tricks on her, putting TraLaLa in her place by cheating her of the profits of their scam and forcing her to deliver the blow job for free. TraLaLa retaliates by walking off the job, jumping in a cab with one of the soldiers she attracts, and taking her business to Manhattan.

Once in Manhattan, however, a location socially and economically as far away from Brooklyn as Paris or Rome, she finds a situation that will be her undoing. TraLaLa meets a young middle-class soldier who values her. He buys her clothes because he likes her, he tells her she's beautiful because she is, and he chooses to stay with her for three days before he leaves for Korea. Unlike the usual representations of the "whore with a golden heart," however, TraLaLa cannot respond to the soldier's kindness. Her desperate class-based struggle for survival has damaged her, making her see the soldier only in terms of the small amounts of cash he can provide her. We can also speculate that since TraLaLa has never been loved, she cannot love. So when the young soldier leaves to fight and possibly die in Korea, TraLaLa does not easily incorporate the loss. Instead, this unconventional character responds with a level of self-destruction symbolic of her rage and degree of repression, and she does so in a way rarely seen before on film.

On returning to Brooklyn from Manhattan, TraLaLa reels at the loss of what she does not entirely understand. To somehow regain control of her life, she responds in the only way she knows. She denies her desperation and her newly found vulnerability, and wrong-headedly she exercises the only callous "power" she has known. She gets drunk, makes sexual advances to a number of men, and then offers to fuck *all* of the men in the rowdy and crowded bar. The furor of the gang bang that results is truly of frightening proportions. The men shout and jeer as they carry TraLaLa's willing body to an abandoned car, placing her in the back seat and repeatedly entering her with a frenzy and abandon that eventually shatters the car's windows. In this scene it seems as if all of the violence inherent to society's abuse of women is brought to the surface. TraLaLa and her image of wanton and available sexuality (an allure that underscores all of the images of "bad" girls from Marilyn to Madonna (Figures 25 and 26) has transgressed the rules, and now she is reduced to a debased object to be taken without concern for her humanity. As we watch her brutal violation by a throng of dirty and sweaty men, the level of the abuse can only make us ashamed at our complicity in her demise.

TraLaLa, as the archetypal bad girl, has drawn to herself what all those sexy pictures had seemed to invite. She has made herself available to the masses, both as a sexual object and as an object of the gaze. In this respect it is not surprising to see that one of the last images of TraLaLa's face, laying on a filthy mattress to which she has been taken, is remarkably similar to Cindy Sherman's Film Stills #93 (1981) (Figure 27) and #153

Figure 25. Marilyn Monroe. Figure 26. Madonna.

Figure 27. *Untitled*, #93, Cindy Sherman, 1981. Courtesy of the Artist and Metro Pictures.

(1989). As an admixture of these two stills, the image of TraLaLa is shot from above like that of the seemingly dead women in Film Still #153, while her smeared makeup, heavy perspiration, and dazed expression recall Film Still #93. The image in *Last Exit to Brooklyn* is thus an apt composite figure, seemingly mixing references to Sherman's work while also utilizing a more crucial visual dynamic. Much as in Sherman's work, we see poor TraLaLa, now living yet dead, and we are made complicit in her demise by our very act of looking. After all, at this moment we can only stare at the aftermath of what we have participated in by witnessing. And we have not acted. In fact, it is only Joey, a young boy from the neighborhood who had innocently loved TraLaLa from afar, who now has the decency to drive off the last of her abusers. But it is TraLaLa's last action toward *him* that solidifies her meaning for us. In a heartbreaking moment, TraLaLa rises to cradle Joey in her arms in an effort to comfort the young boy. In an image arranged to recall Michaelangelo's *La Pieta*, TraLaLa takes on the role of nurturer and mother, and in so doing she reminds us of who she is. She is a woman, like many of those we have known and who have filled our lives with warmth and caring. In this way we can read TraLaLa's act of inviting the gang sex as an act of rage against herself, but also as one that has made manifest her social position, and by extension, that of women in general.

It must be remembered, however, that these ideas have been elicited by a condensed set of images, ones with multiple cultural and media references that now encourage the viewer to complete their meaning. In similar fashion, the "bad girl" TraLaLa is compared to Donna the "good girl" in the film, not to indict either character because of their behavior, but to address the representational and sociological terms themselves. In *Last Exit to Brooklyn*, in fact, the most important difference between TraLaLa and Donna is shown to be the type of men with whom they associate. TraLaLa is not represented as having a family, and so she has no father, or brother, or husband to protect her. Her neighborhood friends are men who are unemployed petty criminals. In contrast, Donna is presented within a family setting. Her father, Paulie, is a working man with his family intact. And although he is boisterous, ill-mannered, and most certainly from the lower classes, Paulie is able to help Donna when she gets pregnant. Donna has been sexually active with a number of different boys (being, as Tommy, the boy who impregnated her, remarks, "no virgin") and is now well into the last trimester of her pregnancy. Donna, however, is able to keep her designation as a good girl because her father and her uncle have

enough "clout" to force the child's father to marry her. In fact these two men literally beat up the young man until he agrees to the union. It is only through the support of the patriarchy, then, that Donna can maintain her status in society.

The film relies on the viewer's historical and cultural knowledge to make its additional points. Although it is not directly shown, we can deduce the destructive dynamic at play in a society where birth control and abortion are not readily available to women. Donna is pregnant and the only way to deal with her condition is through marriage. But *Last Exit to Brooklyn* invites the viewer to speculate further on her situation, noting that this marriage will ultimately prove to be a trap, not only for Donna and her husband, but for their child as well. Donna is married as a teenager, and her male child is born into a social group where the men are physically violent. This point is underlined when a fight breaks out between Donna's father and her new husband at the wedding reception. In the unruly scuffle that results, Donna's baby boy is unwittingly initiated into this male group. His father and grandfather fall against his bassinet and send the infant hurling to the floor. The child is apparently unhurt, and so the people at the party continue their festivities and further celebrate the newlyweds. In fact the mother of the bride loudly wishes the newlyweds *ten more children!* With this statement, and a little critical thought, we can see how the cycle of poverty will continue in this family. We can surmise that Donna has little education and will not find a job outside the home. And like her mother before her, she will be trapped by the limitations of her class, by the restrictions on women's reproductive rights, and by a large unruly family.

Last Exit to Brooklyn also lets us understand that the men of this community are similarly trapped by their social class and by their gender-specific restrictions. These men are shown to live lives of hardship and sometimes squalor, in short, a working-man's life. In *Last Exit to Brooklyn,* many of the men are factory workers who have been on strike for many months. The film thus recalls the union movements of the 1950s, as well as the impact of extended unemployment without government support. This hardship, however, is seen as twofold by one of the films' central characters, Harry. Harry leads a double life. He is a strike foreman and family man, but he is also a repressed homosexual. By centering on Harry's desperation, *Last Exit to Brooklyn* once again brings to the surface what had been submerged or absent in other 1950s nostalgia films. During the 1950s the oppression of the working class, along with the

limitations on women's rights, was matched by the brutal repression of homosexuals.

To allow us to revisit this historical condition, Harry's personal life in *Last Exit to Brooklyn* is presented as one of intense suffering at having to maintain the facade of a sexually active husband. Instead of coming to bed with his wife, for example, Harry anxiously watches television trying to evade the act of making love to a woman. (In this scene, the 1950s-style TV programming, frequently used in nostalgia films to connote a sense of happiness or bygone stability, is instead rendered banal and used by the character literally to escape reality.) But Harry is eventually pressured into performing an act that is against his nature, and so he confronts the viewer with the rage and disgust inherent in living such a lie. And although Harry later finds temporary solace in a male lover, the desperate nature of this homosexual involvement ultimately dooms the relationship. In the end, Harry's overwhelming need causes him to lose both his job and his place in society.

In *Last Exit to Brooklyn,* Harry and another of the film's central gay characters, Georgette, are savagely confronted by the fact that their deepest needs cannot find a suitable social outlet. Harry has been able to disguise his sexuality under a front of conventional masculinity, but the tragedy of Georgette is that she cannot. Georgette is an effeminate homosexual, a "queen" whose swaying hips, high-pitched voice, and exaggerated mannerisms are part of who she is. In this callous Brooklyn setting Georgette finds that her sexuality both repulses and titillates the bad boys in the neighborhood. She is desperately in love with Vinnie, a "straight" boy who alternately taunts her verbally, has sex with her, or tortures her by withholding that act. Georgette is TraLaLa's double in that she is not seen for her humanity. Instead, the neighborhood thugs abuse her, as does her macho brother and, inadvertently, her ineffectual mother. It seems to be open season on Georgette with all of these characters physically and psychologically assaulting her with few or no restrictions on their behavior. In this setting, the homosexual has been deemed unacceptable by society and has been placed beyond the realm of its protection. So when an oncoming car strikes Georgette, sending her body flying into the air like old baggage, it symbolizes the violence and profound disregard that has typified her life. Georgette's lifeless body now lies alone in the street with no one to mourn her. In similar desperate fashion, Harry, after losing his job and his male lover, displaces his sexual needs onto a young boy. For this crime he is beaten and "crucified," left to hang on a fence in his

shame. The lives depicted here can only end in destruction. In *Last Exit to Brooklyn,* however, the onus is placed on a society that has not granted its members their human rights.

The technique of *Last Exit to Brooklyn* is important because of the way it encourages, rather than represses, the viewer's memory, knowledge of history, and knowledge of cinema to complete its meaning. The film presents character types and events that have been largely misrepresented or suppressed in many recent 1950s revival films. Stock characters, such as the "Italian greaser," the "good girl," and the "bad girl," or elusive or absent characters, such as gays or Blacks, are recalled and then shown in a historically and socially complex light. The more far-reaching implications of these characters, however, have remained nonrepresented. They have instead lingered beneath the manifest content of the film and so relied on the viewer's conscious play to complete their meaning. By opening up the recent 1950s screen conventions, *Last Exit to Brooklyn* has shown us a working-class America and has indicted the social conditions of the 1950s, rather than the psychology of the individuals, for its limitations. In this way, *Last Exit to Brooklyn* shows how class, race, and gender were affected by restrictive social mores and the lack of advanced legislation in the 1950s.

But even within in its societal critique, *Last Exit to Brooklyn* foregrounds its status as a representation. The film presents a cinematically coded visual surface that calls attention to itself. As we have seen, that surface is then placed in opposition to the narrative material we find there. Through the critical montage that results, the sign itself has been shaken, and a more historical consideration of the 1950s era has resulted. The nostalgia film, therefore, does not necessarily return uncritically to the past. In a significant number of cases, and most certainly in *Last Exit to Brooklyn,* this return has been undertaken to address both the past and the images that have reproduced it.

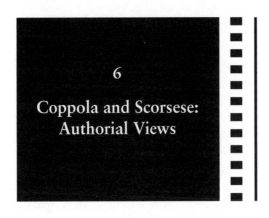

6

Coppola and Scorsese: Authorial Views

Francis Ford Coppola and Martin Scorsese began their careers in the 1960s and have since been among the most important innovators of the cinematic transition of the late 1970s and 1980s. Their work, which is varied in style and content, nonetheless demonstrates a number of core characteristics essential to expanding the present discussion. In a significant number of films, these directors do not so much incorporate the simulacral image, as comment on it, and they not only resuscitate past genric forms, but radically displace their elements.

Coppola's work has been strongly dependent on genre from his earliest productions. These include the "nudie" picture *Tonight for Sure* (1962), his horror film *Dementia 13* (1963) for Roger Corman, the musical *Finian's Rainbow* (1968) for MGM, and his screenplay for the war movie *Patton* (1970). It is only with *The Conversation* (1973), *The Godfather* (1972), and *The Godfather Part II* (1974), however, that Coppola enters into a critical reworking of genre. In these three films the conventions for the detective and gangster genres, respectively, are reused with an acknowledgment of their lost past. In *The Conversation,* for example, Harry Caul is a detective quite unlike his film predecessors in that he cannot successfully decipher the world around him. Harry is instead confronted with an impenetrable system of corporate power and crime that depletes his ability to see or hear the whole truth. Harry has no access to the real, only to representations of the real, here a series of recorded conversations about an impending murder. Harry thus cannot occupy the position of the subject in the same way that the detectives of the classical genres had. Instead, Harry is the object of a corporate nexus that has the power to fix him in its power. Unable to fully detect the truth, Harry is seen, but he is not seeing, a condition dramatized in the closing sequence of the film as a hidden surveillance camera takes Harry as the object of its gaze. In

a way similar to the condition of the subject in the society of late capital as described by Jameson, the classical detective and his all-seeing power is in Coppola's film rendered "dead."

In *The Conversation*, Coppola is working within genre while acknowledging that its assumptions are now outdated. In *The Godfather*, however, Coppola engages genre in a different way. Here he works through the reconfiguration of elements from an older form of the gangster film, making *The Godfather* an early but distinctive example. As a strategy we have been discussing throughout, *The Godfather* resuscitates the original gangster films of the 1930s [*Scarface* (1932), for example] by telling its story from the perspective of the criminals, not from that of the law. And as I have noted elsewhere,[1] Coppola's film also returns to those earlier works by reestablishing a link between ethnicity and crime. In *The Godfather*, the Italian-American criminal, a type once outlawed by the Production Code Administration because it associated a particular ethnic group with criminality, now returns after a period of absence. *The Godfather* also seemingly returns to a classical style of filmmaking in that it rejects some of the more disruptive Hollywood styles of the 1960s. Its integrated forms of editing and narrative, for example, re-create the stable world of Hollywood's classical style, while the chiaroscuro lighting recalls Film Noir of the 1940s as well as the paintings of Rembrandt and other Old Masters. The images of *The Godfather* thus have a feeling of pastness, returning as if from another era, and herein lies much of the film's impact.

The Godfather returns us to the past to more accurately assess the present. It must be acknowledged, however, that the distance produced by radical 1960s films is here replaced by an ambivalence that allows for a variety of readings. *The Godfather* tells the gangster story bigger and better than ever, but it also destroys the gangster hero in a new way. Michael Corleone, for example, does not die in the street, as older convention would have it. Instead, he loses his family in his rise to power. The representation of the central character, however, is the most significant departure from the old genre. Here Michael is an anachronism in every way, much like the elements of the resuscitated gangster genre itself. Michael is his father's son in his attaining of absolute power, but he is also a representational fiction, embodying the wish for individualism in a multinational capitalist economy dominated by a global system. By representing Michael as the embodiment of vast individual power, *The Godfather* can be seen as a denial against the loss of that potential in society. Much of the sadness of watching Michael alone and beleaguered

in the last sequence of *The Godfather Part II* resides in the fact that he, too, is a nostalgic figure, an ethnically pure white male subject, an endangered species in 1970s America. In *The Godfather,* the image surface has recalled other images, other films of the 1940s, and old photographs of New York, but all, including the hero himself, have been erected as a screen against the loss of the real and the rise of simulation. Coppola's later films address this condition more directly.

The Coppola films that follow *The Godfather* show not only the impact of multinational capitalism, but also the direct impact of the Vietnam War and its aftermath. In these later films, beginning with *Apocalypse Now,* Coppola's control of centralized narrative and character seemingly begins to "falter," because he moves away from the classical style of Hollywood filmmaking. Increasingly, for Coppola, past Hollywood styles are malleable units to be fashioned anew with each film. Rather than continue reworking genres, in accordance with the modernist concerns of earlier revisionist filmmakers, Coppola moved into a postmodern language of his own invention that not so much reflected the changing cultural condition, but confronted it, even interrogated it.

Apocalypse Now

Apocalypse Now was released in 1979. Rather than deny the recent past, as *Grease* had done, Coppola's film instead meets it head-on, representing the Vietnam War, the repressed traumatic event underlying many of the films discussed thus far. Of course, *Apocalypse Now* was not the first film to dramatize this event. Two other Vietnam films, *Coming Home* (1978) and *The Deer Hunter* (1978), were released the year before. But Coppola's film was nonetheless widely accepted, in the words of one critic, as "the first film to directly excoriate U.S. involvement in the Indochina War."[2] Although not everyone would agree with this assessment,[3] I would like to consider the use of the verb "excoriate" in this quote, since it means "to condemn severely," but also, "to peel away the skin." *Apocalypse Now* can be seen to "peel away" the hard glossy images of the 1950s nostalgia film we have discussed thus far, to finally expose the traumatized real below. But even with this return of the repressed, we find that the "real" here is also compromised. In *Apocalypse Now* the images openly declare themselves as such, often creating experience and meaning through an obdurate surface of overlapping representations. And even if they seem

to distinguish themselves from simulacral images of the nostalgia film by referring to a lived, even personal, reality, they too ultimately succumb. After all, to most Americans the Vietnam War was, first and foremost, a set of pictures.

The word "apocalypse" also has dual meanings that are important to consider here. Webster's Dictionary defines this term as "any of the various Jewish and Christian pseudonymous writings depicting symbolically the ultimate destruction of evil and the triumph of good." The second meaning of "apocalypse" is "a disclosure regarded as prophetic; a revelation." In *Apocalypse Now* the first definition comprises the film's manifest content, telling the story of the assassination of Colonel Kurtz, the symbolic embodiment of evil. In compliance with its second meaning, however, the film can be seen as a "revelation," literally, a bringing to light of a number of cultural issues, while also making a contribution to cinema history through its vision of our changed world. And since Jameson has called the Vietnam conflict the first postmodern war,[4] in its blurring of boundaries of time, space, and of the self, I would like to consider *Apocalypse Now* as a postmodern war film. In so doing, I will move away from the commonplace understanding of postmodernism as indicative merely of an eclectic style. As we shall see, *Apocalypse Now* is much more than a play of referential surfaces. Instead, it is a work that directly embodies the more far-reaching changes defined by postmodernism.

This is not to say that *Apocalypse Now* neglects to utilize its imagistic surfaces in the construction of meaning and experience. On the contrary, it is precisely here that much of the film's innovation lies. The Vietnam War forms the manifest content of *Apocalypse Now*, filling the film's visual surface, almost as an exposed living organism, and accosting the viewer with the return of the repressed. The images of the Vietnam War are in *Apocalypse Now* returned to a 1979 audience after a distinct period of absence. But it is ultimately the manner in which *Apocalypse Now* reconstructs the Vietnam War experience that most distinguishes it. This film largely rejects the theatrical space and more conventional style of storytelling utilized by most dramatic films. In attempting to render the *experience* of the Vietnam War more than its dramatic re-creation, Coppola turned to the cognitive and perceptual models of the avant-garde film, thereby extending some of its methods and aspirations into the Hollywood mainstream film. In *Apocalypse Now*, however, these elements are utilized with a renewed purpose, and within a now-changed historical and cultural context.

Apocalypse Now presents us with cinematic images that encourage memory and critical thought. Beginning with the opening sequence of the film, this method will be continued throughout. *Apocalypse Now* begins without titles. Instead, we are given an image of the jungle shot in slow motion, a technique that bestows on it a ghostly quality of near movement. This breathless image is then matched with the barely audible sounds of an unseen helicopter. Like the rumble of a distant memory, the chopper comes in closer, suddenly appearing from frame left, crossing the extreme foreground of the image, and disappearing to the right. The 1979 audience is back in Vietnam and it knows these images well, having watched them for years on the nightly television news. Coppola's film continues its sensual re-creation of this war by the pairing of sound and image, and sometimes by opposing the two systems. Here, for example, yellow napalm slowly rises from the jungle floor as music of The Doors is paired with the image. The music's opening riff lingers and fills us with anticipation for the beginning of its lyrics. It teases, as it carries us back to a time and place recently left behind. "This is the end/ beautiful friend/ the end. . . " finally charges the image as the jungle soundlessly explodes into an inferno of flames.

This highly celebrated first sequence of *Apocalypse Now* then continues in ways that are often traceable to avant-garde film sources, incorporating high art forms into a mainstream film. As the images begin to dissolve one into another, intermingling and superimposing shots of the jungle, chopper blades, blades of a ceiling fan, and finally the inverted face of the film's central character, Captain Willard, they recall both the practice and the theories of the avant-garde filmmaker Stan Brakhage. Rather than presenting an exterior world, Coppola's expressionistic multiple superimpositions objectify an interior state, an altered perception. Moreover, the images dissolve into a series of obdurate surfaces, ultimately rendering the film a flat pictorial plane. This is the space of dream, of memory, of hallucination, and we are meant to take it as an expression of Willard's "madness," the mental state of a tormented soul who now awaits his next mission.

Unlike Brakhage's films, which are almost exclusively silent, however, The Doors' music in *Apocalypse Now* is paired with these images in a rhythmic montage of accompaniment and counterpoint. It is through the resulting clash of elements that Coppola begins to put into practice the avant-garde methods of Sergei Eisenstein. In Eisenstein's theory of intellectual montage, the Soviet filmmaker proposed the construction of

an oppositional clash among elements, both within and across the shots, to encourage the viewer to critical awareness. Coppola had earlier employed such methods in *The Godfather* and *The Godfather Part II* (in the baptism sequence of the earlier film for example, or in the alternating sequences between past and present in the whole of the latter), but in *Apocalypse Now* "intellectual montage" becomes the very fabric of the film. In the opening sequence, for example, the pairing of image and popular song recall both this shameful historical past as well as a present meaning. "This is the end/ the end/ of our elaborate plans/ the end" accompanies an image of destruction at once confronting America's failed actions in Vietnam and the now changed 1979 America. And as The Doors' lyrics, "And all the children are insane . . . ," trail off over the image, we are both referred back to a time of impending revolution, and to our own present sense of disorientation in the contemporary world.

In addition to the avant-garde sources, however, *Apocalypse Now* also bears connections to the Surrealist and abstract expressionist film. In attempting to present the Vietnam War as an "irrational" or dissociative experience, Coppola's film can be traced to a Surrealist tradition that sought to render art in the structure of the unconscious. According to the writings of Sigmund Freud that so inspired the Surrealists and their work, however, the language of the unconscious is composed of often-disjunctive visual and auditory material. For this reason it does not comply with the language-dominated models of waking life, and certainly not to those of linear narrative. Instead it is only through a process of secondary revision that the waking dreamer can transform his or her dream material into a semblance of order, and perhaps even into a story. So when these models from the unconscious are used in art, they too resist conforming to linear narrative. In the Surrealist film *Un Chein Andalou,* for example, Luis Bunuel and Salvador Dali attempt to recreate the dream experience before the process of secondary revision has set in. The cinematic images that result present themselves in all their incongruity and discontinuity, and so they are not subsumed under language-dominated theatrical models that would alter or tame them.

The avoidance of linear narrative is also of importance to Stan Brakhage. But even so, Brakhage's films have more in common with abstract expressionist painting than with Surrealism. Brakhage disrupts conventional forms of storytelling, not to re-create an unconscious state, but as a personal expression of, or a metaphor for, a *waking* vision. Brakhage breaks down the representational film images and then

reorganizes them into free-form accumulations. The images move before the viewer in rhythmic interconnection from shot to shot, rejecting the prefabricated forms of storytelling to communicate their experience. Pulsating with color and light, swirling from a moving camera, or vibrating from the effects of scratching or painting on film, the film images give the appearance of the artist's personal reaction to what is seen and what is felt.

Coppola re-creates the dissociative experience of the Vietnam War in a Brakhage-like manner. But in *Apocalypse Now* the events are loosely held together by the film's narrative. Much like the process of secondary revision described by Freud (and surely to satisfy the needs of the commercial film industry) a narrative is imposed on the often disjunctive and highly sensory material of this film. And although the central narrative is that of Captain Willard's journey down river to assassinate Colonel Kurtz, the main emphasis of the film is on the soldier's encounters with the events on shore. Through these events, compiled by the film's screenwriters from the memories of returning GIs, we are presented with a series of dream-like states. These are condensed units, holders of complex meanings and experience, and so not to be taken as mere adjuncts to the narrative development. Meaning in *Apocalypse Now* has instead been displaced away from the more theatrical forms of character, dialogue, and dramatic conflict and shifted onto the film's visual and auditory material. The result is a film that presents us with metaphors on the Vietnam experience and on our cultural experience as well.

Coppola takes inspiration from earlier Surrealistic and expressionistic film experiments, but he does not merely pastiche these styles, nor does he intend a wink at the film cognoscenti in the audience. Instead, he extends the aesthetic and theoretical aspirations of the avant-garde into his mainstream film and then complicates them. The major shift in Coppola's use of these strategies, however, is that they no longer represent purely personal states of being. Although the opening sequence of *Apocalypse Now* is rendered as the possible cinematic expression of Willard's tortured mental state, that same style is then extended to the remainder of the film. In the later sequences, the manipulations of sound and image are no longer meant to express the mental condition of a single character but the "real" of Vietnam itself. Of course it could be argued that expressionistic films from *The Cabinet of Dr. Caligari* (1919) to Film Noir have reflected their ongoing cultural condition, but *Apocalypse Now* alters the cinematic experience in ways significant to its historical period. Here the conditions

of dissociation, from the disintegration of individualism as such, to the loss of orientation in space, and even to the sensory and emotional intensities of the dream state (or that of schizophrenia), are used to represent an external lived reality in the film and in society.

Apocalypse Now approaches these states through the incongruous juxtapositions of elements within its content, through the expressionistic manipulation of the image, and through the dislocation of character and story. To elucidate these dissociative and disorienting strategies, and the meanings they produce, I discuss two of the encounters that the soldiers in *Apocalypse Now* have with events on shore.

This sure enough is a bizarre sight in the middle of this shit . . .

A young African-American soldier named Clean speaks these words to Willard as their patrol boat approaches the Vietnamese shore. An incongruous, even surreal (because of its libidinal implications) sight greets them. Arching park lights and penis-like structures rise into the night as rock music plays in the distance. Made even more incongruous because of its sudden appearance within a war zone, this location is actually that of a USO concert. And although the practice of providing a bit of home to American servicemen abroad through entertainment is quite common, in *Apocalypse Now* it is played for all its absurdity. Here, as in an earlier sequence that featured the military taking of a beach for the purpose of surfing, the clash of disparate elements is presented for its surreal quality, but it is also an intellectual montage.

As the sequence continues, for example, the soldiers get off the boat to find the trading of goods amid a bustling confusion. They enter a warehouse that is incongruously dripping water yet selling anything from Yamaha bikes, to diesel fuel, to Panama Red marijuana. This is a black market where even one cigarette can cost you eight dollars. But when Willard objects to such a swindle, he is quickly offered a bottle of wine and press box seats to the USO concert to ease his pain. The sense of disorientation and dissociation thus introduced is continued in the experience of the concert itself. At this event hundreds of soldiers surround a circular stage decorated with stars and bordered by lights. With eyes turned upward, the soldiers cheer at the sight of an incoming helicopter. In earlier sequences the chopper had been an ominous presence, but now it is presented as an object of desire coming out of the nighttime sky. The aircraft approaches with lights blazing and Playboy insignia visible.

As the helicopter lands to the exuberant first notes of the 1950s song "Suzy Q," three beautiful Playboy Bunnies, Miss April, Miss May, and the Playmate of the Year, emerge. Once on stage, the girls begin to dance provocatively for the soldiers. Shots of the frenzied crowd are intercut with the Playmate's dances, as is the sound of the soldier's shouts and jeers: "Take it off!" and "I'm here, Baby, I'm here!" and "You stupid Bitch!" But the girls are seemingly unfazed by these remarks, humping and grinding to the music and shaking their breasts, as the all-male crowd threatens to overwhelm them or even rape them. The profound sadness of this event, observable in many films of USO performances that present celebrities, like an oversexed Marilyn Monroe, to young soldiers who are going to their deaths, cannot be ignored.

An additional layer of meaning is interjected by the specific costumes worn by the Playboy Bunnies. Here Miss April emerges from the helicopter dressed in a skimpy American Indian costume, followed by Miss May wearing a mock U.S. Cavalry officer's uniform, and lastly, by the Playmate of the Year, resplendent in a blue-and-silver sequined cowboy outfit (Figure 28). These Playboy Bunnies (except for the "American Indian") also carry guns, brandishing them suggestively and using them to caress their crotches and breasts with full phallic meaning. The destructive potential of the weapons, however, is nonetheless maintained.

The costumes of the Playboy Bunnies in this sequence recall the violent history of the American West and also of the Western film genre. By juxtaposing the character conventions of the American Western with the Vietnam War, some of the underlying assumptions of both can be called into question. The history of the American West, once seen as a triumphal fulfillment of Manifest Destiny, and often presented that way in the classical Western, is now understood as a movement that also ravaged the land and its people. So, by opposing "cowboys," "Indians," and the "U.S. Cavalry" to U.S. involvement in Vietnam, *Apocalypse Now* creates an internal clash of elements that foregrounds the genocidal aspects of both conflicts. To emphasize this point, Coppola intercuts a shot of Vietnamese civilians as they distractedly watch the USO performance from behind a fence, noting the profound incursion made by America into this sovereign country. Similarly, the presence of a single Black soldier on the American side of the fence is significant. Sitting without expression, marginalized from the crowd (in contrast to the primarily white soldiers in the concert arena and the all-white Playboy Bunnies), this character can only call to

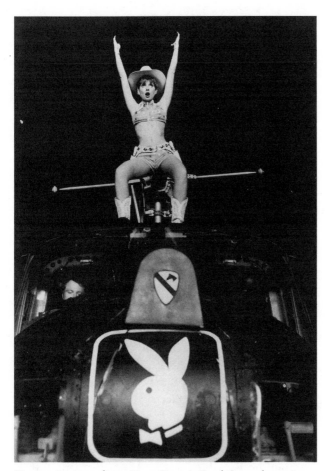

Figure 28. *Apocalypse Now,* Francis Ford Coppola, 1981.

mind the violence and genocide that brought Africans to America and to this war.

The presence of Bill Graham (the real-life promoter of the counterculture's Filmore West) as the erstwhile presenter of the Playboy event, however, helps to further destabilize the image. Here Graham is ironically shown as inciting the soldiers to riot, not for political purposes, but through a redirection of their energies into sexual hysteria. As the soldiers finally storm the stage, Graham hurries the young women into the waiting helicopter. It is here that the impossiblity of continuing the insanity of this spectacle is echoed in the image of escape that Coppola chooses. The

chopper lifts off the stage with one soldier holding onto its base, while another clings to the first man's ankles. Coppola quotes this image from newspaper and television sources, a pathetic sight etched in the minds of Americans from the period. It portrays the frenzy of the American retreat from Vietnam, and it stands both as a humiliating reminder of that failure and as an ironic inversion of the claimed "peace with honor." In *Apocalypse Now,* however, this image is allowed to linger, as the chopper slowly lifts, sending currents of air over the frenzied crowd, and as the two soldiers finally lose their grip and fall almost silently to the water. Like a condensed dream image, it is one that now resonates with profoundly disturbing meaning. It is thus a fitting ending to a sequence that depicts the use of entertainment to drug the masses into intellectual submission.

In a later sequence, the patrol boat again approaches the shore. In an Hieronymus Bosch–like vision of Hell, the boat is greeted by a group of desperate GIs who wade through the black waters, carrying suitcases and yelling, "Take me home!" So begins the Doolong Bridge sequence in which Willard and his men stop for no other purpose than "to see someone about something." This indistinctness of purpose, however, rather than being a failed attempt at cogent screenwriting, is actually a strategy consistent with the visual, spatial, and narrative dynamic to be created here. Once on shore, the view that greets the soldiers blurs the distinction between war and beauty, destruction and wonder. Electric lights lazily define the Doolong Bridge, while an undulating series of flares and explosions streak across the nighttime sky. And on the black water, red and orange bars of color are reflected from an indeterminate source. The scene is like that of an American fairground on Fourth of July, only now it is the war in Vietnam, and so it represents the inversion of America's declaration of independence. This Vietnam is a metaphoric black hole, a place where boundaries are blurred, a place of disorientation and death. As the abject, it is also a place where meaning collapses, or as one soldier tells Willard, "You're in the asshole of the world, Captain!"

But to Lance, a soldier from Willard's boat who has just dropped LSD, this is a place of visual splendor. "It's beautiful," he says in a hushed tone. In keeping with Lance's mental state, Coppola constructs the sequence much like an acid trip, or like the schizophrenic state it mimics. Because it is not only Lance's hallucination, but also the "reality" of Vietnam, the experience is filled with wonder and with terror. To create this effect Coppola draws heavily on the expressionistic visual surface of Stan Brakhage's *Anticipation of the Night.* In Brakhage's film, for example, flashes of light

slowly undulate against a black background and then flicker with bursts of color, at times revealing recognizable objects, and at others existing only in disembodied form, all to express an emotional and perceptual state. In *Apocalypse Now*, Coppola presents a similar surface of flashing lights and partially seen objects. For example, a light from an indistinct source illuminates the scene at steady intervals, revealing the soldiers in their bunkers, and then fading away to black. At other times, however, sudden flares or explosions define a space as silhouettes of light or shapes of color against the darkness. Although this is meant as the experience of Vietnam itself and not the vision of a single character, Brakhage's abstract expressionistic style is not used indiscriminately. In *Apocalypse Now* the usual boundaries between interior and exterior, or between the appearances and the real, are seen to fall away, thereby making more pertinent the use of a personal style to render a cultural experience.

A similar blurring occurs on the level of spatial orientation both for the viewer and for the characters, or as lieutenant Carlson laments:

You don't know how happy this makes me sir. Now I can get out of here – if I can only find a way.

To the feeling of disorientation created by the blurring of visual boundaries, *Apocalypse Now* adds a decentering in the definition of sound and space. Not only do the continual explosions of bombs punctuate the sequence's changing visual surface, but so do a series of difficult-to-locate sounds. Rock music, for example, is heard emanating from a variety of indistinct sources, as are the ever-present shouts and slurs from the Viet Cong. In this darkened space, the cries from the American soldiers or their partially heard dialogue also come from numerous areas. A sense of being decentered, or "lost in space," as on an acid trip or in a waking dream (as in schizophrenia), or more specifically, as in this Vietnam War, is created. Lance and Willard enact the loss of orientation in space as they jump into a darkened foxhole from the relatively lighted ground above. Here the soldiers move through the black space without their knowledge, let alone ours, of where they are going or where they've been. When Willard is then unable to locate the officer in charge, the symbolic implications are clear. Either no one is in command here, or worse, no one knows who is. This is a decentered war, a postmodern war, and one whose moral purpose is brought into question in *Apocalypse Now*.

Many of the soldiers Willard and Lance encounter in the foxhole are African American and so refer to the Army's practice of sending members of this racial group to the front lines in Vietnam. The soldiers are here

portrayed not only as being stranded without a commanding officer but also as being unable to locate the position of the enemy. In this sequence, for example, the voice of a Viet Cong soldier taunts the Americans in the foxhole. His voice is everywhere and nowhere, delivering unrelenting insults and invectives to its American enemy. Driven nearly mad by its insistence, a first Black soldier shoots erratically into the darkness, but he never hits his mark. Then a second Black soldier, one whose racial and ethnic identification is underlined by his African-style necklace and decorated gun, hits his target and silences the voice. But military strength and valor in Vietnam are of little purpose. Soon two American soldiers are seen falling to their deaths from a nearby explosion. In this way an equation is made between the Viet Cong and the African-American soldiers, underlining both their military commitment and their similar fate at the hands of the U.S. Government. Much like the blurring of distinction between the visual surface of fireworks on the Fourth of July and the explosions of war, the Vietnam conflict is shown to be a place where the deeper meaning of both collapses. In this Vietnam War the symbolic meaning of the Fourth of July, which upholds the right to life, liberty, happiness, and equality, is negated.

In *Apocalypse Now*, however, the disorientation of both character and space is not limited to the Doolong Bridge sequence, but it is the structuring principle of the film as a whole. In this postmodern war film, Willard is a weak stand-in for the usual war hero. Especially in comparison to other war films (such as with Coppola's own script for *Patton*), Willard is merely a stand-in, a placeholder, for a more conventional central character. When we first meet Willard, for example, his torment comes primarily from his lack of a mission. Like the characters in Luigi Pirandello's famous play *Six Characters in Search of an Author*, Willard is waiting to be filled with a purpose, a goal. But then as he himself says, "for his sins," he finally gets one. Willard is sent on a secret mission to kill Colonel Kurtz. In *Apocalypse Now*, however, Willard is provided with little of the driving emotional force typical of most central characters. Instead, he remains weak and decentered, following orders without true conviction. It is difficult to identify with Willard because in him the hero position has been largely vacated. It is instead occupied by a character who serves as our "eyes and ears" throughout the film, but who displays little of the individualism or moral purpose of the traditional hero. In *Apocalypse Now*, then, the condition of the death of subject purported to be a defining condition in postmodernism is made manifest by Willard's character.

Along with this decentering and diminishing of the central character in *Apocalypse Now,* a sense of disorientation in space is also created in the film as a whole. First, it should be noted that Willard is the only person on the patrol boat who knows its destination. The information is classified, and so we, along with the crew, ride through a territory for which we have no map. To make this experience all the more visceral, the patrol boat in *Apocalypse Now* is often seen moving into the depth of the image, or traveling across the frame from right to left. In this way, a kinetic sense of moving *into* a space – or of a descent into an unknown territory – is created. The primary purpose of this unmapped journey, however, is to connect the often-disparate encounters on shore, thus reducing the narrative to its most basic function of linkage. Although this sense of disorientation and randomness would seem to substantiate Jameson's claim of the waning of narrativity and of the rise in the image typical of postmodern works, its use here is more provocative. *Apocalypse Now* does not merely reflect a cultural condition; rather, the film confronts it and even broadens our perception of it. Coppola's film cannot be charged with the loss of meaning or depthlessness of such postmodern narratives as *Mortal Kombat* (1995) or *Mission: Impossible* (1996), for example. Nor can the intensity of the images in *Apocalypse Now,* or their sheer beauty, be said to deliver only immediate sensation without contemplation. In *Apocalypse Now* we instead experience the effects of an altered cultural condition, along with one of its defining traumatic events.

Apocalypse Now presents the Vietnam War as an example of what has been described as the loss of the real in contemporary society. It is in Kurtz's final death scene that the collapse becomes both the content and the effect of the sequence. Kurtz, a metaphor for U.S. military involvement in Vietnam, is finally encountered. But since he exists on the same moral plane as his assassins, Kurtz's death at Willard's hands is not cathartic. Instead, it is a gesture that ultimately drains Kurtz's dying words, "The horror . . . the horror . . ." of their impact. The meaning of "horror" has been changed in *Apocalypse Now* to its postmodern embodiment: its emptiness. In this way, the blurring of distinction so insistent in Coppola's film between good and evil, perception and reality, sanity and insanity, has resulted in collapse. *Apocalypse Now* is ultimately about America *after* the Vietnam War. And this America, as Coppola sees it, is one profoundly changed, or perhaps as Willard himself says, one that just "doesn't exist any more."

One from the Heart

You know what's wrong with America don't you? . . . It's all tinsel, its all phony bullshit! Nothing's real anymore.

<div align="right">Hank Poleski, One from the Heart</div>

This movie [One from the Heart] isn't from the heart, or from the head, either; its from the lab. It's all tricked out with dissolves and scrim effects and super-impositions and even aural superimpositions . . . [In it] there is nothing – literally nothing – happening except pretty images gliding into each other.[5]

<div align="right">Pauline Kael, The New Yorker</div>

As evidenced by Pauline Kael's comment quoted here, many critics found the disjunction between the sumptuous visual surface and relatively small story of Coppola's next film, One from the Heart, to be disconcerting. The objections seemed to center on the glittering material of One from the Heart itself, its photography, its sets, and its optical effects, ones that accosted the viewer and brought the film's much-publicized high cost of twenty-seven million dollars into prominent view. But perhaps most curiously, both critics and the film's audiences seemed to be genuinely angered by this. One from the Heart seemed to promise utopia and sensuality but then offered only a kind of distance. Many could therefore agree with Andrew Sarris of the The Village Voice when he wrote:

What made Coppola think that contemporary audiences were nostalgic more for the sets in the background of old movies than for the sentiment in the foreground?[6]

With Variety reporting that One from the Heart initially received two positive reviews, ten negative reviews, and three inconclusive ones,[7] it is not surprising that the film was also a resounding flop at the box office. It initially earned only two million dollars of its original investment, causing Coppola to declare bankruptcy and sell his studio, American Zoetrope. Also added to this insult was the rejection by scholarly film criticism. But Coppola did not give up on his film. After the disastrous opening of One from the Heart at Radio City Music Hall in New York City in 1981, Coppola still maintained:

I'm very proud, and I imagine that years from now, just as my other films, people will see something in it. It was an original work and not a copy of anything.[8]

One from the Heart is an extraordinary work of cinema, both for its conceptual achievements and its aesthetic ones. I will describe its

significance as a work of art and as a self-conscious comment on the changed status of the real (that is, a real now dominated by simulation) in contemporary society. From this lofty perspective, however, the rejection of *One from the Heart* by general audiences could be seen as understandable since the film again extends avant-garde strategies into a mainstream work. And although *Apocalypse Now* had made a similar cross over, *One from the Heart* was perhaps too grounded in its visual and conceptual concerns, and not enough compliant with the conventions for Hollywood story telling. Or perhaps, as I strongly suspect, the general audience received its meaning all too well but found it distressing. Responding to the changed historical moment, to 1981 and the beginning of the Reagan era, *One from the Heart* confronts the viewer with a present tense defined by limitations. Mimicking a cultural condition, Coppola constructs a film in which the images dominate, not only as screens against the real, or even against the trauma of the past, but as material facades in which the distinctions between the image and the real have collapsed. In this way, *One from the Heart* is a film about barriers, and about the image as a replacement for the personal and cultural horizons it once symbolized.

To erect the image as a palpable entity Coppola constructs a film that is a self-conscious simulation on nearly every level of its production. Coppola begins by replicating the production methods of the old studio system. *One from the Heart,* for example, was produced by American Zoetrope and filmed entirely on its reconstructed sound stages. Similarly, it was shot in the 1:33 aspect ratio, the "golden square," typical of all Hollywood films before 1946. Coppola also hired the legendary musical film star Gene Kelly to help re-create the look of that genre in its classical form. Even though these methods evidence a type of homage, or even nostalgia, they should not be confused with the film's primary purpose. Coppola begins a system of replication, copying past forms, not to create a reality, but to stage a picture. In this way *One from the Heart* converges with the contemporaneous art practice of the period. The film, however, is not only concerned with the nature of representation as such, but also with confronting the loss of the real in American life.

The changing nature of America in 1981 is ironically contained in the title of *One from the Heart,* and it is best understood within the context of *Apocalypse Now.* This latter film was based on Joseph Conrad's novella *Heart of Darkness* and was meant as an indictment of America. Continuing with his critique in *One from the Heart,* Coppola collapses his sources, the romantic and the historical, in a title that now implies,

"one from the heart of darkness," or "one from America." For this rea-
son, it is not inconsequential that Coppola's film is set in Las Vegas on
the Fourth of July and that it features two lovers who break up, achiev-
ing their "independence" on this day. In *One from the Heart,* however,
Coppola uses an ordinary story to continue the concerns broached at the
Doolong Bridge sequence of *Apocalypse Now.* The visual splendor of the
Vietnam War's deadly "fireworks" in that earlier film is returned to its
celebration setting in *One from the Heart,* but now as a calcified visual
entity (very much a thing in itself) symbolizing the personal and cultural
limitations engendered by the ongoing historical moment.

But why did Coppola choose Las Vegas to represent a changed America?
First, we should remember that *The Godfather Part II* was set in Las Vegas,
where the Corleone family was seen in its later stages of Americanization,
with the city providing a metaphor for the destructive effects of American
corporate capitalism on the individual. In Las Vegas we saw the Corleone
family diminished in its traditions and less able to provide comfort to its
members because of the furthering stages of assimilation and greed. In
One from the Heart Coppola again uses Las Vegas, but now to a slightly
altered purpose: to symbolize America as a place of illusion and broken
dreams. It's all "tinsel and phony bullshit," as Hank says, a city of glittery
surfaces and rubble-strewed back lots, but it is also a place where the rags-
to-riches dream of ordinary Americans is both kept alive and lost. The
fantasy is that in Las Vegas the ethic of hard work can be replaced by
gambling as a way of acquiring instant riches. Fortunes can be won or
lost in the turn of a roulette wheel, and the hard fact that the "house" (i.e.,
the corporation) invariably wins does not stop the millions of hopefuls
who flock to its gambling tables. Las Vegas in *One from the Heart* can be
seen as a metaphor for the triumph of capitalism in the postmodern world.
To Coppola in 1981 this is a world that curtails the personal freedoms
and limitless horizons that the American dream once implied.

As Coppola puts it:

Las Vegas is the last frontier in America. When they ran out of land, they built
Las Vegas, and it was built on the notion of life and chance – which to me are
sort of like love ... So I said ... why not make it like one of those films that they
make a series out of – relationship films – but kind of like a Kabuki play set in
Las Vegas.[9]

The limitations on westward expansion were supplanted by the simu-
lation of a frontier in Las Vegas, that is, by a city that exits as if those

limitless horizons were still possible. And while the gambling business provides the illusion of instant wealth attainable there, the city's architecture compounds this process of simulation. The architecture of Las Vegas relies heavily on fantasy material, and it does so by drawing its images and allusions from pictures – and most often from the movies themselves. Or, as the architect Morris Lapidus claims:

People are looking for illusions; they don't want the world's realities. And I asked where do I find this world of illusion? Where are their tastes formulated? Do they study in school? Do they go to museums? Do they travel in Europe? . . . Only one place . . . the movies. They go to the movies. The hell with everything else.[10]

Seen in this way, the movie influences of many classic Las Vegas casinos such as The Golden Nugget, The Sands, or Caesar's Place become apparent. Where else would the early Las Vegas patrons have experienced the "Western," "Arabian," and "Roman" associations of these structures if not from films like *The Virginian* (1929), *The Sheik* (1921), or one of Cecil B. De Mille's costume extravaganzas? But then again, the specific sources of these structures are not important because the architecture of Las Vegas is wildly combinatory, made up of an array of movie and popular culture styles described by Robert Venturi as

Miami Moroccan, International Jet Set Style; Arte Modern Hollywood Orgasmic, Organic Behind; Yamasaki Bernini cum Roman Orgiastic; Niemeyer Moorish; Moorish Tudor (Arabian Nights); Bauhaus Hawaiian.[11]

The recombination of this imagistic material creates architecture that is a copy of a copy, a simulacrum disconnected from the natural real. In Las Vegas, the sign forms the new architectural style. Coppola takes us to this Las Vegas to which he equates the status of the film image itself. But *One from the Heart* is more than just a representation *of* Las Vegas. It is also a representation *in the style of* Las Vegas, a film that is itself a simulacrum, but now self-consiously so. To underline this fact Coppola rebuilds the Las Vegas streets and casinos on his sound stages (rather than filmming on location), redoubling their status as replicas, and then films them, extending the notion of the simulacrum, the copy of a copy, to the entirety of the film.

But how exactly does Coppola incorporate these various properties of simulation into the totality of this new work? To understand Coppola's methods in *One from the Heart* a new critical approach will be necessary. Of course, a new perspective has been attempted throughout, but those

strategies already described are both expanded and solidified in this film. In *One from the Heart,* for example, Coppola creates a critical montage of internal elements, and he does so by juxtaposing new material against older generic conventions. Unlike the revisionist genre filmmakers whose work largely recast thematic material, Coppola's method centers on the simulacral image. So while Coppola draws heavily on the classical musical's styles and images, *One from the Heart* is not a film about that genre. Instead, Coppola foregrounds the musical's generic elements as copies, and destabilizes the reality status of the image. Relying on the classical musical's narrative and imagistic strategies, Coppola erects a series of false fronts behind which the real has disappeared.

The best way to understand the shifting of generic elements and the critical clash that results is to compare them to the classical musical conventions on which they are based. We will first address the setting, character, and plot conventions of the classical musical, and later consider the manipulation of that form's imagistic strategies. And while we have already discussed the symbolic implications of Las Vegas, it is important to compare it to the setting conventions for the genre. The classical Hollywood musical had often been set in a metropolitan center. New York City was an important location in such early films as *Goldiggers of 1933* or *42nd Street* (1933) because they told stories of theater performers struggling to achieve success on Broadway. The contemporary setting of Las Vegas then becomes significant when compared to the older convention of a New York setting. A quick fix on the American dream is implied, one that replaces hard work with chance as already mentioned, but that also stands as a debased imitation of the original.

Within a Las Vegas setting so rife with simulation Coppola further displaces the conventions of the classical musical to enhance the notion of the cheap copy. In the classical musical, for example, the lead male had been presented as a highly talented music man. Played by such legendary performers as Fred Astaire or Gene Kelly, this exuberant male was paired with an equally talented female performer like Ginger Rogers or Judy Garland. These pairings often resulted in some of the most exuberant moments in film history, using song and dance to express the love between the musical couple. In *One from the Heart,* however, the classical conventions are not maintained. Instead we are presented with "real" people, "just like us", but (unlike those in the folk musical or in *The Rocky Horror Picture Show*) ones who possess little or no musical talent. Moreover, Fredric Forest and Teri Garr, the actors who star in these roles,

are not beautiful or glamorous in the Hollywood sense. And like many of the baby-boomers in the audience, they are not young. Instead they are approaching middle age, a fact articulated in the opening sequence as Franny worries about the gray strands in her hair and Hank ponders his receding hairline. Nor are they physically perfect: a condition made explicit by Hank's protruding belly as he walks around the house shirtless, or by Franny's ordinary woman's body as she exits the shower. But in *One from the Heart*, it is these "real" people who inhabit the simulated world of Las Vegas and the film.

In *One from the Heart* the conventions of the classical musical are more than simply inverted. The film makes the novel gesture of displacing some of the glamorous qualities of the older musical stars onto the secondary characters in the film. But this too is in the end compromised. For example, the handsome Raul Julia is cast as Ray, a singing waiter and a very distant copy of Fred Astaire. Ray wears a tuxedo, displays photographs of Fred and Ginger on his bedroom wall, makes love to recordings of "The Carioca," and is musically proficient (he can sing, dance, and play the piano.) This latter-day Fred Astaire, however, is no match for his screen model. Ray is very charming, but he is just a cheap imitation.

In a similar strategy of displacement and imitation, the glamorous characteristics of the musical's female star are transferred onto a secondary character. The convention of the talented female performer is now shifted onto Leila, the circus girl. Played by Nastassia Kinski, Leila (whose name means "night" in Arabic and so implies the presence of stars, just as "Ray" refers to their reflected light) is dazzlingly beautiful and costumed in sequins and circus glitter that extend from her scintillating cape to her eye makeup. When Leila is first seen she also holds sparklers in her hands, each one emitting sprays of light and held high over her head to literalize her meaning as a "star." However, Leila is no Judy Garland. She can sing and dance a little, but she is primarily a circus performer, a tightrope walker, and a fortuneteller. Ray and Leila nonetheless hold the promise of the dream. In a classical musical they would have been paired as the romantic couple, but in *One from the Heart* this is not the case. Instead, these two very beautiful people are placed in romantic encounters with Franny and Hank, the film's very ordinary central characters!

"It's the most implausible thing I've ever seen in my life," says Moe as his friend Hank gets a date with Leila. And it seems so to us, too, but we are willing to indulge in Hank and Franny's good fortune, for in *One from the Heart* the displacement of star quality is combined with a

similar slide along the film's narrative elements. The story begins, not with
the meeting of the two central characters as musical convention would
have it, but with their breakup and subsequent pairing with their dream
lovers. Leila falls in love with Hank and wants to run away with him,
while the sensual Ray wants to take Franny on a vacation to Bora Bora.
Perhaps the most satisfying aspect of these new lovers, however, is that
they are kind and supportive of Hank and Franny, providing them with
better relationships than their earlier disappointing one. It would seem,
then, that Hank and Franny have hit the relationship jackpot on a lucky
streak. But in *One from The Heart* the attainment of a Hollywood-style
utopia is quite literally improbable. While Hank and Franny's actions are
presented as "real," the film ultimately confounds the boundaries between
what is real and what is not on both a narrative and representational
level.

The title sequence of *One from the Heart*, for example, introduces
us to a world whose unreal characteristics are openly foregrounded. As
Tom Waits and Crystal Gayle sing the fairy tale – inspired lyrics on the
soundtrack ("... Knowing that you fall in love/ Once upon a time ..."),
an artificial curtain is drawn back to reveal an equally artificial world.
With this gesture we are invited into a fantasy world. Here we have a
fairy-tale musical with two ordinary people who dream of a better life.
Franny works in a travel agency and has a unfulfilling relationship with
Hank, yet she dreams of meeting "Prince Charming" and of traveling to
Bora Bora. Similarly conflicted, Hank is a junkyard owner who cheats
on Franny but then dreams of buying a house and having children with
her. Trapped and going nowhere, Hank and Franny sit in their disheveled
living room, furnished with a car seat on the floor and an old canvas deck
chair, and argue about their meager sex lives. This is a far cry from the
classical musical fantasies of grand romantic love and limitless personal
horizons. But *One from the Heart* is not simply a critique of past movie
fantasies. Rather, it addresses the contemporary conditions in a society
that once produced those fantasies. To this end, Hank and Franny will
ultimately be shown to exist only within the artificial confines of the film
itself.

One from the Heart begins this process of confrontation on a narrative
level by showing Hank and Franny first winning their dream lovers and
then seemingly rejecting them. This loss is disconcerting not only because
it fails to fulfill our fantasies of a perfect love, but also because it blurs
the reality boundaries of the film. After a sexual encounter with Leila, for

example, Hank discovers that Franny and Ray are on their way to Bora Bora. Hank rushes to the airport and begs Franny to stay; but Franny cannot comply. She boards the plane to Bora Bora with Ray. From an objective camera position we watch as Franny's plane pulls away from the gate, and later, as Hank dejectedly walks down the airport ramp to his car. On Hank's return home, however, the "reality" of the previous sequence is put into question, and with it, the film as a whole. Hank enters his darkened living room and kneels to the floor. Crying, he burns Franny's clothes in the fireplace. Then, without explanation, Franny walks through the front door, and bright lights rise up over the image to reveal a neat and carefully designed home. In this renewed setting, Hank and Franny fall into an embrace, caressing each other and professing their love. The once-separated couple in *One from the Heart* has been reunited, but for many in the audience a feeling of utopia did not result. They were disappointed in an ending that seemed to encourage settling for what you've got, for the status quo. And although others in the audience saw the film's ending as an expression of love blind to ordinary faults, it still fell short of the classical musical's promise of ideal love and unlimited personal horizons. But either way, the disjunction in this sequence comes from a confusion as to what is real and what is illusion.

How are we to interpret what is "real" and what is not in this story? Did Franny, for example, go to Bora Bora with Ray, or were Hank and Franny reunited in their home? Are we to assume that Franny caused the plane to return to the gate, or is the couple's final embrace only Hank's dream? A definitive reading is not possible in *One from the Heart* because the clear boundaries between reality and fantasy on a fictional level, or between representation and the real on a referential level, have not been clearly established throughout. Moreover, the confusion of boundaries suggests that the distinction between these two states has been jeopardized. The presentation of *One from the Heart* seems to indicate that *both* characters achieved their dreams: Franny traveling to Bora Bora *and* Hank having his dream house with Franny in it. But then of course this is a movie, an artificial construct where all dreams come true – as well as none of them. It is precisely this fictitious cardboard quality of *One from the Heart* that is foregrounded in its closing sequence. Here a music box on the soundtrack accompanies the image, giving us a sense that Hank and Franny are forever trapped within its confines. As the camera pulls away from the house, for example, the two lovers come out onto the balcony. But the lighting, the street, and the painted backdrop sky now render the

set an obviously two dimensional construction, an effect completed as the artificial curtain slowly closes over the image.

The blurring of fantasy and reality on a narrative level in *One from the Heart* is compounded by the collapse of the distinction between representation and the real on an imagistic level. The image becomes a thing as such. To better understand this manipulation, a comparison between the classical musical's imagistic strategies and those of *One from the Heart* is again useful. In the classical musical, for example, the inventive use of camera movement and cinematic space had been characteristic of the form. Since the film musical had been originally derived from theatrical sources, it sought to compensate for the loss of its live performers by presenting effects not possible on stage. By using a moving camera across a seemingly boundless space, it allowed the audience to kinesthetically "leave" their theater seats and "move" beyond the shallow confines of the proscenium stage, a technique perhaps best realized in the Busby Berkley musicals, where the production numbers transform the shallow space of the dramatic sequences into a phantasmagoria of expansiveness. In these films, the camera moved with ease and freedom, giving the illusion of gliding over, under, and around the represented objects. The effect was additionally created by the elimination of conventional editing strategies in these sequences. Instead, the musical performances were allowed to transform across various spaces like the unfolding petals of a flower. An illusion of moving ever inward was thus created, into the permeable depths of the image, as well as of moving laterally to the apparently limitless spaces beyond the edges of the frame.

This creation of expansive space in the production numbers in some of these early musicals was then subjected to techniques that alternately rendered the image a flat pictorial plane. Most famously in the Busby Berkeley films, overhead shots looked down on performers arranged in changing kaleidoscopic patterns to flatten the image. Additional methods were used in other classical musicals. At the end of the "Broadway Melody" production number of *Singin' in the Rain,* for example, a shot of Gene Kelly and his dancers is used to play with the illusion of depth and flatness in the image. Here the camera quickly recedes, elongating the represented space and leaving the dancers in the distance while Kelly's face advances to the extreme foreground. Mattes of colored marquee lights then surround Kelly's face to further flatten the image surface. It is through this play of flatness and depth that the image of the classical musical is at once rendered a permeable space and an obdurate surface. In the classical

musical, however, this play of depth and flatness is not meant to articulate the film's surface anti-illusionistically. Rather, it is used to engender fascination.

Another important aspect of the musical that can be compared to *One from the Heart* is its use of color and the distinctive type of images it produces. The musical is renowned among classical genres in its utilization of the Technicolor process. Intense reds, blues, and yellows dominate the image, and the films' sets, costumes, and lighting are constructed to fully employ the possibilities of Technicolor. In the classical musical, however, this use of color does not result in a hard, glossy image like those claimed for the postmodern film. In viewing these older genre films today one cannot help but note the warmth and depth of the images, a quality perhaps created by the originality of their conception. Similarly, although some production numbers in the classical musicals do re-cycle images from famous paintings, or even from other films, it should be noted that these images are not constitutive of the film image itself but are included as representations *within* the film narrative. This is true of the Chagall-inspired backdrops in *The Band Wagon* (1953), or even the re-creation of the silent era shooting styles, costumes, sets, of the film within a film presented in *Singin' in the Rain*. For this reason, the represented scenes are not to be confused with the images we are watching. In these classical musicals the assumption is still of a transparent film medium recording a fictional world.

In *One from the Heart*, however, attention is directed to the film image itself. The musical's image conventions are re-presented in ways that calcify its surface. Unlike the Technicolor photography of the classical musical, the still-dazzling array of colors in *One from the Heart* is at once more diffuse and harder. Its images are now awash with color and reflected light to articulate the film's photographic surface. For this reason many of the scenes in the film are bathed in lavish shades of green, pink, or blue as presumable reflections from the Las Vegas neon signs. But light in *One from the Heart* is an element not only *on* the image but *in* the image as well. Electric bulbs and sparkling neon lights cover the surface of buildings and signs, while the exploding Fourth of July fireworks punctuate the frame. These represented lights shine brightly, flaring white across the surface of the film, but also reflecting off the slick Las Vegas streets, the paint of passing cars, and the glass of windows and mirrors. In this way a palpable sense of surface and of tactility is created throughout the film.

Rather than being used to illusionistic effect, however, Coppola's strategy much more recalls that of Jean-Luc Godard in *Weekend* (1967). In this earlier film, the flares of passing streetlights across a car windshield had been used self-reflexively to articulate the film's surface. And while the images in *One from the Heart* are often inflected by this method, they are both flattened through the use of superimpositions or mattes, or rendered permeable through the use of camera movement and dissolves. Here the camera moves into the depth of the image, crossing barriers by means of scrims and dissolves or by moving laterally across rooms, exposing the walls of constructed sets. The camera also travels over, under, around, and through existing structures. But rather than creating a feeling of limitless horizons, a feeling of limitations is instead created in *One from the Heart* because of the reflections, superimpositions, and mattes that now layer the surface of the image with pictures. As a consequence the dissolves and camera movements travel from picture to picture, instead of from illusionistic space to illusionistic space, with each successive layer revealing another flat surface.

In one of the most dazzling moments in *One from the Heart,* for example, a large blue neon sign outlining the contours of a woman's face dissolves into a close-up of Leila. The towering image of Leila now sings to a dwarfed Hank who is superimposed on the lower right-hand corner of the frame. The abrupt clash of scale and surfaces renders the image flat, and certainly not "realistic," a condition that continues through a number of changes in this sequence. These include a camera movement into a huge close-up of Leila's eyes, a superimposed "waterfall" of glitter over her face, and, in the end, a dissolve to Hank, now encircled by mattes of marquee lights that recall Kelly in *Singin' in the Rain.* Through these methods, a scintillating surface is constructed, but it is one that in the classical musical had been primarily reserved for the production numbers. In *One from the Heart,* the distinction between fantasy and reality has collapsed, as has that between representation and the real. In its place a palpable barrier has been constructed out of the everyday world of the characters' lives, one that will ultimately stand as a screen against the real, as much as an embodiment of it.

This comment on the blurring of the distinction between representation and the real in contemporary life is extended to the *mise-en-scene* in *One from the Heart,* again with sources in the classical musical. In the Busby Berkeley production numbers, for example, the artificial sets had been flagrantly foregrounded, with a profusion of "mirrors," "violins,"

"waterfalls," and "lakes" presented in all their plasticity. Of course, the dramatic sequences in these backstage musicals had not been particularly convincing in their realism either, but the production numbers openly flaunted their artificiality. In *One from the Heart,* however, the distinction between reality and fantasy is collapsed throughout the film. The totality of the film's environment is obviously fake; it is a replica with the "real" of Las Vegas reconstructed on a sound stage. As a simulacral world, the homes, the motels, the casinos, and even the desert itself are rendered as artificial sets or painted backdrops. In addition the material of the sets is often foregrounded, giving a sense of tactility and cheap construction. In one scene, for example, Hank drives his car into a wall abutment, exposing it, with the help of the soundtrack, as plasterboard rather than concrete and so obviously a fake.

In this world of artificiality and replication, scale also becomes an issue. In *One from the Heart* some objects are reproduced in their normal size, while others are significantly exaggerated or miniaturized. Las Vegas' Freemont Street, for example, is reproduced to scale and thus rendered seemingly "real." The sizes of other constructions, such as the neon signs that begin the film and serve to "advertise" its credits, are more ambiguous. Here the camera movement and the artificial surroundings make it impossible to assess their size. The glass palm trees and mirror lake in this sequence make the signs look like miniatures. But then the arching camera movements over and through the various signs give the impression of great height. At other times, the alterations in scale and material give the objects a magical or dreamlike quality. In Hank's junkyard, appropriately called "Reality Wrecking," the desert landscape is strewn with the discarded artifacts of American culture. A "76" ball, a sign from Aladdin's casino, and a broken-down car litter the artificial desert landscape and the painted backdrop sky. And while this setting may recall the paintings of Salvador Dali, who once sought to render the unconscious by the scattering of its violent and sexual content across a receding landscape, at Reality Wrecking the "dream" is much more a thing of magic, and a product of culture. Here some of these objects are exaggerated in size, like the waist-high "ruby" ring or the towering neon chorus girl (whose open-armed gesture replicates that of Leila and so designates them both as representational signs). But this artificiality and sense of magic is also extended to the miniaturization of objects. As Hank, Leila, and Moe ride through the outskirts of Las Vegas, for example, they pass trees, churches, and signs that dreamily recall the toy landscapes from some lost childhood.

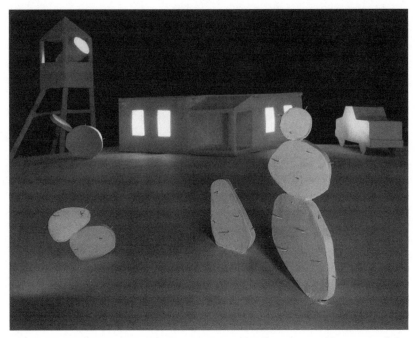

Figure 29. *Desert House with Cactus,* James Casebere, 1980. Courtesy of the artist.

However, the most telling display of artificiality and replication is presented at the shop window of Franny's Paradise Travel Agency. Here Franny arranges miniatures and two-dimensional props to create a window display that in some ways recalls the diorama-like work of postmodern artists Laurie Simmons and James Casebere (Figure 29), as well as the image of the on-going film. In the artwork of Simmons and Casebere the now-simulacral status of the photographic image and its unattainable pastness is underlined through the use of miniaturized and constructed objects. In a similar manner, *One from the Heart* continues the analogy between the shop window of Paradise Travel and the image of the film. Franny (whose name is an obvious reference to Francis Ford Coppola himself) "stages a picture" within a framed shop window rendered in the perfect square of the film we are watching, much as the film director has done within the film image itself. To complete the analogy, the glass of the shop window reflects the neon flares from an unseen casino, much as the surface of *One from the Heart* has articulated the flatness of the image.

Figure 30. *One from the Heart*, Francis Ford Coppola, 1981.

The naming of the Paradise Travel Agency in *One from the Heart* can also be seen as a reference to Hollywood as the "dream factory." Here, however, the notion is redoubled by presenting a film that intertwines dreams and reality on a thematic level, while also commenting on the collapse of representation and the real on an imagistic level. Franny reenacts this strategy in the shop window where she advertises dream vacations to Bora Bora with cardboard miniatures of cruise liners, palm trees, and nighttime stars. While she works, she also talks to Ray, perhaps as "unreal" as any of the props she places in the window (Figure 30). Then these two states – illusion and reality, representation and the real – are collapsed as Franny explains that she makes her windows "from pictures." In so doing Franny foregrounds herself and Coppola as "picture makers," but ones whose access to the real has been seriously jeopardized. Franny is presented as a woman who only experiences her desires through fantasy; similarly, Coppola is a director who now foregrounds the image as a simulacrum, a copy of a copy. Much like the architecture of Las Vegas itself, *One from the Heart* has thus been presented, not so much as a screen against the real, as an artificial construct that replaces it.

The musical sequences in *One from the Heart* also erect a dreamscape where distinct boundaries have collapsed. This is because Coppola displaces not only the film's narrative and formal conventions, but its musical performances as well. In the classical musical these performances had given the genre its very reason for being, while also providing it with its essential structure. In the backstage musicals, for example, the story had been kept separate from the production numbers. In the integrated musicals, in contrast, song and dance sprang from the narrative itself and was performed by the characters within the diegetic space. But in *One from the Heart* the structure of the musical performances has been modified in ways traceable to sources beyond the Hollywood musical, and in so doing, further blurring those boundaries between fantasy and reality and between representation and the real that had been more easily distinguishable in earlier films. True to the combinatory impetus of postmodern work, and in compliance with Coppola's stated intention, the inspiration for *One from the Heart* can now be found in the Japanese theaters of Kabuki and Noh.

As in Kabuki theater, for example, *One from the Heart* tells the story of ordinary people now set within an elaborate visual world and with the accompaniment of music. But as in Noh, another form of Japanese theater, an interlocutor is often allowed to speak for the central characters, in the first person, admonishingly, or even in the second person or the third person. Now in this musical *One from the Heart,* the songs are not sung by the film's central characters; they are instead displaced onto the disembodied voices of Tom Waits and Crystal Gayle on the soundtrack. In this way a kind of inner speech is constructed, one that serves, like the interlocutor in Noh, both to contemplate the actions of the central characters and to advise them on further action. With Waits and Gayle in the male and female roles, respectively, the songs are at times performed in the first person, indicating the thoughts of a single character. In the following example, Tom Waits sings as Hank watches Franny packing to leave him:

> I got upset.
> I lost my head.
> I didn't mean
> The things I said,
> You are the landscape
> Of my dream.
> Darling, I beg
> Your pardon.

In a similar manner, Crystal Gayle sings the following as Franny embraces Hank on returning home to him:

I'm sorry that I broke your heart,
Please don't leave my side.
Take me home you silly boy
'Cuz I'm still in love with you.

At times, however, these first person voices are sung in duet:

WAITS: I've been swindled
 I never bargained for this.

GAYLE: Why don't you get your
 Own place,
 Where you can live like
 You do.

BOTH: I'm sick and tired of
 Picking up after you . . .

At other times, the songs are sung in the second person singular as if a character were talking to him- or herself. When Hank desperately tries to win Franny back, for example, Waits sings the following lyrics:

You can't un-ring a bell,
Junior.
It'll cost you to get out of this one,
Junior.
She's got big plans
And they don't include you . . .

The tone is admonishing, but the method is unlike that of a Greek chorus because Wait's voice has already been identified with Hank.

The songs in *One from the Heart* thus reflect the feelings and concerns of the central characters, sometimes rendered in literal ways, as in the instances cited here, or at other times, in a displaced or poetic manner. After having been abandoned by Franny, for example, Hank walks dejectedly through his junkyard as Waits sings:

Broken bicycles,
Old rusted handlebars
Out in the rain.
Somebody must have an orphanage full
Of things no one wants anymore.
September's reminding July,
It's time to say goodbye.

Summer is gone,
Our love will remain.
Old broken bicycles
Out in the rain . . .

Since these songs are sung by the male and female voices on the sound-
track, the strategy has an additional effect of further decentering the per-
spective in the film. Like the multiple points of view rendered on a single
picture plane in Japanese painting, *One from the Heart* seems to repre-
sent the collective dream of *both* Hank and Franny. And although the
musical sequences do not comprise the film's very reason for being, as
in the classical musicals, they do help solidify its structure. In *One from
the Heart* the distinctions between self and other, interior and exterior,
illusion and reality, representation and the real tend to melt away in these
musical sequences. Presented during the character's more contemplative
or stressful moments, these songs are often paired with a kind of glit-
tery production number that refers to classical musical sources, but that
also characterizes the film as a whole. At these times the sumptuous cam-
era movements, superimpositions, and dissolves described here are often
used. The once-rigid distinctions between story and performance in the
backstage musical or between characters within the story proper are thus
blurred. A new cinematic organization is instead presented that supports
the reading of *One from the Heart* as a kind of fabricated dream world
inhabited by these two characters.

Although most of the musical numbers in *One from the Heart* are
performed on the soundtrack, a few musical performances are included
within the film. These too, however, are used to evoke the simulacral qual-
ity of the film. In one of these numbers, Franny and Ray perform a tango
on a dance floor of one of the casinos. As typical of the classical musical,
however, the two dancers soon leave this location to reveal a completely
different one adjacent to it. From what had seemed like an enclosed inte-
rior space, Franny and Ray now dance before a life-size artificial backdrop
of a tropical paradise, a setting that is an enlargement of the props Franny
had been arranging in the shop window. The balustrade, the ocean, and
ocean liner rise "magically" in the background, making this quite liter-
ally Franny's dream come true (Figure 31), only now without the clear
distinctions between fantasy and reality, or between representation and
the real. This representational tension is further emphasized as Franny
and Ray run into the receding depth of the image and then "explode"

Figure 31. *One from the Heart,* Francis Ford Coppola, 1981.

into the reverse shot as if through the very surface of the screen itself. On the other side, however, this representational surface is revealed to be the curtain backdrop of the Paradise Travel Agency and so, symbolically, of the very film image we are watching.

By breaking the "reality boundaries" of the image, Franny and Hank then jump out the shop window onto Freemont Street where they continue to dance with a throng of revelers. Once back on the street, however, the boundaries between representation and the reality of the characters' lives are again toyed with. In a production number that recalls the "Broadway Melody" sequence of *Singin' in the Rain,* the camera cranes up, viewing the group of dancers from above, and then comes down again to street level. The significant difference between this sequence and that of the earlier film, however, is in the quality of dancers presented. In *One from the Heart* we are given a sense of a general public who can't dance in the standard musical style. And although there are a few beautiful chorus girls dancing in the crowd who tend to centralize the movement, they clash with the surrounding confusion created by the "common people" who dance without professional skill. Franny is the most obvious example of this type of dancer, interjecting a sense of "reality" as she huffs

and puffs through her dance moves. The final sequence of *One from the Heart,* however, sums up this strategy of placing ordinary characters into what was supposed to be a vehicle for fantasy and talent. Before Franny boards the plane for Bora Bora, Hank sings in a way that comments on his lack of musical talent, and on his inadequacy as a fictional music man. Positioned near the end of the film in a mock rendition of the classical musical's culminating production number, Hank pathetically sings "You Are My Sunshine" to Franny. But Hank *can't* sing and so cannot satisfy the illusionistic demands of the musical film.

The world presented in *One from the Heart* is not so much a personal dream as it is a cultural one, and this is where the film's most important contributions lie. While that the landscape of the film may comprise the dream world of the characters, to us it is presented as a particular type of dream world, a cinematic one. The images, the sets, and the story have been constructed from discarded cinematic and cultural conventions, confronting us with a sense of surface and artificiality. We have seen two characters struggle to find their dreams in this false world that promised depth but offered only false fronts. And here the conventions of the classical musical were not merely quoted, or used expressionistically. Instead they were displaced, and so used to confront the cultural and social limitations Coppola sees in his contemporary America.

The Last Temptation of Christ

In *The Last Temptation of Christ* (1988) Martin Scorsese approaches the issues of representation, especially the conditions of the generic image and story, from a highly personal perspective. Scorsese revisits the story of Jesus Christ, one of the world's great religious traditions, and one to which both he and the film's screenwriter, Paul Schrader, share a deep commitment. Scorsese's well-documented religious background is matched by Schrader's own, with Scorsese a one-time seminary student and Schrader the son of a Calvinist minister. The unconventional rendering of the life of Christ in this film may at first seem at odds with the backgrounds of its filmmakers, but the disruptive, and to some even blasphemous, representations are ultimately in keeping with the complexity of the religious beliefs held by both men. *The Last Temptation of Christ* centers not only on the life of Jesus, but also on the very question of representation.

In this film Scorsese sets up a critical montage between the traditional representations of Christ and one that is a new rendition. Scorsese's intention, however, is not to alter the meaning of the original, or to unmask its "lies." Instead, the meaning is renewed, revealing what the filmmakers see as an essential truth of their faith, a truth perhaps obscured by the accumulation of older representations.

In "The Precession of Simulacra" Jean Baudrillard recalls the old Church fathers who acknowledged the power of images to replace their referents. The most famous of these dissenters within the Church were the Iconoclasts, men who demanded the destruction of images, fearing that these objects would become ends in themselves and mask the existence of God. Opposing them were the Iconolaters, those who willingly accepted the worship of God through images and, as Baudrillard observes, perhaps understood that to destroy those images would reveal there was nothing behind them. Although these two positions are seemingly at odds, Baudrillard argues that both betray a fear of the absence of God: in the former, the fear that He will be replaced, and in the latter, the fear that He never existed at all. To these contentious Church views, then, Scorsese interjects his own interpretation and concerns. For Scorsese, God is present beyond the images, and in spite of them. The images themselves are only malleable objects to be used as conduits, as facilitators of speech. In *The Last Temptation of Christ,* Scorsese attempts to "shake the sign," that is, to unhinge the film from a literal reading by separating the representation from its referent. In Scorsese's film the images often refer to themselves as such, while the story is openly defined as a fiction. In the rupture that results, Scorsese defamiliarizes the story of Christ and so allows a fresh encounter with its meaning.

One of the major ruptures in *The Last Temptation of Christ* is the representation of Christ himself. The film is adapted from a novel by Nikos Kazantzakis, a fictional work in which Jesus is presented as an ordinary man faced with the daunting prospect of becoming God. From the beginning, this character varies from the traditional representations that have depicted Jesus as a man who was already fully divine. In the major films that have told the story of Jesus, such as Cecil B. DeMille's *King of Kings* (1927), George Steven's *The Greatest Story Ever Told* (1965), and Pier Paolo Pasolini's *The Gospel According to St Matthew* (1964), the sanctity of Jesus is maintained throughout. These films may vary in the representation of Christ's temperament, either as the meek and loving savior in *The*

King of Kings or as the strident and self-confident leader in *The Gospel According to Saint Matthew,* but they all present Jesus as God in the form of a man. In *The Last Temptation of Christ,* however, this formulation is inverted. By telling the story from a fully human perspective, Scorsese presents Jesus' struggle to accept the will of God. What results from this approach is a journey of becoming, one in which Jesus ultimately *chooses* to accept his being as the Son of God.

There have been other attempts to humanize the Christ story, such as the musicals *Jesus Christ Superstar* (1973) and *Godspell* (1973), but these films only updated styles and music to accommodate contemporary tastes while staying true to the Gospel story. In *The Last Temptation of Christ* the changes are more fundamental. Here we see Christ within a story openly declared to be a fiction. From the opening titles we are informed that *The Last Temptation of Christ* is not taken from the Gospels, presumably the word of God, but from a fictionalized account. Scorsese then draws heavily on traditional Christian painting and sculpture and so creates a shifting double exposure, putting the old generic elements in conflict with the new and thereby introducing us to a Jesus we know quite well yet not at all. At the beginning of the film, for example, we are content to watch the familiar figure of Jesus the carpenter as he works in wood. But in *The Last Temptation of Christ* we soon learn that this Jesus is not simply fashioning chairs or cabinets for his customers. Instead, he is making crosses for the Romans. Moreover, he is attending the crucifixions and aiding in the process of sacrificing the victims. With a narrative strategy that is almost Brechtian in its disjunction, we are distanced from the story of *The Last Temptation of Christ.* This is because the story is made up of many of the Gospel's essential elements in the life of Christ, but also of ones that are not "true."

By separating the representation from the "real" in this way, a very important distinction is observable between the story of Christ and the genre films we have been discussing. Unlike the secular works of the Western or the musical, the story of Christ demands a strict conflation between the representation and its referent. In the revisionist Western, for example, the inversion of convention resulted in a dismantling of the Western myth, but not of any real person. In the Christian tradition, on the other hand, the images and stories of Jesus are meant to replicate that figure in such a way that any tampering with the former constitutes a tampering with its scared referent. And while the Church acknowledges that the representations of

Christ are not themselves Christ, any desecration of those objects nonethe-
less constitutes a sacrilege. For Scorsese in the fictional *The Last Temp-
tation of Christ,* however, the representations are just that and so can be
manipulated as speech. Here he attempts to renew the meaning of the
Christ story by dislodging the representation from the "real," having its
essential meaning shine through from the clash that results.

But to fully appreciate Scorsese's strategy, we must acknowledge the fig-
ure of Jesus as a point of personal identification in Christianity. To many
in the Catholic Church, for example, the Stations of the Cross offer a nar-
rative sequence of Christ's Crucifixion and serve as a sustained experience
of empathy for believers who follow through his stages of suffering. In a
similar manner, the paintings and sculptures presented in church encour-
age the faithful to relate their own experiences of being human with these
representations. In *The Last Temptation of Christ,* however, Scorsese dis-
lodges the representation of Jesus from his traditional characterization to
now address contemporary concerns. Jesus is presented, like many in the
audience and certainly like the filmmakers themselves, as an individual
struggling with his identity and his faith. So when Scorsese explores the
fictional account of "What was it like for the man Jesus to encounter
his role as the Son of God?," it resonates with the concerns of ordinary
people who also confront difficult choices in their lives. In keeping with
the tradition of Christian representation, the film is meant to implicate
the viewer. But because of the particular character of Scorsese's Jesus, it
does so with a significant difference. Jesus is not initially presented as a
confident individual, nor is he presented as one who knows the answer to
the questions that plague him. This Jesus must search. At first he rejects
the role that has been given him, struggling to deny the will of God, until
he finally accepts it at the end of the film. In this more flawed and human
Jesus, then, we may see the struggles of our own lives, but we are also
distanced from the filmic representation. *The Last Temptation of Christ*
encourages a more critical approach, removing the viewer from a purely
emotional compliance with the film's illusionistic elements and encour-
aging a confrontation with its representational system, all to enhance its
sacred meaning.

Since Scorsese's film is a work based on a Christian tradition, however,
it may split the audience along lines of religious affiliation. To devout
Christians who expect a conventional reading of the life of Christ, this
film can be seen as blasphemous. In fact, the theatrical opening of *The*

Last Temptation of Christ was met by religious indignation, with lines of picketers protesting the film. On the other end of the spectrum are the many non-Christians in the audience who have little or no investment in the film's religious discourse and so may find the film of only secular interest. Positioned in the middle (and so continuing the privileged need for audience response in the completion of these highly referential works) are those who have not yet made up their minds, or who have put aside the question of their beliefs. But regardless of religious background, it is to those willing to expose themselves to the film's searching, questioning attitude that the film is particularly addressed.

Perhaps for this reason Jesus in *The Last Temptation of Christ* has qualities in common with other Scorsese cinematic characters. Like Charlie in *Mean Streets* (1973) or Travis Bickle in *Taxi Driver* (1976), for example, Scorsese's Christ is an outlaw who struggles to reconcile the dual sides of his nature to achieve redemption. The attempt to broaden and humanize the representation of Christ is also evident in the film's casting. Since Christ himself was a rebel who associated with outlaws, Scorsese has cast actors associated with the art or music scene in New York, or even with his own earlier crime films. Willem Dafoe, who plays Christ, had worked in the experimental Wooster Group Theater in Soho; John Lurie, cast as the apostle Mark, is a saxophonist and part of the Downtown art scene in the late 1970s and 1980s; and Harvey Keitel, here cast as Judas (and speaking his lines with a full Brooklyn accent), played the lead character, Charlie, in Scorsese's *Mean Streets*. It is through these characters, and this cast, that the various members of the film's audience may find points of identification. So whether the conflict is between the human and the Divine, or between the self and the acceptance of life's challenges, it is a human conflict understandable to many.

But *The Last Temptation of Christ* is perhaps most distinctive in that the Jesus it represents struggles to play the *role* of a specific character in a mythical story. In this way, myth as a representational system is foregrounded, and its use value in society is acknowledged. As Jesus suffers on the cross, for example, he "dreams" the life of an ordinary man. In this dream he comes down from the cross, takes a wife, and fathers children. During the course of his long life, however, Jesus encounters his old disciple, Paul, who is now preaching the story of Christ to a crowd. On seeing Jesus, Paul recoils and strongly admonishes him for his failure to become the Son of God. Paul also reminds him that it is the story of the *resurrected Christ* that is of importance to people, not that of the ordinary human

being Jesus has now chosen to become. Much like the newspaperman in *The Man Who Shot Liberty Valence* who advised his underling to "print the legend," *The Last Temptation of Christ* acknowledges the value of myth as such. In Scorsese's film, however, the myth is not taken as an already closed system. Through a rupturing of its surface, the process of becoming myth is openly exposed.

In *The Last Temptation of Christ* this process of becoming is rendered through the film's growing narrative compliance with the gospels and with the increasing compliance of its visual images with traditional Christian painting and sculpture. The drastically refigured character of Jesus in the beginning sequences, for example, slowly begins to comply with the Christ of scriptures as the film progresses. As Jesus starts to accept his role as Christ he preaches to the crowds, at first haltingly, searching for the right words to respond to the stoning of Mary Magdalene, for example, or fumbling for the best way to explain his parables at the sermons on the mount. But Jesus' initial insecurities and lack of focus confuse his followers. The most vocal of these is Judas, presented as his staunchest supporter, who now faults Jesus for his inconsistent philosophy of preaching love one day and the sword the next. But Judas soon learns a difficult lesson of his own: He too must choose to submit to the will of God and play his allotted role. In this story of redemption, Judas's role is to betray Jesus so that the meaning of the Gospels can be fulfilled. To help achieve this end, Judas complies.

Just as the character of Jesus moves from being fully human to finally submitting to his divinity, so too the visual and narrative elements of the film grow toward a more traditional rendering. In keeping with the presentation of Jesus as a man in the process of becoming God, the visual elements are constructed with a kind of primitivism that slowly evolves toward the more traditional representations of Christ. This primitivism, however, is also an attempt to authenticate the time and place described in the Gospels. Although the Gospels set the Christ story in Palestine, this location is rarely represented in art or on film. Much of Renaissance painting, for example, is set in Italian locations (again to ensure maximum identification among its viewers), whereas the film versions of the Christ story, although nominally set in Palestine, are often shot elsewhere. A curious example of this practice is George Steven's *The Greatest Story Ever Told* (1965), a film starring Max Von Sydow as Christ, Charlton Heston as John the Baptist, and John Wayne as the "Centurion," and filmed in the Arizona desert, complete with Monument Valley in the background.

The Last Temptation of Christ is shot in North Africa and so features a rugged desert landscape and golden light closer to the original location of the Christ story. To further complete a more authentic sense of place, Scorsese fills his frame with indigenous African and Semitic peoples, while also complying with modes of dress and local customs of the region. This is especially striking in the well-researched Jewish wedding at Canaan, presenting women with richly tattooed hands and feet, guests with characteristically embroidered costumes, and music, composed by Peter Gabriel, that recombines rhythms and chants from Middle Eastern sources. This tendency to authenticity is also apparent in the rite of baptism performed by John the Baptist and Jesus' miracle of casting out devils. As scenes often represented in European religious paintings as saintly occurrences, these events are here also portrayed in all their primitiveness. The baptism of the faithful, for example, is seen almost as a rite of possession, with naked bodies undulating to the beat of drums and high-pitched chanting. And the casting out of devils is rendered surrealistically, as the violent expulsion of humanlike ashen forms from irregular holes in the earth.

The tendency toward visual authentication, however, is considerably diminished in the figure of Jesus. When he is first presented as a man bearing little relation to the traditional Christ, Jesus is dressed and made up contrary to expectation but nonetheless played by Willem Dafoe, a fair-haired white man and not a Middle-Eastern Jew. This choice of actor ultimately facilitates the transformations to follow. During the course of the film, Dafoe is slowly fashioned with longer hair and beard, white V-necked robe, and distinctive lighting to look more like the Christ of painting and sculpture (Figure 32). This growing compliance with the traditional visual representations is then extended to other aspects of the film. In the early part of *The Last Temptation of Christ,* the color had been rendered in the tones of traditional Christian paintings, while the content of these images had significantly diverged from the originals. In some of these more startling scenes Christ was uncharacteristically pictured with a blood-splattered face when aiding in a crucifixion, or as writhing on the floor gripped by seizures. As Jesus grows toward his calling, however, the film begins to adhere more closely to traditional visual representations of him. When preaching on the mount, he begins to look more like his well-known images, although his demeanor and expressions are still misplaced. But in scenes such as Jesus' celebratory ride on Palm Sunday, or his passion in the garden before his crucifixion, his actions match his

Figure 32. *The Last Temptation of Christ*, Martin Scorsese, 1986. Copyright 1988 Universal City Studios Inc.

visual presentation and thus create tableaux that strongly refer to traditional Christian painting. This is especially striking as Christ carries his cross through a jeering crowd, and Scorsese creates a cinematic image recalling Hieronymus Bosch's painting of that same event. And although Scorsese keeps within traditional representation when depicting the Crucifixion itself, he also makes a significant contribution to its history on film. Scorsese pictures Jesus on a gnarled cross set against a blazing blue sky, and through a camera movement that twists and turns expressionistically, he renders the agony and the exhaustion of the Crucifixion as never before seen on film.

This image of the Crucifixion, however, is not the last one of the film. Instead, a rupture occurs during this sequence that reverses the film's visual and narrative compliance with traditional representation. In Scorsese's film, Christ's suffering on the cross is suddenly rendered silent. In the "dream" sequence mentioned earlier, Jesus is shown coming down off the cross and walking away and, for an entire thirty minutes of screen time, living the life of an ordinary man. The traditional painterly settings replicated by the film proper are in these sequences replaced by radically unconventional locations and images. Jesus, for example, enters a leafy forest and comes home to a wooden cabin. Here he finds Mary Magdalene and makes love to her in full view of the camera. As the "dream" progresses, Jesus is shown in different stages of his life, raising children in one segment, idly living through his days in another, and then finally dying as an old man. But these images and stories feel very wrong to us. So when Jesus finally accepts the will of God, begging to be crucified and to be His Son, the sequence that follows is one of great power. With a cut and a dynamic zoom into the image, we are returned to a close-up of the traditional Christ on the cross and to the full sound environment of jeers and shouts from the attending crowd. It is in this return to representation and to "reality" that Christ declares, "It is accomplished."

A palpable sense of completion and release is created by this visual and aural reintegration and is compounded by the high-pitched chanting that now rises on the soundtrack. As the chanting escalates, the representational image of Christ is replaced by rapidly alternating strips of blank film. Silhouetted, tinted various colors, and emitting pulsating flashes of light against a white background, these end flares, with sprocket holes visible, recall the work of Stan Brakhage. In *The Last Temptation of Christ*, however, the material basis of film, or film's transcendence of it, is taken as a metaphor for the unrepresentable itself. In the moment of Christ's death, and his uniting with God the Father, we have reached the promise of redemption. The exuberant nonrepresentational image and the soaring sounds of the chanting convey an unremitting sense of euphoria. In Christ's death we are offered the hope of being saved, or as Lazarus had stated earlier, the wish that death "is not a door that closes, but one that opens, and you step through it."

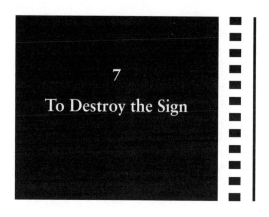

7

To Destroy the Sign

Even after the close of the 1970s, the films of the 1980s and the 1990s continued to engage the image in its diminished relationship to the natural real. In this chapter I will consider a number of these later films, but I will not necessarily claim that they are "resistant." The films cited take a variety of positions regarding their replication of old images, and in so doing they raise new questions. The first involves the further calcification of the image through its transformation from television, comic books, and other serialized forms into film. The second is the thorny issue of the contemporary "remake." Within this obsessive recycling of past forms, then, I will confront the issue of repetition itself as sharing the structure of a traumatic neurosis in response to recent historical events. In this way, the works already cited will be contextualized, and their early impetus will be traced to more recent practice.

The Loss of the Real

Sydney: This is my life! This isn't a movie.
Skeet: Sure it is, Syd. It's all a movie. It's all just one great big movie.

Scream, 1996

When everything feels like a movie/
Yeah, you bleed just to know you're alive.

The Goo Goo Dolls, 1998

By the late 1990s the understanding that media images dominated our lives had become a commonplace notion. A general feeling of being "trapped in a movie," or of what Baudrillard had called the loss of the real, was often expressed in cultural works. Along with it came the

impulse to break out of that confine, as dramatized by several recent films. In the *Truman Show* (1998), for example, the central character is trapped in a false world where he is actually an image on a popular TV show (Figure 33). The hapless Truman is the victim of a conspiracy that has rendered him the object of fascination watched by an entire society of viewers. In his life of spectacle, Truman inhabits a fabricated world, an exact replica of the "real" world, but not itself real. During the course of the film, Truman finally realizes that his life is a lie. In an attempt to escape his picture world Truman sets out to sea only to find a delimiting wall at its outer edges. But Truman is undaunted. He finds the door of the studio set and walks through it to the "real" world beyond. Of course *The Truman Show* is only a movie. For us, escaping to the real may not be that simple.

The complexity of our cultural experience is expressed in *The Truman Show* through a narrative that allegorizes our remove from the real because of the dominance of representation in our lives. But perhaps most disconcerting is that in 1998, well after the nostalgia of *Grease* and *Back to the Future*, the cultural products of the 1950s were still with us. A trap in itself, *The Truman Show* demonstrates this closure by now conflating the 1950s era into the 1990s, and it does so primarily through its reference to television. Truman (whose name recalls the 1940s–1950s President Harry S. Truman) inhabits a cheery but sterile world of manicured gardens, white picket fences, and cordial relations with the neighbors. Presented in the style of a 1950s TV sitcom, the film is nonetheless set in a contemporary period featuring bigger houses, brighter colors, and, in all political correctness, African-American neighbors. In Truman's world, however, there are no racial or social problems. Instead, lived experience is blurred with that of television to form an uneasy alliance between the two. So while Truman's world may be too cheery, too clean, and too trouble-free to be real, it has completely permeated his life.

In "The Truman Show," even the commercials are seamlessly incorporated into life. Truman's wife, for example, does the honors as she delivers a sales pitch for cereal directly to the camera while talking to an unsuspecting Truman. But the cracks in Truman's "reality" eventually begin to show, and he grows uneasy with his situation. At first Truman suspects the motives of his wife, and then his friends, and even his mother (all of whom are hired actors). He slowly begins to believe they are conspiring to stage his life. Through this structure of growing suspicion, *The Truman Show* may recall a *Twilight Zone* – like episode in which the main character is

Figure 33. *The Truman Show,* Peter Weir, 1998. Copyright 1998 by Paramount Pictures.

trapped in another dimension, or it could even mimic that paranoid state in which the individual believes the world is staged for his or her benefit. The conspiracy against Truman, however, is not supernatural or imagined; it is "real." By so blurring the boundaries between fantasy and reality within the fiction of Truman's life, the film comments on the deep incursion of images and simulation into our own daily lives.

The Truman Show is only a 1990s example of films that show their characters entering or being trapped in the image. As previously noted, the protagonist of the 1924 silent classic *Sherlock Jr.* had also entered the movie image to find fantasy fulfillment. Furthermore, in the 1980s, several films presented characters entering the image, but with differing results. In *Pennies from Heaven* (1981), for example, the characters and their hopeless Depression-era lives are contrasted to the utopian fantasies of 1930s film musicals. Re-created are images from the past of the Hollywood cinema, such as Busby Berkeley production numbers and Ginger Rogers and Fred Astaire dance routines. The "Let's Face the Music and Dance" number from *Follow the Fleet* (1936), for example, is restaged in *Pennies From Heaven* and rendered cinematographically in a way that duplicates the original. Here, however, the film's drab central characters respectively inhabit the Rogers and Astaire roles. Played by Bernadette Peters and

Steve Martin as a going-nowhere couple, these characters do their best to mimic the old masters, but they are sadly always themselves. The comparison between the glamorous Hollywood image and the "reality" of the characters is meant to comment on the incongruity between movie fantasies of the 1930s and the daily life of that era. And although the illusionistic system of *Pennies from Heaven* itself has not been broken by this method, the style of including the characters into past images has made its thematic point clear.

Pennies From Heaven was released the same year as *One from the Heart,* and though their overall effect is quite different, they share an important concern. *One from the Heart,* too, had played with the notion of characters trapped in the ruins of a Hollywood musical, but in Coppola's film the usual distinction between representation and the real to which it refers had not been maintained. In the pseudo-documentary, *Zelig* (1983), Woody Allen again toys with the representational capacity of the image. Here the main character, Zelig (played by Allen himself), has a rare condition that makes him replicate the qualities of those around him. The joke comes as Zelig is cinematically interjected, through a process of optical printing, into actual documentary footage from the early part of the twentieth century. Allen/Zelig is transformed, often physically, and set beside the documentary images of historical figures such as Charles Lindbergh and Adolf Hitler. So although *Zelig* may comment on the socially constructed nature of the self, it is most distinctive on the level of the image. Just as Zelig the man can take on the characteristics of others, the film is itself fashioned to be what it is not. It is not, for example, a document of Zelig's (or Woody Allen's) attendance at the various historical events presented. Instead, the spatial and temporal incongruity of Zelig/Allen's documentary presence now underlines the damaged reality claims of the image itself. The film documentary is a fake. *Zelig* thus stands as a premonition of the future, of the rise of computer-generated technology in the 1990s, and of the threat it poses to the photographic/film image.

Woody Allen's subsequent film, *The Purple Rose of Cairo* (1985), continues this concern for the image's relationship to the real. Allen now openly draws on Buster Keaton's *Sherlock Jr.,* but he reverses its central dynamic. In Allen's film, it is not Cecilia, the meek and unattractive central character played by Mia Farrow, who enters the movie image to find her dream. It is the glamorous screen star, Tom Baxter, who comes down off the movie image and into Cecilia's life. As in *Sherlock Jr.,* however, *The Purple Rose of Cairo*'s illusionistic system remains intact, while the

fantasy–reality confusion is played out only on the level of content. In one of the early sequences of *The Purple Rose of Cairo,* Tom Baxter emerges from the image to inhabit Cecilia's world, but then the remainder of the film proceeds as a typical Woody Allen story of mismatched love. The only significant twist comes when the transposed film star is shown to be too limited for real life. As a written entity, Baxter is a two-dimensional figure, not a living person, and so is unworthy of being loved.

The crossing of the boundary between the screen image and the "real" world represented in the film is not dissimilar to the central premise of *Pleasantville* (1998), a film made some thirteen years later. Here the contemporary characters of the film are drawn into a 1950s TV sitcom, rather than into a classical movie. This shift of media is significant, however, because it signals the updating of nostalgia for a younger generation and also because it points to television as a source for many of the films already discussed. In *Pleasantville* the practice of rebroadcasting 1950s TV sitcoms on 1990s cable television is exploited (as it is in *Pennies From Heaven*) to comment on the incongruity between the "happiness" of those shows and the difficulties of contemporary lives. Here we watch two teenagers from a dysfunctional single-parent household as they enter the image world of a *Father Knows Best* – like sitcom. By cinematographically replicating the black-and-white television images of the 1950s, *Pleasantville* shows the characters moving from the color world of their 1990s film "reality" into the monochrome images of another era. But then, as in *Back to the Future,* the contemporary characters bring present-day enlightenment into the past (metaphorically rendered by reinfusing the image with color), while teaching the conservative 1950s TV characters about love, creativity, and the dangers of conformity.

Across these often-staggering blandishments, *Pleasantville* shows characters entering images not contemporaneous with their own time. In this way, *Pleasantville* is a type of "time travel" film (like *Back to the Future*), but it also recalls the almost incessant returns, reruns, and remakes of the past through the re-creation of its old images. I am not claiming that *Pleasantville* is a deep or complex film; my view is quite the contrary. Its obsession for the 1950s is of interest, however, because it would seem that by 1998 this era had been represented so often as to make the film unreleasable. But *Pleasantville* opened to fair reviews and did respectable business, indicating that the mania for the 1950s had not been exhausted. From this obstinate perspective, then, I will consider a number of issues that now come into focus. The first is the importance of television as a

source for imagistic returns. The second is the function of compulsive repetition itself in structuring nostalgic works.

Television

Most Americans have seen their old movies primarily on television. This point cannot be emphasized enough for it reflects a distinct generational difference among viewers. Movie audiences of the 1930s and 1940s saw Hollywood classics in the movie theaters. But baby boomers, the most significant generation of makers and consumers of the nostalgia film, watched these films primarily as television reruns. Moreover, they did so as children, accruing to these images, and perhaps to the entire medium of television from that period, the connotation of childhood. This association was apparent from the early nostalgia films *Star Wars* and *Raiders of the Lost Ark,* both works based on 1940s serials but originally seen by baby boomers on TV. Television was also a source for viewing the classical musical, the Western, and the horror film, as well as the other old movie returns we have noted. It is important to mention that the French New Wave filmmakers, who also incorporated classical Hollywood conventions into new works, saw the original films as adults, at a historical remove because of the intervening World War II years, and projected on the film screens of Henri Langlois's Cinematheque. The reuse of Hollywood elements by the French thus could not carry the same connotations of lost innocence it did for the Americans. For the French New Wave, the classical Hollywood film represented the world of the victors, a cinema they could both emulate and oppose. The work of the post-1960s American filmmakers must therefore be judged from a different perspective. Among the possible reason for the cinematic returns, one should include not only the rise of film schools but also the centrality of television in the childhood viewing experiences of both filmmakers and audiences.

This conflation of television and childhood is especially apparent in the films produced in the late 1980s and 1990s. In a seeming attempt to appeal to younger audiences, a number of films were adapted from television series as a more contemporary format. On closer inspection, however, the source television programs again comply with the childhood viewing experiences of baby boomers. Examples of these television-inspired films, and the significant dates of their source material, include *The Untouchables* (1987), originally aired as a series from 1959 to 1963;

Dennis the Menace (1993), which aired from 1959 to 1963; *The Flintstones* (1994), which aired from 1960 to 1966; and *Maverick* (1994), which aired from 1957 to 1962. The original *Dennis the Menace* and *The Flintstones* were also shown on the contemporary TV cable program Nickelodeon, making them accessible to young viewers (and so broadening their box-office appeal). The act of remaking and rerunning these programs demonstrates a strongly maintained cultural compulsion to return to a specific historical period. It must be noted, however, that these shows were originally aired in the prepolitical early 1960s, suggesting not so much a nostalgia for that past as a denial of the historical disruptions that follow. Recent revivals such as *Mission: Impossible* (1996) and *The Wild Wild West* (1999) were first aired during the turbulent years 1966–1973 and 1965–1969, respectively, and so seem to contradict this assumption. The structure of TV viewing during that period, however, must be considered in order to understand the source material. In the flow of television programming, these shows were originally scheduled *adjacent* to the nightly news and its images of unrest and war. The shows themselves reflected little of this historical upheaval; instead, they presented viewers with linear narratives, stable time and space, and integrated characters and images. The return of these products in our contemporary era still carries the connotation of order within a context of historical disruption and hence serves as a form of denial. The process of transforming these old television programs into a cinematic form in the 1990s, however, causes a number of significant alterations.

The most apparent alteration is the enlargement of the image to comparatively gigantic proportions. Enhanced by new technologies and supported by the powerful economics of the New Hollywood, the once small, black-and-white, and often low-budget TV image is now increased in size and intensified by high-resolution color, computer-generated effects, and increased production values. The new productions are often shot on expensive sets or on location, feature big-name movie stars such as Tom Cruise in *Mission: Impossible* or Elizabeth Taylor in *The Flintstones*, and are embellished by resounding Dolby soundtracks. And while these TV-into-film productions often replicate the well-known look of the original characters and settings (that is, its images), the story itself often takes on a whole new dimension. In most cases, only the shell of the original story remains. But of course there was never one original text in such weekly series as *Dennis the Menace* or *The Wild Wild West*. Instead, the earlier characters and situations are used as raw material for the later works.

This is especially apparent in *Dennis the Menace,* a John Hughes film that recasts the past television characters in a story that now draws heavily from the director's own hit *Home Alone.* And even though the schism between the image and narrative could create an oppositional clash between the two systems, these films evidence little or no critical stance either toward their original material or the status quo.

The disconnection is compounded by the fact that young members of the audience lack any direct memory of either the 1960s or of the original television shows. This two-tiered system has been with us from the beginning of our discussion, with films appealing to the young while addressing the memory or knowledge of their parents, but in the TV remake films the "past as the present" becomes more pronounced. Here the image is posited as "bigger and better than ever" and then rendered experiential through the hyperbolization of the once small TV image. Exaggerated in size, it is erected as a screen, not so much against the real, but as a thing in itself. This is the society of the spectacle, the image as the reification of capital as proposed Guy Debord,[1] now made unmistakable. Up there on the screen we confront the might of an economic system capable of producing such an image. Those viewers who can remember the original TV shows can now make a comparison to the economic growth that has produced these later images. But to all other viewers (and all viewers around the world, it should be added), the sheer size and sound of the spectacle underscores that capitalism is triumphant and that the threats once posed to it are now passed.

This reassertion of capital is matched only by the reassertion of patriarchy itself. A majority of these films return not simply to childhood but specifically to boyhood. This is especially true of films adapted from comic books, many of which were also television series. These include such films as *Superman* (1978), *Superman II* (1980), *Superman III* (1983), *Superman IV* (1987), *Batman* (1989), *Batman Returns* (1992), *Batman Forever* (1995), *Batman and Robin* (1997), *Dick Tracy* (1990), and those taken from later comics such as *The Crow* (1994) and *Judge Dredd* (1995). These works transform the original comic book drawings, exaggerating the small, serialized, predominantly male format, into film through a technologically advanced display of image, sound, and action. The scale and decibel levels of these films often serve to dwarf the individual, reasserting that the past has been superseded. Through these "boy games," a strongly militaristic stance is implied, one now staged by a physically inflated and powerfully magnified hero.

The transformation of smaller or less technologically advanced mediums onto film has long been a staple of Hollywood. This most recent impulse, however, is distinctive in a number of ways. From the early days of film, such as in the musicals discussed earlier, filmmakers have devised innovative strategies to create experiences not possible in another medium. In the 1970s *Star Wars* and *Raiders of the Lost Ark* had brought increased scale, color, and expertise to the old serials and so more "thrills and chills" to a boyhood viewing memory. The important contribution of the 1990s TV and comic book adaptations is that they now use computer-generated effects to amplify past images. Visions unimaginable in the originals are thus created, but more importantly, the film image subsequently loses its indexical relationship to reality. Of course TV and the comic book image never had that relationship to reality in the first place, but that is entirely the point. A new image is created, one reminiscent of the original only through a series of representational removes, and so attaining a simulacral status.

Serialized Forms

In remakes of old television programs and comic books, the question of seriality itself becomes an issue. Before addressing the impact of this serial impulse in popular culture, however, we must note the crisis around the notion of the "remake" as a descriptive category.[2] The once seemingly distinct notion of the remake, as opposed to other imitative practices such as adaptation or genre, not to mention pastiche, allusion, or nostalgia, seems to be ever more obscured. The practice of remaking an old movie had once seemed distinguishable from that of adapting a novel into film, for example, or of presenting a subsequent version of a genre work. The notion of pastiche had also seemed distinct since it implied the piecemeal rearrangement of old elements, whereas the remake had suggested a more integrated re-creation of past works and often carried the title of the original. Examples of this older tendency can be seen in such remakes as *Dr. Jekyll and Mr. Hyde* (1931) and *Dr. Jekyll and Mr. Hyde* (1941) or *The Last of the Mohicans* (1920) and *The Last of the Mohicans* (1936).

Looking at Hollywood from its inception, however, one is overwhelmed by the number of works that have been remade, recycled, adapted, and copied, with the distinction between these various categories of replication not always clear. The most obvious example is *Dracula,* with nearly thirty

films made about this subject. These films were adapted from the novel by
Bram Stoker, often by way of the various stage productions of *Dracula,*
recycled as part of the horror genre, and then later pastiched and parodied
in works of film, stage, and art.[3]

Nonetheless, contemporary works evidence an *intensified* level of rep-
etition, not only in practice, but also on the level of source material. The
serialized sources of *Star Wars* and *Raiders of the Lost Ark* have already
been noted, as have the serial format of the original television programs
and comic books remade into film. But many of the 1970s and 1980s films
already discussed also drew heavily on genre as a repeating form. The com-
pulsion to repeat already repetitive patterns and to do so at a historical re-
move must be looked at as a distinctive feature of this period. The very no-
tion of an original falls away when "remaking" a serial. The *form* itself is
instead invoked, as is its overriding pastness. And while individual stories
may be pastiched in a fragmentary fashion in these films (as is *West Side
Story* in *Grease* or the Odessa Steps sequence from *Battleship Potemkin*
(1925) in *The Untouchables*), it is the return of widely acknowledged dead
or past forms that is especially significant. This past quality then allows
for the reconfiguration of old elements into new works, as well as engen-
dering a shifting double exposure between the new material and the old.

Unlike the earlier practices of remakes, adaptations, and genre that
meant to replace the old works, we are now confronted with a potentially
dynamic model. In these works the old is not erased but ever present, and
if the friction is critical enough (as in *Last Exit to Brooklyn* or *The Last
Temptation of Christ*), a rupture will result in its representational surface.
But if the opposition is less critical (as in *The Flintstones*), the very insis-
tence of the process of replication tends to block the real and confound
our place in history. The materialized image that results functions as a
barrier and, ultimately, as a thing in itself. It is on the level of this calci-
fied image that the latter-day "remakes" are distinctive. Often literalized
by copying the look of the original photographic/film image, this prac-
tice is distinguishable from classical remakes and their largely thematic
re-creation of older material (as in the *Dr. Jekyll and Mr. Hyde* remakes
already noted). There may be some compliance with previous narrative
material in these more contemporary works, but the compulsion to repli-
cate images cinematographically is their most distinctive feature.

Serialization is an overdetermined quality of many contemporary
works, existing on the levels of both source material and production.
In its very structure, then, the cultural compulsion to repeat mimics a

traumatic neurosis in the individual. As described by Sigmund Freud, the neurotic individual repeats the traumatic event in symbolic form until his or her psychic need is exhausted. In art practice, this repetition compulsion and its (arguable) deadening of affect can be seen, for example, in Andy Warhol's silk-screen canvases on which the images of traumatic events, such as the mangled car crash victims in *Saturday Disaster* (1964), are represented. But in the films discussed here, the traumatic moment is not seen. It is the style of the era just *preceding* it that is repeated. In structure, then, this contemporary practice is more like the psychic trauma of the castration complex, where the trauma of feared loss is substituted, according to Freud, by a fetish, an object on which the *gaze fell* just prior to the trauma. In a similar manner, there seems to be a compulsion in popular culture to return to the visual material from a pre-1960s era, to a time just before the historical trauma. The returns can be seen to function as denials of disruption and loss, or perhaps as reassertions of the values that existed before its traumatic events. In keeping with the Freudian model, this hyperbolized stance of denial evidences an insistence on the "phallic" glory of capitalism and patriarchy.

The Return of the Classical Film Genres

Within this whirlwind of return and repetition we must not fail to consider other repeating forms during this period. In earlier chapters we discussed individual films that seemed to conform to classical film genre categories. As we move into a discussion of 1980s and 1990s film, however, we must acknowledge the further alterations in film genres. During this period, entire "cycles" of past-inspired genres – musicals, horror films, and Westerns – seem to stage a return. Unlike the genres of an earlier period, however, these forms display a second-hand quality, a feeling of being copies of the originals. Because they so strongly evoke the past forms themselves, they can be seen as simulated genres.

The Stalker Film

The stalker film, technically a subgenre of the horror film, is made up of dead things. Like the Frankenstein monster reassembled from parts of corpses, the stalker film is resuscitated from parts of old films,

old genres, and even bits of film theory now used as codes. *Psycho* is its most important precursor. Also evident, however, are elements from the science fiction films of the 1950s, from the Western, and even from Freudian theory now filtered through feminist film criticism. As I have argued elsewhere, the resulting amalgam of elements provides the viewer with a kind of game,[4] a web of already-seen material through which the shocks and challenges of the new film can be experienced. As the film that began this cycle, *Halloween* (1978) was openly intended to stage the present in terms of the past. As its writer–director John Carpenter has stated:

I remember there came this big moment of truth. They (USC film school) encourage socially conscious films and they want them to be personal, and I finally said, "What I care about is escapist entertainment. Those are the films I grew up on, and I want to do for audiences the things those movies did for me."[5]

In this intent to return to past forms, *Halloween* recycles many elements from *Psycho,* but most importantly, it returns the visual dynamic of the famous shower scene and extends it throughout the entirety of the new film. Here the camera frames the victim while keeping the killer off screen. This said, however, it must be stressed that the narrative structure of *Halloween* in many ways owes more to the science fiction films of the 1950s and to the Western than it does to *Psycho.* As in the 1954 science fiction film *The Thing,* for example, a murderous threat is posited against an American community. Unlike this earlier film, and many more of its genre, however, the threat in *Halloween* does not come from outer space. Instead, the killing impulse springs from the very community on which it now preys. Moreover, this murderous threat is itself presented as a return, and one now defined by specific dates. In *Halloween* Michael Myers is shown to commit his first murder in 1963 and to stage his return in 1978. These dates also closely correspond to the historically significant ones we have noted throughout. What is unavoidable in *Halloween* is a return to old values, accomplished by returning to a pre-1960s period in both style and content. It is from this warped temporal perspective, then, one that returns to forms of *mystification* (rather than of *demystification* typical of the 1960s), that Laurie, the film's central character, tells us that the bogeyman is real. *Halloween* thus shares plot similarities with the Western film genre since the threat to an American community is here answered by the justifiable use of violence.

The almost obsessive compulsion to repeat these elements in the stalker film cycle that followed, however, did not result in a barrier against the real. Instead, it was a call to murder, a call often voiced by the film's audiences in the late 1970s and early 1980s. Here a movie game was played, participated in by males and females alike, as audience members shouted their support for *both* the film's heroine (who in most cases was female, but not in all) and the killer. With hindsight, we can now see that these films, poised at the beginning of an era of resurgent capitalism, heralded a film style that would continue to articulate a position of national power and might.

Scream

After nearly twenty years of relative dormancy, the stalker film returns again in *Scream* (1996). Written by Kevin Williamson and directed by Wes Craven, *Scream* has been described as a "neo-stalker," a nostalgia work for Generation X, one which now recalls the 1970s stalker films this younger group once saw as children.[6] Similarities between the stalker film and *Scream* can certainly be noted, but it is the altered self-reflective attitude of the latter that most distinguishes the two. *Scream* is self-conscious in a way that can best be described as "self-reflexive." The quotation marks here indicate that in *Scream* the modernist strategy of self-reflexivity has itself become a code and that it is now used to enhance illusionism rather than rupture it.

Following the dictates of this "self-reflexive" strategy, for example, *Scream* continuously reminds the viewer that it is a film and, moreover, that it is a stalker film. The characters, for example, note the similarities between their filmic situation and the conventions of the form. The film's dialogue is replete with references to late 1970s stalker films such as *Halloween* and *Terror Train* (1980), to their well-known star, Jamie Lee Curtis, and to plot conventions such as the virginal status of the heroine and the secret identity and location of the killer. Formal elements are also foregrounded, with knowing and direct reference to characteristic camera positions, such as the one that conjoins the vision of the killer with that of the audience. The highly repetitive nature of the story formula is also addressed, as is the status of the film experience itself as a "game." But a distance from the inner workings of the film is not provided. Instead, the film anticipates and incorporates the audiences' own well-worn responses

into itself. Through this dynamic an equation is established between the characters in *Scream* and the members of the audience, one that tends to blur the distinction between the two. The fiction of *Scream* is that the film's characters live in a "real" world that is "just like a movie" and that the audience is deeply implicated in this world through a shared knowledge of film.

The effect of being "trapped in a movie" is literalized here. Whereas we have discussed films such as *Badlands* and *One from the Heart* whose characters were also "trapped" within genres, the purpose in those films was to negate old myths, or to confront the confinement of images themselves. In *Scream*, however, the ongoing cultural condition is not challenged – it is exploited. *Scream* does this first by establishing a dynamic that seemingly "distances" viewers while simultaneously implicating them deep within the fiction. As in the earlier stalker films, the traveling point-of-view shot links our vision with that of the killer, displacing our complicity onto an unknown character, while bringing us into close contact with the attack on the victim. The primarily young viewers of *Scream* are thus allowed a disconnected encounter with murder, but one that now gleefully blurs the distinction between the film and reality. *Scream*'s contribution is that this "distanced" dynamic is now incorporated into the film's narrative, alluded to by the characters, and then knowingly discounted, as one of the killers refers to today's media-saturated youth, calling them "a whole generation of heartless, desensitized little shits."

It is difficult to gauge the ultimate effect of this type of confusion on a society and its young people, but a retroactive reading of the film is a chilling one. In *Scream*, the updating of the stalker formula by substituting the psychiatrist Dr. Sam Loomis in *Halloween* with Gail, the aggressive TV news anchor more interested in career advancement than the suffering of her subjects, is very disturbing after the events at Columbine High School. Seeing *Scream* today, with its two blood-splattered teenage killers who murder their classmates, one may recall the subsequent serial shootings of Columbine students and the voracious media coverage of it. But *Scream* ironically heads off any accusations that this film, released three years before the massacres, may have caused young people to kill, by having one of its murderers "self-reflexively" claim, "Movies don't create psychos. Movies make psychos more creative!" Although this may be the case, some works do counter, rather than succumb to, the overriding cultural condition that confounds the boundaries between fantasy and reality, representation and the real.

Psycho

Although Gus Van Sant's *Psycho* is a mainstream Hollywood film, it is also a conceptual work that confronts the central issues of representation raised here. This is especially important because so many of the films classifiable as stalker/slasher have drawn on *Psycho*, and now the remake of *Psycho* itself marks a special moment in the recycling of old films. *Nosferatu the Vampyre* (1979), Werner Herzog's remake of F. W. Murnau's *Nosferatu* (1922), can be cited as a similar gesture, but there are important differences. In *Nosferatu the Vampyre*, the constant reference to Murnau's classic diminishes the new film's link to a natural real and ultimately renders it a thing in itself. The remake of *Psycho* encourages a similar response, but it is significant that it does so by the (near) replication of its original images as well as its story. The play of images in this new *Psycho* is made possible because of the original film's wide popularity. The limited familiarity with Murnau's *Nosferatu* by American audiences, in contrast, precludes a similar type of comparison, causing the new film to be read as a simple variation on an old story. In Van Sant's *Psycho* the audience's awareness engenders an almost unavoidable comparison between the two imagistic and narrative texts. It is perhaps *Psycho*'s historical positioning that fuels its peculiarity. The 1978 remake of *Nosferatu*, for example, returns to the 1920s, confronting German society with the uncomfortable historical connotations of that period. In *Psycho*, Gus Van Sant not only returns an early 1960s film but also infuses a feeling of the 1950s/1960s into the 1990s, confounding the past and the present in a way that addresses our current historical period.

When one is watching Gus Van Sant's *Psycho*, the original is always present in one's memory, or better still, in one's "mind's eye." Although some critics have described the experience of viewing remade films in our contemporary period as having the effect of a palimpsest, with the writing of the original text existing under the present material, what occurs in *Psycho* is more like a double exposure because of its strong visual component. Here the titles are presented as almost (but not quite) identical to the originals. The vertical and horizontal lines, for example, still "slash" the screen as in the original, while the credits appear in the same typeface and accompanied by the famous Bernard Herrmann musical score. But times have changed, and this change is inevitably registered in the image. The images of Gus Van Sant's *Psycho* are no longer black and white. Instead,

the new color film image renders green slashes across a black screen. The most telling reminder of the passage of time, however, is in the credits themselves. Here we see the changed names of the actors and production crews, and, most poignantly, that of the film director himself – which is to say, everything has changed. This film is a copy par excellence, and from it Gus Van Sant has fashioned a new work.

The dynamic opposition between past and present is further constructed in the opening sequence. Here the famous wide shot of Phoenix, Arizona is reprised, but now with a number of subtle variations. The forty years that separate the two films have changed the city's skyline. The framing of the shot in Gus Van Sant's *Psycho* is identical to that of Hitchcock's film, but now new buildings stand where others had been. Moreover, Van Sant acknowledges the passage of time by presenting the title "Phoenix, Arizona 1998" over the image, thus causing another disjunction from the original in which no year had been given. But the shots and music of this early sequence continue as remembered. The camera again pans to a building on the right, locates a window, and zooms toward it. Reaching the window, the camera peers through the bottom of the open shades and then enters the room in "birdlike" fashion to spy on two lovers. And while the shots and the *mise-en-scene* have been replicated to perfection, the content has been altered.

An almost unavoidable tension results from this method, which causes us to compare the past and the present films. We may notice, for example, that the building the camera approaches is different from the original, or that the window it enters lacks the white venetian blinds of the earlier film. Once in the room, we become aware that the arrangement of objects in the room and the positioning of the camera are similar but that the style of the bed, the bedclothes, and even the character's clothes are slightly incongruent. In fact, they do not so much mimic the styles of the early 1960s outright as present a 1990s retro-style that features an early 1960s "feel." A schism thus begins to tear at the surface of the film, one that is especially apparent in the presentation of the actors. Although it is not surprising that a remake would include contemporary actors who may or may not recall the original, it is the selective matching and mismatching of those actors that now reveals the indelible marks of the older film on the new. In Van Sant's *Psycho* it seems as if the very skin of the film, what Barthes had described as the light from the once-photographed body, has been peeled away to expose a whole new presence. New actors now exist in the same configuration as the old (Figure 34), speaking the

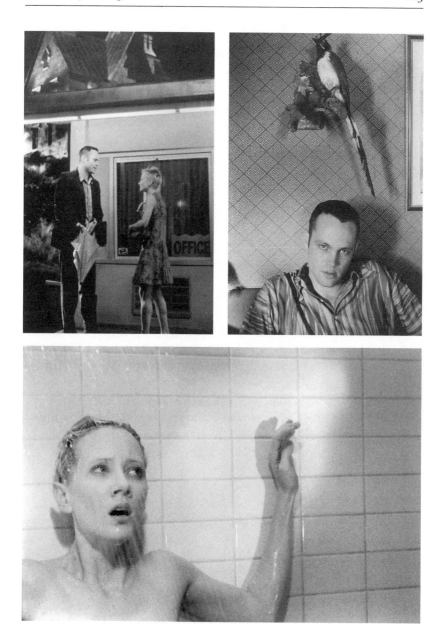

Figure 34. *Psycho*, Gus Van Sant, 1998. Copyright 1998 Universal City Studios Inc.

past lines with a grain of the voice and inflection of speech that alter the representational surface of the original.

Van Sant causes a disturbance not only on the denotative level of the film but on its connotative level as well. Anne Heche, who is cast as Marion Crane, for example, has the delicate features and short blonde hair of the original actress. Heche's well-publicized lesbianism, however, blocks our usual relationship to her character. The original Marion's body had been made visible to the camera as an object of desire for the male gaze. Heche's persona complicates this dynamic. In the 1990s Heche had been presented as unapologetic for her sexual preference and as very much involved with her female lover, Ellen De Generes. For this reason, her image is less available to the male viewer, and fantasy access to her body is diminished, even distanced. We are instead left with the surface of the image in a way that will both literally and connotatively typify the central dynamic of Van Sant's *Psycho*.

The comparison with the original is so insistent in Gus Van Sant's *Psycho* that the resulting literalized image ultimately corrupts the film's ability to communicate meaning and feeling. Instead of referring to a natural real, Gus Van Sant's *Psycho* refers to an already existing text and ultimately creates a set of material signifiers that refer primarily to themselves. The opening sequence of Hitchcock's *Psycho*, for example, had once registered a tension of sinful passions for which Marion's murder served as an ironic form of retribution. This meaning is now almost entirely lost in the remake because in the contemporary social context, sex and divorce are less of social transgressions. Furthermore, although Heche's homosexuality may raise eyebrows in some communities, it is largely left outside the fiction of the film. It is from an emotionally distanced position, then, that Gus Van Sant re-creates an almost exact replica of *Psycho*'s original shower scene. The more detached viewer is free to note surface discrepancies: the fact that Marion's blood now runs red, for example, (contrary to Hitchcock's wishes), or that the sounds of the stabbing have been augmented. The material density of the film's surface is foregrounded, but only to be ruptured by further inconsistencies.

Disruptions are interspersed at different intensities throughout the film. Several of these disruptions have the distinct feeling of a "pop," altering the original on an image and a narrative level as well. When the used-car salesman chides Marion about changing her mind, for example, adding the line from the original *Psycho*, "Being a woman you will," the outmoded attitude regarding gender is disruptive to the fiction, but it is also

unsupported by the 1990s connotations in the new film. A similar disruption occurs in the peephole sequence at the Bates Motel. Here Norman masturbates below the frameline as he watches Marion undress, making sounds and movements disturbingly dissimilar from the original (although entirely consistent with its meaning).

By the end of Van Sant's *Psycho*, the accumulation of these disjunctions almost totally dismantles the new film's ability to signify a fictive world. When the psychiatrist delivers his speech diagnosing Norman's psychosis, for example, we are more likely to attend to the cadence of the man's voice than to receive the supposed revelatory meaning of his words. Regardless of these disruptive methods, however, Norman/Mother's gesture of looking straight into the camera at the end of *Psycho,* across the skin of the film to the audience, can still send chills up one's spine. But unlike the original, we are not put in confrontation with Norman himself. Instead, we are confronted with the image produced by the camera, with the picture of Norman and its film history.

In Van Sant's *Psycho,* the viewer has been presented with the image itself and has been made to compare its material surface to the original, not as parody, but to reveal its status *as* an image. Unlike *Les Carabiniers,* however, this conclusion has not been reached by having the characters touch the film screen, but by having us experience its flatness, and its materiality, through an encounter with its semiological surface. A form has thus been activated that sets the old in subtle disjunction with the new to dismantle the sign itself. The film surface has again been "slashed," but now to reveal it as such, rather than as lived reality.

The Western

In all this, even repetition itself, in earlier times a vital instinct, is an irrelevant concept, since it is a repetition which is here merely represented (rather than being repeated "for the first time"). [7]

<div align="right">Fredric Jameson</div>

Hollywood of the 1980s and 1990s attempted to resuscitate the Western as a genre. Unlike the prolific production of Westerns in its heyday, however, this manufactured cycle produced relatively few works, and with varying results. In some of these new Westerns, the surface elements returned while their deeper structures seemed to have been left behind. In

Silverado (1985), for example, the classic costumes, locations, characters, plot elements, and type of dialogue were re-presented without the meaningful deeper structure of the old Western. *Silverado* is a work of nostalgia, with bits and pieces of old Westerns reassembled into a pleasant but largely superficial play of elements. Even within this apparent lack of depth, however, the return of the Western as a cycle raises a number of pertinent questions. Why, for example, did the Western find a renewed audience in the 1980s and 1990s, well after its ideological assumptions had been depleted and its form deconstructed?

One way to assess this new development is to analyze the disjunctions between the new films and classical Westerns. The most telling divergences in *Silverado* is its lack of a strong central hero and its deviation from the Western's classical plot structure. The hero of the earlier Westerns had once embodied civilization and wilderness, a duality that allowed him to defeat the wild villains and to establish a "civilized" society (a community he, himself, stood apart from). As a foundation myth, the Western embodied many American values, but most importantly, it justified the use of violence.[8] In the 1960s, revisionist Westerns such as *The Wild Bunch* (1969) and *Little Big Man* (1970) staged an attack on the conventional form of the genre, demystifying its ideological assumptions. It is therefore significant that in the 1980s the Western returns as a set of iconic conventions, and by reinscribing a classical style of filmmaking.

The return of the Western in the 1980s had some serious obstacles to overcome especially after the death of John Wayne and the "death" of the Western itself. At first the new Western seems to return as a series of false fronts, constructed out of the surface material of the older films and reconfigured to speak new texts. But the reconfigurations in most of the new Westerns do not result in the type of rupturing we have discussed. This is largely because the tension between the surface material and its underlying structure do not effect a critical opposition. This is true in *Silverado* in which the almost free play of surface material allows it to stand as a purer example of pastiche. Some of the Westerns that follow *Silverado* seem to take a different approach. These films also use the exterior casing of the old Western, but now they do so to restate perceived untruths in the original myth. Many of these new Westerns, however, do not so much explore the depths of the myth as extend it into new territory.

In *Dances with Wolves* (1990), for example, a young white cavalry officer lives among the Indians, a people presented as being in perfect harmony with the land and with each other, and not the savages of the

classical Western. In *Dances with Wolves* it is the white men who are savages, murdering and despoiling their way across the country in a triumphalist expansion westward. *Dances with Wolves* thus does not tell a story of how the West was won, as had the original Western, but how the movement westward destroyed the land, its people, and its wild life. Regardless of this historical rereading, however, *Dances with Wolves* still adheres to the deeper form of the classical Western. To begin with, the hero of *Dances with Wolves* is a white man (played by Kevin Costner). This Western hero, whose Indian name is "Dances with Wolves," embodies the traditional duality of civilization and wilderness, although now recombined for more contemporary tastes. Costner is a white cavalry soldier who lives on the western lands and acquires the ways of its indigenous people. The hero thus has access to both worlds, which gives him the strength to fight the villains, here presented as white cavalrymen, and to protect the community, now rendered as the Indians. Regardless of this updating, however, *Dances with Wolves* still tells a story that legitimizes the use of violence. The hero fights valiantly, destroying all the villains, but he cannot ultimately save the Indians. With their defeat inevitable, "Dances with Wolves" and his wife, a white woman who is also a bit "savage" because she lived with the Indians, escape to civilization.

The new Western returns as a resurgence of old ideas and old values for a 1980s and 1990s America moving toward an ever more empowered world position. So while the heroes in these Westerns may at first seem compromised, the films often tell stories promoting strength and renewed force. To aid in this effect, the new Western also returns with the full impact of advanced cinematic technology. This is especially true in films such as *Posse* (1993) and *Bad Girls* (1994), two Westerns that seemingly right the wrongs of race and gender representation. *Posse*, for example, is an all-Black Western made to correct the misconception that cowboys, historically, were all white men. In *Posse* we are introduced to a group of African American cowboy heroes who fight with great force to build a new community and who are threatened by a repressive white society. *Bad Girls* claims to accomplish a similar gesture in terms of gender, but it ultimately exploits the very idea of the strong woman heroine by presenting some of Hollywood's sexiest young actresses as provocatively dressed prostitutes who also happen to shoot and kill. But however these roles are reversed, the new Westerns, like the old, justify the use of violent force.

Another of these 1990s Westerns, *The Last of the Mohicans* (1992), takes a slightly different approach. It remakes the James Fennimore Cooper novel on which the classic formula was based and so discards the conventional surface features of the later Westerns. In *The Last of the Mohicans* the distinctive Western setting, costumes, and era are altered, while the structure of the original founding myth is maintained. We see that from the beginning of the genre the "man of the wilderness" is a white man. It is this characteristic that allows him to defeat the dual threat of "civilization" (presented as the British) and "wilderness" (the bad Indians) to build a new society. But here, too, the new Western tells the story of legitimized violence. In *The Last of the Mohicans*, the hero attacks with unrestrained force, an experience made especially visceral by the glossiness of the film image and the loud, impact-laden soundtrack.

The renewed justification for violence is especially apparent in Clint Eastwood's *Unforgiven* (1992). Released subsequent to the Gulf War, Clint Eastwood returns as the hero of a classic Western and attempts to reinhabit the hero position left vacant by John Wayne. Drawing on his own persona as the star of such Sergio Leone Westerns as *A Fistful of Dollars* (1964), and also from his appearance as the vindicating killer in *Dirty Harry* (1971), Eastwood forges a returned Western hero. Rather than deconstruct that character, however, he reconstructs it as the *resurgence* of a once deadly force. In *Unforgiven* a retired gunslinger is called back into action, as in the classic Western *Shane*. But the story is now made more resonant because of the film's historical positioning. Within the context of the Gulf War, *Unforgiven* can be read as legitimizing the use of force, replacing the defeats of Vietnam with an America that is once again strong. Like many of the films we have discussed, especially those of the 1990s, *Unforgiven* denies the losses of the past by reasserting American dominance. At the end of the film, for example, after having savagely but justifiably murdered to achieve vengeance, Eastwood vows to continue with acts of retributions if he is again harmed. This statement is made all the more emphatic because it is delivered by Eastwood framed from a low angle and set against a waving American flag that fills the background. As with many of the films that remake TV shows and comic books, *Unforgiven* denies recent loss by the emphatic reassertion of power, not only in stylistic terms, but through the familiar dictates of the Western as well.

Geronimo: An American Legend (1993) is probably the only film among these generic returns that negates the Western on its own terms.

In some ways reminiscent of John Ford's *Cheyenne Autumn* (1964), *Geronimo* tells the story of the defeat of a people, now without the earlier film's luxury of denial. *Cheyenne Autumn* had depicted the expulsion of the Indians from their land, but it had softened the blow by showing their temporary return to it. In Walter Hill's *Geronimo,* however, there is no happy ending, even a provisional one. *Geronimo* reconstructs a Western gutted of its essential elements. This is especially striking in the splintering of the central white hero. In *Geronimo* the hero position is divided between Gatewood, a weak and decentered protagonist, and the young Dillon, from whose point of view the film is narrated. Because neither of these characters has the strength of the traditional Western hero, an empty space is created at the center of a film that takes Geronimo as its subject. A position is thus cleared for Geronimo to enter center stage. But Geronimo is a new kind of Western hero. Often photographed against the expansive and majestic landscape, he is the embodiment of the wilderness itself.

The battles that Geronimo must fight cannot be won, however. The enemy is simply too numerous. With the last image of the film, the fate of Geronimo, and symbolically that of the Western itself, is sealed. Geronimo surrenders to the U.S. Cavalry and he and his people are cynically shipped from their homeland, the plains of North Dakota, to a reservation in distant Florida. The displacement of the Indians is complete and their defeat is total, a condition symbolized by a close-up of Geronimo on his way into exile. With downcast eyes and head lowered, Geronimo is set against the flat brown boards of the wagon that carries him. Palpably caught within the confines of the camera frame, the image is limited in its expansion and depth. Geronimo, who once had been as wild as the wind, has reached his end. This last image is a terrible blow to the Western and can be seen as a companion piece to *The Shootist* and the death of the Western hero. For now not only is the Western bereft of its hero, but of its antagonist, the Indian, as well. And through this loss, the Western is again pronounced "dead." In the 1990s, at least, there seemed to be no more horizons for a Western genre exposed as a racist and imperialist form.

The Gangster/Crime Film

The return of the classical gangster/crime film in this contemporary period is more diffuse than the recurrences of the Western and the stalker film. Although individual crime films such as *The Godfather, Badlands,* and *Body*

Heat returned some of the conventions of the form, it is difficult to isolate a consistent popular cycle of new works. The individual elements of the crime film seem to be dispersed among a wide variety of films. This return sometimes occurs with the inclusion of old film clips into new works, like those from the earlier crime film *Crossfire* (1947) that are incorporated in Martin Scorsese's *Mean Streets* (1973). At other times, the impulse can be noted in the return of a classic crime film title, as in Brian DePalma's *Scarface* (1983), while the film itself significantly refashions the source material. In yet other films, the past genre returns in films that recall a Film Noir atmosphere, like *Devil in a Blue Dress* (1995), or films that quote aspects of its central characters and story, like *L.A. Confidential* (1997).

But aside from these cinematic quotations, what seems distinctive about the gangster/crime genre during this period is its return to the traditional sources of its inspiration. The genre had traditionally prided itself on the "reality" of its source material, claiming from its inception that its stories were "ripped from the headlines." In the 1980s and 1990s, this "commitment to truth" becomes especially pronounced in such crime shows as *Cops* or *America's Most Wanted*. But along with such true crime documentaries as *Aileen Wuornos: The Selling of a Serial Killer* (1992), or even the media coverage of the O. J. Simpson trial, these real events are often structured in accordance with conventions of the crime genre or resound against those earlier forms. Aileen Wuornos, for example, is a female prostitute serial killer, a real woman who does what the femme fatale in earlier Film Noir symbolically threatened. And O. J. Simpson is the up-from-nowhere everyman who murders the beautiful blonde who tempted and betrayed him (the story of both *Double Indemnity* and *The Postman Always Rings Twice*). This awareness of the blurring of the media boundaries between reality and fiction is further dramatized in the pseudo-documentary *Man Bites Dog* (1992). Here the supposed humor of watching a fictional killer participating in the making of an ongoing documentary turns into the hideous reality of watching the brutality of the film itself.

This continual slide between reality and fiction also arises in the restaging of one of the most traumatic events in American history – the assassination of John F. Kennedy and the supposed conspiracy that surrounded it – in Oliver Stone's film *JFK* (1991). The blurring of the boundary between truth and fiction has plagued the film *JFK* from its initial release. It has been criticized not only for its historical inaccuracies but also for its particular restructuring of historical events into a narrative film. Stone has

responded by claiming that he never intended to tell the truth of the situation, although this is precisely what the end titles of the film imply. Stone instead insists that *JFK* is "countermyth," one meant to jolt audiences away from the complacency of the Warren Commission findings and toward a more critical stance regarding the assassination of the President.[9] In response to this claim, however, one must acknowledge that even prior to seeing Stone's film, a majority of Americans already believed the assassination of John Kennedy to be part of a conspiracy.[10] One wonders, then, whether the film *JFK* is really capable of changing thought or of supplying answers to difficult questions, or whether it simply supports an already existing belief.

First, it must be noted that *JFK* is not so much a crime story "snatched from the headlines," as it is a crime story snatched from headlines nearly thirty years old. In going back to this era, *JFK* presents us with events that have been directly or symbolically referred to in many of the films already discussed. Films like *Badlands* and *Halloween,* for example, had posited the year 1963 as a pivotal date, while others had underscored a sense of melancholy or denial created by this trauma as a symbolic watershed moment. Within the context of these films, it would seem that *JFK* forces a confrontation with the events of November 1963. But the promise of any such revelations in *JFK* is encased within the conventions of the traditional detective/crime film, a genre in which a fact-finding hero is drawn into an underworld of wealth, crime, and corruption. *JFK*'s claims to truth or historical accuracy seem doubly suspect since the film is subjected to the constraints of both the narrative form and the crime genre as well.

JFK presents us with past images that have different claims to the truth. The film begins with a montage of documentary footage, accompanied by a voice-over that authoritatively traces Kennedy's rise to power. As the film progresses, however, we are given a dizzying mix of visual and auditory information, ranging from the dramatic and often fictionalized material of Jim Garrison's investigation, to a mix of simulated documentary footage. This "documentary" material includes the near-perfect replication of such well-known historical footage as the shooting of Lee Harvey Oswald on national television, the Abraham Zapruder 16-mm film of the assassination (Figure 35), as well as the speculative renderings of eyewitness testimony. The reality confusion of this montage is then extended with the inclusion of *actual* footage from both the Oswald murder and the Zapruder film. And while the footage from the Zapruder film presents events that

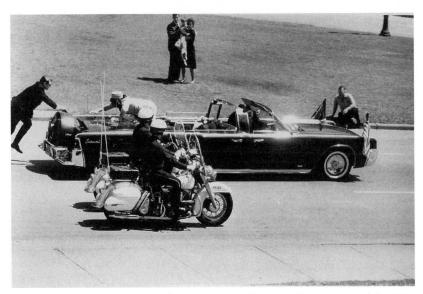

Figure 35. The assassination of John Fitzgerald Kennedy is recreated in *JFK*, Oliver Stone, 1991. Copyright 1991 Warner Bros. Inc.

seemingly cannot be denied, it, too, has been subjected to years of conflicting interpretations.[11] The most disturbing allegations come from the copying and tampering of original footage both by *Life* magazine and the Warren Commission itself. In fact J. Edgar Hoover conceded that frames 312–314 of the film showing President Kennedy immediately before and after the fatal head wound were erroneously, and purposefully, printed in reverse,[12] obfuscating the direction from which the bullet was shot and so the position of the gunman.

The image on frame 313, however, stands on its own, regardless of the direction of the bullet or who may have fired it. The truth of that photographic/film image is undeniable. Here the President's head explodes in just one frame, his brain literally "popping" onto the surface of the film and creating a bloody mark across it. But whereas the other images of the Kennedy assassination are repeated throughout Stone's film, frame 313 appears only in the courtroom sequence. It is repeated three times as Garrison shows the shocking film to the jury, while describing the movement of Kennedy's head across the frames presented in slow motion. "Back and to the left, back and to the left...," Garrison intones, as Kennedy's brain bursts and flops from side to side. This image ruptures

the surface of the film, a surface, as Barthes had theorized, that literally shares the same skin of light as the photographed object. (And perhaps this is the archetypal rupture standing for all of the 1960s cultural and political disruptions we have cited.) The obsessive repetition of the sequence also recalls the Andy Warhol serialized disaster images that had placed us in direct confrontation with images of trauma. In *JFK,* however, we view these images across the timed sequence of film. And as in a traumatic neurosis, we are returned to the event as if to fully assimilate it into psychic life, dulling our senses to it, but also keeping it ever vivid.

But this is only a momentary rupture. The image of impact against flesh opens up for an instant, and then *JFK* closes in around it. The photographic imprint of Kennedy's head wound is only one in an onslaught of images within Stone's film, a composite structure that serves to encase it. The death of John F. Kennedy becomes a movie much more than a once-lived event, or even a memory. It is this tear in the surface of the film, this repeated slash, that is ironically finally entombed, declaring both the death of the myth of John F. Kennedy within its calcified image and the death of the image itself. The ability of the photographic/film image to claim a privileged relationship to reality is damaged. In *JFK* we encounter the cultural truth of the loss of the hero and the loss of the subject the hero once symbolized. But we also face a wall of images that ultimately blocks our access to the real.

Conclusion

In a recent essay, Thomas Elsaesser has offered a definition of the distinctive style of 1980s and 1990s film, which he calls "postclassical film."[13] Elsaesser approaches the postclassical film by a formalist analysis that maintains the language of classical film criticism. He analyzes the films in terms of visual perspective, subject positioning, and temporal narrative structure, and he takes Francis Ford Coppola's *Bram Stoker's Dracula* (1992) as his primary example. Elsaesser notes the extensive use of multiple superimpositions, the subsequent material density of the image, and its weakened ability to represent reality visually. From this perspective, Elsaesser also cites the tendency of the postclassical film to generate narrative from multiple or shifting points of view, and by means of an involuted time structure.

Since Elsaesser's conclusions in some ways resonate with our own, it is important to note crucial differences. Our conclusions are based on a broader body of works and on an approach that formulates issues of textuality, temporality, and the relationship of the image to the natural real. The image here has not solely been rendered material through the process of superimposition. Instead, the replication of old images and texts, and the subsequent layering of references (which we saw operating from *Badlands* to *Dennis the Menace*), has calcified the surface of the image, giving it a material density and rendering it a thing in itself. Complementing Elsaesser's observation of the multiple points of view in postclassical film, we have noted a broader category of the weakened or absent subject, often of the white male hero. Seen in almost all of the films cited here (including *The Texas Chainsaw Massacre, Last Exit to Brooklyn, The Rocky Horror Picture Show,* and even *The Last Temptation of Christ*), this diminished hero position has had the effect of transforming and splintering traditional narrative. Lastly, we have seen how the insistent quoting of past media images has infused the films with a connotation of pastness. For it is not necessarily a convoluted narrative structure that confuses the past and present. Instead, this conflation of time periods has been an inherent quality of the images and the narratives, bestowing on the films the temporal structure of the photograph. The works have thus underlined their spatial proximity and their temporal anteriority, a present tense that is now manifestly past.

But these formal characteristics describe only part of the new style. We have proposed a dynamic model, a resistant practice that can be seen to counter the waning of historicity of postmodern works and this materiality of the sign. Calcified images and old generic elements have formed possible points of resistance through a system of displacements and disruptions. Used as codes, these elements have engendered an internal friction between past and present, between old images and new narratives, and between representation and the real. Instead of diminishing our ability to picture our historical moment, this method has often encouraged confrontations with the present through the rupture of representational surfaces.

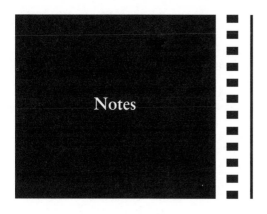

Notes

Chapter 1. The Returned Image

1. Fredric Jameson, "Postmodernism and Consumer Society," in *The Anti-Aesthetic: Essays on Postmodern Culture*, ed. Hal Foster (Port Townsend: Bay Press, 1983). In a later study, *Postmodernism, or, The Cultural Logic of Late Capitalism* (Durham and London: Duke University Press, 1991), Jameson adds to the list of postmodernism's constituent features. These include a new depthlessness, a weakening of historicity, an emotional tone of "intensities," and the relationship of all these to new technologies and to the economic world order (pp. 1–54).
2. See, for example, E. Anne Kaplan, ed., *Postmodernism and Its Discontents: Theories and Practices* (London and New York: Verso, 1988); Perry Anderson, *The Origins of Postmodernity* (London and New York: Verso, 1998).
3. Jameson, "Postmodernism and Consumer Society," 125.
4. Jameson, *Postmodernism, or, The Cultural Logic of Late Capital*, 284
5. Hal Foster, "(Post) Modern Polemics," in *Recodings: Art, Spectacle, Cultural Politics* (Seattle, Washington: Bay Press, 1985).
6. Hal Foster, *The Return of the Real: The Avant-Garde at the End of the Century* (Cambridge, Massachusetts: The MIT Press, 1996).
7. See Hal Foster's discussion of the importance of temporality and textuality in the neo-avant-garde art, ibid., 1–32.
8. Noel Carroll, *Mystifying Movies: Fads and Fallacies in Contemporary Film Theory* (New York: Columbia University Press, 1988), 209–210.
9. Roland Barthes, *Image, Music, Text* (New York: Hill and Wang, 1977). See also Roland Barthes, *Camera Lucida* (New York: Hill and Wang, 1981).
10. Susan Sontag, *On Photography* (New York: Dell Publishing Co., 1973), 54.
11. Barthes, *Camera Lucida: Reflections on Photography*. For Barthes this is the "This has been" of the photograph, a property not before possible in the drawn image, and one that now shares with its referent the very emanation of light. He continues, " . . . light, though impalpable, is here truly a carnal medium, a skin I share with him or her who has been photographed." (126–127).

12. Laura Mulvey, "Visual Pleasure and the Narrative Cinema," *Screen* Vol. 16, No. #3, Autumn 1975.

13. J. Hoberman, "After Avant-Garde Film," in *Art after Modernism: Rethinking Representation,* ed. Brain Wallis (New York: The New Museum of Contemporary Art, 1984).

14. Clement Greenberg, "Modernist Painting," in *The Collected Essays and Criticism,* Vol. 4, ed. John O'Brian (Chicago: Chicago University Press, 1993).

15. Douglas Crimp, "The Photographic Activity of Postmodernism", *October* #15, Winter 1980.

16. ———, See an early discussion of this practice in *Pictures,* catalogue for exhibition, Artists Space, New York, September 24–October 29, 1977.

17. Jameson, "Postmodernism and Consumer Society," 117.

18. Roland Barthes, *Mythologies* (New York: Hill and Wang, 1957), 135.

19. Roland Barthes, "Change the Object," in *Image, Music, Text* (New York: Hill and Wang, 1977), 167.

20. See Hal Foster's discussion of appropriation and trauma in the work of Richard Prince and other contemporary artists in *The Return of the Real,* 145–152.

21. Noel Carroll, "The Future of Allusion: Hollywood in the Seventies (and Beyond), *October* #20, Spring 1982, 56.

22. Ibid., 61.

23. Robert Kolker, *A Cinema of Loneliness,* Second Edition (New York: Oxford University Press, 1988), ix–xv.

24. Kerry Brougher, *Art and Film Since 1946: Hall of Mirrors* (New York: Monticello Press, 1996).

25. Foster, *The Return of the Real,* 93.

26. Barthes, "The Rhetoric of the Image," 38.

Chapter 2. Art and Film: New York City in the Late 1970s

1. Roland Barthes, *The Pleasure of the Text* (New York: Hill and Wang, 1975).

2. Clement Greenberg, "Modernist Painting," in *The Collected Essays and Criticism,* Vol. 4, ed. John O'Brian (Chicago: Chicago University Press, 1993), 85.

3. Douglas Crimp, "Pictures" *October* #8, Spring 1978. See also *Pictures* by Douglas Crimp, op. cit.

4. Barthes, *Camera Lucida,* 15.

5. Carroll, "The Future of Allusion," 70.

6. Arthur C. Danto, *After the End of Art* (Princeton, New Jersey: Princeton University Press, 1997), 15.

7. Greenberg, "Modernist Painting," 85.

8. Rosalind Krauss, "Sculpture in the Expanded Field," in *The Anti-Aesthetic,* ed. Hal Foster (Port Townsend: Bay Press, 1983), 41.

9. Crimp, "Pictures," 177.

10. See Dick Hebdige, *Subculture: The Meaning of Style* (London and New York: Routledge, 1987).

11. In conversation with Robert Longo and Eric Bogosian, 1977.

12. Crimp, "Pictures," 181.

13. Ibid.

14. Jean-Pierre Oudart, "Cinema and Suture," *Screen*, Vol. #18, No. 1, (1974). See also Daniel Dayan, "The Tutor Code of Classical Cinema," *Film Quarterly*, Vol. 29, No. 1 (Fall 1975) and William Rothman, "Against the System of the Suture," *Film Quarterly*, Vol. 29, No. 1 (Fall 1975).

15. Foster, *The Return of the Real*, 138–141.

16. New York Punk music and styles should be distinguished from the nearly contemporaneous emergence of British Punk in the late 1970s. Based on the different social and economic conditions, each resulted in varying forms of subversive music and styles. New York Punk was more characterized by the ironic displacement of old music forms and images (often alluding to photographic or television sources such as the Blondie songs "Picture This" or "Fade Away and Radiate") and so connected with art concerns of the period. British Punk, in contrast, was more aggressive and nihilistic, responding to the British economic depression of the 1970s. Characterized by such groups as the Sex Pistols and the Clash, the music and its once individualistic styles of body piercing, ripped clothing, spiked hair, and stage diving have since been incorporated by much of Punk culture today. Commercialized, it has lost much of its original cutting edge. See also Dike Blaire, *Punk* (New York: Urizen Books, 1978).

17. Foster, *The Return of the Real*, 1–32.

18. Peter Burger, *The Theory of the Avant-Garde* (Minneapolis: The University of Minnesota Press, 1994).

19. P. Adams Sitney, *Visionary Film* (New York: Oxford University Press, 1978), vi.

Chapter 3. Returned Genres: The Dream Has Ended

1. Michael Walsh, "Jameson and Global Aesthetics," in *Post Theory: Reconstructing Film Studies,* ed. David Bordwell and Noel Carroll (Madison: The Wisconsin University Press, 1996), 496–499.

2. In our discussion, the designation "the 1960s" will be used to refer to the politically crucial period encompassing the years 1963 to 1973. Accordingly, the period "the 1950s" will include that decade proper, as well as the politically conservative period of the early 1960s.

3. Hal Foster, *The Return of the Real*, 136–144.

4. Ibid., 145.

5. Ibid., 130–136.

6. Robin Wood, *Hitchcock Revisited* (New York: Columbia University Press, 1989), 150.

7. William Rothman, *The Murderous Gaze* (Cambridge: Harvard University Press, 1986), 332–336.

8. Rothman, *The Murderous Gaze* (Cambridge: Harvard University Press, 1986), 229.

9. Robin Wood, "An Introduction to the American Horror Film," in *American Nightmare* (Toronto: Festival of Festivals Publications, 1979).
10. See Hal Foster, "Postmodernism in Parallax," *October #63,* Winter 1993, 8, for a discussion of the representation of the imaginary body.
11. Julia Kristeva, *The Powers of Horrors* (New York: Columbia University Press, 1982).
12. Richard Eder, *The New York Times,* August 12, 1976, 38:1.
13. Will Wright, *Sixguns and Society* (Berkeley: University of California Press, 1975), 32–58.
14. Jane Feuer, *The Film Musical* (Bloomington: Indiana University Press, 1982), 110–111.

Chapter 4. Reconsidering the Nostalgia Film

1. Bernardo Bertolucci as quoted by T. Jefferson Kline, in *I Film di Bernardo Bertolucci: Cinema e Psicanalisi* (Roma: Gremese Editore, 1994), 83.
2. Ibid., 84.
3. J. Hoberman, *Midnight Movies* (New York: Harper and Row, 1983), 176.
4. Ibid., 179.
5. Mikhail Bakhtin, *The Problems of Dostoyevsky's Poetics* (Ann Arbor, Michigan: Ardis, 1973).
6. Robert Stam, *Reflexivity in Film and Literature: From Don Quixote to Jean-Luc Godard* (New York: Columbia University Press, 1992), 167–208.
7. Hoberman, *Midnight Movies,* 177.

Chapter 5. A Return to the 1950s: The Dangers in Utopia

1. Jameson, *Postmodernism, or, The Cultural Logic of Late Capital,* 19.
2. *Grease* began as a small stage production in Chicago in 1971 before steadily growing in popularity. By 1979 it had become the longest running show on Broadway, and with the release of the film version in 1978, the biggest hit movie musical of all time. Both the film and the stage play thus reached the peak of their market potential in the late 1970s. In the present discussion, however, I will address only the film version, showing how a cultural group embraced *Grease*'s thematic and cinematic elements at a particular time in history.
3. Fredric Jameson, "The Transformation of the Image," in *The Cultural Turn: Selected Writings on the Postmodern, 1983–1998* (London and New York: Verso, 1998), 129.
4. The name "Zuko" is only presented in spoken form throughout the film and so is understood as an Italian surname. When presented in the film's end credits, however, one could note that there is no "k" in the Italian alphabet. The casting of the Italian-American John Travolta as Danny Zuko, however, further implicates the character as being of Italian extraction.

5. Sonny's last name, for example, could be spelled "La Tijera," making him of Spanish extraction. Since his name is never presented in written form throughout the film, the association remains ambiguous.

6. Jameson, *Postmodernism, or, The Cultural Logic of Late Capital*, 1–54.

Chapter 6. Coppola and Scorsese: Authorial Views

1. Vera Dika, "The Representation of Ethnicity in *The Godfather*" in *Francis Ford Coppola's* The Godfather *Trilogy*, ed. Nick Browne (New York: Cambridge University Press, 2000).

2. *Variety*, "Apocalypse Now," May 16, 1979.

3. See, for example, Frank P. Tomasulo, "The Politics of Ambivalence: *Apocalypse Now* as Pro-war and Anti-war Film," in *From Hanoi to Hollywood: The Vietnam War in American Film*, ed. Linda Dittmar and Gene Michaud (New Brunswick and London: Rutgers University Press, 1990), 145–158.

4. Jameson, *Postmodernism, or, The Cultural Logic of Late Capital*, 44.

5. Pauline Kael, "The Current Cinema: Melted Ice Cream," *The New Yorker*, February 1, 1982, 118.

6. Andrew Sarris, *The Village Voice*, January 27, 1982, 45.

7. "New York Critics Scorecard," *Variety*, February 17, 1982, 8.

8. Francis Coppola, as quoted by Ted Johnson, "The Gambler," *Variety*, November 11, 1997, 20.

9. Francis Coppola, quoted in Jonathan Cott, "*Rolling Stone* Interview: Francis Coppola," *Rolling Stone*, March 18, 1982, 25.

10. Morris Lapidus, quoted in *Progressive Architecture*, September, 1970, 120.

11. Robert Venturi, *Learning from Las Vegas* (Cambridge, Massachusetts and Cambridge, England: MIT Press, 1972), 80.

Chapter 7. To Destroy the Sign

1. Guy Debord, *The Society of the Spectacle*, transl. Donald Nicholas-Smith (New York: Zone Books, 1995).

2. See Andrew Horton and Stuart Y. McDougal, eds., *Play It Again Sam: Retakes on Remakes* (Berkeley: University of California Press, 1998).

3. See Ira Konigsberg, "How Many Dracula's Does It Take To Change A Light-bulb?" and Leo Baudry, "Afterword: Rethinking Remakes," in Horton and McDougal, *Play It Again Sam*.

4. Vera Dika, *Games of Terror: Halloween and the Films of the Stalker Cycle* (Rutherford: Fairleigh Dickinson University Press, 1990).

5. John Carpenter, interview, "Riding High on Horror," *Cinefantastique*, Vol. 10, No. #1, Summer 1980, 6.

6. Steve Schneider, "Kevin Williamson and the Rise of the Neo-Stalker," *Post Script: Essays in Film and the Humanities*, Vol. 19, No. #2, Winter/Spring 2000, 73–87.

7. Fredric Jameson, "Transformation of the Image in Postmodernity," *The Cultural Turn* (London: Verso, 1998), 99.

8. Will Wright, *Six Guns and Society* (Berkeley: University of California Press, 1975).

9. Oliver Stone interview with Col. L. Fletcher Prouty, January 15, 1992. *Oliver Stone Discusses His Film JFK* (yahoo.com, search: JFK).

10. See Christopher Sharrett, "Conspiracy Theory and Political Murder in America: Oliver Stone's *JFK* and the Facts of the Matter," in *The New American Cinema,* ed. Jon Lewis (Durham and London: Duke University Press, 1998).

11. Art Simon, *Dangerous Knowledge: The Assassination in Art and Film* (Philadelphia: Temple University Press, 1996), 35–54.

12. Ibid., 40.

13. Thomas Elsaesser, "Specularity and Engulfment: Francis Ford Coppola and *Bram Stoker's Dracula,*" in *Contemporary Hollywood Cinema,* ed. Steve Neale and Murray Smith (London: Routledge, 1998), 191–208.

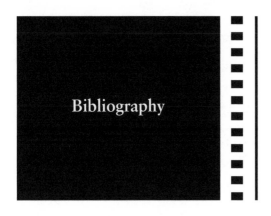

Bibliography

Altman, Rick. *The American Film Musical*. Bloomington: Indiana University Press, 1989.

Anderson, Perry. *The Origins of Postmodernity*. London and New York: Verso, 1998.

Ansen, David. "Coppola's Fairy Tale World" (review of *One from the Heart*), *Newsweek*, January 25, 1982, p. 74.

Bakhtin, Mikhail. *Problems of Dostoyevsky's Poetics*. Ann Arbor, Michigan: Ardis, 1973.

Barthes, Roland. *Camera Lucida: Reflections on Photography*. New York: Hill and Wang, 1981.

———. *Image, Music, Text*. New York: Hill and Wang, 1977.

———. *Mythologies*. New York: Hill and Wang, 1977.

Battcock, Gregory, ed. *Super Realism: A Critical Anthology*. New York: E.P. Dutton, 1977.

Baudry, Jean-Louis. "Ideological Effects of the Basic Apparatus," *Film Quarterly*, Vol. XXVI, No. 2, Winter, 1974–75.

Baudrillard, Jean. *Simulations*. New York: Semiotext(e), 1983.

Bazin, Andre. *What is Cinema?* 2 vols. Berkeley: University of California Press, 1967.

Belton, John, ed. *Movies and Mass Culture*. New Brunswick, New Jersey: Rutgers University Press, 1996.

———. *American Cinema/American Culture*. New York: McGraw–Hill Inc., 1994.

Benjamin, Walter. *Illuminations*. New York: Schochen Books, 1968.

Benson, Sheila, "One From the Heart" (review), *Los Angeles Times*, January 22, 1982, Section 6, p.1.

Bergen, Ronald. *Francis Ford Coppola Close Up: The Making of His Movies*. New York: Thunder's Mouth Press, 1998.

Berger, John. *Ways of Seeing*. London: Penguin, 1972.

Blair, Dike. *Punk*. New York: Urizen Books, 1978.

Bordwell, David, and Noel Carroll, eds. *Post-Theory: Restructuring Film Studies*. Madison: University of Wisconsin Press, 1996.

Bordwell, David, Janet Staiger, and Kristin Thompson. *The Classical Hollywood Cinema: Film Style and Mode of Production To 1960*. New York: Columbia University Press, 1985.

Brooker, Peter, and Will Brooker, eds. *Postmodern After-Images: A Reader in Film, Television, and Video*. London: Arnold, 1997.

Brougher, Kerry. *Art and Film Since 1946: Hall of Mirrors*, catalogue for exhibition at The Museum of Contemporary Art, Los Angeles. New York: Monocelli Press, 1996.

Burger, Peter. *The Theory of the Avant-Garde*. Minneapolis: University of Minnesota Press, 1984.

Carroll, Noel. *Theorizing the Moving Image*. New York: Cambridge University Press, 1996.

_____. *The Philosophy of Horror or Paradoxes of the Heart*. New York: Routledge, 1990.

_____. *Mystifying Movies: Fads and Fallacies in Contemporary Film Theory*. New York: Columbia University Press, 1988.

_____. "The Future of Allusion: Hollywood in the Seventies (and Beyond)," *October* #20, Spring 1982.

Cawelti, John G. *The Six-Gun Mystique*, Bowling Green: State University Popular Press, 1984.

_____. *Adventure, Mystery, and Romance*. Chicago: University of Chicago Press, 1976.

Clarens, Carlos. *Crime Movies*. New York: Da Capo Press, 1980.

Clover, Carol. *Men, Women, and Chainsaws: Gender and the Horror Film*. Princeton, New Jersey: Princeton University Press, 1992.

Corrigan, Timothy. *A Cinema Without Walls: Movies and Culture After Vietnam*. New Brunswick: Rutgers University Press, 1991.

Crimp, Douglas. "The Photographic Activity of Postmodernism," *October* #15, Winter 1980.

Crimp, Douglas. *Pictures*. Catalogue for exhibition at artists Space, September 24–October 29, 1977.

_____. "Pictures," *October* #8, Spring 1978.

Danto, Arthur C. *After the End of Art*. Princeton, New Jersey: Princeton University Press, 1997.

Deren, Maya. "Cinematography: The Creative Use of Reality," *Daedalus*, Winter 1960.

Debord, Guy. *The Society of the Spectacle* (translation by Donald Nicholas Smith). New York: Zone Books, 1995.

Dika, Vera. "The Representation of Ethnicity in *The Godfather*," in *Francis Ford Coppola's The Godfather Trilogy*, edited by Nick Browne. New York: Cambridge University Press, 2000.

_____. "From Dracula With Love: *Bram Stoker's Dracula*," in *The Dread of Difference: Gender and the Horror Film*, edited by Barry Keith Grant. Austin: University of Texas Press, 1996.

———. *Games of Terror: Halloween and the Films of the Stalker Cycle*. Rutherford, New Jersey: Farleigh Dickinson University Press, 1991.

———. "Robert Longo in Performance," *Artscribe*, July 1988.

———. "The Stalker Film 1978–1981," in *American Horrors*, edited by Gregory Waller. Urbana and Chicago: University of Illinois Press, 1987.

———. "A Feminist Fairytale: Ericka Beckman's *Cinderella*," *Art in America*, Spring 1987.

Dittmar, Linda, and Gene Michaud, eds. *From Hanoi to Hollywood: The Vietnam War in American Film*. New Brunswick: Rutgers University Press, 1990.

Elsaesser, Thomas. "Specularity and Engulfment: Francis Ford Coppola and *Bram Stoker's Dracula*," in *Contemporary Hollywood Film*, edited by Steve Neale and Murray Smith. London: Routledge, 1998.

Feuer, Jane. *The Film Musical*. Bloomington: Indiana University Press, 1982.

Foster, Hal. *The Return of the Real: The Avant-Garde at the End of the Century*. Cambridge, Massachusetts: The MIT Press, 1996.

———. "Postmodernism in Parallax," *October #63*, Winter 1993.

———. "(Post) Modern Polemics," in *Recodings: Art, Spectacle, Cultural Politics*. Seattle: Bay Press, 1985.

———. ed. *The Anti-Aesthetic: Essays in Postmodern Culture*. Port Townsend: Washington Bay Press, 1983.

Gallagher, Steve, ed. *Picture This: Films Chosen by Artists*. Buffalo, New York: Hallwalls, Contemporary Arts Center, 1987.

Godard, Jean Luc. *Godard on Godard*. New York: Viking, 1972.

Greenberg, Clement. "Modernist Painting," in *The Collected Essay's and Criticism*, edited by John O'Brian. Chicago: University of Chicago Press, 1993.

———. "Avant-garde and Kitsch, " in *Art and Culture*. Boston: Beacon Press, 1961.

Hager, Steven. *Art After Midnight*. New York: St. Martin's Press,1986.

Hebdige, Dick. *Subculture: The Meaning of Style*. London and New York: Routledge, 1979.

Herr, Michael. *Dispatches*. New York: Vintage Books, 1991.

Hoberman, J. "After Avant-Garde Film," in *Art After Modernism*, edited by Brian Wallis. New York: The New Museum of Contemporary Art, 1984.

Hoberman, J., and Jonathan Rosenbaum. *Midnight Movies*. New York: Harper & Row, 1983.

Horton, Andrew, and Stuart Y. McDouglas, eds. *Play it Again Sam: Retakes on Remakes*. Berkeley: University of California Press, 1998.

Hutcheon, Linda. *Irony's Edge*. London and New York: Routledge, 1994.

———. *The Politics of Postmodernism*. London and New York: Routledge, 1989.

Huyssen, Andreas. *After the Great Divide*. Bloomington and Indianapolis: Indiana University Press, 1986.

James, David. *Allegories of Cinema*. Princeton, New Jersey: Princeton University Press, 1989.

———. *Power Misses: Essays Across (Un)Popular Culture*. London and New York: Verso, 1996.

Jameson, Fredric. *The Cultural Turn: Selected Writings on the Postmodern, 1983–1998*. London and New York: Verso, 1998.

———. *Postmodernism, or, The Cultural Logic of Late Capitalism*. Durham and London: Duke University Press, 1991.

———. *Signatures of the Visible*. London and New York: Routledge, 1990.

———. "Nostalgia for the Present," *South Atlantic Quarterly* Vol. 88.2, Spring 1989.

———. "Postmodernism and Consumer Society," in *The Anti-Aesthetic*, edited by Hal Foster. Port Townsend, Washington: Bay Press, 1983.

———. *The Political Unconscious: Narrative as a Socially Symbolic Act*. Ithica, New York: Cornell University Press, 1981.

Johnson, Ted. "The Gambler," *Daily Variety*, November 11, 1997.

Jay, Martin. *Downcast Eyes*. Berkeley: University of California Press, 1993.

Kael, Pauline, "The Current Cinema: Melted Ice Cream" (review of *One from the Heart*), *New Yorker*, February 1, 1982, p. 118.

Kaplan, E. Anne, ed. *Postmodernism and Its Discontents: Theories and Practices*. London and New York: Verso, 1988.

———. *Rocking Around the Clock: Music Television, Mass Media, and Consumer Culture*. New York: Methuen, 1987.

Kline, T. Jefferson. *I Film di Bernardo Bertolucci: Cinema e Psicanalisi*. Roma: Gremese Editore, 1993.

Koch, Stephen. *Stargazer*. New York: Praeger Publishers, 1973.

Koehler, Robert. "Kurtz's Horror Almost Coppola's Waterloo," *Daily Variety*, November 11, 1997.

Kolker, Robert Phillip. *A Cinema of Loneliness*, second edition. New York: Oxford University Press, 1988.

———. *A Cinema of Loneliness*, first edition. New York: Oxford University Press, 1980.

Krauss, Rosalind. Essay in *Cindy Sherman 1975–1993*. New York: Rizzoli, 1993.

———. "Sculpture in the Expanded Field," in *The Anti-Aesthetic*, edited by Hal Foster. Port Townsend, Washington: Bay Press, 1983.

Lewis, Jon, ed. *The New American Cinema*. Durham and London: Duke University Press, 1998.

———. *Whom God Wishes to Destroy*. Durham and London: Duke University Press, 1995.

McArthur, Colin. *Underworld USA*. New York: The Viking Press, 1972.

Michelson, Annette. "Camera Lucida/Camera Obscura," *Artforum*, January, 1973, pp. 30–37.

Mulvey, Laura. "Visual Pleasure and the Narrative Cinema," *Screen*, Vol. 16, No. 3, Autumn 1975.

Neale, Steve, and Murray Smith, eds. *The Contemporary Hollywood Film*. London: Routledge, 1998.

Propp, Vladimir. *The Morphology of the Folktale*. Austin: The University of Texas Press, 1968.

Ray, Robert. *A Certain Tendency in the Hollywood Cinema*. Princeton, New Jersey: Princeton University Press. 1985.

Rothman, William. *Documentary Film Classics*. New York: Cambridge University Press, 1997.

_____. *The Murderous Gaze*. Cambridge, Massachusetts: Harvard University Press, 1986.

Schatz, Thomas. *Hollywood Genres*. New York: Random House, 1981.

Selby, Hubert, Jr. *Last Exit to Brooklyn*. New York: Grove Weidenfeld, 1957.

Sharrett, Christopher. "Conspiracy Theory and Political Murder in America: Oliver Stone's *JFK* and the Facts of the Matter," in *The New American Cinema*, edited by Jon Lewis. Durham and London: Duke University Press, 1998.

Simon, Art. *Dangerous Knowledge: The JFK Assassination in Art And Film*. Philadelphia: Temple University Press, 1996.

Sitney, P. Adams. *Visionary Film*. New York: Oxford University Press, 1972.

Sontag, Susan. "The Decay of Cinema," *The New York Times Magazine*, February 26, 1996.

_____. *On Photography*. New York: Dell Publishing Co., 1973.

Stam, Robert. *Reflexivity in Film and Literature: From Don Quixote to Jean-Luc Godard*. New York: Columbia University Press, 1992.

Variety. "New York Critics Scorecard," *The New York Times*, February 17, 1982, p. 8.

_____. "*One From The Heart*," January 20, 1982.

_____. "*Apocalypse Now*," May 16, 1979.

Venturi, Robert, Denise Scott Browne, and Steven Izenour. *Learning from Las Vegas*. Cambridge, Massachusetts, and Cambridge, England: The MIT Press, 1972.

Wallis, Brian, ed. *Art After Modernism: Rethinking Representation*. New York: The Museum of Contemporary Art, 1984.

Walsh, Michael. "Jameson and 'Global Aesthetics'," in *Post-Theory: Reconstructing Film Studies*, edited by David Bordwell and Noel Carroll. Madison, Wisconsin: The University of Wisconsin Press, 1996.

Wood, Robin. *Hitchcock's Films Revisited*. New York: Columbia University Press, 1989.

_____. *Hollywood from Vietnam to Reagan*. New York: Columbia University Press, 1986.

_____. "Introduction to the American Horror Film," in *American Nightmare*. Toronto: Festival of Festivals Publications, 1979.

Wright, Will. *Sixguns and Society*. Berkeley: University of California Press, 1975.

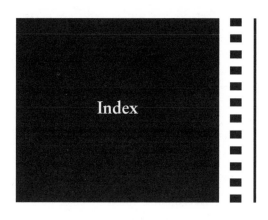

Index

abstract expressionism, 161
Allen, Woody, 200–201
American Graffitti, 10, 56, 89–94
 Jameson on, 89
Anthology Film Archives, 8
Anti-smoking ad, 12–14
Anticipation of the Night,
 166–167
Apocalypse Now
 African Americans in, 164–165,
 167–168
 apocalypse in, 159
 decentering in, 167–169
 postmodernism and, 159, 168
Arnulf Ranier, 7
artificial myth, 12
Astaire, Fred, 175
Avant-garde films, 5
 narrative in, 50. *See also* Narration
 See also specific films, directors

baby-boomers, 142, 202
Bacall, Lauren, 80
Back to the Future, 144–145
Badlands, 56–65
Bakhtin, Mikhail, 106
Band, The, 84–87
Barthes, Roland, 6–7, 11–12, 212,
 225n11
Baudrillard, Jean, 189, 197
Benjamin, Walter, 4, 39, 105
Bertolucci, Bernardo, 95–102

Blank Generation, The, 48–49, 87, 88
body, 66, 73–76
Bonnie and Clyde, 63
Bosch, Hieronymus, 195
Brakhage, Stan, 7, 160, 161, 166–167
Bram Stoker's Dracula, 223
Buñuel, Luis, 106, 113

Cabinet of Dr. Caligari, The, 162
Camera Lucida (Barthes), 225n11
carnivalesque, 106–107
Carpenter, John, 16, 208
Carroll, Noel, 14–15, 29–30, 66, 94,
 116
Casebere, James, 182
Catholic Church, 113, 189
Chapman, Michael, 86
Christ, 188–196
Cinema of Loneliness, 16, 17
cinema-verite, 69, 84
classical film genres, 16, 43, 83
Cole, Nat King, 62
Columbine shootings, 210
comic books, 204, 205
Coming-of-age films, 127
Conformist, The, 95–103
Conversation, The, 156
Conrad, Joseph, 171
Coppola, Francis Ford, 16, 17–18,
 156–188, 223
Cornell, Joseph, 18
Craven, Wes, 209

Crimp, Douglas, 26, 41
Curry, Tim, 116

Dadaists, 106
Dafoe, Willem, 192, 194
Dali, Salvador, 181
Dances with Wolves, 216–217
Danto, Arthur C., 30
Davis, Bette, 1
Dean, James, 58, 59, 94, 127
Debord, Guy, 204
Dennis the Menace, 203
Deren, Maya, 5–6, 7, 8, 29
detective genre, 156
The Doors, 160, 161
Dracula, 67, 205–206
Dylan, Bob, 84, 86

Eastwood, Clint, 218
Edel, Uli, 145
Eisenstein, Sergei, 160
Elsaesser, Thomas, 223–224
Elvis I and II (Warhol), 39, 40
ethnicity, 157, 131–134, 142

fascism, 95–96, 101
Fellini, Federico, 97
fetish, 207
Feuer, Jane, 84, 116
Film and Art after 1946 (MOCA), 18
Film Noir, 51, 157, 162
Flintstones, 203
The Foreigner, 50–54
Forest, Fredric, 174
Foster, Hal, 2, 12n20, 20, 45, 48,
 65–66, 74n10, 75
Frampton, Hollis, 25
French New Wave, 40, 41, 202
Freudian theory, 161, 207, 208

Gabriel, Peter, 194
Gangster/Crime film, 157, 219–223
Garr, Teri, 174
Gayle, Crystal, 176, 184, 185
Gaze, 45, 73, 207

Gein, Ed, 68
gender, 7, 46, 150, 133–140, 142,
 149–150
Geronimo: An American Legend, 218
Godard, Jean-Luc, 4, 7, 9, 15, 50, 97,
 106, 180
Godfather, The, 17, 157–158
Godspell, 190
Goldstein, Jack, 8, 26–36
Graham, Bill, 165
Grease, 123–143, 228n2
 ethnicity in, 132–134
 female sexuality and, 134–140
Greenberg, Clement, 8, 30
Gulf War, 218

Hall of Mirrors (MOCA) exhibition,
 18–20
Halloween, 208–209
Heart of Darkness (Conrad), 171
Heche, Anne, 214
Hitchcock, Alfred, 67, 71
Hitler, Adolph, 100
homosexuality, 98, 102, 106, 117,
 141, 154
Hopper, Edward, 60, 147
horror film, 66, 68
Howard, Ron, 80
Hughes, John, 204

iconoclasts, 189
ideology, 12
image, debates on, 4–20

Jameson, Fredric, 1, 56, 90, 122–123,
 124, 215
 on multinational capitalism, 1, 55
 on narrativity, 169
 on the nostalgia film, 9–10, 123
 on pastiche, 1–2, 11, 33
 postmodernism and, 2
 on schizophrenia, 2, 11, 33
Jarry, Alfred, 106, 107, 110
Jesus Christ Superstar, 190
JFK, 220–223

Jouissance, 26
Julia, Raul, 175
Jump, The, 26–31

Kabuki theater, 184
Kael, Pauline, 170
Keaton, Buster, 19, 106, 199, 200
Keitel, Harvey, 192
Kelly, Gene, 171, 174, 178
Kennedy, John F., 62, 93, 220–223
Kinski, Nastassia, 175
Kraus, Rosalind, 31
Kristeva, Julia, 76
Kubelka, Peter, 7

Lacan, Jacques, 45, 65
Las Vegas, 172–174, 179, 181
Last Exit to Brooklyn, The, 145–155
Last of the Mohicans, The, 218
Last Temptation of Christ, The,
 188–196
Last Waltz, The, 83–88
Leven, Boris, 85
Leone, Sergio, 218
Longo, Robert, 8, 9, 36–37, 39–41
Lucas, George, 89
Lurie, John, 192

Malick, Terrence, 56–65
Man with a Movie Camera, 5
Marlboro ad, 12–14
McCabe and Mrs. Miller, 15, 16
Men in the Cities, 36–41
Michelson, Annette, 8
mirror stage, 74
Mission: Impossible, 203
MOCA. *See* Museum of
 Contemporary Art
modernism, 30, 106
Moravia, Alberto, 96
Mudd Club, 116
Multinational Capitalism, 1, 55
Mulvey, Laura, 7, 116
musical, the, 83–84, 118–119, 140,
 178

generic elements, 174–188
See also specific films
Mussolini, Benito, 100
mystification, 208
myth
 artificial myth, 12
 Barthes on, 11–12
 definition of, 11
Mythologies (Barthes), 11

narrative, 42–43, 49, 50, 161, 169
Nazi concentration camps, 67
Neo-avant-garde, 48, 69, 225n7
New Wave, 41, 202. *See also* Punk
Noh theater, 184–185
Nostalgia, 25–26

object gaze, 45, 66
One from the Heart, 170–188
 aspect ratio, 171
 classical musical the and, 174–188
 color in, 179
 Las Vegas and, 172–174, 179, 181
 Pennies from Heaven and, 200
 postmodern art and, 182
optical unconscious, 39
Oudart, Jean-Pierre, 44

pastiche, 1–2, 33
Peggy Sue Got Married, 145
Penn, Arthur, 63
Pennies from Heaven, 199–200
Peters, Bernadette, 199
photorealist painting, 60, 65, 69
Pictures group show, 8, 26
Piro, Sal, 105, 116
plaisir, 26
Plato's cave, 100
Pleasantville, 201
Poe, Amos, 9, 48–49, 50
Pollock, Jackson, 25
Posse, 217
postclassical film, 223
postmodernism, 1, 2, 30–31, 49, 107,
 159, 167

Prince, Richard, 226n20
Production Code Administration, 157
Psycho, 67, 71, 72, 73, 77, 208, 214
Psycho (Van Sant), 211–215
Punk films, 9, 50
Punk music, 47, 49, 51, 227n16
Purple Rose of Cairo, The, 200–201

Raiders of the Lost Ark, 1, 205
Ramones, The, 47
Ray, Nicholas, 63
Reagan era, 171
real, the, 2–3, 65–66
 loss of, 169, 171, 197–202
 representation and, 156, 158, 171,
 173, 178, 183, 190–191, 198
 trauma and, 3, 65–66, 75, 77, 102
Rebel without a Cause, 91
resistance, 2–4, 11–14
Resnais, Alain, 97
Return of the Real (Foster), 65–66
Ricci, Christina, 1
Riefenstahl, Leni, 28
Robertson, Robbie, 84
rock concert film, 83, 84, 86
Rocky Horror Picture Show, The,
 103–121

schizophrenia, 1, 2, 11, 33, 65
Schrader, Paul, 188
Scorsese, Martin, 16, 83–88, 156,
 188–196
Scream, 209
Selby Jr., Hubert, 145
self-reflexivity, 18–19, 29, 33, 97, 112
serialized forms, 205–207
ShaNaNa, 125
Shane, 218
Sherlock Jr., 19, 106, 199, 200
Sherman, Cindy, 9, 41–46, 75, 150,
 152
Shootist, The, 78–83, 219
Siegei, Don, 79
Silverado, 216
Simmons, Laurie, 182

Sitney, P. Adams, 8, 24, 49
Six Minute Drown, The, 32–33
Snow, Michael, 7, 27
Spielberg, Steven, 16
stalker films, 207–215
Stam, Robert, 106
Star Wars, 1, 205
Stevens, George, 193
Stewart, James, 80, 81
Stone, Oliver, 220
Streets of Fire, 143–144
structural film, 7, 24
A Summer Place, 127, 128, 136–137
surrealism, 69, 74, 106, 161
suture, 44

television, 202–205
The Texas Chainsaw Massacre, 66–78
 body in, 74
 mirror stage and, 74
 postmodern art and, 78
 Psycho and, 77
 Wood essay, 74
They Live by Night, 63
time-travel films, 201
traumatic illusionism, 65
traumatic realism, 65–66, 75
Truman Show, The, 198
Twilight Zone, The, 198
Two Fencers, 31–32
Tzara, Tristan, 107

Ubu Roi (Jarry), 107, 110
Un Chien Andalou, 75–76, 107, 161
Unforgiven, The, 218
Untitled Film Stills (Sherman), 41–46

Van Sant, Gus, 211–215
Velasquez, Diego, 46
Venturi, Robert, 173
Vertov, Dziga, 5, 6, 19
Vietnam War, 55, 63, 65, 70, 71, 77,
 94, 158, 159, 162, 164, 168

Waits, Tom, 176, 184, 185
Warhol, Andy, 34, 39, 50, 60

Watergate, 63
Wavelength, 7–8
Wayne, John, 78–79, 80, 82, 216
Western genre, 70, 78, 79, 82, 164,
 190, 215–219
Western hero, 217
Where the Boys Are, 137
Wild Wild West, The, 203
Williamson, Kevin, 209

Wood, Robin, 74
Woodstock, 84, 126
"Work of Art in the Age of
 Mechanical Reproduction, The"
 (Benjamin), 4
Wyeth, Andrew, 60

Zelig, 200
Zemeckis, Robert, 144